Picturing the City
in Medieval
Italian Painting

Picturing the City in Medieval Italian Painting

FELICITY RATTÉ

McFarland & Company, Inc., Publishers
Jefferson, North Carolina, and London

LIBRARY OF CONGRESS CATALOGUING-IN-PUBLICATION DATA

Ratté, Felicity.
Picturing the city in medieval Italian painting / Felicity Ratté.
p. cm.
Includes bibliographical references and index.

ISBN-13: 978-0-7864-2428-3
ISBN-10: 0-7864-2428-1
(softcover : 60# alkaline paper) ∞

1. Cities and towns in art. 2. Architecture in art.
3. Narrative painting, Italian. 4. Painting, Medieval—Italy. I. Title.
ND1460.C57R38 2006 758'.74509022—dc22 2006020674

British Library cataloguing data are available

On the cover:
Allegories of Good Government: The Effects of Good Government in the City and Country,
Ambrogio Lorenzetti, fresco, Pallazzo Pubblico, Siena, Italy, 1338-39

Manufactured in the United States of America

*McFarland & Company, Inc., Publishers
Box 611, Jefferson, North Carolina 28640
www.mcfarlandpub.com*

Acknowledgments

This book was quite some time in coming and it has benefited greatly from the author's slow process of maturation and the input of countless people along the way. It was begun as a dissertation; that work established the question that is finally answered, although still perhaps inadequately, in the present book. I wish to thank my professors and colleagues at the Institute of Fine Arts, particularly Marvin Trachtenberg, for their assistance with the initial phase of this work.

My post-dissertation research into the question of the meaning of medieval architectural images was sifted through ten years of classroom teaching in which I had the great good fortune to encounter a wide variety of intellectual challenges. Thus I shall begin my acknowledgments by thanking my students. From them I have learned things that I never could have learned in the library, the archive or the museum, and for them I have tried to write this book.

Marlboro College, and the former Dean of Faculty, John Hayes, who supported many years of summer research and provided an atmosphere of intellectual rigor that kept this project alive, also deserves my heartfelt thanks. Without that community this book would not have been possible.

It gives me great pleasure to also acknowledge my great debt to the institutions that make this work possible, in particular the Biblioteca Herziana and Biblioteca Vaticana in Rome, the Archivio di Stato di Siena, the Biblioteca del Sacro Convento di Assisi, the Biblioteca Nazionale in Florence and most importantly the Kunsthistorisches Institut Florenz and its fototeca.

I would like to thank my colleagues at Marlboro College, particularly Seth Harter, Carol Hendrickson, Meg Mott, Kate Ratcliff, and John Sheehy, for reading and commenting upon drafts of chapters. Carol should be singled out for her unstinting interest in my work, which was inspirational and deeply appreciated. For reading and commenting on various drafts of chapters, I am also indebted to my colleagues in the fields of Trecento, Medieval and Byzantine studies: Betsey Ayer, George Bent, Rebecca Corrie, Sharon Gerstel, Dale Kinney, Debra Pincus, Kim Sexton, Laurie Taylor-Mitchell, Anne Marie Weyl-Carr and especially Megan Holmes. Throughout the process of

writing this book I have benefited greatly from Megan's input and if this book has any merit a large part of it is due to her. Thanks are also due to Laura Stevenson and Lou and John Ratté for reading drafts of the entire text. My copy editor Hilly Van Loon also contributed to the final product.

No author ever finishes a book without the support of family and friends. My sincere thanks to Bernd Dotzauer, who always assumed this book could be written and in doing so made me believe it too; and to John and Lou Ratté, to whom this book is dedicated. It is a small token of my limitless admiration for them and thanks for all that they have taught me.

Contents

List of Illustrations

Introduction

The city was well accommodated with many beautiful palaces and buildings, and in this time there was constant building, improving works to make them more comfortable and splendid, bringing forth examples of every improvement and beauty. Cathedral churches and churches for every order of priests and friars; in addition to this there was not a citizen—"popolo" or "grande"—who did not possess land in the countryside who had not built or was building on it even more richly than he built in the city....[1]

Thus does Giovanni Villani, merchant and chronicler of Florence, describe the greatness of his city by listing its architecture and its ongoing building projects. In the first half of the fourteenth century, Villani exemplifies for us the keen architectural awareness that characterized the inhabitants of central Italian city-states. This study is an examination of that awareness and its meaning from another perspective, that offered by the pictorial image as exemplified by the city that rises behind the figures of Joachim and Anna in Bernardo Daddi's image of the *Meeting at the Golden Gate* (Figure 1).

Since the beginning of the twentieth century architectural historians have been aware of the role that the built environment, by which I mean both buildings *and* the space around them, plays in formulating the collective identity of an urban population. But what of the represented city, building or space? To what extent are viewers of painted urban scenes meant to understand their identity through the pictorial representation of urban space such as that depicted by Maso di Banco or Simone Martini (Figures 2 and 3)? And how do these representations relate to the built world? These questions underpin this book, which looks at architectural imagery in narrative paintings primarily in the cities of Rome, Assisi, Siena and Florence from c. 1250 to c. 1390.

As in any field, there are a number of issues that have acted as loci for ongoing debates among scholars of the Due- and Trecento. I have chosen four of the most important of these to structure the study of change in architectural imagery and urban identity. The first of these issues is the role that Roman artists played in the flowering of fourteenth-century painting in Tuscany. The second is the relationship between Tuscan and Byzantine artists from the middle to the end of the thirteenth century. The third is the role and meaning of "naturalistic" representation in late thirteenth- and

1

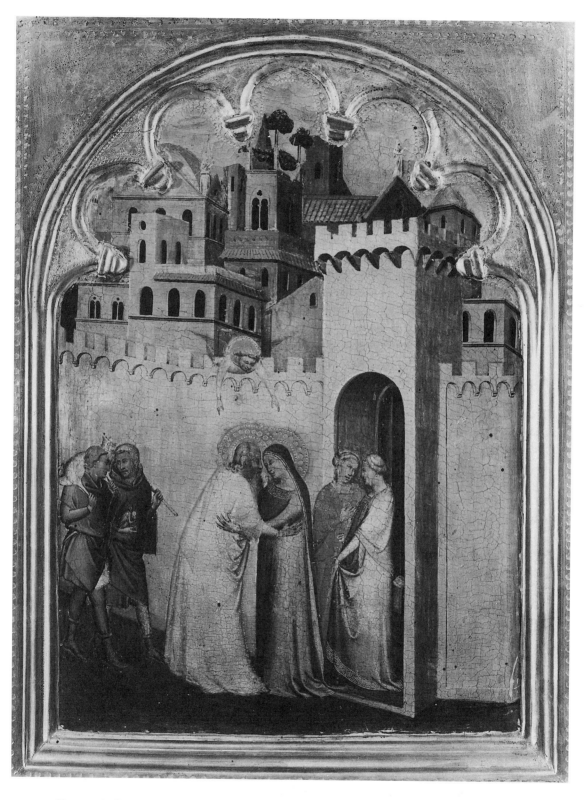

FIGURE 1. Bernardo Daddi, *Meeting at the Golden Gate*. Florence, Uffizi (SUPERINTENDENT OF FINE ARTS, FLORENCE).

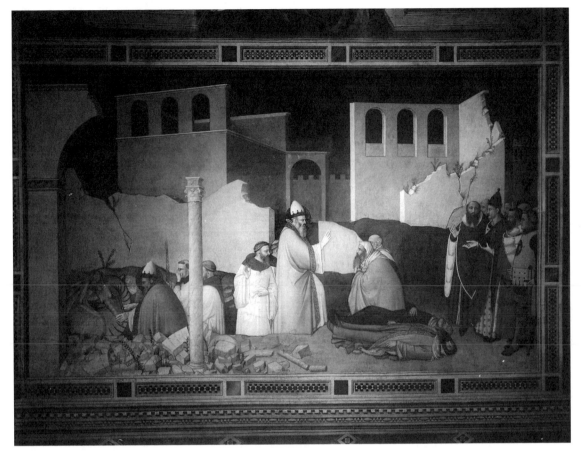

FIGURE 2. Maso di Banco, *Saint Sylvester muzzles dragon*. Florence, Santa Croce, Bardi di Vernio Chapel (SUPERINTENDENT OF FINE ARTS, FLORENCE).

fourteenth-century painting. And the fourth is the mechanics and meaning of the stylistic changes that roughly coincide with the arrival of the bubonic plague in the middle of the fourteenth century.

Role of Roman Artists

Because of Rome's busy history, much of the evidence of the medieval appearance of the city has either been lost or compromised. For this reason, scholars in the past focused on the physical remains of the sixteenth- and seventeenth-century growth and development, which are far easier to work with. Enough of medieval Rome remains, however, to demonstrate that its artists played a key role in the development of pictorial imagery in general, and architectural imagery specifically, in the thirteenth century. Their role is made manifest in the clear relationship between images of architecture in Roman painting, and real architectural developments in the city during this time. A series of popes over the course of this century became actively involved in restoring the

FIGURE 3. Simone Martini, *Beato Agostino and scenes of his life*. Siena, Pinacoteca (Superintendent P.S.A.D–Siena, with permission of the Ministry for Art and Cultural Activity).

city and in so doing called attention to both the classical and Early Christian urban fabric. These newly restored or decorated buildings were the focal points of papal ceremony of which the first jubilee in 1300 is only the most grandiose example. As a major pilgrimage destination, Rome's urban core was a powerful symbol. The papacy exploited this symbolic potential in its ongoing struggle for dominance against foreign emperors, kings and Italian city-states as well as hostile factions within the papal states and the city itself. Images of architecture need to be examined within this context if their significance is to be appreciated. This is the focus of Chapter One, *Rome Rebuilt*.

Cultural Exchange between Italy and Byzantium in the Thirteenth Century

In order to understand the framework for Chapter Two, *Byzantium Bypassed*, a little more context is necessary. Art history has a long and varied historiography, but many

say it got its start with the pen of Giorgio Vasari, a sixteenth-century painter, designer and architect who worked in the court of the Medici in Florence. Vasari's *Lives of the Most Eminent Painters, Sculptors and Architects*, first published in 1550, laid out the history of the visual arts in Italy by focusing, as the title suggests, on artists' biographies, beginning with the late thirteenth-century Florentine painter Cimabue. This work has continued to have relevance for historians of Italian art up to our own time. But for the period of the fourteenth century, it is woefully inaccurate and biased. The aspect of the Vasarian account that will concern us here is the portrayal of the relationship between Italian and Byzantine painting that has clouded the study of both until quite recently.[2] The aim of Chapter Two is to clarify some aspects of this relationship. Put simply, Vasari, and others before him, treated Byzantine painting primarily as a stylistic category characterized as backward, flat and compositionally hierarchical. The Italians, Giotto specifically, Vasari said, triumphed over this staid style. Changes in style are thus seen as occurring within a closed artistic environment that has not only made Byzantine painting appear unidimensional in many different ways, but has also excluded the cultural, social and historical context from the history of art. Chapter Two takes a different look by setting changes in architectural imagery into the context of cultural exchange between Italy and Byzantium over the course of the thirteenth century.

Role and Meaning of "Naturalistic" Representation

Chapters Three, Four and Five address in varying ways the role and meaning of "naturalism" in images of architecture. I have put the word in quotes here to draw attention to the fact that, for art historians, the meaning of the term is in a state of flux. "Naturalism," by which is generally meant the representation of the visible world, is a feature of art in many cultures and thus its study is the purview of scholars in different areas. Recent studies have demonstrated that, across the discipline of art history, "naturalism" is no longer thought to be an end in itself, and its various conventional forms, technical means, and cultural meanings in the periods in which artists have recourse to it are being carefully investigated. Architectural imagery is a particularly fertile area for investigating the meaning of "naturalism" in trecento, or fourteenth-century, painting for two reasons. First is the clear relationship that exists between images and actual built structures and the number of variations in imaged architectural forms that illustrate a complex rather than straightforward relationship with the built environment. Second, the paintings as a whole can be connected to the actual use of the urban landscape in ritual activity, such as processions, thus suggesting multivalent meanings for reproducing the visible world.

Chapter Three focuses on a particular kind of architectural image, the architectural portrait, or image of a known or identifiable building. Like human portraiture, this type of architectural representation calls into question the idea of naturalism as relating directly to the visible world in a simple mimetic way because there are many variations in the portraits. Sometimes the source building is denoted synechdotally, by its distinct roof form, as is most often the case with images of the Temple in Jerusalem,

whereas at other times noteworthy details such as a stone surface or particular window types are used. Because these differences demonstrate that artists are not simply transcribing visual appearances, it calls into question what exactly is meant by the term "naturalism" in relationship to how a work of art is understood. The same can be said for the more generic details of architectural images—windows, doors and structural forms—that relate to the built environment. These details will be discussed in Chapter Four alongside the conventional forms of architectural imagery that seem to contradict the naturalism of the details. In this chapter we will get a deeper idea of how images of architecture work in conjunction with the artistic environment of the fourteenth-century city-states by examining the images in the context of ritual practice.

At mid-century there is a transitional point from one typology of architectural image to another that I will argue corresponds—not coincidently—with the arrival of the bubonic plague. Although stylistic changes are evident before the plague struck in 1348, the arrival of the Black Death is emblematic of wider social, economic and political transformation that took place. It was the question of the impact of the Black Death on painting style that inspired Millard Meiss to write the first major study of the Trecento that connected stylistic change to historical circumstance. Although many of Meiss's conclusions have been called into question since the publication of his book in 1951, his stress upon the importance of the plague in contextualizing religious art in the second half of the fourteenth century continues to influence the discipline.

Chapter Five addresses the changes that images of architecture demonstrate in the period following the plague. Here again the question of the character, role and meaning of "naturalistic" representation will be important. Although it cannot be my purpose here to review the entire complex discussion surrounding the artistic concept of "naturalism," it is important to add some further explanation, because the last three chapters deal with the issue directly. "Naturalistic" representation is a key characteristic of the art of fifth-century B.C.E. Greece and first-century Rome during the classical antique period, with the renewed interest in mimesis by painters and sculptors in fifteenth-century Italy one of the major features of the Italian Renaissance. Within the discipline of art history, rooted in a historiographic tradition that dates back to the writings of Vasari, who celebrated the Renaissance renewal of naturalism, it was established as a standard according to which the art of different historical cultures was categorized and critiqued.[3] "Naturalism" was constructed as an end in itself, and so shifts away from mimetic concerns evident in the period of the Late Antique (c. 300–500 C.E.) when the representation of the human figure became rather formulaic for example, were understood simply as periods of decline.[4] Up until fairly recently, the dominant view of fourteenth-century Italian painting saw it as a precursor to the Renaissance, with references to the visible world in trecento imagery construed as proto-Renaissance manifestations.[5] The possibility of more complex meanings of naturalistic details in trecento imagery was not considered.

Two changes have taken place that have served to destabilize this view. Scholars of the Trecento have increasingly insisted on the unique qualities of the art of this period that cannot be explained as simple precursors of the Renaissance.[6] Trecento studies now demonstrate that the social, political and intellectual circumstances of the fourteenth century were quite distinct from those of the period that followed it. In

particular the structure of podestarial regimes of the Italian city-states were quite distinct from the oligarchic and signorial rule of the fifteenth century. (Details of these regimes will be discussed further below.) It should be noted that the government structure had a far-reaching effect on artistic production, because the state was not only a primary patron of both art and architecture in the fourteenth century but also included among its office-holders and committee members both patrons and artists.

The second important change is that the very concept of what "naturalism" means and its relationship to art history has been brought into question. An important force in the reassessment of the meaning and importance of "naturalism" in Renaissance art was Michael Baxandall's book *Painting and Experience in Fifteenth Century Italy* (1972). In this book Baxandall introduced the concept of the "period eye," which suggested that pictorial style does not have universal meaning and thus our reading of an image's meaning today is quite distinct from what it could have meant to viewers standing before it when it was made. This is as true for the overall image as it is for its details. In order to get at the meaning of an image when it was made, one must reconstruct the "period eye," the context and viewing experience at the time the painting was made. Now, so many years after the publication of this important idea, it has become a commonplace in the study of art history. However, it is not without its challengers as well, who have argued that it is impossible, given our historical remove, to ever fully see through the period eye.[7] Nevertheless, in this book part of our re-examination of "naturalistic" representation of images of architecture will be done via the period eye that can be created by examining ritual practice in order to see the images within their cultural and ritual viewing context.

Trecento Society Religious Belief and Secular Practice

The importance of the religious context in which trecento images operated cannot be overemphasized, and the certainty of their multivalence, that is the multiple layers of meaning that are present in each image, as with all visual imagery, is clear to the viewer who has both the historical and the religious background necessary. The Christian concept of history, social behavior and even time permeated every aspect of the lives of the viewers of the images, the patrons who commissioned them and the artists who produced them. In addition, and quite specifically important for our purposes, was the civic context in which the images operated. Although these two are so closely intertwined as to be inseparable in this period, we must focus for a moment on the specifics of the religious context.

In trecento Italy the populace held a common belief in the existence of the Christian god and of his continued and perpetual activity in the affairs of men through the saints, both living and dead.[8] People also believed that their experience of life on earth constituted only a part of the realm in which God operated, which included heaven, to which they would gain access after their deaths, and hell, also accessible after death, although not desirable. For the people of the trecento, time and history were bound up in the fact of Christ's eventual return and the end of the world.[9] God was present,

but at a remove. People believed that the jurisdiction of their faith was held by "Christ's vicar," the pope in Rome, although they were well aware that there was a distinction between the office and the man who held it. The pope's power was, in turn, held on the local level by his representatives, lesser church officials, including bishops and priests. Increasingly important in the thirteenth and fourteenth centuries as representatives of organized faith were the mendicant friars and other reform orders. The relationship between faith and the institution of the church in Rome was a problematic one throughout the period of this study as was the form that individual faith took. The political abuses of the church were common knowledge, but as far as can be determined from the historical record, these did not disturb the bedrock faith in God. In order to demonstrate and maintain this faith, trecento citizens acted out a series of prescribed rituals—attending mass, celebrating certain feasts, and participating in the sacraments of baptism, communion, marriage and funeral rites at death.[10] Many of them also belonged to confraternities that engaged in a variety of ritual forms of worship, including participating in processions, singing hymns or *lauds*, administering charity and commissioning works of art.

One important distinction between the medieval Italian Christian worldview and that of the modern period, particularly as it relates to cultural production and consumption—the commissioning, making and use of works of art and architecture—is that for the trecento citizen there was a porous line between religious belief and practice and what we might refer to as "secular" pursuits, that is political and social events and activities, particularly those connected to the fortunes of the city-state. Examples abound in the historical record, including the extremely elaborate procession to honor the Virgin that the Sienese held in 1260 on the eve of the battle of Montaperti, or the fact that the Sienese government paid for the altarpieces that were to grace the side altars of its cathedral. What we might see as purely religious celebrations, such as festivities that took place on the day commemorating the Virgin's assumption in Siena or the birth of Saint John in Florence, had distinctly political overtones. Not only in ritual but also in many of the images that will be discussed, religious thought and what we might think of as secular ideology are combined. For example, the very political *Expulsion of the Duke of Athens* from Florence on the 26th of July in 1343 is shown in a fresco as sanctioned by, and perhaps even accomplished because of, the will of Saint Anne (Figure 4). The term *civic religion* has been used by scholars to capture this interdependent relationship.[11] For our purposes, this concept is particularly felicitous because the "civic," in its built form, is clearly present in our images. An underlying argument of this book is that images of architecture in the late Duecento and first half of the Trecento idealized civic experience in a way that gave it sacred meaning.

Uses of Images and Meanings in Christian Worship

While the political ideological message of a given image, such as that of the *Expulsion of the Duke*, is readily apparent as commemoration and celebration, the way images operated spiritually needs some further explication, particularly as it relates to the ques-

FIGURE 4. *Expulsion of the Duke of Athens.* Florence, Palazzo Vecchio (SUPERINTEN-
DENT OF FINE ARTS, FLORENCE).

tion of the meaning of "naturalism." I do not mean to discount here the complex ide-
ological function that images had in the non-religious context. This context included
both public and private meanings, because the patrons of private chapels certainly had
a private motivation, while the images themselves functioned publicly as well. The same
can be said for state-sponsored art, which aimed both at terrestrial aggrandizement and
religious merit for the material display of devotion. This argument will be continuously
made throughout the remainder of the book. The role of narrative paintings in Chris-
tian practice has a long history that begins with Early Christian rejection of images
based upon their prohibition in the second commandment. Although representations
of one sort or another appear to have been made from the beginning of Christianity,
the prohibition against them was consistently under discussion among theologians from

the Early Christian period up to and beyond the Trecento. The most well-known and often quoted example of this is the seventh-century letter written by Pope Gregory I to Serenus, bishop of Marseilles, reprimanding him for destroying images in his church. The pope admonishes the bishop because, he says, "The picture is for the simple man what writing is for those who can read, because those who cannot read see and learn from the picture the model they should follow."[12] From the sixth century on, image apologists developed a more complex way of understanding the role that images could play in Christian worship. The debate was enhanced during the eighth and ninth centuries when the Byzantine Empire banned the use of figurative images in its churches, forcing theologians in Europe to justify their continued use.[13] In the late thirteenth century, John of Genoa notes three important functions of images within the context of worship. The first is as instruction for the illiterate and the second as an aid to memory, while the third is "to excite feeling of devotion, these being aroused more effectively by things seen than by things heard."[14] Within the context of the fourteenth century, images were understood not just as devices that could instruct the illiterate but also as tools that could aid in the contemplation of God, to bridge the gap between the experienced world and the divine.[15] It is clear that both trecento viewers and painters were quite aware of the power of the image to represent the world as it appeared but that they saw this as having an important mystical potential and not as an end in itself. A noteworthy quote from the Sienese statutes of the painter's guild reminds us that trecento viewers were actively cautioned to see the separation between the representation, the real and the idea(l):

> This image you look at is neither God nor man.
> But this image signifies God and man.
> Do not hesitate to pay homage to the portrait of Christ.
> However, do not adore the portrait, but whom it depicts.
> Do not believe this is Christ, but believe in Christ through this.[16]

This quote, which evokes the entire tradition of Christian image apologists going back to Gregory's letter to Serenus, alerts us to the complex viewing context in which the images we are discussing were engaged and in which "naturalism" for its own sake is clearly rejected. Many scholars of the Trecento have noted that one of the most influential forces behind the use of "naturalistic" representation in fourteenth-century religious imagery was the theology of the mendicant friar Francis of Assisi.[17] We should look more closely, therefore, at what the Franciscans said about how images should be used. Saint Bonaventure, the late thirteenth-century minister general of the order and the man who wrote the canonical life of Saint Francis in 1266, discussed the spiritual use of images in a veiled way in his text *The Journey of the Mind to God*.[18] In this text Bonaventure describes levels of meditation, the first of which begins with the literal world (i.e., the image). As the mind focuses, it moves beyond this realm to the spiritual plane that transcends sensory experience.[19] These texts give us a way of understanding the images of architecture and contextualizing both the appearance and meaning of naturalistic details. The image was understood to be a path, not an end. Where the path lead was to a greater interaction with the divine that transcended the time and space in which the image and the viewer existed.

"*Urban Identity*" *and the Trecento City-States*

As the question of the meaning of naturalistic rendering underlies all five chapters, so too does the issue of *urban identity construction*. By urban identity I specifically mean to highlight the cultural phenomenon of associating one's fortune with that of the stones and bricks of a city, anthropomorphized into something much greater than their material substance. This is a phenomenon that clearly has roots stretching back to the first cities and forward to our own day. Anyone who has lived in a city can attest to the power of its monuments to create a sense of belonging and identity, as New Yorkers most recently were painfully made aware. The most poignant moment of my arrivals in Florence via train are always when I catch my first glimpse of the famous dome of the cathedral. Just as Alberti noted in the preface of his treatise *On Painting*, this building evokes and circumscribes not just the entire city but also, to an extent, my identity as a scholar. What is working on me is not simple nostalgia, but rather something much more culturally constructed and significant, in the sense that the forces at work in identity construction contribute to how one sees oneself in the world and thus how one responds to events in it. It is no accident that Florence's dome stands for the entire city, its history, its people and its creative strength. It has been reproduced so many times, and in so many different contexts, from bus tickets, to advertisements, to menus, that it can now stand on its own for all things Florentine. This book is an argument for something similar happening in the fourteenth century, and not just with one or two particular buildings but rather with the built environment as a whole, by which I mean also urban space. It is in this period that these things really mattered in the lives of the people who both made and paid for art. It is in this period when Romans, Florentines and Sienese understood that their fortunes rose and fell with the destiny of the city. And the city is symbolized by its buildings.

The book begins in the thirteenth century in Rome at the height of the power of the medieval papacy and moves from there northward to Assisi, Padua, Siena and Florence, ending circa 1400. The thirteenth century is dominated by the power struggle between the papacy and the Holy Roman Empire, epitomized by the fight between the popes, Gregory IX and Innocent IV, and the emperor Frederick II in the middle of the thirteenth century. This conflict translated into the city-states as they drew themselves up on either side of this ideological divide. The parties that sided with the emperor were known as the Ghibellines and those of the pope, the Guelfs. For a time in the thirteenth century, the two major city-states of Tuscany, Florence and Siena, were respectively Guelf and Ghibelline. Ghibelline Siena, in fact, won its greatest victory over Guelf Florence at the battle of Montaperti in 1260. This victory was short lived, though; only nine years later, at Colle Val d'Elsa, the Guelfs won back all they had lost at Montaperti. But even before that, the imperial threat had been extirpated by the death of Manfred (Fredrick's successor) at the battle of Benevento in 1266. The two names, Guelf and Ghibelline, cease to have simple meaning by the time we get to the fourteenth century, because by that point, the Hohenstaufen dynasty had ceased to be a threat to the peninsula, and thus Ghibellinism was no longer a viable political category associated with imperial aspirations. In place of the Holy Roman Empire were the kings of Aragon who settled in Naples (and until 1282, in Sicily). The Guelf party continued to wield

power both in Florence and Siena while Ghibellinism seemed to be little more than a name that could be attached to any political enemy.[20]

Alongside the battles, ideological and military, for dominance on the peninsula, the thirteenth century witnessed the Latin sack of the Byzantine capital of Constantinople in 1204 and its recapture by the Byzantine emperor Michael VIII Palaiologus in 1261. The papacy was implicated in this conflict for having encouraged the sack. Innocent III's ill-advised letter of congratulation when he first heard the news of the Latin conquest is one of the reasons for Byzantine enmity of the Latins that developed and deepened over the course of the thirteenth century. But the root of the conflict between the Latins and the Byzantines was religious doctrine, and our images, being primarily religious, must also be examined in this light. We can think of one segment of the ideological conflict here as being fought out via urban consciousness. Constantinople was an ideological as well as a real prize and its capture by the Latin forces in 1204 needs also to be understood as a realignment of the idealized vision of urban identity. Rome, presented anew to the thirteenth century pilgrim via its renovation by the popes, can be set in contrast to the vanquished city of legend, Constantinople.

Focused urban identity is also key to trecento Florence and Siena. The fourteenth century saw the height of power of the podestarial regimes, that is, representative elected governments of the city-states of Tuscany.[21] The structures of these regimes were outlined and established in the late thirteenth century. Both were principally based upon government by a ruling body of officials elected from a selected group of eligible citizens who were chosen from among the major guilds.[22] In Florence these men were called *Priors*, in Siena, the *Lords Nine*, or simply *the Nine*. In both cities, because the nobility, or magnates, exhibited a penchant for taking the law into their own hands, pursuing violent vendettas rather than choosing legal means of reparation for perceived wrongs, the thirteenth-century laws were aimed at reducing their influence in the government. In fact, the magnates who were elected to serve had to post security on their good behavior for their time in office. This meant that they had to give a certain amount of money to the state to assure that they would behave themselves while in office. If they did not behave, the money was forfeit. Laws limiting or restricting magnate participation in government continued to be a point of contention throughout the fourteenth century. The group of men who played the largest role in government were the *popolo grasso*, literally the fat people, wealthy merchants, bankers and industrialists. Eligible men from this group were elected to two-month terms in the Signory, the governing body made up of eight priors and the Standard Bearer of Justice. Under this committee were a series of other committees, also elected, that dealt with various issues of governance, such as tax collection and urban design. In addition to these bodies there was a *podestà*, a chief magistrate, who was usually a foreigner (meaning not from the city). The *podestà*'s role was to maintain order and to this end he had a military force under his command.

In Siena, the framework of the system was similar. There was also a *podestà* and he too was not from the city itself. In addition, there was the *Consitoro*, made up of a number of committees, the most important of which were the Nine chosen from a group of eligible men also largely from the merchant class and serving for two-month terms. There were a number of other elected committees that dealt with financial and military issues.

The government of the Nine proved to be more stable than any Florentine governing body, since this system was maintained from 1287 until 1355. We can use the restriction of the magnate class from the government as an emblem of the centrality of urban identity in the power politics of both Florence and Siena. The magnates were the landed gentry, that is, people whose base of power was derived from their land outside the walls of the city, whereas the *popolo grasso*'s power resulted from their urban affiliations to guild, shop and family and wealth which they had earned within the city.

Trecento conflicts, as well, are largely urban. One of the reasons for the complexity of the government system and the special precautions, such as choosing the *podestà* from outside the city, was the factionalism of inner-city politics. Among the constant threats that the city-states faced were those posed by exiles who took advantage of the ready military forces present in Italy throughout the fourteenth century to regain their positions within the city by toppling the standing government.[23] When governments fell in either of these city-states, there was not the sort of dramatic transformation that the concept might suggest to a modern reader. Power changes in Florence and Siena in the fourteenth century always appear to involve the same basic groups of people, the *popolo grasso* and the magnates. Only at the end of the century, and then for a very brief moment, did the *popolo minuto*, literally the "little people," consisting of shopkeepers and laborers, make successful grabs for power in both Siena and Florence.[24]

Factionalism was an important component of daily life of all of the cities that we are looking at, although in the case of Assisi, the viewer experience that we will focus on will be that of the visiting pilgrim, and so we shall be less concerned with how the architectural environment functions in relationship to local collective identity and more concerned with its relationship to the greater collective of pilgrims and believers. But for Rome, Florence and Siena it is important to visualize the city as plagued by inner divisions among the *popolo grasso*. These divisions are etched into the face of the city as different factions lived in different areas of town. Conflicts that erupted between these different factions not only played themselves out in ritual activities, such as processions, but also on the actual fabric of the city, as those who lost the battle often paid the price of having their houses and towers destroyed by the victors.

Artists and Audience

This necessarily cursory glimpse into the political environment gives us some context for understanding the way in which the built environment signifies, but also it introduces us to the viewers of the images that are examined in the book. It is important to qualify here who these people were, because at times over the course of this study, the modern viewer is evoked, walking the streets of Rome or contemplating the mosaics of the Kariye Cami in Istanbul. Today's viewer is at a far remove from the rather restricted and stratified group of viewers of the Due- and Trecento. Only the pilgrims in Assisi and Rome are a broadly defined group in relationship to both class and gender. Otherwise, the trecento viewer who is looking at the images and is most clearly identified as their intended audience is most likely male and most likely belongs to the *popolo grasso*. These are the viewers who not only paid for the paintings discussed but

also, depending upon the location, were sometimes the only ones who had access to them. For example, in the churches of Santa Croce and Santa Maria Novella in Florence, the space of the nave was divided in two by a tramezzo, or choir screen, that stretched from one wall to the other about halfway down the nave. In Santa Croce this structure was about fifteen meters high and held private altars.[25] Access through it to the transept and apse of the church was limited to those individuals who had business in the transept, which initially meant individuals who had rights to chapels in there. However, over the course of the fourteenth century, this group was augmented by the inclusion of confraternities who held services there.[26] Although access was allowed for a variety of men, all women were excluded from the area behind the tramezzo.[27]

It is possible in some instances to actually identify who these viewers were. Patronage studies are a recent and emerging field in the discipline of art history.[28] Although for the Due- and Trecento the scarcity of documentary information has impeded attempts to clarify the relationship between artists and their patrons and in many instances to identify patrons at all, some work has been done. In Rome, we shall be concerned particularly with the patronage of the popes and cardinals, whose names we actually have. As noted, however, the viewers for a number of the Roman cycles are a far more diverse group. In the case of Padua, where we will be looking at the Arena Chapel frescoed by Giotto in around 1305, we are fortunate to have not only the name of the patron but also possibly his motive. It is well known that Enrico Scrovegni, who paid for the chapel in order to have a place for masses to be said for his soul, gained his fortune from what were perceived to be the sins of his usurious father, and his offering of the chapel was, in part, payment toward his salvation.

In Florence and Siena the case is somewhat different. Only rarely will the men responsible for the images discussed have names—the Bardi and the Peruzzi families are two notable exceptions. But we can generalize about their characteristics because they all had to come from a socioeconomic class that would have made it possible for them to afford such works. They were members of the *popolo grasso* or magnates, and therefore a large number of them most certainly held government posts at least once in their lives.[29] In Siena, the state played a strong role in commissioning art in the first half of the fourteenth century. In both these cities we will also be discussing works that had multiple patrons, meaning one person who paid for the work and others who directed its subject matter and were on-site during production. Again, in the example of Santa Croce, it is generally accepted that the friars of the monastery played a fairly important role in the process of identifying the subject matter for the transept chapels, although these paintings were paid for by private citizens. This is actually a matter of debate among art historians. Some believe that a patron would certainly have had rights to the dedication of his chapel to his own particular saint. Others believe that in monastic establishments, such as Santa Croce and Santa Maria Novella, the monks would have established the various dedications even before the rights to the chapels were sold. Santa Croce provides a good case in point here, because it is clear that since the church is dedicated to the Holy Cross, its apse chapel decoration would also be dedicated to the cross. As a Franciscan church, it would have had to have a cycle of the life of its patron saint. This suggests that, indeed, the exigencies of the ecclesiastical establishment would have had precedence over the desires of individual patrons.[30] We must thus consider

that the images that we examine in Florence and Siena were intended for, and utilized by, a select group of individuals.

As for the artists who produced the works discussed, in most cases we know little. In the thirteenth century, particularly in Rome, it is frustrating to admit that we do not know who worked for Nicholas III in the chapel of the Sancta Sanctorum. In Florence, where more archival material survives, more is known. We know, for example, that some of the more well-known painters belonged to the guild of the *Medici e Speziali*, the Doctors and Apothecaries, one of the seven major guilds, although it was not one of the most important (the wool guild, the bankers guild and the cloth guild were of loftier position) and the painters were considered to be minor members.[31] Nonetheless their presence there does give us some sense of their social standing. In 1339, painters formed their own confraternity, the confraternity of the Saint Luke, patron saint of painters, which gave them greater coherence.[32] And in 1378 they were granted their own guild. For some artists, such as the Florentine Giotto, painting was quite a lucrative profession. Giotto achieved fame in his own lifetime, being made the *capomaestro* of the cathedral works in 1334 and immortalized by Dante. Men such as he must have wielded a certain amount of power in the city. In the second half of the century, a number of artists participated on government committees that helped to design the new cathedral. In Siena, a number of artists also served in high government posts.[33] When, in 1378, the artists in Florence were given permission to split away from the *Medici e Speziali* and form their own guild, the act that affirms this right notes that their work "had consequences of great importance in the life of the state and appeared already advanced for the life of the state."[34] Thus in the chapters that follow, when we discuss both the viewers and the makers of images, the reader should imagine well-off men who were politically and culturally active, believing themselves and their cities to be fortunate in the face of God and destined for greatness.

For this select group of viewers, the images of architecture discussed in the chapters that follow were powerful tools. They became emblems of their identity as well as visions of their city's potential. For the broader category of pilgrim viewer the same can be said, but the collective identity created by the images viewed by the pilgrims was broader. It extended beyond any specific earthly city to the community of the faithful. This community too was architecturally circumscribed, and thus urban. The Due- and Trecento in Italy is a period that witnessed the rise in urbanism and architecture as well as painting. Images of architecture help us to see the interconnectedness of these categories—architecture, urban design, pictorial imagery—and in so doing enrich our understanding of the artistic culture as a whole.

Chapter One

Rome Rebuilt: Architectural Imagery and the Revival of Medieval Rome

When Pope Boniface VIII declared the Jubilee[1] in February of the year 1300, he was continuing a cycle of revived attention to the Eternal City that had begun over a hundred years previously with his predecessor Innocent III in 1198. For Rome, the thirteenth century marked a period of revitalization and renewal. Many of its most important churches received new decoration or architectural additions.[2] The attention that the popes directed at the physical monuments of the city went hand in hand with a rise in the political power of the papacy itself. The thirteenth century was the high point of the secular power of the medieval papacy.[3] For the popes who were native Romans— Honorius III, Nicholas III, Honorius IV—and for those who came from linked towns such as Anagni—Innocent III, Alexander IV and Boniface VIII—the renewed interest in the classical monuments of the city was inspired not just by the role that they had played in the religious history of the city but also by their political and historical significance.[4] Rome, like any other medieval Italian city, was divided by different family factions. Disputes between these factions in the never-ending struggle for power in the city etched themselves onto the face of the architectural environment as various monuments came to represent and demarcate the areas of the city when one family or another held sway.[5]

What made the Classical and Early Christian monuments important symbols of renewed papal power and drove thirteenth-century popes to revitalize them was the potential they had for linking the built environment with an illustrious past and with the politics of the present. Papal commissions displayed a historical awareness that was pivotal for the dramatic stylistic change in architectural imagery ushered in during the last quarter of the thirteenth century. This stylistic change focused the attention of the viewer of pictorial narrative on the architectural assemblages or groups of figures that act out the hagiographical—dealing with the saints—and biblical narratives. It also

demonstrates a transformation in the iconographical potential of architecture in imagery. This change had wide-reaching effects on the architectural images of the fourteenth century, from Rome to Assisi and thence to Florence and Siena.

"Reconstructing" Medieval Rome and Its Art

Rome today gives away little information about its medieval past.[6] A pilgrim walking its streets during the most recent jubilee (2000) had to use a great deal of imagination as she made her way past the Colosseum, up the Via di San Giovanni toward the Lateran basilica of St. John, to conjure up the memory of this road as a main thoroughfare marked by the ancient basilica of San Clemente and overlooked by the monastery and papal stronghold of the Quattro Coronati on the hill. As one arrived at the crest of the Celian Hill, the sprawling Lateran Palace and basilican complex would have met the eye, marked by its collection of antique sculptures and the massive Early Christian basilica of St. John at the Lateran. Now, the ancient palace of the popes no longer exists, replaced by another palace in a slightly different location, and the basilica has been completely remodeled and refaced. Only the fourth-century baptistery, now a freestanding building positioned behind and to the right of the apse of the basilica, stands out in its brick facing as a remnant of the medieval architectural environment.

If our hypothetical pilgrim had gone the other direction and headed out from the classical center of the city to the present seat of the papacy at the Vatican on the other side of the Tiber River, she might not even have seen a single medieval building as she moved past the Capitoline Hill through the Piazza di Venezia and along the Corso Vittorio Emanuele to the bridge of the same name. There she would have been confronted by the massive Castel Sant'Angelo, originally the tomb of the emperor Hadrian, but transformed by the medieval popes into a fortress and prison. Leaving the seventeenth-century basilica, St. Peter's, behind her and moving along the bank of the Tiber, she might start to understand something of the scale and surface of the medieval city as she made her way through the narrow streets of Trastevere. There the basilica of Santa Maria in Trastevere, with its apse mosaics, the eleventh-century mosaic of *Christ and the Virgin Enthroned* and the thirteenth-century scenes of the *Life of the Virgin* (shown in Figures 5, 45 and 46), might give her some idea of the city that greeted the pilgrim who visited it 700 years before.

Equally evocative, although also hidden behind its seventeenth- and eighteenth-century shell, is the basilica of Santa Maria Maggiore, reached by moving northwards from the Lateran Basilica along the Via Merulana.[7] Our intrepid pilgrim would find there the late thirteenth-century mosaic program in the apse: the central scene in the conch of the *Coronation of the Virgin* and scenes from her life arrayed below. As she emerged from the basilica and moved back toward the ancient center of town she might notice the remains of two medieval towers, and she would glimpse the majestic mass of the Torre delle Milizie—a remnant of the conflicts between different families that took place within the city during the medieval period—that would give her just the briefest glimpse into the Rome that was revived, renewed, reexamined and most importantly, for our purposes, represented by the papal patronage of the thirteenth century. The

path that this pilgrim traced would be the one that was marked by the comings and goings of popes, cardinals, kings, emperors and pilgrims over the course of the thirteenth century. Each building, now only vaguely visible or no longer visible to her, would have stood out to these thirteenth-century viewers as emblems of Rome's imperial past and its proud Christian present.

In order for us to understand something about this architectural environment we need to equip ourselves with more than a guidebook and a good pair of shoes. Medieval texts and archival documents provide necessary tools to recapture the appearance of the medieval city. One such text stands out because of the attention that it pays to the architectonic appearance of the city, as well as the stress that its author places on the classical buildings that still marked many of the city's most important areas in the twelfth-century: *Mirabilia Urbis Romae*, or the Marvels of Rome.[8] The text was written circa 1148, probably by a canon of St. Peter's. It is still a matter of debate what the original purpose of this text was. It contains both a description of the city that links it to classical *laudes urbs*, literary descriptions of cities, and a series of narratives that situate the viewer before a particular classical monument and relate the Christian legend of the event that occurred there.[9] It is most useful for us for two reasons. First it gives us an idea of the appearance of the city in the medieval period. Second, it demonstrates that, already in the twelfth century, Rome's classical monuments were connected to its Christian history. This connection was exploited by the church in the thirteenth century in a number of ways. As we shall see, some of the architectural imagery of the later half of the thirteenth century surpassed the *Mirabilia* in recapturing the classical past and eliding it with the medieval present. A similar text, perhaps written by the Englishman, Master Gregory, at the end of the thirteenth century, also gives us evidence that can be used to recapture the feel of the medieval city and the extent to which it was dominated by its classical monuments.[10]

In addition to these textual sources, there are numerous baroque copies of both destroyed and extant medieval mosaics and frescoes that not only demonstrate the antiquarian zeal of seventeenth-century Romans but also give us some sense of lost medieval pictorial cycles. Of the thirteenth-century cycles that are of interest to us, only some of the portico frescoes at San Lorenzo and the apse decoration of the basilicas of Santa Maria Maggiore and Santa Maria in Trastevere are still extant. The narrative Old Testament scenes in the transept of Santa Maria Maggiore, which in any case were left incomplete, were destroyed when vaulting was inserted into the transept.[11] The narrative cycles of Saints Peter and Paul from the portico of St. Peter's were destroyed along with the church in the seventeenth century. These frescoes were copied in two manuscripts now in the Vatican Library: *Archivio di San Pietro Cod A Ter*, and a two-volume manuscript that Giacomo Grimaldi presented to Pope Paul V Borghese, which documented the appearance of the basilica of St. Peter's shortly before it was destroyed.[12] The restored fresco cycles of the Old Testament and the Book of Acts along the left and right wall of the nave of St. Paul's were destroyed, along with much of the rest of the church, in the fire that gutted the building in 1823. These cycles were copied at the behest of Cardinal Francesco Barberini in 1634. The manuscripts that resulted from these documentary projects are in the Vatican Library in Rome.[13]

Many other baroque copies of medieval mosaic and fresco cycles were also executed.[14]

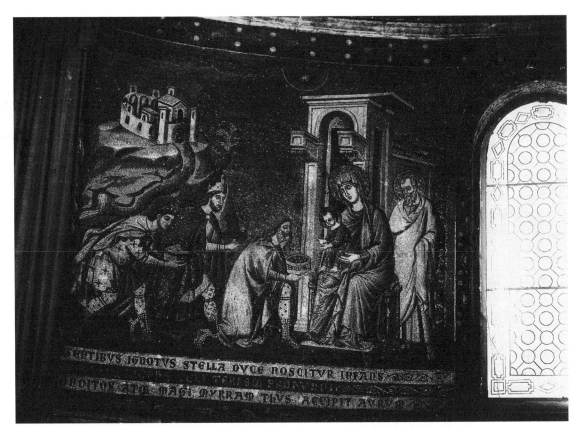

FIGURE 5. Pietro Cavallini, *Adoration of the Magi*. Rome, Santa Maria in Traste-
vere (PHOTOGRAPHIC ARCHIVE, VATICAN MUSEUMS).

The source images of some of these are fortunately still in existence. Thus it is possible
to achieve an understanding of the accuracy of the copies and to clarify the extent to
which they can be studied as direct versions of the original paintings and mosaics. We
can review their accuracy using two examples: In the seventeenth century, watercolor
copies were also made of the mosaics of the apse of Santa Maria in Trastevere, so we
can compare the copies with the originals (Figures 5 and 6) and see that, as far as the
representation of the architecture is concerned, the copyists were quite precise in their
renderings.[15] The details of the palace behind the Virgin are carefully represented: the
recessed doorway, the projecting corbels and the flat overhanging roof, as well as the
extension which recedes off the picture plane behind Josef. Even the details of the
walled city seen in the distance to the left are captured carefully. The same can also be
said for the copies made in 1639 by Antonio Eclissi of the portico frescoes at San
Lorenzo.[16] Because we still have these frescoes (even though their appearance is some-
what marred by the effects of the bombing that the church sustained during World War
II) we can still compare them to demonstrate the accuracy of the baroque copies (Fig-
ures 7 and 8). The salient details of the architectural images have been carefully trans-
ferred to the copy, including the form and decoration, columns, roof tiles and basic
shape. Thus, in the analysis that follows we will discuss discrepancies and difficulties

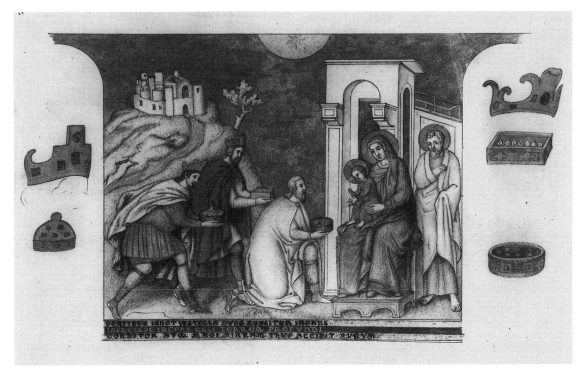

FIGURE 6. *Adoration of the Magi*. Vatican City, Biblioteca Apostolica Vaticana, ms. Barb. Lat. 4404, f. 20 (APOSTOLIC LIBRARY, VATICAN).

where they arise but by and large we will use the copies as examples of thirteenth-century images. The particularly complicated case of the nave frescoes from the church of St. Paul's will be discussed in more detail below.

Recently another window has been opened into this obscured past by the restoration of the frescoes in the chapel of St. Lawrence, once located in the Lateran palace, the original palace where the popes lived before the construction of the palace at the Vatican.[17] If our pilgrim were to continue her journey past the transept entrance to the basilica of St. John and along the flank of the new Lateran palace she would come face to face with the last, now completely refaced, section of the sprawling Early Christian palace of the popes, begun during the reign of the emperor Constantine when the Lateran Basilica, as the seat of the bishop of Rome, was considered the most important of Roman churches. Within this truncated structure are the holy stairs, which, legend says, came to Rome from the palace of Pilate.[18] They are the stairs that Christ stood upon when he was presented to the crowd in Jerusalem. Above the stairs is a grate that guards a window through which the chapel can be viewed. Around the corner a small but impressively padlocked door leads into the chapel of St. Lawrence, better known as the Sancta Sanctorum. This chapel was refurbished by Pope Nicholas III in 1279 when it was used to house all of the most important relics that the papacy possessed.

For years this chapel had been off limits to regular tourists. Even scholars had a hard time getting access to it.[19] Since the transfer of the papacy to the Vatican palace, a process that began in the thirteenth century, and the transfer of the most important

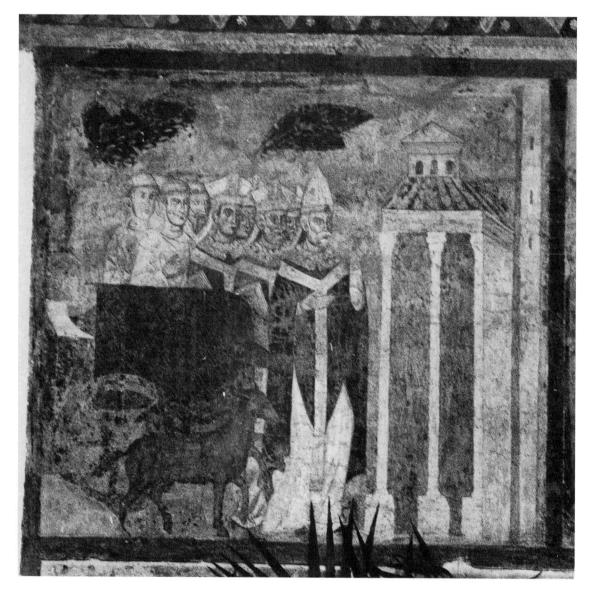

FIGURE 7. *Saint Stephen's body brought to Rome*. Rome, San Lorenzo Outside-the-Walls, portico (PHOTOGRAPH BY THE AUTHOR).

relics once held there to the basilica of St. Peter's on the other side of town, this chapel had lost its importance for the papacy. In the early 1990s, however, it received an extensive restoration, and the frescoes, once considered to be analyzable only as ghosts of thirteenth-century fresco technique, have emerged from underneath their Renaissance repainting as some of the finest and most well-preserved examples of medieval painting to be found in Rome.[20] The architectural images in these eight frescoes are remarkable

FIGURE 8 (*opposite*). *Saint Stephen's body brought to Rome*. Vatican City, Biblioteca Apostolica Vaticana, Barb. Lat. 4403, f. 12 (APOSTOLIC LIBRARY, VATICAN).

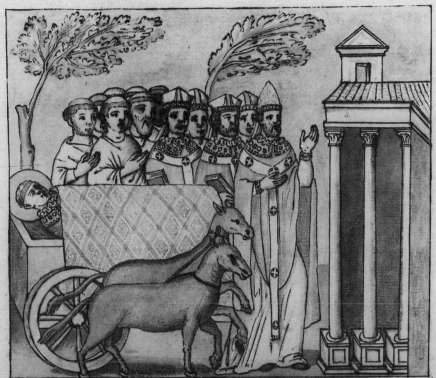

QN DNS PAPAS PORDVATT CORPVS AD ECCLESIAM LAVRENTIVM

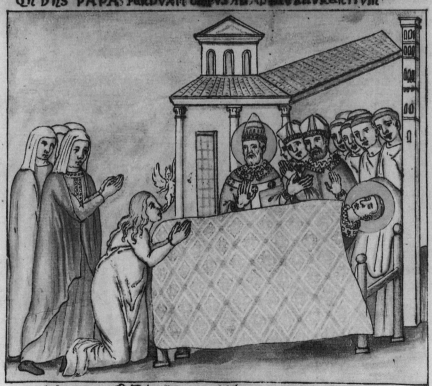

A HIC FILIA IMPATORIS LIBERATAM FVIT A ISM LAVRENTIVM

in every way. They demonstrate a diversity of type and precision of form, which can only be guessed at in other less well preserved and lost fresco cycles that could have been found in the city in the thirteenth century. Because of their state of preservation, and because of their central importance within the iconography of the papal revival of the city, they can stand as the primary examples of the innovative uses of architectural imagery in late thirteenth-century Rome. In addition, their typological diversity suggests something of the cosmopolitan artistic environment that characterized Rome at this time.

The innovations of architectonic form that are evidenced in the images in the Sancta Sanctorum set in motion a transformation in this part of the language of pictorial imagery that had wide-ranging implications for painting in Rome and for the development of pictorial imagery in Umbria and Tuscany. As we shall see in the following chapters, the introduction of specific and carefully rendered mimetic details into architectural imagery, and the complex iconographic way in which this imagery can be read, is developed from this period on into a rich variety of architectonic form that signifies in widely diverse ways depending upon its context. This context includes not just the location of the image but also the identity of the viewer since those immersed in the earthly power plays of papal policy would read the paintings differently from the medieval pilgrim on a spiritual quest. In order to understand how those forms develop and to help us figure out how to read them, we must look closely at their genesis in the Sancta Sanctorum.

The Sancta Sanctorum and the Image of Rome

The chapel is square in plan with a raised rectangular extension on the west that is separated from the main body of the chapel by two columns. This space contains the chapel's altar upon which sits its most important relic, the painted panel of Christ, the *Acheropita*; it has low vaults decorated with figures of saints and angels in mosaic in the lunettes surrounding the figure of Christ above the altar.[21] The floor of both the altar zone and the chapel proper is covered with an impressive "Cosmatesque" marble inlay.[22] The elevation of the main body of the chapel has three distinct levels, each richly decorated. The lower wall is embellished by marble panels; above the wall rises a blind arcade decorated with spiral columns supporting lobed arches. Within the niches of the arcade are painted figures of standing saints.[23] Above the row of standing figures on all four walls, the lunettes are divided in two by tall lancet windows. On each side of the window, except on the wall above the altar, is a hagiographical scene, six in all. As one enters the chapel from the single door located on a side wall, one is confronted by scenes of the *Martyrdom of Saint Agnes* and the *Saint Nicholas giving the dowry money* (Figure 9). While Agnes's grisly death scene is explained by the presence of her head among the relic collection housed in the chapel, the benign image of the generous Saint Nicholas providing dowries for three women directly refers to the patron of the chapel. The viewer understands immediately that he is meant to link the generosity of the saint with the pope who has refurbished the chapel. Turing to the left, the wall is decorated with two more scenes of martyrdom, that of Saints Stephen and Lawrence (Figure 10).

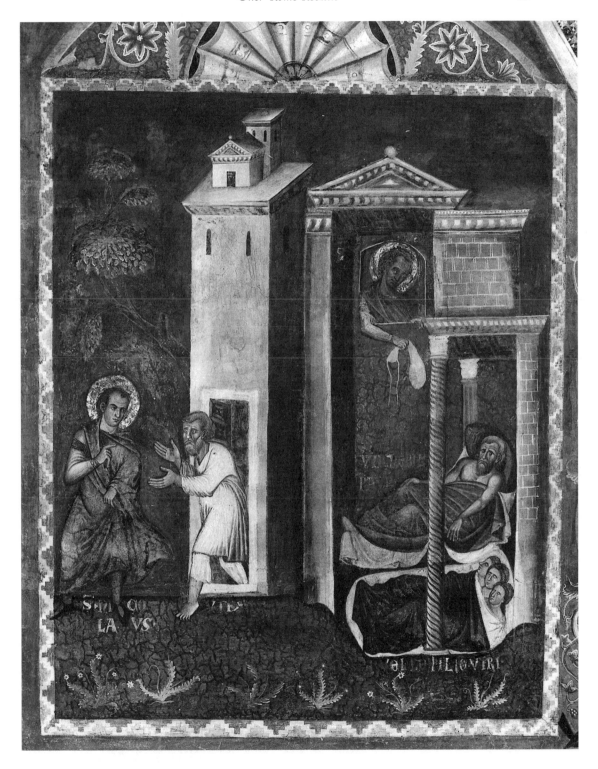

FIGURE 9. *Saint Nicholas giving dowry money.* Rome, Sancta Sanctorum (PHOTO-GRAPHIC ARCHIVE, VATICAN MUSEUMS).

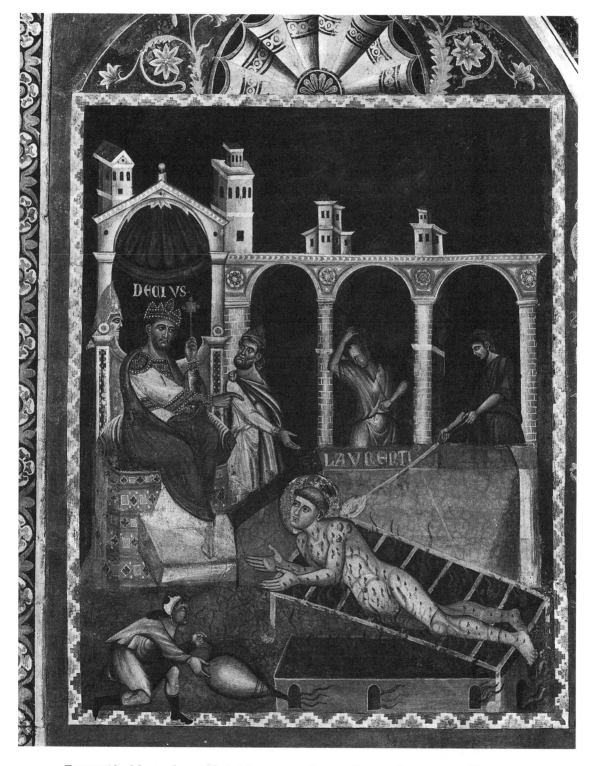

FIGURE 10. *Martyrdom of Saint Lawrence.* Rome, Sancta Sanctorum (PHOTOGRAPHIC ARCHIVE, VATICAN MUSEUMS).

On the wall above the altar the pope himself kneels before Christ holding a diminutive model of the chapel as his offering. As the eye of the viewer moves around to the next wall she is brought up short by the two scenes of the martyrdoms of the Roman church's founding saints, Peter and Paul.

In *The Martyrdom of Saint Peter*, Peter, crucified upside down (Figure 11) is framed by two strikingly detailed and structured buildings in the immediate background and two groupings of buildings in the far background. The two closer structures, centered behind the crucifix, mark both the time and place where the depicted event happened. They also relate directly to the Rome of Nicholas III. On the left is a multisided, cone-shaped, classical building, no longer extant by the time of Nicholas III, but described in the *Mirabilia* and called "the Terebinth."[24] The building on the right of the Sancta Sanctorum scene is the Castel Sant' Angelo, identified by its circular structure and separate levels.[25]

These two readily recognizable classical monuments are joined in the far background by two contemporary, or thirteenth-century, architectonic assemblages, a complex of buildings which frame the classical monuments in the scene. The complex on the left is clearly located on a hilltop, identified as the Capitoline Hill, the site of ancient Rome's most important temples and, in the twelfth century, the site of the renewed importance of the senate when a building to house the senate's meetings was built there.[26] The identity of the complex on the right is still debated.[27] The style of both these complexes differs from the way in which the classical monuments are rendered in that they are smaller in scale and do not contain any of the architectural detail that helps us to identify the classical buildings. In addition they relate more closely in form, although not in embellishment, to the architectonic forms in the slightly earlier frescoes from the chapel of St. Sylvester in the church of the Quattro Coronati, a short walk from the Lateran (Figure 12).

The frescoes in the chapel of St. Sylvester that narrate the story of Saint Sylvester and the emperor Constantine were painted circa 1245 and display a marked difference in style from those of the Sancta Sanctorum. According to the textual source for the scene, pope Sylvester fled Rome at Constantine's arrival in the city. The emperor then fell ill, in a dream he is visited by two figures—later identified as Saints Peter and Paul when Constantine is shown painted images of the saints—who tell him that Sylvester can cure him. The emperor seeks Sylvester out, is duly cured and welcomes the pope back into the city with great pomp. The scene in Figure 12, *The Presentation of the Icon*, when Constantine identifies his nocturnal visitors, shows the kneeling emperor in front of a city wall, above which rises the city gate, with assorted towers right and left. These buildings with their various roof forms are similar to those found in the background of the Sancta Sanctorum scene, although their ornate embellishment is quite distinct. They are worth looking at a little more closely because of the comparison that they offer for the later scenes.

The frescoes in the Quattro Coronati relate quite specifically to the contemporary historical situation during which they were painted. They were commissioned by Cardinal Stefano, who, along with the other cardinals, had been left in Rome when Pope Innocent IV fled the city in 1245 to avoid an encounter with Frederick II.[28] Recent work on the chapel demonstrates that its pictorial program can be explained as Cardinal

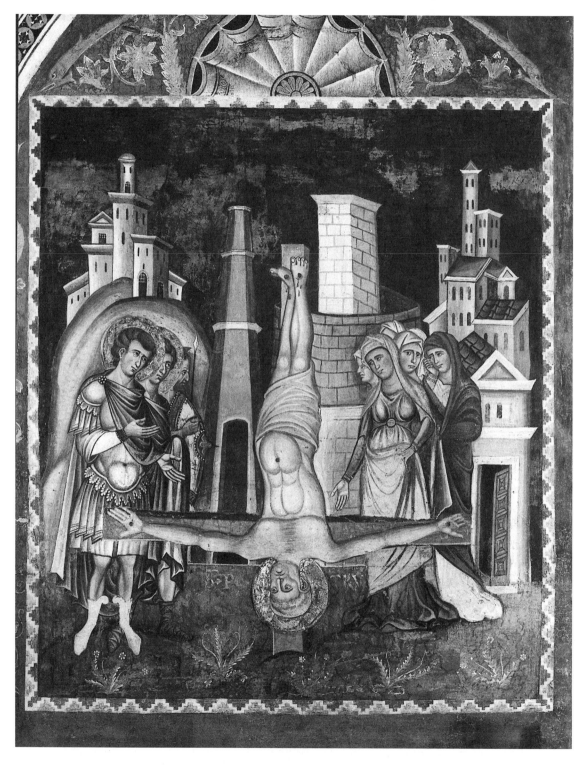

FIGURE 11. *Martyrdom of Saint Peter*. Rome, Sancta Sanctorum (PHOTOGRAPHIC
ARCHIVE, VATICAN MUSEUMS).

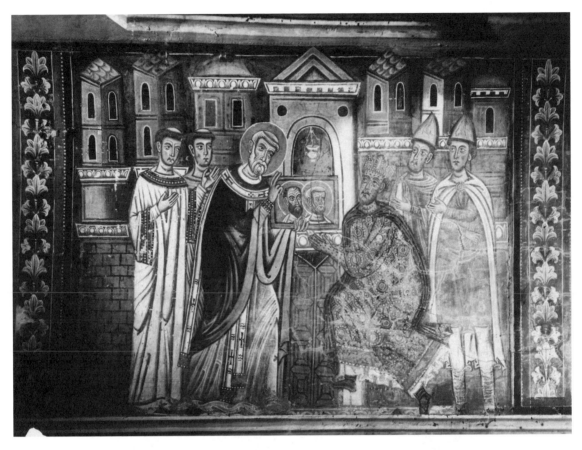

FIGURE 12. *Presentation of the Icon.* **Rome, Church of the Quattro Coronati, Chapel of Saint Sylvester** (PHOTOGRAPHIC ARCHIVE, VATICAN MUSEUMS).

Stefano's call to Innocent IV to stand up to the emperor and return to the city as Saint Sylvester does (Figure 13). What is most interesting about this image of the return of Sylvester to Rome, and true of the image of the *Presentation of the Icon* as well, is that although the architectural environment in the fresco is clearly intended to be read as Rome, there are no specific buildings that allow us to define the city as such. Contrast this to the fresco that we have just been looking at in the Sancta Sanctorum.

It is worth noting, in the scene of the *Martyrdom of Saint Peter*, that contemporary architecture is rendered using the established stylistic "vocabulary" of towers and windows, although the structures are identified as a specific group of buildings by their topographical siting. The classical monuments, the Terebinth and the Castel Sant'Angelo, are rendered with far more attention to their specific features in addition to the fact that their scale alone sets them apart from the other buildings.[29] Also worth noting is that the artist renders both buildings on equal terms, even though the Terebinth by that point in time existed only in written sources. The artist has thus taken the text of the *Mirabilia* one step further and created a visual image of the city that elides past and present. In this way, both the importance of the locale and its relationship to the present pope and its ability to fix the event and the site in the past is maintained. This con-

FIGURE 13. *Saint Sylvester returns to Rome.* Rome, Church of the Quattro Coronati, Chapel of Saint Sylvester (PHOTOGRAPH BY THE AUTHOR).

sciousness of the complex iconographical potential of architectural imagery was not present in the frescoes in the chapel of St. Sylvester.

 This focused reading of the architectural imagery, which a contemporary viewer would certainly have done, works politically as well as hagiographically.[30] Nicholas III Orsini, when he was elected in 1277, was the first pope of Roman origin since Honorius III (1216–1227). His short reign was characterized not only by extensive restoration of the architectural environment of the city but also a return of the power of the senate to the people of Rome.[31] He, himself, served as a senator for a time.[32] The appearance of the senatorial palace on the Capitoline Hill to the left of the scene of Saint

Peter's crucifixion (Figure 11) thus is directly related to Nicholas's Rome. So too the Castel Sant'Angelo, a papal stronghold for the Vatican, can be connected to Nicholas, because he built a fortified walkway to it from the Vatican Palace along the top of Leo VIII's walls.[33] The presence of the Terebinth, however, suggests something different: the use of architectural imagery to reach across time to link past and present and thus augment the religious experience of the viewer. Therefore, in this scene, the specific architectural "quotations" function not only as references to the specific circumstances of the painting itself—the patronage and the political environment—but deepen the power of the hagiographical narrative by representing the event within an identifiable architectural locale.

In order to understand how this particular use of architectural imagery to enhance the spiritual reading of a painting develops, one must see that architecture, both real and represented, has the potential to transcend chronological boundaries.[34] One must imagine the temporal and spatial location of the biblical or hagiographical event in a fixed place in time, as for example the *Martyrdom of Saint Peter* in the Circus of Nero, an arena close to the Tiber River on the opposite side from the center of the city. In Peter's time certain buildings existed, such as the tomb of the emperor Hadrian. Moving through time, other buildings might be added and others taken away, such as the circus structure itself or the Terebinth. At a fixed point later, when the painting is made, both the temporal and the spatial qualities of the narrative are collapsed into the present by the conscious use of architecture, the inclusion of buildings which still exist, the Castel Sant'Angelo as well as those that no longer exist, the Terebinth, to reach across time to link the experience of the viewer with that of the figures in the narrative. Thus we see that in the Sancta Sanctorum architectural imagery is used on a number of levels. It reinforces the links between Nicholas and Peter by connecting buildings that Nicholas had a hand in restoring or altering with the first pope. It also suggests a more immediate reading of the narrative by creating an architectural environment which brings together past events, the actual martyrdom of Saint Peter, with the present, the viewer's experience of the Sancta Sanctorum.

A further complexity of the role of architectural imagery in relationship to historical time is illustrated in the fresco depicting the decapitation of Saint Paul (Figure 14), pendant to the martyrdom of Saint Peter in the Sancta Sanctorum. In the *Martyrdom of St Paul*, the setting is decidedly rural, coinciding with the textual source, the rolling landscape broken only by the presence of a basilica flanked by two towers that appears in the background of the scene. The basilica might easily be identified as St. Paul's except for the curious and clear presence of the two towers which are not part of the extant structure.[35] The presence of the apostle's church in the background of a scene which depicts his own martyrdom is an interesting one. Like the appearance of the thirteenth-century senatorial palace in the scene of Peter's martyrdom, it is evidence of another feature of represented architecture that develops in this period. That is, not only does it cross temporal boundaries, but it can also exist (at least pictorially) outside them. In the same way that some biblical figures appear in contemporary dress in later images, architecture appears to be constructed according to a formula which is most assuredly not based upon a simple observation from nature but rather on a more nuanced understanding of how mimesis can work iconographically. In this image and

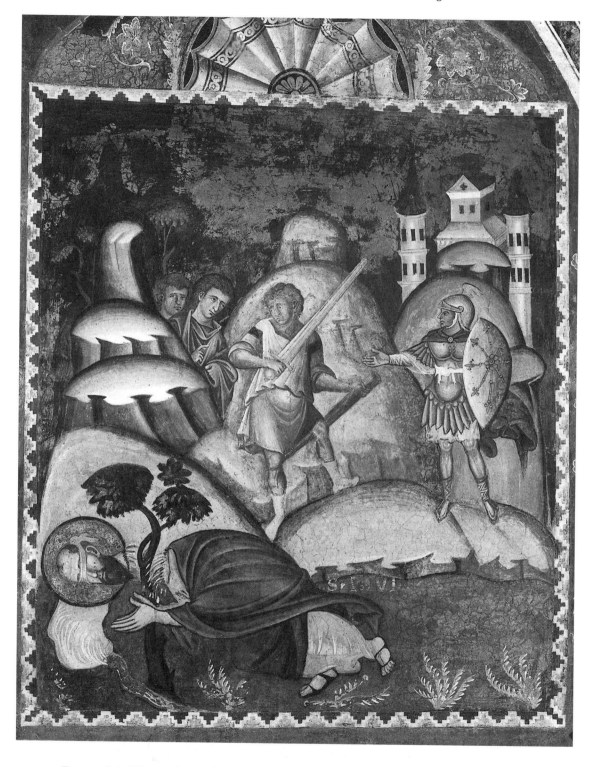

FIGURE 14. *Martyrdom of Saint Paul*. Rome, Sancta Sanctorum (PHOTOGRAPHIC ARCHIVE, VATICAN MUSEUMS).

in later images, mimetic forms are utilized to offer an entry point into the spiritual experience of the viewer. As we can see in the political overtones of Nicholas' imagery, however, there is more to the mechanism of architectural imagery than the spiritual pathway that it opens. Architectural imagery is also utilized to create a vision of civic stability, which is also "constructed" and not real.[36] In order to see the multiple ways in which these innovative potentials of architectonic form are exploited in Roman painting we can turn to the nave frescoes at the church of Saint Paul's Outside The Walls.

In the context of the Sancta Sanctorum it is important to recognize that the intended audience is a very specific and sophisticated one, one that would have immediately understood the textual reference noted in the rendering of the Terebinth. It is the pope and cardinals who were allowed access to the chapel and to the sacred relics that it housed. Therefore the monuments should, and in fact do, specifically reference sites in Rome that are important to the pope himself.[37] What is significant for our analysis is that architecture in these images takes on the role of mediating between the narrative and the viewer and adds an extranarrative function to the images by using them to reinforce Nicholas's power. The rendering of architectonic forms, which Nicholas played a role in transforming, serves not just to memorialize the pope's good works, but specifically to link those works with the lives of the founder of the church. In addition, through the "quotations" of the *Mirabilia*, a link is forged between Nicholas and the revival of interest in Rome's past strength and with that past itself, in as much as it contains the narratives of the lives of the saints.

Thirteenth-Century Restoration of St. Paul's and the Pilgrim Experience

Nicholas III was also probably the pope responsible for the restoration of the Early Christian frescoes along the nave of the basilica of St. Paul's Outside The Walls. The extensive fresco cycle can be used to outline the different ways in which the architectural environment is rendered when a different, less specific audience is identified. The extensive restoration of the Early Christian cycles of the Old Testament and life of Saint Paul along the nave of the basilica was most likely begun circa 1278, although actual dating and patronage questions are still problematic. The fifteenth-century Florentine sculptor Lorenzo Ghiberti noted in his *Commentary* that Pietro Cavallini painted the frescoes of the Old Testament on the right side of the nave.[38] To this scanty documentation has been added the date, between 1275 and 1289[39] and the patron, Nicholas III,[40] through study of the baroque copies and the donor figures and inscriptions that are found in them.

The appearance of the two cycles and the extent of the thirteenth-century restoration present further difficulties for analysis because they were completely destroyed in 1823. They survive for us in a number of guises, the most extensive of which is a baroque manuscript, now in the Vatican library, which was done for Cardinal Barberini in 1634.[41] This manuscript contains forty-two watercolor representations of the scenes. For the study of the architectural images, these copies present one important problem: The format of the manuscript pages differs from the format of the nave frescoes, and the copies

FIGURE 15. *Plague of Serpents*. Vatican City, Biblioteca Apostolica Vaticana, Barb. Lat. MS 4406, f. 55 (APOSTOLIC LIBRARY, VATICAN).

consistently cut off the upper sections of the frescoes.[42] This is relevant for our purposes because the architecture consistently occupies the upper parts of the scene, and thus the roofs of some of the buildings are often missing. Another and more accurate but less extensive copy of some of the scenes in the cycle appears in the engravings done in the nineteenth century by Seroux d'Agincourt and later published by him.[43] The greater accuracy of the architecture in these copies is attested to by comparing two scenes from the plague cycle in the Old Testament (Figures 15 and 16). In the watercolor, the upper portion of the square castellated building behind the Pharaoh is cut off, whereas in the Agincourt drawing the entire roof with its crenellations is shown. We must therefore use both copies in our analysis of the architectural imagery in these lost frescoes. The pitfalls of trying to conclude anything about medieval architectonic imagery from these copies, as discussed above, is thus obvious.[44] But the cycle was so extensive and obviously so important for thirteenth-century painting that one simply cannot disregard the evidence that it offers of a real transformation in the approach to architectonic form.

 To demonstrate the closeness of the forms in the copies to thirteenth-century architectural imagery, the architectural images in the copies from Saint Paul's can be compared to similar buildings in extant thirteenth-century frescoes. This gives us an idea not only of the accuracy of the copies but also of the original appearance of the fres-

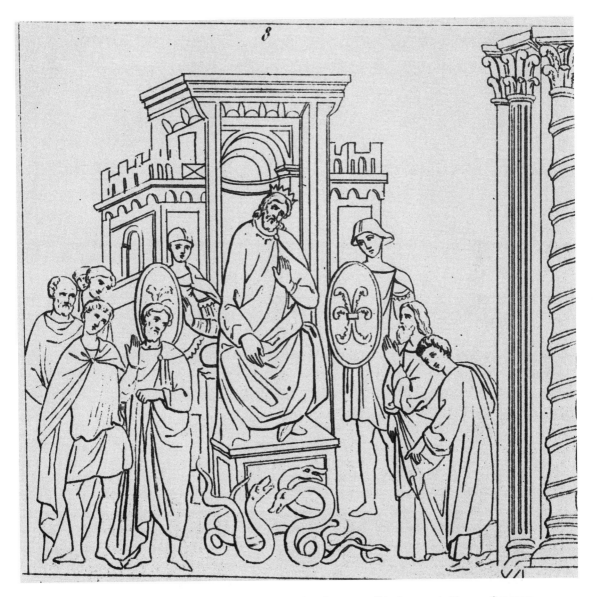

FIGURE 16. *Plague of Serpents.* Engraving by Seroux d'Agincourt (AFTER SEROUX D'AGINCOURT, STORIA DELL'ARTE, PLATE CXXV).

coes themselves. Such a comparison can be found in a nave fresco from the church of San Saba on the Aventine. Like much Roman painting the exact date of these frescoes is debated, although scholars have settled on a date close to the end of the century.[45] In the middle scene of this fragmentary set of images is a representation of the legend of Saint Nicholas in which the young saint is seen giving money for dowries to three unwed sisters (Figure 17). In the scene, the three women are shown lying before a composite structure embellished with carefully delineated "bricks" and an arcaded loggia on its roof in which the saint stands. This structure is very similar to the one found to the right of the figure of the Saint in the scene from the Saint Paul frescoes and thus

FIGURE 17. *Saint Nicholas giving dowry money.* Rome, San Saba (PHOTOGRAPH BY THE AUTHOR).

one can use the San Saba image to try to get a sense of the tonality and design of the Saint Paul images (Figure 18).

The question of the extent of the thirteenth-century artists' overpainting of the earlier fifth-century frescoes during the restoration must also be dealt with before we can examine these architectural images.[46] Careful scrutiny of the baroque copies reveals that there are dramatic differences in some of the architectural images in the scenes. These differences reinforce the claims of some scholars that only a few of the fifth-century scenes were in good enough condition in the thirteenth century to be left more or less intact. There are ten such scenes that stand out from the rest because of their distinct stylistic differences. The scale and simplicity of the architecture in these scenes, all of which come from the Old Testament cycle and depict the plagues of Egypt, demonstrate quite clearly that they are fifth- rather than thirteenth century.[47] A quick glance at one of the scenes, the *plague of locusts* (Figure 19) shows two small-scale, peaked-roofed buildings with scant embellishment. This type of architecture coincides quite closely with those found in the fifth-century mosaics of Santa Maria Maggiore. The other scenes, however, for example the scene just discussed of the *Plague of Serpants* (Figure 16) demonstrates a radically different approach to architectonic form.[48] The architecture depicted here, which stretches to the height of the picture plane, appears on an angle to the picture so that it recedes into space and contains architectonic detailing

FIGURE 18. *Scene from the life of Saint Paul.* Vatican City, Biblioteca Apostolica Vaticana, Barb. Lat. 4406, f. 105 (APOSTOLIC LIBRARY, VATICAN).

FIGURE 19. *Plague of Locusts.* Vatican City, Biblioteca Apostolica Vaticana, Barb. Lat. MS 4406, f. 58 (APOSTOLIC LIBRARY, VATICAN).

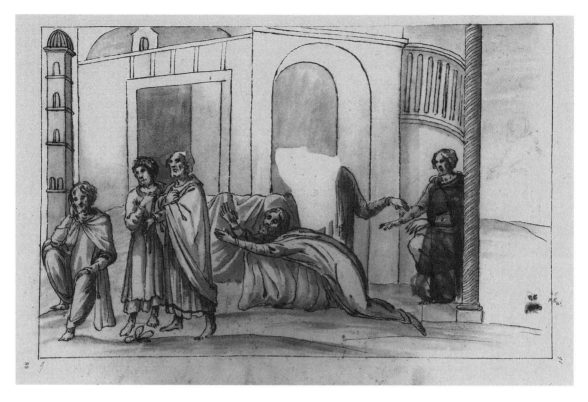

FIGURE 20. *Conversion of Saul.* Vatican City, Biblioteca Apostolica Vaticana, Barb. Lat, 4406, f. 89 (APOSTOLIC LIBRARY, VATICAN).

derived from actual buildings, is quite distinct from the simple rectangular buildings with peaked roofs that appear behind the Pharaoh in the scene of the plague of the locusts. Scale and spatial complexity distinguish the two.

 Therefore it can be concluded that, as far as the program itself is concerned, it is most likely that Cavallini and the other artists that worked there followed the basic program as it was laid out in the fifth century. However, they also made changes where they saw fit, and those changes included the transformation of the fifth-century architectural images into the more iconographically and compositionally complex buildings of the thirteenth century.[49]

 The frescoes at Saint Paul's offer a good contrast to the images from the Sancta Sanctorum because they date to the same period but were intended for a different much more broadly defined audience. Unlike the Sancta Sanctorum, access to which was limited to members of the pope's entourage, St. Paul's was an important pilgrimage basilica. These frescoes most certainly identified the pilgrim as their primary audience. Two key differences between these forms and those found in the Sancta Sanctorum are the monumentality of the architectonic forms and their more generic and yet typologically, in the sense that they evoke a particular kind of building, specific depictions. There are no references to specific buildings in these frescoes, but mimetic details, which are linked directly to the architectonic environment of Rome, abound. In the scene of the *Conversion of Saul* (Figure 20), although the architectural setting in the copy is some-

FIGURE 21. *Conversion of Saul.* Vatican City, Biblioteca Apostolica Vaticana, Cod. Lat., 9843, f. 4 (APOSTOLIC LIBRARY, VATICAN).

what confusing, it is clear that in scale and complexity it dominated the stage of this dramatic and important scene. Here, again, is a good example of the difficulty in reading the baroque copies as pure renderings of the thirteenth-century original. The architecture in the baroque copy differs markedly from that found in the Agincourt drawing where two separate architectonic assemblages are shown (Figure 21). Comparing and contrasting these images with extant thirteenth-century architectural imagery seems to point to the conclusion that the Agincourt drawing is the more accurate.[50] The Agincourt drawing here gives us a clearer idea of the original configuration of structures in this scene. In the watercolor, the figure of the falling Saul is framed by a huge ambiguous structure made up of three distinct architectonic forms. A large rectangular doorway dominates the left side of this structure, an arch appears in the center and a round or semicircular apse-like appendage appears on the right.[51] In the Agincourt drawing it is clear that Paul received the message from God just as he was about to enter the city. He is shown before a monumental gateway with the structures of the city rising behind it. The thirteenth-century artist thus opened the cycle of Paul's life by positioning him outside the walls of the city. This is just the place where pilgrims gazing up at the frescoes find themselves, because the basilica of St. Paul is located outside the walls. A further connection to the architectonic environment of the pilgrim is made by the appearance of the spiral column at the far right of the scene. This most certainly refers

FIGURE 22. *Paul's entry into Cesaria.* Vatican City, Biblioteca Apostolica Vaticana, Barb. Lat, 4406, f. 102 (APOSTOLIC LIBRARY, VATICAN).

FIGURE 23. *Saint Paul preaching.* Vatican City, Biblioteca Apostolica Vaticana, Barb. Lat. 4406, f. 119 (APOSTOLIC LIBRARY, VATICAN).

to the antique spiral columns of Trajan and Marcus Aurelius that mark the center of Rome.

In other episodes similar stress has been placed not just on rendering the iconographic complexity of the architectural environment (that is, carefully identifying different building types), but also on rendering specific architectural forms that can be linked directly to Paul's historical moment and to the pilgrim's environment. It should be noted that according to the textual source only the final scene in the cycle actually took place in Rome, and yet the architecture that appears in the other scenes, as we have seen in the example of the *Conversion,* is clearly derived from classical prototypes. Thus while these architectural images do not directly link the pilgrim's location to the narrative that they are reading in the fresco, there is a clear link made between the classical world and Rome's importance in that historical moment, and the medieval pilgrim.

Two scenes which show cityscapes can act as examples of this: the scene of Paul's entry into Cesaria[52] (Figure 22) and the scene of Saint Paul preaching (Figure 23). Both scenes mix the commonly found medieval type of generic architectonic form, such as the tower and church with classical building types: the domed building with iconic arcade in the scene of Paul in Cesaria and the triumphal arch and rounded arcade building on the far right in the preaching scene. The cityscape, in scale, detail, and variety of building type is quite distinct from that offered in the city view from the earlier scene found in the cycle of the *Life of Saint Sylvester* in the chapel of the church of the Quattro Coronati (Figures 12 and 13).

One other scene demonstrates an even more marked observation of classical architectonic features. This scene (Figure 24), which shows Saint Paul being "scourged,"[53] contains an image of a ruler seated in front of a temple.[54] The precision with which the temple form, the pediment and fluted columns is executed suggests that the artist is conscious of classical temples, which come both from an observation of relief sculpture and from the few temple fronts that were still extant in Rome, the Temple of Portunus (Figure 25) and the Pantheon being, of course, the two best examples. The classical forms stand as identifying marks of the time where the event depicted occurred, and through this they reinforce the link between the city of Rome, which was filled with like structures, and the time of Paul and the apostles. Thus the viewer's own experience of the event at the place where he stands is reinforced by the mimetic architectural references to the past.

The Portico at St. Peter's

A similar link between past event and present circumstance appears in the roughly contemporary frescoes in the portico of St. Peter's Basilica, hereafter referred to as the St. Peter's portico cycle. Some of these architectural images, however, are of a very different type from the buildings found in the basilica of St. Paul's. The original appearance of the paintings from the portico at Saint Peter's is a matter of some debate, and because they too are no longer extant, we must turn to the copies. A number of copies exist, the most well-known of which are the nine ink drawings in the manuscript now

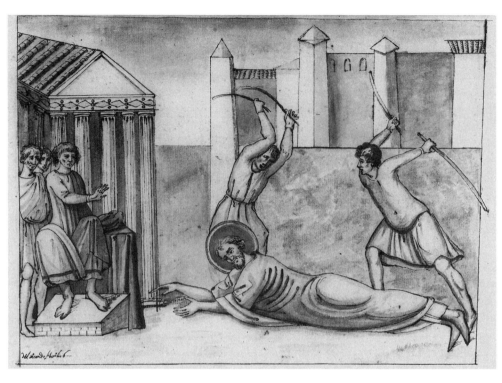

FIGURE 24. *Saint Paul being scourged.* Vatican City, Biblioteca Apostolica Vaticana, Barb. Lat, 4406, f. 100 (APOSTOLIC LIBRARY, VATICAN).

in the Vatican Library produced by Giacomo Grimaldi for Pope Paul in 1620.[55] An earlier more legible copy in watercolor and pencil by the painter Domenico Tassili was executed in 1605 at the behest of Grimaldi, who probably used it for his own drawings.[56] The Tassili drawings are more readable today because the Grimaldi manuscript has writing on the reverse side of four of the drawings, which has bled through to the front page obscuring much of the pictures.[57] For this reason, and because the later Grimaldi drawings were dependent upon the Tassili images, the following analysis will focus on the drawings that appear in the Tassili album.

It is clear that the nine scenes represented in the copies do not represent the complete portico cycle. It is probable that the original cycle of the life of Saint Peter occupied walls on both the interior of the church and the exterior portico, twenty-two scenes in all, with a possibility of another seven.[58] We must keep in mind, therefore, that the political role of the cycle, to reinforce the status of St. Peter's as the primary Roman church,[59] was carried by a good deal more images than we are able to discuss and analyze here. The missing scenes also included some very important representations of architecture, the loss of which makes any conclusion about the cycle's architectural imagery provisional.[60] Because the political role of these images, like those in the Sancta Sanctorum, had an effect on the choices made in the representation of architecture, we need to assess the propaganda role of each of the scenes chosen.

The frescoes contain a diverse group of scenes dedicated to the lives, or more accurately the deaths, of Saints Peter and Paul. In the Tassili album, the scenes do not appear

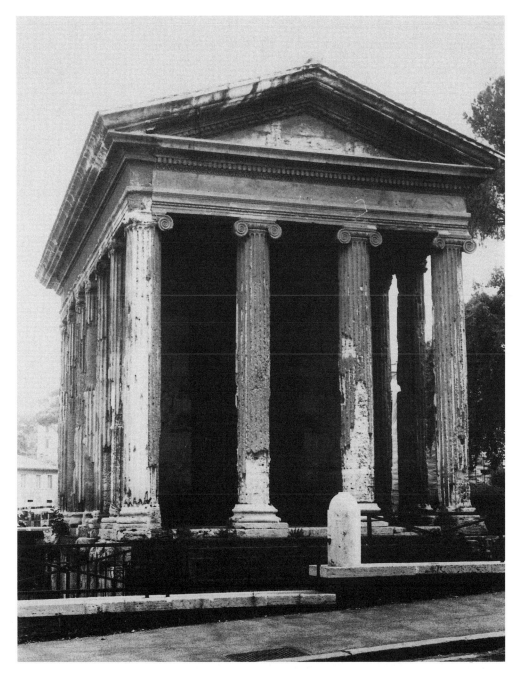

FIGURE 25. Rome, Temple of Portunus, facade (PHOTOGRAPH BY THE AUTHOR).

in any understandable order, but there is an inscription which appears on folio 10 of the manuscript alongside a drawing of the facade and portico of St. Peter's, which notes that the images appeared in the portico and identifies them in order.[61] Of this list, one scene, the burial of Saint Peter in the basilica by Pope Sylvester, is not listed, although it is depicted.[62] In the Grimaldi manuscript, these scenes appear in chronological order.[63]

Crucifixio B· Petri inter duas metas siue sepulcra, quonã unũ in
Theatro Palatij Apostolici, alterũ ubi est Palatiũ s· Officij ex Leo=
nis IX· bulla in Archiuo Basilicæ Vaticanæ; et antiquis libris ma=
nuscriptis de antiquitatibus Vrbis in Vaticana Bibliotheca; Quæ hi=
storia crucifixionis erat in Porticu veteris memoratæ Basilicæ
supra arcus columnarũ satis antiqua. Et ex libro Benedicti
presbyteri de mirabilibus Vrbis in Vaticana Bibliotheca

FIGURE 26. *Martyrdom of Saint Peter.* Vatican City, Biblioteca Apostolica Vaticana,
Archivio di San Pietro, Cod A 64 Ter, f. 39 (APOSTOLIC LIBRARY, VATICAN).

The nine scenes represented correspond to the life of Saint Peter and the history of his cult in the *Acta Sanctorum*, except for the scene of the reburial of his body by Pope Sylvester.[64] The explanation for this particular configuration of scenes here is quite straightforward and plays a role in the way the images of architecture are constructed. The scenes from the *Life of Saint Sylvester*, *Constantine's Dream* and the *Presentation of the Icon of Peter and Paul*, narrate the story of a very important relic in the possession of the church of St. Peter's at the time, the double portrait of Saints Peter and Paul.[65] The scenes, which deal with the death and burial of Saint Peter, including the scenes of the catacombs, can be understood within the ongoing competition between St. Peter's and the church of St. John Lateran for primacy in the Roman see.[66] They also act to reinforce the importance of the basilica as the resting place of the body of the saint.[67] More importantly, I think, these images create an entry for the thirteenth-century pilgrim into the hagiographical narrative.

There is one scene out of the nine in which the architectonic references made are specific to particular identifiable structures, both of which are ancient monuments. In the scene of the *Martyrdom of Saint Peter* (Figure 26),[68] the figure of the saint appears crucified upside down between the Meta Romuli[69] on the left and the Terebinth on the right. We have noted in our discussion of the crucifixion scene in the Sancta Sanctorum that the Terebinth existed only in textual sources, in the *Mirabilia*, and was specifically related to classical descriptions of Saint Peter's burial.[70] The Meta Romuli, however, was still extant at the time that the portico frescoes were painted.

Close rendering of the Meta and the Terebinth, the two structures mentioned in the *Mirabilia* as located near the site of Saint Peter's martyrdom, marks the exact location of the event, grafting it into the cityscape, so that pilgrims viewing the paintings would be able to place themselves on the sacred site in the exact location.[71] The absence of the other buildings, which appear in the scene in the Sancta Sanctorum (Figure 11), the Castel Sant'Angelo and the Capitoline Hill, serves to reinforce the reading of the architectural imagery in that scene as specific to Nicholas III. References to these buildings would have been meaningless in the context of a pilgrim's visit to Saint Peter's tomb. The appearance of the Meta also would help the pilgrim to link the ancient founding of the city to its Christian founding by the martyred saint since the Meta Romuli was associated in the medieval period with Rome's mythical founder Romulus.

The only other scene that survives in the seventeenth-century copies, which could have served a similar function, is the scene of the *Burial of Saint Peter* in the basilica (Figure 27). This scene[72], however, does not take place within a recognizable rendering of the interior of old St. Peter's.[73] The architectural image in this scene is quite different in form from any of the images that we have looked at so far. The three-part structure of the fresco is rather classical in its details and has no details that would define it specifically as a church. It represents only a skeletal architectonic form rather than a complete structure, a difference explained by the location of the depicted event within a building rather than outside it. This is a new kind of representation in the thirteenth century, although in form it rather follows similar structures found in earlier fifth-century relief sculpture and some eleventh- and twelfth-century frescoes.[74] It differs from these fresoces in the more sophisticated way in which the semicircular apses and the

Humatio Sanctissimi Corporis Principis Apostoloru̅ ex Porticu veteris Va- ticana Ba- silicae an- tiqua pi- ctura us. Quando S. Silue- Ster re- condidit corpus eius.

FIGURE 27. *Burial of Saint Peter.* Vatican City, Biblioteca Apostolica Vaticana, Archivio di San Pietro Cod. A 64 Ter, f. 43 (APOSTOLIC LIBRARY, VATICAN).

central nave recede into space, as well as the appearance of the carefully observed classical architectonic vocabulary of pediments and fluted columns.

To the extent that the vocabulary of this image is derived from extant classical buildings, it can be related to the representations of exteriors that we have been looking at. That it is not a specific rendering of the extant basilica itself, however, suggests that there are certain subtleties of the language of architectural form that require further discussion. Clearly, the representation of, or quotation from, specific buildings was a device that was used judiciously. Mimetic details, which reference identifiable buildings appear in the both scenes of the *Martyrdom of Peter* (Figures 11 & 26) to reinforce the historicity of the event and more importantly the sacredness of the pilgrimage site. In the *Burial*, however, the classical features of the architecture and the sarcophagus are used to mark the event in a specific moment in time in the past, rather than a specific location. The absence of a building that could have been identified as the basilica then works to reinforce the date of the event in the past. In both these scenes, however, there is a consistency in the use of architectonic form to create a pathway into the viewer's understanding of the spiritual significance of the event. In the *Martyrdom* that path leads the viewer to a specific site, a site, in fact, which she has come to find. The image suggests to her that both in the portico and at the Meta Romuli, she is to recall the

saint's sacrifice. In the *Burial*, on the other hand, the pilgrim's knowledge that the body of the saint resides here in the basilica, and the temporal distance that separates her from this event is given concrete form thus allowing her to "experience" the event as it occurred.

In the Sancta Sanctorum, the frescoes at St. Paul's and in the portico of St. Peter's, a viewer is directed to the immediate architectural environment which acts as a mediator between the viewer's experience and the pictorial narrative. In addition, in the Sancta Sanctorum the painted architecture specifically serves to reinforce Nicholas III's link to Rome's saints by directly relating his building programs to their lives.

In the portico frescoes at San Lorenzo Outside The Walls we see this iconographical use of architectural imagery on another level. For some time, this cycle was dated to the reign of Honorious III (1216–1227), the pope responsible for the building's enlargement in the thirteenth century; but it is now generally believed that the frescoes which comprise three extant cycles (*Lives of Saints Stephen and Lawrence* and *The Legend of the Golden Chalice*) were painted close to the end of the thirteenth century. Our analysis of the architectural imagery reinforces this dating.[75] This fresco cycle, which was severely damaged by bombing during World War II, also has a set of baroque manuscript copies. We are thus fortunate to have both the original and the copy to examine (Figures 7 and 8). In these two scenes, which come from the life of Saint Stephen on the left of the entry wall, the body of Saint Stephen is shown arriving in Rome with Pope Pelagius. The crowd appears to the left of a carefully rendered church which is clearly meant to be identified as the church of San Lorenzo, as is shown by its general profile and by the exceptionally large bases that support the porch columns (Figure 28). Thus the connection made between the contemporary viewer, the architectural environment and the narrative scene is complete. Like Saint Stephen, the pilgrim also arrives at the portico of the basilica, and like the empress Eudoxia, shown being healed in the scene on the right, the pilgrim is made to understand and expect the healing that the saint and now the site can provide. The architectural image is thus used to break through the barrier of time to bring the pilgrim and the saint face to face.

The Artistic Environment in Rome and Beyond at the End of the Thirteenth Century

We can see from these various examples that in thirteenth-century painting, when mimetic details are used, or actual built structures are rendered, their iconographic purpose is always significant and their context specific. As with the frescoes in the Sancta Sanctorum, the appearance of identifiable structures is found in the portico of San Lorenzo in only this one very specific example. In the frescoes in St. Paul's, the use of classical building types was used to link the pilgrim's actual experience with the hagiographical narrative. The same was true in San Lorenzo, although because the building in the narrative is, in fact, the one in which our pilgrim find's himself, the link is a good deal stronger. In St. Peter's, the classical monuments in the crucifixion scene mark the spot at which the event happened. This spot can be subsequently visited and the narrative reinforced when the pilgrim passes by the Meta Romuli upon leaving the basilica.

We shall continue our discussion of the process by which the viewer's space and place is connected to the location within the narrative scene and the relationship between built structures and imagses in Chapters 3 and 4. We must now turn, briefly, to the other kinds of architectural images in Roman painting. While we have focused on these few examples of a new type of architectural imagery, which uses mimetic rendering to make more complex the reading of a scene, we must be cautious not to overlook the other types of architectural images found in Roman painting in the thirteenth century. These other types, suggested by the images from the chapel of St. Sylvester and the *Burial of Saint Peter* from St. Peter's portico, are varied in form and embellishment as well as the sources from which they are derived. They are important because they give us a sense of the broad diversity of artistic currents that were present in Rome in the thirteenth century. It is against this backdrop of diversity that the architectural type that references the built environment rises to prominence in the early fourteenth century in Tuscany. Thus, in order to get a fuller picture of the triumph of this one type, we need to have some sense of the variety that preceeded it.

It might be useful then, to separate out the different building types that we are discussing. All of these types, modified in most instances to incoporate quotations from the built environment, continue into the Trecento. The first type, which we have spent most of the chapter discussing, is characterized by the use of mimetic details that constitute a sort of early "portrait," or image of a known building (discussed in detail in Chapter Three). This type is free-standing and represented by a formal vocabulary that is derived either from textual sources, such as the Terebinth, or from observation of extant structures. We have seen examples of this in the Sancta Sanctorum, St. Peter's portico and at San Lorenzo (Figures 11, 26 and 7). The second type, discussed briefly, which appeared in the portico of St. Peter's, is used for representing the interior of a building. It is a frame-like structure representing architectural parts of a building (Figure 27): columns, walls, semicircular apses and pediments. Such a manner of denoting architecture can be referred to by the literary term synecdoche, a part standing for the whole. This type of representation is related to the free-standing buildings in that it is made up of architectonic vocabulary derived from built structures and yet it is different because it is incomplete. It is used when a scene is taking place inside, although interior scenes are not always depicted using it. There is a third type of building, the inside/outside type, which combines the free-standing structure and the synecdochal structure and like them combines prethirteenth-century forms with the greater detail and more sophisticated spatial rendering found in the images already discussed. This type of image shows the interior and exterior of a building simultaneously, hence the name. Examples can be seen in the thirteenth-century crypt frescoes in Agnani and in the frescoes in the portico of San Lorenzo (Figures 89 & 91).[76]

Stylistic Diversity in Thirteenth-Century Rome

So far we have not discussed the sources for any of the architectural imagery that we have been examining. Our aim was rather to point out a feature that developed in the second half of the century and contributed dramatically to later architectural images,

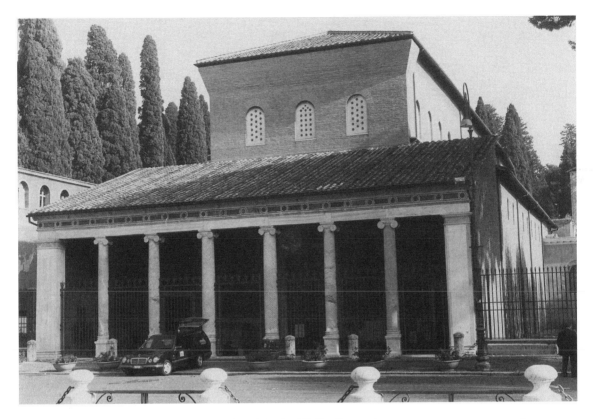

FIGURE 28. Facade, San Lorenzo Outside-the-Walls, Rome (PHOTOGRAPH BY THE AUTHOR).

both in their formal language and their iconographical use. But our story would not be complete without understanding something of the diverse stylistic forces that were at play in Rome in the thirteenth century. This diversity contributed to the richness of the artistic environment of medieval Rome but it also suggests a less restricted understanding of the form that architectural imagery could take than that which we shall see dominated in the fourteenth century. It is worth taking a closer look at these diverse forms.

There are multiple sources for each of these different types. These different sources and variations suggest something of the vibrancy of Rome's artistic environment in the thirteenth century, a vibrancy that Rome's busy history has all but erased. The early portraits have precursors. For example, in the town of Anagni close to Rome and under papal jurisdiction in the thirteenth century, a frescoed image references Rome with a monumental spiral column.[77] These frescoes are dated to first half of the thirteenth century. We have already noted that the frame-like structures found in the *Burial* in St. Peter's portico have roots in fifth-century sculptural relief. In a similar scene, the *Dream of Constantine*, also from the portico of St. Peter's, the interior location of the scene is further reinforced by the use of two hanging drapes, one behind the figure of Paul and the other behind the head of the sleeping emperor (Figure 29). The use of a drape stretched across the framing architecture to denote an interior space comes from Byzantium.[78]

To return to our central cycle in the chapel at the Sancta Sanctorum, we can look

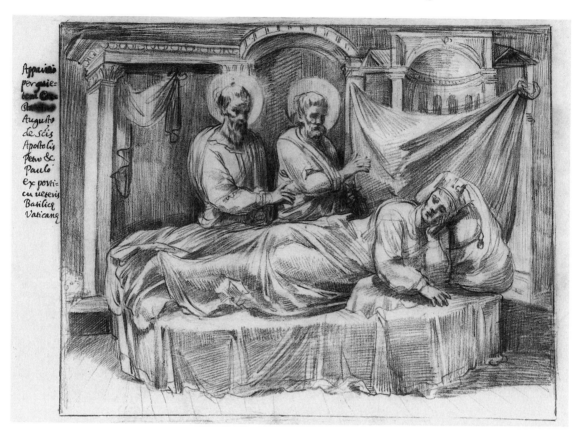

FIGURE 29. *Dream of Constantine*. Vatican City, Biblioteca Apostolica Vaticana, Archivio di San Pietro, Cod. A 64 ter, f. 46 (APOSTOLIC LIBRARY, VATICAN).

at two further scenes that demonstrate the diversity of both architectural type and sources in Roman painting. The first, the *Martyrdom of Saint Lawrence* (Figure 10), takes place in an architectonic setting that is similar to the frame type found in St. Peter's portico, except that the arcade that projects outward from the semidomed apse, in which the emperor Decius sits enthroned, is crowned by miniature architectural complexes. The apse itself supports similar assemblages. These miniature buildings relate directly to a type of architectural image found in northern Europe and first identified in an article in French by the term "villes sur arcatures."[79] The "villes sur arcatures" are columnar structures crowned sometimes by groups of, sometimes by single, miniature buildings. Similar tall thin structures with miniature buildings atop them are found in German painting of the tenth and eleventh centuries, for example in the paintings in the St. George church in Reichenau, Germany, dated to tenth century. They are also found in later, twelfth-century, Venetian mosaics.[80] In addition, in the scene of the *Saint Nicholas giving dowry money* (Figure 9), the father rushing to thank the saint exits an improbably elongated structure embellished only by two small windows on its facade and two miniature structures atop it. The proportions of this building relate to similar types of architectural form found in contemporary Byzantine painting.[81] Both Venetian and Byzantine artists and art were known in Rome, and thus it is not unusual to

find shades of their style in Roman frescoes. A similar diversity of architectural form is found in the six scenes of the *Life of the Virgin* in the apse of Santa Maria in Trastevere executed by Pietro Cavallini circa 1290 (Figure 5).[82] In these mosaics, the restrained domestic structure behind the seated Mary in the scene of the *Adoration of the Magi* constrasts dramatically with the confusingly elongated "portico" to the right of the tabernacle in the scene of the *Presentation in the Temple* (Figure 45). This structure, in particular, shows that Cavallini was looking at Byzantine images.[83]

We find a similar diversity of architectonic types not far from Rome at the basilica of San Francesco in Assisi where Roman, Tuscan and Umbrian artists worked side by side for a period of roughly fifty years.[84] There has been much ink spent on the question of the role of Roman artists in the Assisi church.[85] The evidence of the architectural imagery reinforces the idea that Roman artists played an important role here, but also that their forms were modified by the innovative thinking of other artists, particularly in evidence in the cycle of the *Life of Saint Francis* in the nave of the upper church.

The Florentine artist Cimabue's cycle of five scenes from the lives of Saints Peter and Paul in the transept of the same church in Assisi has long been recognized as a "copy" of the slightly earlier cycle of frescoes in the portico of St. Peter's.[86] Interestingly enough, however, the only scene in which he followed the Roman model in his representation of architecture was in the scene of the *Martyrdom of Saint Peter* (Figure 30) in which the two buildings that flank the saint, the Meta Romuli and the Terebinth, are copied exactly. In the other scenes the influence of Roman architectural imagery comes out only in his use of classical details. This can be seen in the classical temple front, the pediment and the fluted columns that appear on the domed building in the scene of *Saint Peter healing* (Figure 31). The precise detail, fluted columns and pediment, repeat those found on the buildings in both the scene of the *Burial* and the *Dream of Constantine* (Figures 27 and 29). The other buildings, such as the u-shaped structure behind the figure of Nero in the *Fall of Simon Magnus* (Figure 32), show the influence of Byzantine types such as those that influenced the artist who painted the Saint Nicholas scene in the Sancta Sanctorum (Figure 9).

In the frescoes of the New Testament cycle painted along the upper section of the nave of the Assisi Basilica, two images in particular stand out because the details of their forms can be related to the buildings represented in the St. Peter portico cycle. In the first, the *Presentation in the Temple* (Figure 33), the tabernacle where the event takes place is embellished with egg-and- dart molding and supported by spiral columns similar to those found in the *Dream of Constantine* (Figure 29). The tripartite structure behind the figure of the Christ in the *Dispute in the Temple* (Figure 34) is similar in type and design to the building in the scene of the *Burial of Saint Peter* (Figure 27).

Finally, the twenty-eight-scene cycle of the *Life of Saint Francis*, the last section to be painted in the Upper Church (c. 1295) is rightly seen as one of the crowning works of this period. Unfortunately, the debate that has raged around who its author is has made it almost impossible to look at the images without seeing the reflection of the hand of this or that artist. I am not going to enter into this debate, but only wish to make this one point in relation to the preceding discussion: One of the most noteworthy aspects of the Saint Francis cycle is the representation of specific, recognizable, contemporary architectural sites (Figure 35). Given what we have just seen of the development

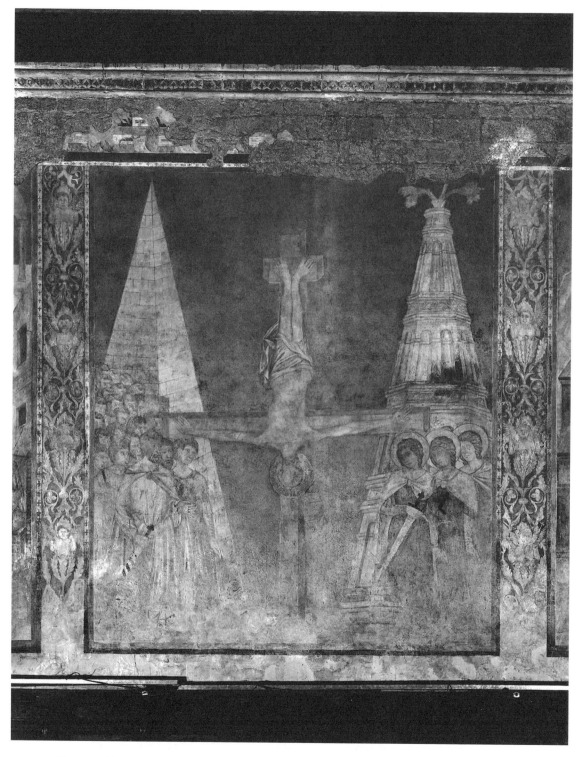

FIGURE 30. Cimabue, *Crucifixion of Saint Peter*. Assisi, Upper Church of San Francesco, north transept (GERMAN INSTITUTE FOR ART HISTORY, FLORENCE).

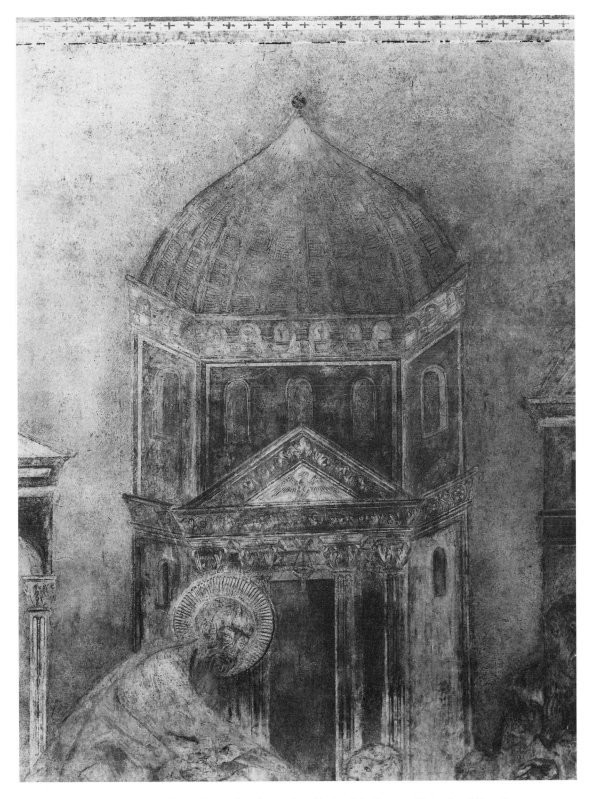

FIGURE 31. Cimabue, *Saint Peter healing*, detail. Assisi, Upper Church of San Francesco, north transept (GERMAN INSTITUTE FOR ART HISTORY, FLORENCE).

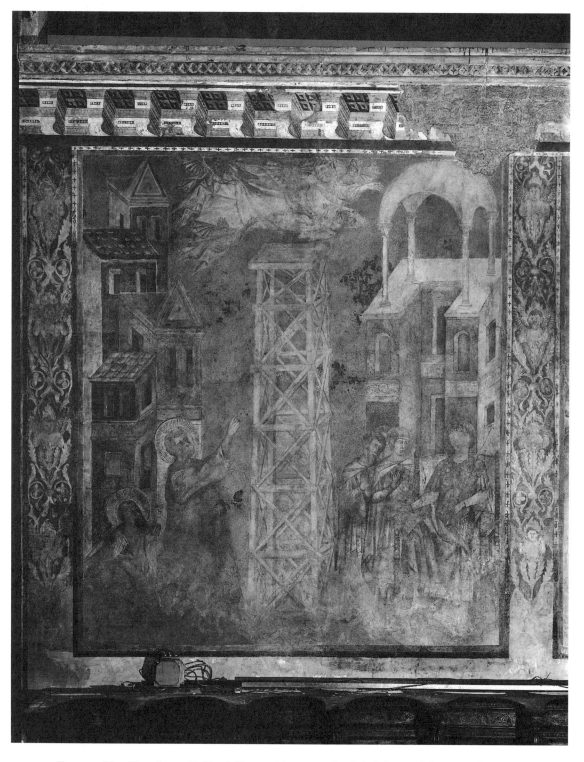

FIGURE 32. Cimabue, *Fall of Simon Magnus*. Assisi, Upper Church of San Francesco, transept (GERMAN INSTITUTE FOR ART HISTORY, FLORENCE).

FIGURE 33. Life of Christ, *Presentation in the Temple*. Assisi, Upper Church of San Francesco, nave (GERMAN INSTITUTE FOR ART HISTORY, FLORENCE).

FIGURE 34. Life of Christ, *Dispute in the Temple*. Assisi, Upper Church of San Francesco, nave (GERMAN INSTITUTE FOR ART HISTORY, FLORENCE).

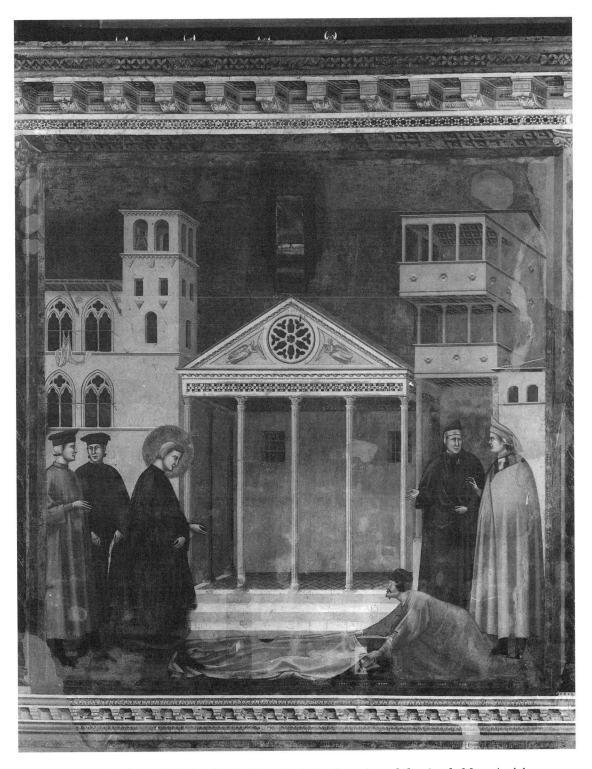

FIGURE 35. Cycle of the Life of Saint Francis, *Saint Francis and the simple Man*. Assisi, Upper Church of San Francesco (GERMAN INSTITUTE FOR ART HISTORY, FLORENCE).

of architectural depictions in Rome, it seems quite obvious that the Assisi cycle owes a good part of it innovatory style to ideas that are devised and experimented with in Rome where the readily identifiable characteristics of classical monuments and then contemporary ones are first exploited to advance both the readability and the efficacy of the pictorial narrative and the pilgrim's experience. Because the primary audience of the Saint Francis was the pilgrims, the connection between the Assisi cycle in iconographic function and the above examined cycles in Rome further reinforces the link between Assisi and Rome. No such sites, linking hagiographical events with extant architecture existed in Tuscany (although they would shortly); only in Rome could the connection between depicted event and the contemporary site make sense.

The artistic environment in Assisi, as in Rome at the end of the thirteenth century, was rich in diversity. Histories of medieval Italian painting suggest that there is a direct link between the changes that we have been looking at here in the specific use of mimetic details and the painting in the subsequent early decades of the fourteenth century in Tuscany. The architecture of these Tuscan paintings differs in particular aspects from that which we have been discussing, however. The building types found in Tuscan painting are not nearly as diverse. For example there are not as many stylistically different architectonic forms appearing in a single set of scenes—such as that in Cavallini's Trastevere mosaics, a cycle that, as we have seen, demonstrates a broad diversity of formal types—in later Florentine painting. Thus before we follow the path of these mimetic forms into the fourteenth century we must go back and trace the fall of the plural style of Roman painting in the thirteenth century. By far the strongest outside stylistic influence at play in the art of Rome during this century is Byzantine.

Chapter Two

Byzantium Bypassed: Architectural Images and the Rejection of the Maniera Greca c. 1300

A viewer who could stand with one foot in the former Church of Christ in Chora (now known as the Kariye Cami) in Istanbul and the other in the Arena Chapel in Padua would be hard pressed to understand how the artists who worked in each place could ever have had anything in common. The mosaics by the unknown artist of the Kariye are dominated by their shimmering gold and by the fantastical—sometimes minimally adorned, sometimes unabashedly ornate, blocky and spatially telescoped—architectural settings around which the figures interact (Figure 36). Giotto's architectural structures in Padua sit solidly in space and sport careful detailing that bridges the gap between the viewer's actual experience of the space within the chapel and the painted narrative (Figure 37). And yet, both these cycles are only one generation removed from a period when Byzantine art was the stylistic foundation upon which Tuscan artists self-consciously constructed their architectural images. This stylistic foundation was known by contemporaries and later scholars as the *maniera greca* (Greek manner or style) since Greece was part of Byzantium at this time. The stylistic break between the *maniera greca* and the Italian style that is evidenced by this comparison between the Kariye and the Arena is brought about not just by the rise of a new form of architectural image in Roman painting, because in Rome, as we saw in Chapter One, the tradition of artistic influence from Byzantium was sustained throughout the period of innovation. It is evocative of a deeper ideological split.

To some extent, we might be able to understand the Tuscan shift away from Byzantine models as coming about because of the Roman interest in extant and legendary real buildings discussed in Chapter One. This interest in extant buildings is not found in Byzantine architectural images. But from what we have seen of papal commissions,

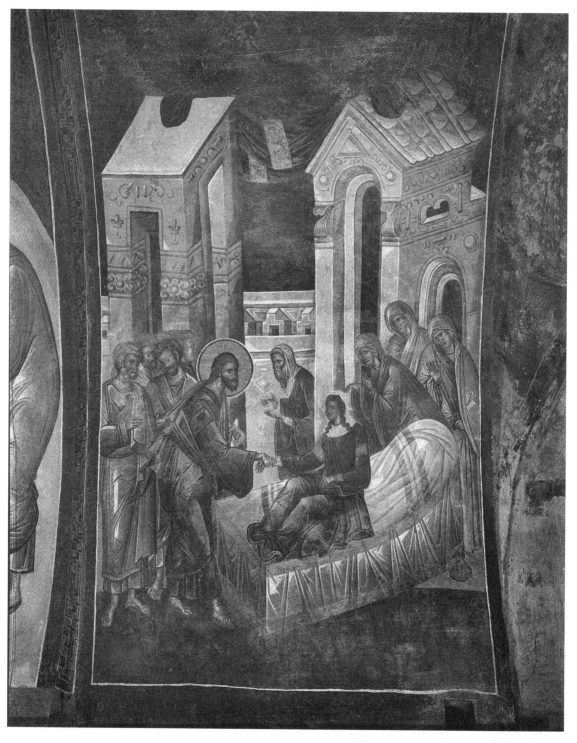

FIGURE 36. *Raising of the daughter of Jarius.* Istanbul, Kariye Cami, Parekklesion
(DUMBARTON OAKS, BYZANTINE PHOTOGRAPH AND FIELDWORK ARCHIVES, WASHINGTON,
D.C.).

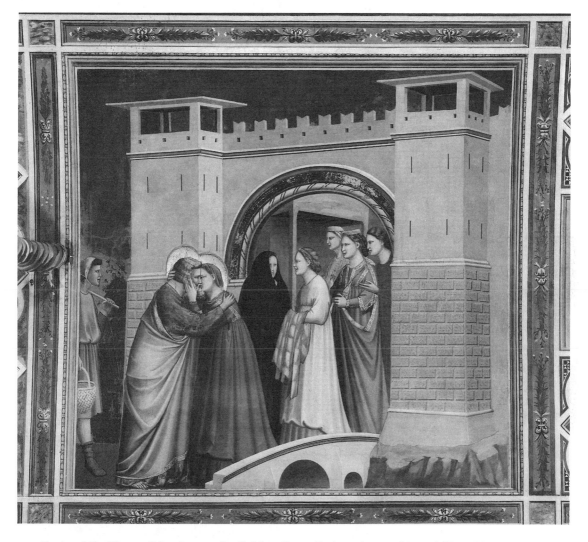

FIGURE 37. Giotto, *Meeting at the Golden Gate*. Padua, Arena Chapel (CITY MUSEUM, PADUA).

specifically the frescoes in the Sancta Sanctorum, we know that it is possible for these forms to coexist with the more conventionalized mode of rendering architecture that was popular with Byzantine artists. In other words, the presence of one should not preclude the use of the other. The historical context of the thirteenth and early fourteenth century, characterized as it was by the decline of Byzantine power and the rise of the Tuscan city-states, offers another explanation for central Italy's rejection of Byzantine form, one that might help to broaden our understanding of the multifaceted way in which architectural imagery functioned, as well as understand some of the complexities of cultural interaction during this period.

The mosaics and frescoes of the Kariye Cami are the best, and most complete, remaining examples in Istanbul, once the capital of the Byzantine Empire, of the final phase of Byzantine art. This phase is known by the name of the period itself, "Palaiolo-

FIGURE 38. Plan, Kariye Cami, Istanbul (DRAWING BY JOHN RATTÉ AFTER MATTHEWS).

gan," after the dynasty of Michael VIII Palaiologus that ruled Byzantium from the mid-thirteenth century until its fall in the fifteenth.[1] The Kariye is a typical middle-Byzantine construction with a central domed church reached through a narthex and exonarthex, added at the time the mosaics were made in the fourteenth century (Figure 38).[2] It also has a parekklesion running along the south flank where the church's patrons were buried. The mosaics of the central church have been lost except for two figures, the Virgin on the right and Christ on the left of the sanctuary, and a scene of the *Dormition of the Virgin* above the entry door. Mostly well-preserved mosaics decorate the exonarthex and narthex, and the frescoes in the parekklesion are also in a good state of repair.

The Arena and the Kariye Compared

Both the building and decoration of the Kariye Cami provide a stark stylistic contrast to the slightly earlier Arena Chapel painted by Giotto circa 1305. The Arena Chapel is a single rectangular-shaped space with a narrower extension off the eastern end where the altar is. The cycles in the exonarthex and narthex of the Kariye and the central chapel in the Arena have the same subject matter, however, and the buildings themselves are roughly the same intimate scale. In addition, they were both built through private commissions by single individuals—Theodore Metochites, the Grand Logothete of the emperor Andronicus II for the Kariye, and Enrico Scrovengni for the Arena.[3] For these reasons and because of their fine state of preservation, both these buildings present a neat opportunity for comparative analysis.

The complexity of the architectural forms in the cycles arrayed along the walls and vaults of the Kariye is worth careful scrutiny. The mosaics cover the vaults, pendentives, arches and lunettes. The lunettes offer the only wall surface that is flat; and so it must be kept in mind that often the spatial distortion of the buildings in a scene derives in part from the way in which they have been stretched across the concave surface of a vault or pendentive as from the scene's particular compositional form (compare Figures 39 and 40). In the Arena Chapel, on the other hand, the wall surface is flat and unadorned by extraneous architectural articulation.

The Kariye mosaics consist of four different cycles, and thus they contain many narrative episodes not found in the Arena. They begin, chronologically, with the cycle of the *Infancy of the Virgin* in the northern arm of the inner narthex. The nineteen scenes that tell the story—narrated for the most part in the *Protevangelium* of James, a second-century apocryphal text—occupy the pendentives, lunettes, arches and vaults of three bays of the inner narthex.[4] The second cycle is concerned with the *Infancy of Christ* based on the biblical texts of Matthew and Luke as well as certain apocryphal texts, the fifteen scenes of which occupy the lunettes of the exonarthex wrapping around into the parekklesion.[5] The *Life of Christ and His Miracles* occupied the seven vaults above the bays where the cycle of the *Infancy* was in the exonarthex and one vault of the inner narthex. Unfortunately, much of the mosaic of this cycle is lost. Finally the two bays of the parekklesion, where the patron Theodore Metochites and his wife were buried, are decorated with frescoes that illustrate scenes of redemption, centering on the *Anastasis* in the semidome of the apse and the *Last Judgment* in the vault of the easternmost bay.

In the Arena Chapel the frescoed cycle of the *Life of the Virgin* occupies the upper zone of the three-tiered program with the *Life of Christ* in the middle and the *Passion* on the bottom tier. The *Life of the Virgin* series begins on the right (south) wall at the east end and continues around, skipping the west wall, to end at the east end of the left (north) wall, twelve scenes in all. The cycle of the Life of Christ then begins with the *Annunciation* on the east wall above the apse and continues around the second tier. The last scene in the second tier, on the south wall, is the *Entry of Christ into Jerusalem*. This scene begins the series of scenes that occupy the lowermost tier of narrative images. On this tier the end of Christ's life and his return after death, known collectively as the Passion, is represented. The entire west wall, which the viewer faces when he turns to leave the chapel, is entirely filled with the *Last Judgment*.

FIGURE 39. *The enrollment for taxation.* Istanbul, Kariye Cami, exonarthex (DUM-
BARTON OAKS, BYZANTINE PHOTOGRAPH AND FIELDWORK ARCHIVES, WASHINGTON, D.C.).

　　In the Kariye the architecture of the scenes is at times quite restrained, and at times
dramatically elaborate. An example of both of these aspects can be seen in the exonarthex
scene of *Enrollment for Taxation* from the *Life of Christ* (Figure 39). The wall that stretches
behind the figures is unadorned, save three narrow lines that suggest a cornice and a
small double-light window on the far left. However, the restraint in surface articulation
is not carried over to the other architectural forms found in this scene. Behind the two
central figures, the governor on the left and the Virgin on the right, there are two strik-
ing architectural assemblages.

　　On the left rising from directly behind the figure of the seated governor is a nar-
row square tower, the top two stories of which, just visible behind the governor's head,
are open loggias supported on columns and a single back wall. Behind the Virgin an
equally ambiguous mass of masonry frames her figure. It is made up of two stories; its
lower square base has a recessed entry but no visible door. Perched atop this base is a
u-shaped structure, the sidewalls of which are embellished with large corbels support-
ing a column that also supports a corbel. Neither this structure nor the one on the left

suggest any kind of known built form. Even their details do not correspond to known building types. Rather their role appears to be to frame and emphasize the two figures. They work, in conjunction with the low wall behind them, to enclose the scene and focus the eye of the viewer on the central figures. Behind the figure of the governor a length of red cloth stretched from a small portico to the top of the tower denotes the interior location of the scene.

We see a similar type of portico in the Kariye Cami in the scene of Joachim and Anna *Meeting at the Golden Gate* (Figure 40). This scene is also found in the Arena (Figure 37), and thus it is easy to compare the choices made by the two different artists. In the Kariye scene, the lower section of the gate has been lost, but it resembles in form the portico on the right in the *Enrollment for Taxation* scene. It is a tall structure, u-shaped with a wide, low base upon which sits a rectangular block fronted by two ornate columns. The flat roof of this structure is capped by a low wall pierced with rounded arches at the sides and back. Like the porticos in the previous scene, this architectural assembly seems to relate only tangentially to built structures. In the Arena, however, the vocabulary of the gate that rises behind the two embracing figures is derived in part from the Roman gate found in nearby Rimini.[6] The watch towers closely resemble those surrounding the Arch of Augustus that guarded the bridge of Tiberius.[7]

The low wall that runs across the background and thus contains the scene in the *Enrollment for Taxation* is repeated in a number of scenes in the Kariye. As we have seen, this wall is often used to connect two opposing architectural structures denoting an interior space, but it also functions spatially to limit the zone in which the figures act. In this it functions in an opposite way from the walls in Giotto's images, which are used, as in the *Presentation of the Virgin in the Temple* (Figure 41), to project into space at an oblique angle, thus augmenting the space within the picture plane and connecting it to the space in the chapel.[8] In addition to this, the lack of a link between the represented structures and built architecture is enhanced by the narrow uninhabitable quality of the architecture in the Kariye scenes an impression that is created by the lack of visible or suggested interior space as well as by their small size. The Kariye scene of the *Presentation of the Virgin in the Temple* (Figure 42) further illustrates the separation between these two different conceptions of architectural imagery, both in terms of how it functions and how it relates spatially to the figures. In the Kariye scene, which takes up the whole of the vault, the entire temple precinct is represented. The simple house-like structure at the top of the scene is the entry portico through which Joachim and Anne enter, but it is also the main building of the precinct, as is shown by the temple virgins seen exiting from the other side.[9] Below, the Virgin rushes with open arms to the priest who stands before the sanctuary, denoted by a low chancel barrier that encloses the altar, which is covered with a ciborium with a curved vault. In the Arena scene, the temple precinct is marked off from the viewer's space by a low wall that runs obliquely across the picture plane. The priest stands at the entry welcoming the young Mary who is dutifully climbing the steps to approach the door. The sanctuary beyond the wall is denoted in much the same way as it is in the Kariye by a ciborium, although here the pyramidal roof and single column sit solidly in space.

In the two scenes of the *Annunciation to Anne* (Figures 43 and 44) we see the distinctions between Giotto's construction of interior space within an architectonic set-

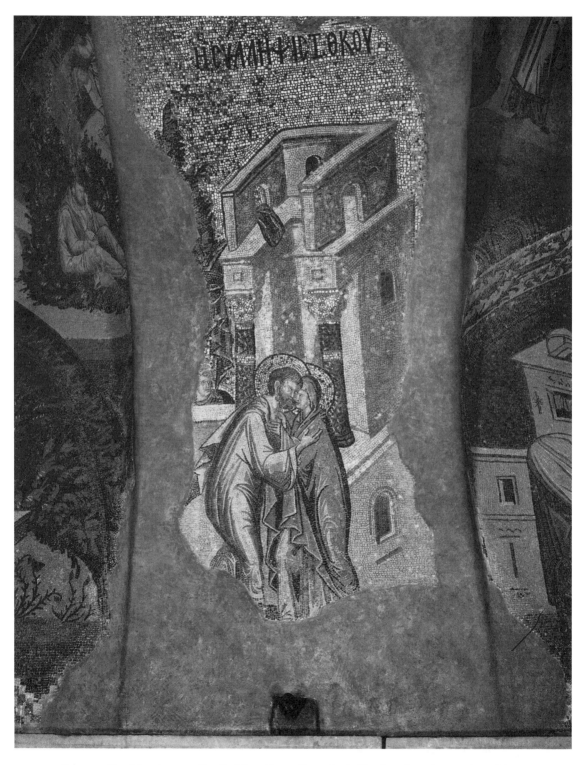

FIGURE 40. *Meeting at the Golden Gate*. Istanbul, Kariye Cami, narthex (DUMBAR-TON OAKS, BYZANTINE PHOTOGRAPH AND FIELDWORK ARCHIVES, WASHINGTON, D.C.).

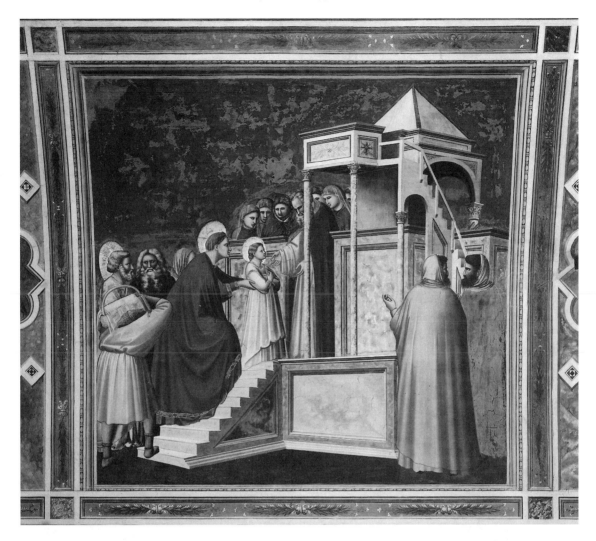

FIGURE 41. Giotto, *Presentation of the Virgin in the Temple*. Padua, Arena Chapel (CITY MUSEUM, PADUA).

ting that coheres in scale (almost) and detail with built structures and the Kariye artist's complex architectural ensemble. The Kariye scene takes place outdoors; although the complex building on the left is draped in an ornate cloth, the presence of the fountain denotes the exterior location. The ornate pile behind Anne can be compared to the simple box in which Anne kneels in the Arena. Two side walls recess obliquely into space to the back wall. The fourth wall, parallel to the picture plane, is missing so that we are allowed to look into the building to witness the miraculous event.

There are two preliminary conclusions that we can draw about the differences between the architecture in the Kariye and the Arena Chapel. The first is that the Byzantine representation of pictorial space is confined, using a wall, to a frieze of space in the foreground of the picture plane in which all the action of the narrative scene must take place. The second, and more important for purposes of comparison, is that the

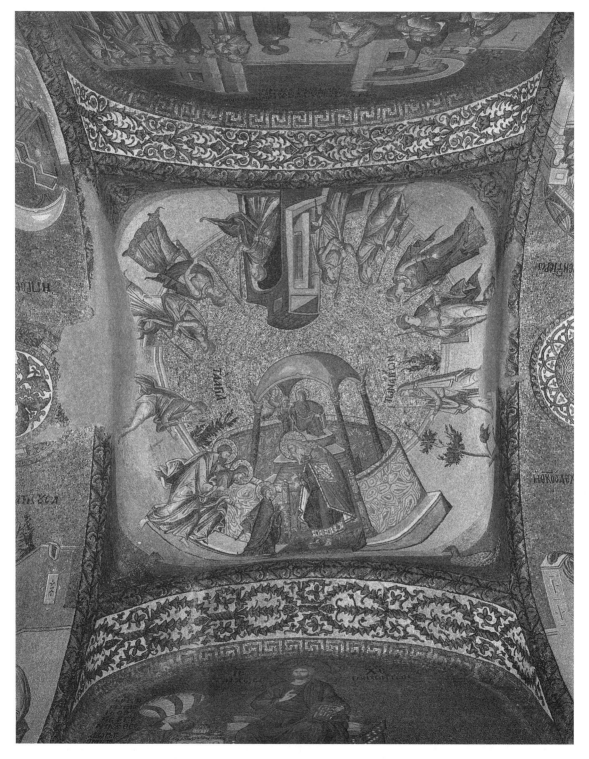

FIGURE 42. *Presentation of the Virgin in the Temple.* Istanbul, Kariye Cami, Narthex (DUMBARTON OAKS, BYZANTINE PHOTOGRAPH AND FIELDWORK ARCHIVES).

FIGURE **43.** Giotto, *Annunciation to Anne.* **Padua, Arena Chapel** (CITY MUSEUM, PADUA).

use of the elaborate fantastical architectonic assemblies—seen both in the *Enrollment for Taxation* (Figure 39), the *Meeting at the Golden Gate* (Figure 40) and in the scene of *Christ raising the Daughter of Jarius* (Figure 36) with which we began our comparison—suggests a disjunction between the built environment and the representation of architecture, which runs contrary to the Roman innovation of representing identifiable buildings that Giotto is clearly developing in the Arena Chapel.

Italian and Byzantine Artistic Currents and Interchange

Curiously enough, the stark contrast between the Kariye and the Arena scenes is not in evidence in the paintings that we examined in the previous chapter, where there

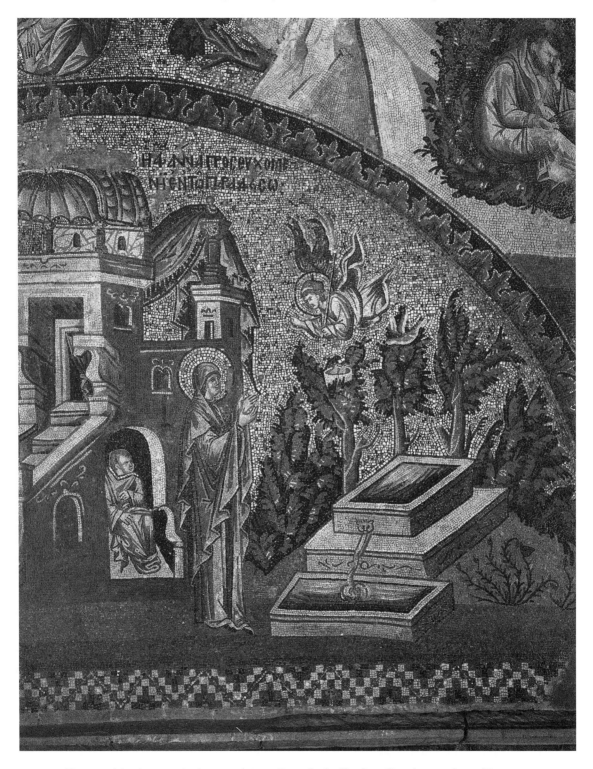

FIGURE 44. *Annunciation to Anne.* Istanbul, Kariye Cami, narthex (DUMBARTON OAKS, BYZANTINE PHOTOGRAPH AND FIELDWORK ARCHIVES, WASHINGTON, D.C.).

were stylistic links between architectural images in the Sancta Sanctorum and Assisi and contemporary Byzantine painting. These links were particularly pronounced in the scene of the *Saint Nicholas giving dowry money* (Figure 9). The blocky, shallow, minimally adorned structure in this scene is formally linked to Palaiologan forms found in the earlier paintings, such as those in Sopocani, Serbia (c. 1265) and made more elaborate in the Kariye.[10] Although there is no one-to-one correspondence between these forms, the influence of Byzantine-style buildings is clear in the blockyness and scarcity of detail, as well as the buildup of architectonic forms that don't seem to relate to built architecture at all. This correspondence between Palaiologan forms and contemporary Italian painting is found in other works as well. For example, in the five scenes from the *Life of Saint Peter,* done by the Florentine artist Cimabue in the right transept of the Upper Church in Assisi, similar architectonic assemblages occur. In the scene of the *Fall of Simon Magnus* (Figure 32), a large u-shaped portico rises up behind the figure of the emperor. In scale and in spatial solidity this building differs from Palaiologan architectural images, but its blocky quality, its overall shape and its lack of a source in the built environment all link it to the Byzantine forms. It can be compared favorably with the structure to the right of the lower scene on the right of the Saint Francis altarpiece, now in the Museum of the Convent in Assisi that is attributed to a Byzantine master.[11] Its presence suggests a source for Cimabue's knowledge of the Palaiologan structures.[12]

Pietro Cavallini's cycle of the *Life of the Virgin* from the apse of Santa Maria in Trastevere in Rome also shows a synthesis of the Palaiologan style of architecture. For example, in the *Presentation in the Temple* (Figure 45) the very tall narrow structure that rises up behind the figures of Joseph and Mary on the left is similar to contemporary Palaiologan structures seen in the *Death of the Virgin* in the Church of the Virgin Peribleptos in Ohrid, in the Republic of Macedonia.[13] The ciborium that rises above the altar and the u-shaped elongated structure on the right are again evocative of Byzantine forms. At the same time the Roman artist is clearly looking toward Byzantium, some of the imagery in this cycle is quite distinct from anything found in Byzantine sources, such as the *Birth of the Virgin* (Figure 46) in which Anne is shown in a carefully articulated rectangular interior space, the precursor to the form found in Giotto's *Annunciation to Anne* (Figure 43).[14] This "space-box"—its original source is obscure, although it is probably derived from Antique, first and second century CE, prototypes—is never found in Byzantine painting.[15]

Returning to Assisi, we note that in addition to Cimabue's Saint Peter cycle, generalized Byzantine-inspired imagery has always been acknowledged in the Old and New Testament cycles on the upper walls of the nave but curiously never in the cycle below in which the story of Saint Francis is told. We have already noted that in a number of the scenes from this cycle the Roman innovation of representing identifiable buildings within the narrative is exploited in a dramatic way.[16] But a remarkable and yet often unremarked upon feature of the Saint Francis cycle is the diversity of types found in its architectural imagery. Alongside the carefully rendered identifiable buildings, such as that found in the scene of the *Simple Man* (Figure 35) there are also quite odd architectural assemblages that relate only tangentially to built structures, such as that found in the scene of the Francis' renunciation (Figure 47). In this scene Francis's father and his supporters stand in front of a clearly articulated domestic structure whose link to the built environment consists of carefully executed windows and roof tiles as well as an

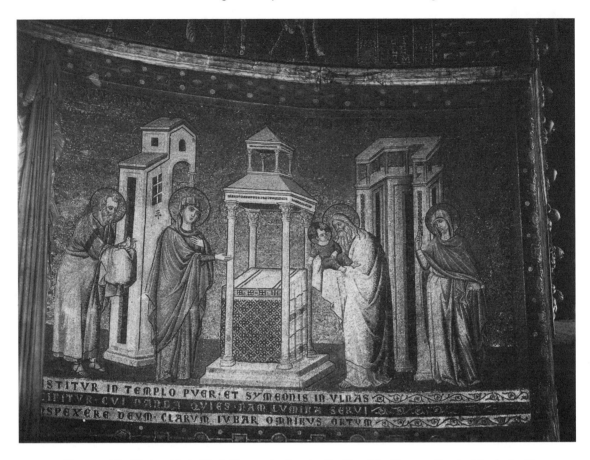

FIGURE 45. Pietro Cavallini. *Presentation in the Temple*. Rome, Santa Maria in Trastevere (PHOTOGRAPHIC ARCHIVE, VATICAN MUSEUMS).

elaborate outdoor stair. Behind Francis and the bishop, however, a completely different "structure" rises. This pile of architectonic form composed, like the structures of Palaiologan paintings, of elements of built form and sculpture, is quite unarchitectonic except for its substantial size. It is shallow in form, and again like Palaiologan buildings, appears uninhabitable. Similar shallow, uninhabitable and unidentifiable structures appear in three other scenes, although they are not quite as striking this one is.[17]

Accustomed as we are to seeing fresco cycles like that of Saint Francis as emblems of a new era of painting we might find it difficult to reconcile this vision with this obvious evidence of Byzantine influence within the cycle. This is because the idea of Byzantine painting as static and flat, a notion which is not born out by the pictorial evidence, has been firmly established in the literature of Italian art history. In addition, the rejection of Byzantine style by the artists of Italy as an essential component of their own artistic development was so firmly established in this literature that it has all the appearance of fact. This inaccurate idea of Byzantine artistic backwardness has allowed the Italian innovations of the fourteenth century to be seen in simplistic relief, and has created problems for historians of Byzantine art who have had to struggle against it. For those of us who study Italian art, it has shut out a more complex and nuanced reading

FIGURE **46**. Pietro Cavallini, *Birth of the Virgin*. Rome, Santa Maria in Trastevere (PHOTOGRAPHIC ARCHIVE, VATICAN MUSEUMS).

of the history of this period, which would give us a more nuanced understanding of its art and a more sophisticated way of examining the interactions of Italian and Byzantine artists. It also prevented us from thinking more complexly about the remnants of Byzantine art that continue in the art of some trecento artists, such as the Sienese painter Duccio. From Giotto's time onward, these continued influences are definitely not seen in architectonic form which, I shall argue, is the key feature that both the Greeks and the Italians use to draw distinctions between their art. The critical tradition that has constructed this vision goes back a long way, and it is worth reviewing it before we can begin to understand not only how Byzantine and Italian architectural forms could go hand in hand but also how they could so quickly diverge from the time of the painting in Assisi to Giotto's work in the Arena Chapel less than ten years later.

Inventing the "Maniera Greca"

In circa 1399, Cennino Cennini established his right to discuss artistic techniques by cataloging his painterly lineage beginning with Agnolo Gaddi, son of Taddeo. Agnolo

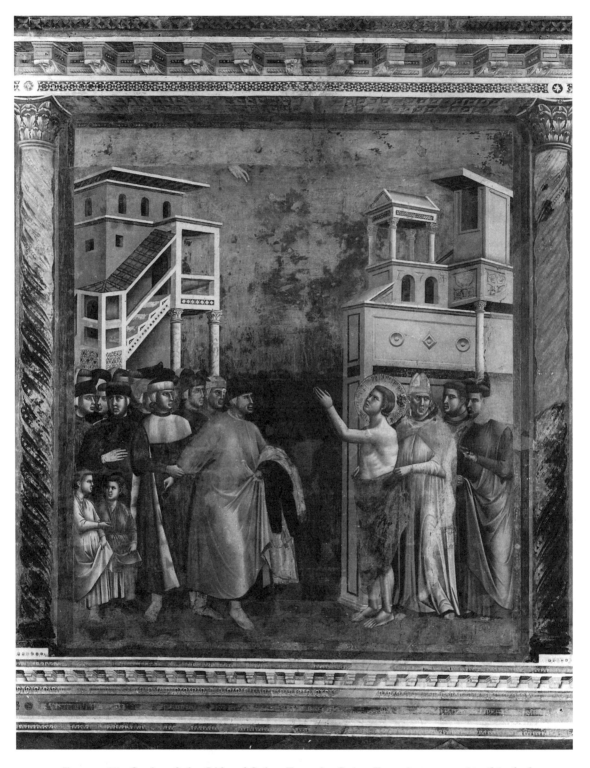

FIGURE 47. Cycle of the Life of Saint Francis, *Saint Francis renouncing his father*.
Assisi, Upper Church of San Francesco (GERMAN INSTITUTE FOR ART HISTORY, FLORENCE).

in turn, learned painting from his father who studied with Giotto, and, Giotto, Cennini notes pointedly "changed the profession of painting from Greek back into Latin, and brought it up to date."[18] While this passage is often used to demonstrate the strength of Giotto's stylistic influence across the span of the fourteenth century, its characterization of the artistic change which took place during the great Florentine painter's lifetime along regional lines, has received little comment.

A more complex understanding of the stylistic transformation of central Italian art circa 1300 is hinted at by Cennini's choice of words. We understand that Greek art is *retarditare*, or backward, because of the appended clause "and brought it up to date." The pejorative characterization of Greek art and the condemnation of the *maniera greca* becomes clear cut in the later sources. Lorenzo Ghiberti, noting the innovations of Giotto, remarks that the Tuscan "left the crudeness of the Greeks."[19] As time goes by the condemnation builds. Vasari remarks of Giotto, that he "totally banished the rude Greek manner."[20]

The Italian characterization of Greek art as "crude" continued to be accepted up to and into the twentieth century when Byzantinists began the struggle to take apart the myth of Greek stylistic backwardness and give a more accurate rendering of Byzantine artistic development and its relationship to the West.[21] The question of the real character of Byzantine painting and its relationship to the West was raised and responded to in a symposium sponsored by Dumbarton Oaks in 1965 entitled "The Byzantine Contribution to Western Art of the Twelfth and Thirteenth Centuries." Some of the papers read there were subsequently published in the *Dumbarton Oaks Papers* (1966) dedicated to clarifying the positive and powerful stylistic influence that Greek artists had on Italians in the thirteenth century.[22] Ernst Kitzinger, in an article published in the *Dumbarton Oaks Papers*, noted that the evidence of Greek stylistic influence on Italian artists is clear; it is only the interpretation of that evidence which is problematic. "Was Byzantium essentially a retarding, chilling, and obstructing element in Western art or was it a positive, life-giving, and constructive one?" The article goes on to prove the latter, noting as he does so that profound influence of the contemporary documents on our understanding of artistic tradition. "[The implications of Vasari's works is that] ... the *maniera greca* was taught only to be overcome. It was simply the dead hand of tradition and had no positive role in the emergence of Western art."[23] In addition to Kitzinger's article, this volume of the *Dumbarton Oaks Papers* contained the first revisionist assessment of the influence of Byzantine painting on Italian thirteenth-century painting by James Stubblebine.[24] Stubblebine's article, relying on the then newly discovered icons at the monastery of St. Catherine at Mt. Sinai, systematically demonstrated the points at which Italian painting was based on Byzantine prototypes. Stubblebine was careful to argue that the Italian artists did not merely copy the Byzantines, however. In 1970, Otto Demus's *Byzantium and the West*, was the first book-length study to offer necessary revisions to the art historical record regarding Byzantine art and Italy. In Demus's book, he went a good deal further than Stubblebine, suggesting that the Italians were swept away by the powerful images of the Byzantines responding to it by copying whatever they could get their hands on.[25]

Two books by Hans Belting also addressed the question of the influence of Byzantine painting on Italian art. The first—*The Image and Its Public in the Middle Ages: Form*

and Function of Early Paintings of the Passion, published first in German in 1981 and made available in English in 1990—concerned itself with devotional images of the dead Christ (Pieta).[26] The later book, also originally published in German and later translated into English, entitled *Likeness and Presence: A History of the Image before the Era of Art* likewise concerned itself only with devotional imagery, excluding narrative images.[27] Belting's conclusion that Italian painters set out to make faithful copies of their Byzantine sources because their antiquity gave them an added aura of holiness is therefore not directly relevant to the images that we will look at here.[28]

More recently modifications have been suggested to the overhaul offered by Demus, Stubblebine and Belting. Where they wished to see the influence of Byzantium as transcendent over the Italian artists, scholars today see a modulated interaction that involved the Italian artists as active recipients of stylistic influence, taking some things and disregarding others.[29] Although it still seems unclear exactly how much Byzantine art the Italians were exposed to and how, the images demonstrate clearly that Italian artists were looking at Byzantine painting.[30] In terms of architectural imagery, we have already seen that Palaiologan stylistic features were integrated into contemporary Italian painting in the last quarter of the century in Rome and Assisi. The stylistic influence of earlier eleventh- and twelfth-century Byzantine painting is stronger in Tuscany from the mid- to the late thirteenth-century. But it is modulated and not slavish.

Returning to the Italian texts of the late fourteenth century and to Vasari in the sixteenth century, I believe that they offer an insight into the Italian rejection of Byzantine painting at the end of the thirteenth century. No one has yet tried to understand the implications of what it strikes me can only be called the Italians' conscious "smear campaign" in the distinction that they draw up between the *maniera greca* and their own art. These implications are far reaching and they can help us to broaden our understanding of the artistic environment and culture in late thirteenth- and early fourteenth-century Italy. Scholars have sought to understand the art of the early Trecento in a variety of different contexts. But in each of these explanations we are given an image of artists and patrons who are consciously turning toward a particular style, that of ancient Rome. But we have seen in the previous chapter that the innovations of pictorial form in the thirteenth century appeared in conjunction with Byzantine images. Thus what we have is not so much a turning toward, as a turning away. What I propose is that the wholesale shift to the innovative, mimetic architectural forms found in Tuscan painting in the beginning of the fourteenth century was the outcome not of a triumph of locally derived imagery for its own sake but rather of a conscious and determined rejection of Byzantine art which had played a strong role in central Italian pictorial form throughout the thirteenth century.[31]

The evidence in support of this hypothesis can be seen in the architectural images themselves, in the dramatic quality of the stylistic shift in both Byzantine and central Italian imagery, and in the interactions between Italians and Greeks during the crucial period in which the transition takes place. The relationship between Italy and Byzantium in the thirteenth century has been dominated in historical writing by the diversion of the Fourth Crusade by the Venetians in 1203, the subsequent sacking of the imperial city of Constantinople in 1204 and the establishment of the Latin Empire there under Emperor Baldwin. While it is impossible to overstate the importance of

this event, it is also necessary to recognize that relations between Byzantium and the West continued after the conquest, and so did artistic interaction over the course of the thirteenth century, indeed into the painting of the basilica of St. Francis in Assisi. It is only at the beginning of the fourteenth century that painted narratives begin to be dominated by a single kind of architectural image, one that is grounded in built structures both in its details and its spatial solidity, that we see evidence of a break in Byzantine and Italian artistic interaction.

It is the architectural images in Byzantine mosaics in the Kariye and not the figures which exoticize and dramatize the difference between them and the Italian paintings in the Arena Chapel. We have seen in Chapter One how the growing awareness of the iconography of the built environment transforms both the form and function of represented buildings, particularly in terms of the architectonic detailing. Given this, we should not imagine that the Italian break with Byzantine style can be understood only in terms of stylistic preference or in terms of education that is intimated by writers since Vasari. There is something conscious about this break and about the way in which the forms that triumph are specifically the architectonic forms found in the Italian urban environment. A key to understanding the break, then, is to see this difference in architectural imagery in conjunction with historical events. Together they show that the Italian rejection of the *maniera greca* might more productively be understood as echoes of a politically charged ideological argument.

Relations between Byzantium and Italy, Artistic and Otherwise

The complex interrelationship between art and artists of Italy and Byzantium has a long history beginning in the fourth century when Rome and Constantinople would have been two halves of the same imperial coin. Byzantine art was highly influential in the papal city in the eighth and ninth centuries and an important part of the artistic revival under the abbot Desiderius in the monastery of Montecassino in the mid-eleventh century.[32] At the beginning of the thirteenth century, Byzantine painting had a strong influence on the development of Italian altarpieces for which the Lateran council of 1215 had created a new demand.[33] The architectural imagery found in the narratives of historiated crucifixes, altarpieces with images of the enthroned Virgin as well as those of standing saints show a direct correlation with those found in contemporary and earlier Byzantine icons and manuscripts.[34]

Striking resemblances between building type, composition and decoration characterize the relationship between the architectural images of central Italian painting and Byzantine images. In addition, almost all of the building types that appear in Italian painting appear in Byzantine imagery prior to the thirteenth century, dating back, in some cases, to the tenth century.[35] Of building types, the most links are seen in the simple rectangular structure with a triangular pediment, peaked roof and doorway that can be seen in a number of the scenes of the early thirteenth-century Saint Nicholas icon in the monastery of St. Catherine at Mt. Sinai (Figure 48).[36] This same building is found in many Tuscan panels including the Bardi Chapel *Saint Francis* painted for an altar in

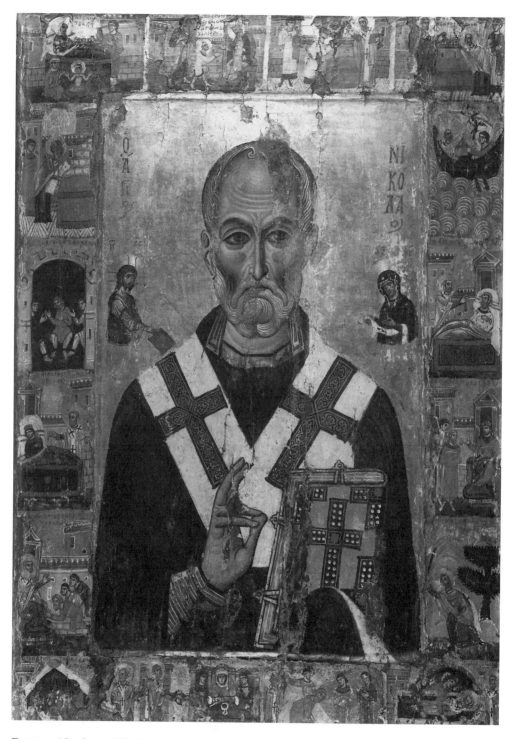

FIGURE **48**. *Saint Nicholas and scenes of his life*. Egypt, Mount Sinai, Monastery of Saint Catherine (PUBLISHED COURTESY OF THE MICHIGAN-PRINCETON-ALEXANDRIA EXPEDITION TO MOUNT SINAI).

FIGURE **49** *(opposite)*. *Saint Francis and scenes of his life*. Florence, Santa Croce, Bardi Chapel (GERMAN INSTITUTE FOR ART HISTORY, FLORENCE).

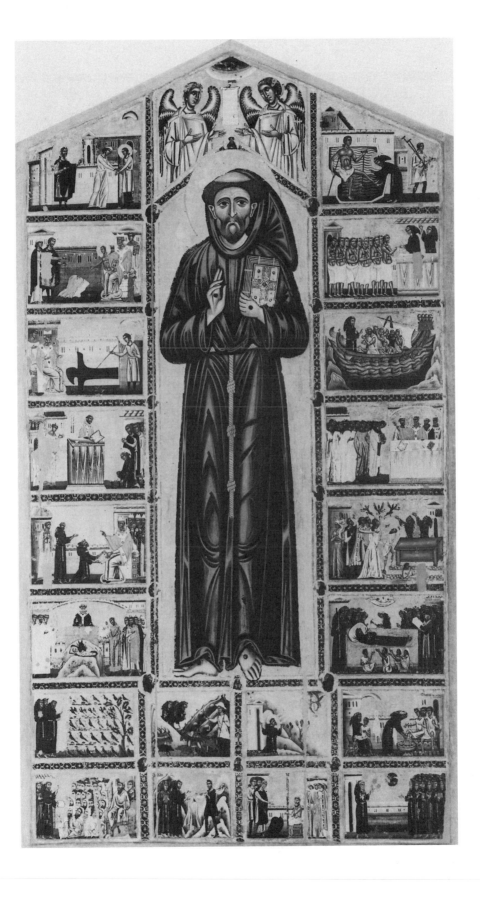

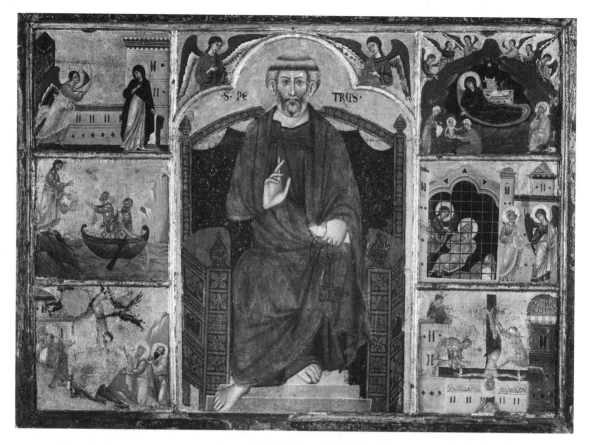

FIGURE 50. *Saint Peter and scenes of his life*. Siena, Pinacoteca (SUPERINTENDENT P.S.A.D–SIENA, WITH PERMISSION OF THE MINISTRY FOR ART AND CULTURAL ACTIVITY).

the church of Santa Croce around 1250 or the Sienese panel of *Saint Peter* with six scenes of his life (Figures 49 and 50). Another commonly found building type that derives from Byzantium and is used in much imagery in Tuscany is the tower. In the Saint Nicholas icon (Figure 48), it can be seen in two scenes on the right of the image of the saint in which it appears in opposition to the basilican-like structure just described. Again, the same type of structure reappears in the Florentine panel one hundred years later. From these examples we can see that not only the form but also the compositional mode of using two structures on opposite sides of a scene is taken from Byzantine examples and reused by the Italian painters. These opposing structures often reinforce oppositional groups of figures and are connected by a low wall.

Another and more eye-catching link between Byzantine prototypes and the Italian representations is the use of carefully constructed architectonic detail. In our example of the Saint Nicholas icon the scenes are so small that the precision of detail is not very fine. We can turn to the panel of the *Miracle at Chonai* to see more clearly how finely constructed these architectonic details were (Figure 51). They consist both of carefully rendered patterns of ashlar blocks for walls, a variety of window types, elegant architraves and cornices and, particularly in this icon, elaborately conceived roof tiles. The

FIGURE 51. *Miracle at Chonai.* Egypt, Mount Sinai, Monastery of Saint Catherine (PUB-LISHED COURTESY OF THE MICHIGAN-PRINCETON-ALEXANDRIA EXPEDITION TO MOUNT SINAI).

FIGURE 52. *Scenes from the Lives of Saints Francis, Clare, Bartolomeo and Catherine.* Siena, Pinacoteca (Superintendent P.S.A.D–Siena, with permission of the Ministry for Art and Cultural Activity).

same attention to these architectonic embellishments characterizes the Italian images. These can be seen in the Bardi Chapel altarpiece and in more elaborate detail on the Sienese Saint Peter and on a pair of retable doors also from Siena (Figures 49, 50 and 52). A particularly striking similarity is notable between the domes in the Byzantine icon and on the building to the right of the body of the crucified Saint Peter in the Sienese altarpiece. We now recognize that the same kind of detail and building type characterize the architecture in the frescoes of the St. Sylvester Chapel in the church of the Quattro Coronati in Rome. The wall that separates the figures from the complex of buildings denoting the city in the scene of the *Presentation of the Icon* (Figure 12) is similar to that found in the fresco of the *Visitation* from the church in Kurbinovo dated 1191.[37]

As we have noted, in Byzantine imagery, some time in the early decades of the thirteenth century, the rounded buildings seen in the Saint Nicholas icon or the icon with the *Miracle at Chonai* are replaced by more staid and far less heavily embellished structures with smooth wall surfaces and heavy protrusions, columns and porticos. An example of these forms can be seen in the church of the Holy Trinity at Sopocani dated to circa 1265.[38] They are fully formed and complexly conceived by the time we get to the imagery of the Kariye. These distinctive porticos in Palaiologan paintings are visually striking and yet to a viewer used to the Western tradition they are exceedingly difficult to understand. They are not inhabitable—there are no doors—nor does their articulation denote any specific type of building. They contrast sharply with the contemporaneous innovations in architectonic forms that were occurring in Rome. Their appearance can, however, be explained through their visual correspondence to the architectural imagery found in earlier, tenth-century, Byzantine painting. For example, in the scene of *The Anointing of David* (Figure 53) from a famous Bible made in Constantinople around the middle of the tenth century now in the Vatican in Rome and known as the *Leo Bible*, the elaborate architectural detail on the portico behind the figure of the priest is similar to that found on the buildings that form the backdrop of the *Raising of the Daughter of Jarius* (Figure 36). In addition, the blocky u-shaped structure behind the figure of the Virgin in the *Enrollment for Taxation* (Figure 39) is reminiscent of the doorless 'entry-way' behind the crowd of figures on the left of the manuscript image (Figure 53). At the time of the production of the *Leo Bible* the Byzantine empire was at a high point, not only in terms of its political position in relationship to other world powers but also in terms of its artistic production. The arts flourished under the patronage of emperors and civic officials.[39] The revival of tenth-century architectural imagery in the Palaiologan period might then be read politically.[40] As the Byzantines struggled to maintain their culture against the threats from both the Turks and the Europeans throughout the Palaiologan period, a revival of the artistic style that flourished during a period of Byzantine military strength and cultural hegemony, makes sense.

As we have seen in Chapter One and in Pope Nicholas III's commissions, conceptions of architecture and its representation are intimately linked to political identity at the same time that they reflect the growing complexity of notions of the importance of place and time. The shift in architectural imagery in Byzantium away from the representation of combinations of towers, walls and basilican-like buildings to more fantastical porticos could be construed as a conscious revival of architectural types found in

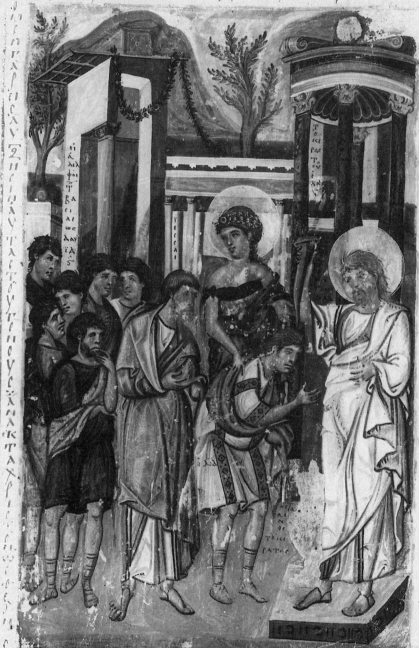

earlier imagery. This revival should be seen in the same light as the construction of newer architectural forms in Roman painting. Looking back at the events of the thirteenth century, the interactions between Italians and Byzantines creates a framework for understanding the Byzantines' conscious maintenance of an earlier style of painting, as well as central Italian preference for the innovations that emphasized their own urban settings, and through this, their developing national identity. I should note here that there is a profound difference between the way Byzantine imagery works theologically and the way Italian images, at the end of the thirteenth and fourteenth century, work under the influence of Franciscan spirituality. In his discussion of the representations of saints in Byzantine imagery Henry Maguire remarks that the generic quality of the representations were key to the images' accessibility and usefulness for a variety of viewers. In this context, specific architectural references would be counterproductive.[41]

In the spring of 1204, a combined force of Crusaders, encouraged by the Venetians, broke through the land walls of Constantinople and forced the recently installed Byzantine Emperor Alexius V Murzuphlus to flee.[42] The Latin troops then were allowed three days to sack the fallen city. Many of the soldiers set themselves to mindless destruction and desecration, but there was also an extensive collection made of booty, which was divided by the conquerors at the end of the three days.[43] With the city in ruins around them, the conquerors set about electing a new emperor to head a Latin empire with its capital in Constantinople and dividing up the lands of the conquered empire. In addition they elected a Latin patriarch to head the church. Historians do not tire of noting the powerful impact that the sack of the city had on the Byzantine people.[44] It is from this date that Runciman dates the beginning of a transformation in the Byzantine psyche that grew into a new national identity linked to the Hellenic and not the Roman past.[45] No doubt the impact of the fall was just as important for the West. The imperial city, which had been set up as the pinnacle of cultural achievement and Christianity, had fallen.

The sack of Constantinople was not the result of any one single event. It was rather the culmination of an enmity between East and West that had been growing since the eleventh century, fueled by the schism that had taken place between the two churches in 1054 and by trade disagreements with the Venetians who played a major role in instigating the sack. Without a doubt the doctrinal split between the Eastern and Western churches was a contributing element in the legitimization of the conquest. The schism was based upon disagreements over three things: the wording of the creed,[46] the Greek use of leavened bread for mass, and the position of the pope in the church hierarchy.[47] While the beginning of the schism has been dated to the year 1054, the year of the mutual excommunication of pope and patriarch, it is not evident that it was clearly identified by the citizens until much later.[48] In 1245, Innocent IV noted that only recently had the Greek Church become schismatic.[49] Art historical evidence also demonstrates that the Greek Church was not understood to be heretical until the outbreak of open hostilities in the thirteenth century. A number of Byzantine religious images were considered to be sacred in the West because their chronological and geographical closeness

FIGURE 53 (*opposite*). *Annointing of David.* Leo Bible, Vatican City, Biblioteca Apostolica Vaticana, Reg. Gr. 1B, folio B 263r (APOSTOLIC LIBRARY, VATICAN).

to the people that they represented gave them the aura of relics—body parts, or objects touched or owned by holy persons.[50]

Over the course of the thirteenth century, however, this changed. The enmity between East and West that had exploded in the conquest of the Byzantine capital continued to seethe. Now that the idea of a Latin empire in the East had been introduced, it would always be something that the popes could use in their attempts to bring about church unity. More importantly, in central Italy the thirteenth century was a critical period of development. It is during this period that the central Italian city-states began their rapid political and economic growth.[51] Hand in hand with this growth comes a developing sense of historical identity.[52] Thus, at the same time that the conquest of Constantinople ushered in a revival of specifically "Hellenistic," or Greek, artistic forms in Byzantium, the central Italians were developing a sense of their own regional identity.

We have seen in Chapter One that, during the thirteenth century the papacy was at the height of its power. It was inevitable that, with the reestablishment of papal power and the reform of the institution of the church, healing the rift between the Eastern and Western churches would become an important part of papal policy. Innocent III endorsed the Fourth Crusade's attack on Constantinople because, in part, he assumed it would insure the immediate unification of the two churches.[53] Innocent's hasty endorsement of the conquest, later retracted when he was told the details of the sack, fixed his responsibility for the attack in the minds of the Byzantines.[54]

Innocent's hopes for church union as a result of the conquest of Constantinople proved ill founded. Instead of succumbing to their Latin overlords, the Byzantines fled the city and three Byzantine splinter states were set up. Of these three the one that rose to prominence was that led by Theodore Lascarus, with the capital in Nicaea. When Theodore took the title of emperor, his patriarch, Michael Autoreianus, was seen as the rightful patriarch of Constantinople, thus displacing the Latin patriarch who had been elected to the post by the Crusaders.[55] But it was still necessary for the Byzantines to maintain ties with the Roman pontiff. As far as the Byzantines were concerned, the pope was one of the few people who could protect them from Latin aggression and aid them in retaking their city. Theodore's successor, John III Vatatzes, entered into negotiations for church unity with the pope, but these never amounted to anything, because in the end the rapid decline of the Latin Empire made papal support unnecessary for the Byzantines' reconquest of their capital.[56]

By the mid thirteenth century, the time of the painting of the Bardi *Saint Francis* and the cycle of the *Life of Saint Sylvester* in the Quattro Coronati, the pope had temporarily fled Rome because of the threat posed by Frederick II. The Latin Empire in Constantinople was in serious decline, its recapture by the Byzantines only a matter of time, and the unification of the two churches had become a matter with more political than theological relevance. The political use that both sides made of the issue of church unity created an atmosphere in which either side could and did level the accusation of heretic and schismatic on the other and used this judgment to further their political ends. While this is true even before the thirteenth century, as is demonstrated by the use of the term "heretic" in the accounts of the capture of Constantinople[57] in the thirteenth century, it is more common and comes not from chroniclers but from

the leaders themselves.[58] In addition, because of the interaction of the arts and the growing power of the Italian city-states its meaning takes on more significance.

By the time of the Council of Lyons in 1274 there seems to be little possibility that any real agreement between the two sides could be found. Certainly, events following the recapture of Constantinople in 1261 demonstrate the way in which union was a political and not religious concept. When Michael VIII Palaiologus recaptured Constantinople in 1261, the envoys he sent to Rome were ill-treated.[59] By 1264, Pope Urban IV was preaching a crusade to recapture the Latin kingdom and its capital city.[60] The historian Deno Geanakoplos notes that, when Michael suggested the complete submission of the Greek Church to Rome, :

> To both sides union was simply an instrument: for Michael it was only a means of warding off the danger of a Latin attack and providing a respite from his Moreot defeats; to Urban it was primarily a way of preventing the realization of his gravest fear—a Hohenstaufen Constantinople. Clearly, religious accord was secondary in importance to political aims.[61]

Urban IV died before any meaningful talks could come of Michael's overtures, but Geanakoplos's assessment suggests that no real agreement would have been possible.

Although the politicization of union made the actuality of an agreement unlikely, the concept was kept alive by both Michael and some of the popes. Ten years after Michael and Urban's aborted attempt, three delegates sent from the court of the Byzantine emperor professed their allegiance to Rome and their submission to the pope in a solemn ceremony at the Council of Lyons in 1274. Not until 1439 was there another point at which union was so close.

In 1274 Michael VIII saw unification as the only protection he could get against the threat of the king of Sicily, Charles of Anjou, whose ambition was to reestablish the Latin Empire.[62] For the emperor, in fact, an alliance with the pope was the only way of preserving his empire.[63] The pope, Gregory X, for his part seems to have been ready to overlook the political motivations in order to bring about the union for which he fervently wished.[64] He sent the Greek born Franciscan John Parastron to Constantinople to instruct Michael in ways of the Roman church. Later Parastron was joined by three more Franciscans who were there to assist in bringing about an agreement between the two churches. Although Parastron was well liked in Constantinople, by both pro- and anti-unionists, few who were not already well disposed toward union changed their attitude.[65] By this point, in fact, the orthodox faith was seen by the Greeks as being an important part of their ethnic identity; subordinating it to Rome would have been equal to giving up part of what made them Greek.[66] In addition, the sack of Constantinople had proven to the Greeks that the Latins were duplicitous and untrustworthy. They, the Latins, were not in a position to be dictating matters of faith.

It is clear from the documents that the mistrust of the Byzantines for the Latins was matched by an equal mistrust by the Latins for the Byzantines. Even during the ceremony in which the Greeks pledged their allegiance to Rome there were grave doubts on the on the part of the Westerners as to the sincerity of the Greeks.[67] Because the delegates had brought with them a profoundly ambiguous letter of agreement from the Byzantine clergy it is clear that the misgivings noted in the documents were not

unfounded.[68] In the end there was no support for unification among the Byzantine people and Michael VIII's attempts to persuade his people shifted to persecution that did nothing other than increase the support for orthodoxy and increase the enmity of the Greeks for the Latins.[69] Michael's inability to persuade his people was, on the other hand, considered by the popes to be treachery. When Gregory X died he was succeeded by Nicholas III, who continued to support the idea of union and to keep Charles of Anjou in check. Remember, it was in Nicholas's chapel in the Lateran Palace where Byzantine Palaiologan architectural forms and the new Roman style appear together. But with Nicholas's death in 1280, a Frenchmen became Pope Martin IV in 1281. Martin was swift to turn the tables against the Greeks, excommunicating Michael and putting his support behind a holy war to oust the emperor and to reestablish the Latin Empire in the East.[70] Martin, however, was not much of a patron of the arts so it is difficult to judge at this point if there was a relationship between Byzantine and Italian art.

The popular uprising in Sicily in 1282, known as the Sicilian Vespers, effectively put a stop to Charles of Anjou's Eastern ambitions and gained Byzantium some breathing room and a respite from the question of unification. It also weakened the papacy's bargaining position. When Michael VIII Palaiologus died later in the same year, his son, Andronicus II, took over the empire and was quick to cancel the Orthodox Church's submission to Rome and to rally support for himself by formally rejecting the agreement reached at Lyons.[71]

Andronicus's reign was dominated by the loss of most of Asia Minor to the Turks. His dire economic straits forced him to abandon a standing navy, relying on the Genoese, with whom he had a trade agreement, for his naval defense.[72] The loss of the Byzantine navy and the reliance on foreign mercenaries to protect its shrinking domains in Asia Minor reduced the empire to the status of a second-rate power. This change in status certainly did not go unnoticed by the Italians. In spite of its loss of status, however, the late thirteenth and early fourteenth century in Constantinople was marked by a cultural flowering.[73] This "renaissance" was characterized, as we noted above, by its revival of a style of imagery from a period of Byzantine history when the empire was at the peak of its strength and dominated the West, both politically and culturally.[74] Thus, one of the important effects of the sacking of Constantinople and the establishment of the Latin Empire for the Greeks was the spark it gave to a developing sense of national identity. Since the establishment of the capital of the Roman empire by Constantine in the eastern city of Constantinople in the fourth century, the Byzantines had identified themselves as Roman.[75] Over the course of the thirteenth century they increasingly saw themselves as Hellenes and as quite distinct from the Latins.[76] That this developing sense of identity was closely tied to the orthodox faith played an important role in the breakdown of friendly relations between the Byzantines and the Latins.

Although it is somewhat more difficult to chart, there is also a pattern of a developing sense of regional identity on the part of the central Italians over the course of the thirteenth century and into the fourteenth. This can best be seen in rising popularity of historical chronicles in this period. These chronicles demonstrate a growing sense of identification of the central Italians with their Roman past and with their own futures. The case of Florence, which is the best documented, is also the most readily readable. Giovanni Villani, the early fourteenth-century chronicler of Florence, notes

pointedly in his introduction that Florence is the inheritor of Rome.[77] In the painting of the period the architectural imagery, which emphasized the immediate architectural environment—first in Rome, then in Assisi and, as we shall see, also in Florence and Siena—can be used as evidence of a growing sense of identity associated with specific and identifiable urban and cultural environment. Thus, at the same time that the Greeks were looking back to a period in the past in which their cultural hegemony was unparalleled, the central Italians began developing a new identity based first upon the revival of an earlier Roman-based imperial past symbolized by classical architectonic form. This past pointedly preceded and thus did not include the Byzantine empire.[78]

The growing cultural divide, which appears so clearly in the historical record, has not, however, received much attention from art historians.[79] Perhaps because scholars have been focused on the question of understanding just exactly how Byzantine and Italian art and artists interacted—in other words, in the logistics of moving works of art—that the questions raised by the breakdown of relations between the two sides has been left in the background.[80] However, within the context of the events just described, the stylistic shift in the architectural images underlined by the difference between Giotto's paintings in the Arena Chapel and the Kariye mosaics, makes absolute sense. As the Byzantines shifted their style of painting to reflect their artistic heritage, Italian patrons began to prefer the style that reflected their own artistic and historical tradition as it was represented by their architectural environment, first of classical Rome and later of communal Italy. This preference can be seen in the loss of variety of architectonic forms that were found within the Assisi cycles, both in the *Saint Francis* cycle and in Cimabue's vault and transept frescoes. Architectural imagery is thus key to understanding the stylistic shift because of its very concrete link to the built environment seen in the paintings in the Sancta Sanctorum and St. Paul's, which gave visual form to the developing ideas of regional identity.

Links between art and the historical events can also be found in the two new art patrons who were establishing themselves on the forefront of artistic innovation, demanding new types of imagery and spending newly available sums on it. In Chapter One we discussed primarily papal artistic patronage but later thirteenth- and early fourteenth-century Tuscany was characterized by the rise of a class of merchants and bankers, who not only spent great sums of money on their own private chapels and altars but also, as government officials, participated in ever- expanding civic commissions in both churches and civic buildings.[81] While the bankers would have followed with great interest the rise and fall of the fortunes of the Roman papacy in its interactions with Byzantium, some of the merchants and traders would have had firsthand experience with the Greeks.[82] In addition, when the Byzantines regained control of the capital city, the deposed Latin emperor Baldwin II actually spent some time in Florence.[83] After the Council of Lyon, open hostility is noted between Latin and Greek traders. Although documents are scarce, the historian Angeliki Laiou characterizes the period as one in which Latins and Greeks display a constant and sometimes violent distrust of each other.[84]

In addition to the merchants and bankers who might have had the opportunity to have firsthand contact with the Byzantines and who certainly would have been well-informed about all of the events related above, the Franciscan friars, who were extremely

important patrons of the arts in the early fourteenth century, played a significant role in developing East/West policy. In the crucial years between mid-century and the Council of Lyon, a significant proportion of papal diplomats sent to Constantinople were Franciscans.[85] Because Saint Bonaventure, head of the Franciscan Order, was present at Lyon (indeed he died there days after the agreement between the churches was celebrated) it can be assumed that the Franciscans would have developed a fairly detailed and critical picture of the Greeks. In addition, a number of Franciscans, including two whose names, Ranierio da Siena and Fra Bartolomeo da Siena, denote them as heralding from the Tuscan city of Siena, spent considerable periods of time in Constantinople.[86]

Thus it is not difficult to imagine a growing sense of critical unease with the open integration of Byzantine and Italian styles of architectural imagery which we have seen is so distinctive in painting in both Rome and Assisi close to the end of the thirteenth century. The innovations in architectonic form, introduced by the painter in the Sancta Sanctorum and later picked up by painters in Assisi and most importantly by Giotto, offered a convenient, but more importantly, an iconographically powerful alternative to this integrated style. The mimetic forms of Giotto and the earlier Sancta Sanctorum painters served double duty, shifting the eyes and mind of the viewer away from Byzantium and toward the immediate architectural environment that was to become the emblem of city-state pride.

The reader is fully aware that there is never one single historical event that can be pointed to as an explanation for social, historical or cultural change. This truism is as essential for art historians as it is for historians. So while we can understand that the ideological divide that grew between the Italians and Greeks over the course of the thirteenth century—and was exploited for political ends by leaders such as Charles of Anjou and for theological ends by some popes from Innocent III to Nicholas III to Boniface VIII—had an effect on how Greek pictorial style was received by both patrons and artists in Italy. We should be cautious about how far we want to go with this conclusion. It is most useful to see it not as the single most important event that brought about change but rather as one more facet of the story.

Another influence was the new Italian understanding of the way in which religious imagery could work in conjunction with the new ideas of individual interaction with the divine introduced by Saint Francis at the beginning of the thirteenth century, which will be discussed further in Chapter Three.[87] While Byzantine artists used historicizing architectonic forms to emphasize the gap between the religious narratives and the environment of the viewer, first Roman and then Tuscan artists were doing the opposite, using mimetic architectonic forms to close that gap. From the Sancta Sanctorum to the scenes of the *Life of Saint Francis* in Assisi to the mid-fourteenth-century Florentines, as we shall see, architectural form was used to connect the spatial and architectonic environment of the viewer with that of the religious narrative. In Rome the explanation for this artistic conceit could be found in the papal attempts to stabilize and maintain their power by linking themselves to Rome's imperial past. But it is also evocative of a new theological outlook, one in which the immediate experience of the viewer with the image is seen as potentially transcendent. In Chapter Three we shall investigate further how the architectural portrait exploits this potential and rises to iconographical and compositional prominence in the painting of the early fourteenth century.

Chapter Three

Picturing Places:
Trecento Painting and
the Emergence of the
"Architectural Portrait"[1]

In the thirteenth-century Franciscan text the *Meditations of the Life of Christ*, the reader confronted with the narrative tale of Christ's life is exhorted at key points to imagine herself (for the original reader was a nun) in the scene. In addition, this text tells the story of the life of Christ replete with "human interest" details of Christ's relationship to his mother and details of the other characters in the story, which are designed to encourage the reader to assume an active role in the story as it unfolds. In telling the story of the arrival of the three kings, for example, the author describes the treasure brought by the kings and then asks the reader: "What would you have done with the gold they offered, which was of great value?"[2] Individual participation in religious ritual was the cornerstone of the Franciscan approach to lay devotion. The Franciscan stress on poverty is particularly evident in this example. On a primary level this new affective piety emphasized, as did Saint Francis himself, direct experience with the events of the Bible. Thus, a painted image was supposed to encourage an immediate human response to the event depicted, as if the viewer were witnessing it.[3] This response was evoked through sensory and moral stimuli, such as the question about the gold, that the viewer/pilgrim would have personal experience of.[4] Saint Bonaventure's text *The Journey of the Mind to God* envisions the contemplation of the divine as a mental pilgrimage.[5]

In Chapter Two, we began our discussion of the possible political/social significance of images of architecture emerging at the end of the thirteenth century. We should now turn to look more broadly both at how they functioned within the historical context and within the context of religious practice.

91

The Pilgrim Experience at Assisi

When the early fourteenth-century pilgrim entered the vast nave of the Upper Church of San Francesco in Assisi he might have initially been overcome with awe at the magnificence of the site (Figure 54). And yet when he summoned his courage to study the frescoes in the lowermost level of the nave that, in a very detailed way, narrated the life of the saint to whom he had come to pay homage he would have immediately felt settled within the narrative because the architectural imagery in the first scene would have recollected for him the built environment that he had just passed through (Figure 35).

We have already noted how first Pope Nicholas III in the Sancta Sanctorum and then later the artists and patrons of the portico frescoes of San Lorenzo used images of architecture replete with mimetic details to connect the viewer's experience in an immediate way with the narrative in the fresco. The artists in Assisi who worked on the *Legend of Saint Francis* developed these innovations in a dramatic way by linking the viewer's experience of the fresco not only with his immediate architectural environment but with various sites that could be visited on a Franciscan pilgrimage in Italy, essentially creating a pictorial pilgrim guide. Architectural imagery, and specifically the images of identifiable buildings, functioned to enrich the pilgrims' spiritual journey by offering a visual structure that would enable them to graft the hagiographical narrative onto the Italian landscape. In this way they extended the scope of their Franciscan pilgrimage to include other sites within Italy which were impressed upon their memory by the architectural images of known buildings.

Before looking more closely at how these images worked at Assisi we need to take a moment to name this particular kind of architectural image. The term "portrait" has been used by other scholars for the images discussed here (as well as for a number of others). I have chosen to use the term as well, not only because it is convenient to distinguish this particular type of architectural image from others but also because it immediately conjures human portraiture. I shall suggest below that there are some interesting similarities between the way in which architectural portraits and human portraits can be read. For now we need to clarify the characteristics of the architectural portrait and what distinguishes it from other types of architectural imagery.[6] As we noted in both the preceding chapters, images of architecture increased in prominence around 1270 mainly because of their increased size and their eye-catching references to the contemporary built environment. In Rome, the local setting was evoked by generic references to classical details that would have had visual analogues in the buildings around them, for example in the St. Paul's frescoes (Figure 23). But these generic images are not portraits. Their references to the built environment function more generally within the context of collective urban identity construction and therefore do not function in the specific iconographic way that can be ascribed to the portraits. (We will discuss these generic images in Chapter Four.) Images such as the representation of the Castel Sant' Angelo in the Sancta Sanctorum, on the other hand, are clearly portraits, not only because they have a formal relationship to the source and reproduce quite clearly some of its details, but also because the narrative of the scene itself suggests the presence of a specific building (Figure 11). As we shall see, however, there is a wide variety in accu-

FIGURE 54. Assisi, Upper Church of San Francesco, nave (ALINARI/ART RESOURCE, NEW YORK).

racy in the portrait images. Some carefully adhere to their source building while others seem quite dissimilar. These variations can be explained in relationship to the different iconographical functions of the images and the paintings in which they appear.

In this chapter we will examine a number of examples of architectural portraits within their visual and historical context with the aim of deepening our understanding of how they might have been read by a contemporary viewer, pilgrim or citizen. This analysis is specifically aimed at augmenting the conversation that has gone on around these well-known images and in so doing to add something more to the way in which we perceive "naturalistic" or mimetic visual imagery. The portraits are quite clearly "naturalistic" in the sense that they do re-present the visible world. But, of course, they are also much more than just representations of the what is seen. In the discussion that follows the Assisi images will be examined in the context of memory techniques, much more prevalent in the fourteenth century than they are today, as a way of uncovering some of the possible complex readings of images that are often masked by the characterization of them as simply "naturalistic." We will then expand the discussion to include a variety of architectural portraits that occurred in Tuscan painting over the course of the fourteenth century to show something of both the variety and complexity of the iconography of this type of image.

Returning to Assisi, the context of pilgrimage is key to understanding how the architectural images of known buildings work. They can be read as mnemonic devices, or memory aids, embedded in the Saint Francis cycle to assist the pilgrim in forging an active relationship between Saint Francis's life and his own. This process is similar to that that the Franciscan author of the *Meditations* exhorts his reader to undergo in imagining herself to be present at biblical events. Within the twenty-eight-scene cycle of the Life of Saint Francis in Assisi, the six portraits provide a real stage upon which the fourteenth-century believer familiar with Francis' encouragement to active religious practice, can reenact the moral tale of Francis's journey from his youth to his true identity as a saint. If we look at the Assisi scenes in the context of the Franciscan urge to actively participate, as encouraged in the *Meditations*, the architectural images acting as memory triggers, can be explained in part by their ability to offer the viewer an entry into the events depicted, specifically within the context of the pilgrim's experience at the very sites which he sees reproduced in the frescoes. As the pilgrim moved around the walls of the basilica following the events of the saint's life, he remembered his actual presence in the places depicted. In activating this memory, the experience of the pilgrim elides with the life of the saint. This works because the pilgrim is not simply a traveller or tourist. In the Middle Ages, as today, pilgrimage is as much a spiritual journey as a physical one. The expectation of such a journey is that the mind and spirit will go much farther than the body possibly can. Indeed the very identity of the pilgrim becomes enmeshed with that of the holy men and women who are honored at the shrines that he visits.[7] A key to explaining how these images functioned as memory aids and thus to understanding how they enhanced the pilgrim's experience is to recognize the distinctions between each portrait and its source building. If they were accurate renderings, carefully reproducing the details of the buildings they represent, the contemporary site would take priority over the textual one and would only enable the pilgrim to recognize the place within his own personal experience of it, and not understand it

as a stage for the hagiographical event. That is, the real world would be foregrounded at the expense of the spiritual one. This will be discussed further below.

The Saint Francis fresco cycle is an extensive retelling of the life of the saint in twenty-eight scenes. The viewer is assisted in identifying the scenes by the quotations from Saint Bonaventure's *Legenda Maior* (written 1260–1263), which appear below each scene. Probably the average pilgrim could not read the Latin in which the text was written and thus the words functioned to reinforce the veracity of the image but not in a literal way. In addition, the pilgrims might have been guided through the cycle by friars (much like today), who would have translated the text for them.[8] As the viewer moved around the nave from left to right following the story of Francis' life, each pivotal event in the saint's growth toward sanctity is carefully stressed by the prominence of the architectural images within each scene. The progression of the life of the saint around the nave unfolds as much across narrative space as it does across narrative time. The specific sites of Francis's journey are emphasized in different ways. The cycle opens with the young Francis securely located within his hometown of Assisi in the central piazza (Figure 35). As the scenes continue, he moves both around the nave and around Italy. His movement is marked and delineated by dramatic transformations in the architectural settings. In six scenes, located evenly around the nave, the buildings which form the backdrop are distinguished from the other architectural images by specific architectural features, such as added relief decoration or a particular plan or elevation, which allow them to be identified as known, extant buildings. These images are architectural portraits. They are different in form from the earlier Roman examples discussed in Chapter One in the precision of their detail and complexity of their spatial construction.

The places these portraits represent are, in order, Assisi, Rome, Arezzo, La Verna, Assisi, and Rome. In Scene 1 Francis is shown before his conversion walking through the central piazza of Assisi (Figure 35). In Scene 6 Francis is shown holding up the crumbling Lateran Basilica in Rome (Figure 55). In Scene 10, Francis kneels behind the cathedral of Arezzo (Figure 56). In Scene 19, Francis receives the Stigmata (the five wounds resembling those of the Crucified Christ) on Mount La Verna, framed by the two chapels known to have existed at the site during the saint's lifetime.[9] In Scene 23, Saint Clare mourns over the body of Saint Francis before the newly built basilica of Santa Chiara in Assisi (Figure 57). And finally, in Scene 28, Francis, having just liberated Peter, the heretic, soars above an elegant Roman cityscape (Figure 58).

These portraits, like the mimetic images in the Roman paintings that we examined in Chapter One, function specifically within the context of the contemporary viewer's experience. As in Rome, the viewer in Assisi is a pilgrim. Thus, in order to appreciate the iconographical function of these portraits, the cycle of the *Life of Saint Francis* must be understood not just as a retelling of the chronological events of the saint's life, but also as a narration of Francis's spiritual pilgrimage to sanctity. This journey is reenacted, but also made anew both by the movement of the pilgrim around the basilica as he "reads" the story told there and by that same pilgrim's journey through Italy, to and from the shrine itself. In fact, the pilgrim's ability to get the most out of his visit to Francis's tomb was enhanced through the use of architectural imagery, which helped to collapse the temporal distance that separated the viewer from the saint by identifying actual sites that the pilgrim could visit. This directed viewing experience is further

FIGURE 55. Cycle of the Life of Saint Francis, *Dream of Innocent III*. Assisi, Upper Church of San Francesco (GERMAN INSTITUTE FOR ART HISTORY, FLORENCE).

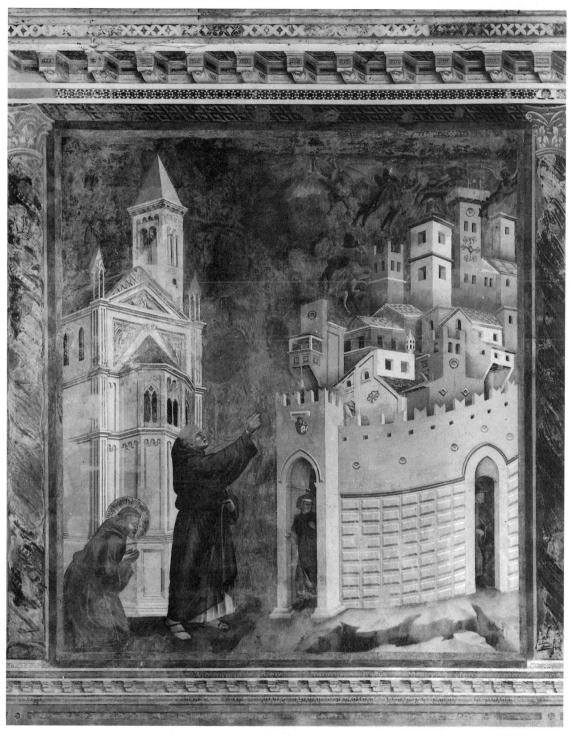

FIGURE 56. Cycle of the Life of Saint Francis, *Saint Francis expelling the demons from Arezzo*. Assisi, Upper Church of San Francesco (GERMAN INSTITUTE FOR ART HISTORY, FLORENCE).

FIGURE 57. Cycle of the Life of Saint Francis, *Saint Clare mourning over the body of Saint Francis.* Assisi, Upper Church of San Francesco (ALINARI ART RESOURCE).

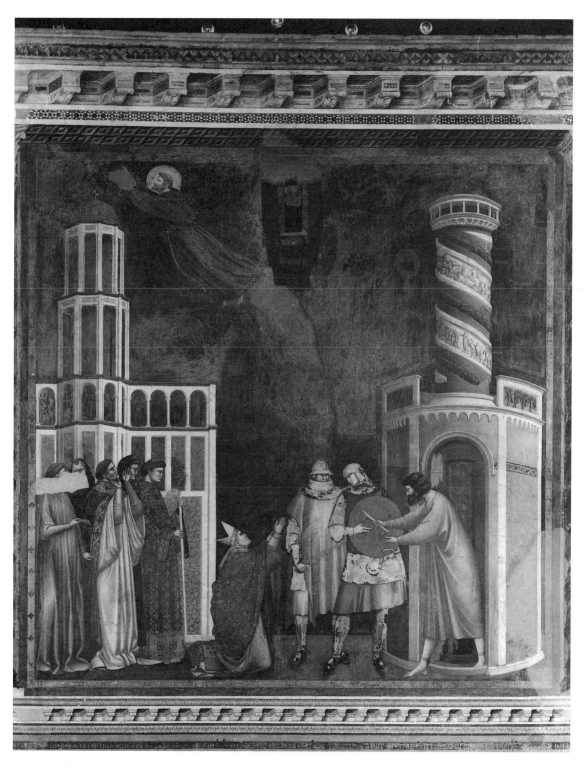

FIGURE 58. Cycle of the Life of Saint Francis, *Liberation of Peter the heretic*. Assisi, Upper Church of San Francesco (GERMAN INSTITUTE FOR ART HISTORY, FLORENCE).

reinforced by certain discrepancies between the architectural portraits and the built structures that they represent.

Memory Techniques and the Architectural Portraits

The discrepancies between the architectural portraits and the built structures that they reference—which include carefully portrayed, yet inaccurate, architectonic details—are important features of the images that have not yet been adequately explained in the vast literature on Assisi. The inaccuracies, which will be described in greater detail below, can be seen most clearly in the portrait of the Temple of Minerva in Scene 1 (Figure 35), the Cathedral of Arezzo in Scene 10 (Figure 56), and the Assisi Church depicted in Scene 23 (Figure 57). In these portraits the discrepancies are too precise to be explained away as arbitrary stylistic features or mistakes made by an artists unfamiliar with the setting. The studied quality of the alterations points to a purpose. What this purpose might be is suggested by the fact that Assisi was a pilgrimage destination of the utmost importance in this period, and pilgrimage an important part of devotional practice. Within the context of devotional practice, the inaccuracies can be understood as memory triggers embedded in the architectural portraits specifically to reinforce the pilgrim's experience not just of the painted narrative but of the entire pilgrimage journey. The discrepancies in the architectural images act as mnemonic devices extending the pilgrim's Franciscan journey beyond the doors of the Assisi Church.

Today we are not as aware, nor are we as dependent upon, the capacity of our own memory as they were in the Medieval period. Training the memory by using visual cues of places and things was an art that was passed from the Ancient Greeks to the Romans and then to early Medieval Europe. Mnemonic techniques were exploited in the early medieval period chiefly by theologians, but beginning at the end of the thirteenth century they were increasingly integrated into the religious practices of the lay population as a means of enhancing religious devotion.[10] These techniques were based principally on the classical rhetoric text, the *Ad Herenium*, of the first-century BCE, which was attributed to Cicero in the middle ages.[11] The library of the Sacra Convento at Assisi contains two copies of this text listed in the earliest inventory.[12] This text, which was incomplete and its discussion of artificial memory confusing, was modified and adapted in the mid-thirteenth century by Thomas Aquinas in the *Summa Theologiae* (II, II, 49). The Assisi friars also were in possession of a copy of this, interestingly though, they did not own the whole text which included five volumes but only the so-called *Secunda Secunde* which was the section on memory techniques.[13] The sophisticated techniques of associating concepts with mental visual images used by the classical rhetorician were modified in order to be useful for instructing a lay audience. An example of how these mnemonic techniques are modified for a lay devotional audience is found in the fourteenth-century text, *The Pilgrimage of the Life of Man*.[14] In addition, the fact that our pilgrim audience might have been largely illiterate, gives us some room for understanding how and why these techniques were translated into pictorial imagery.[15]

The memory enhancing techniques contain two key features that can be related to the architectural images in Assisi. The first of these was the construction of unique or

extraordinary mental images. The fourteenth-century Dominican friar Bartolomeo, basing his ideas on Thomas Aquinas's *Summa Theologiae*, notes: "Of those things which a man wishes to remember, he should take convenient similitudes, not too common ones, for we wonder more at uncommon things and by them the mind is more strongly moved."[16] We can turn to allegorical text, *The Pilgrimage of the Life of Man*, to get some idea how this mnemonic technique got translated into practical advice for the layperson.[17] There is one interesting example of the creation of an extraordinary mental image offered at the outset of the pilgrim's journey in order to prepare him for what he will experience. He is asked to put his eyes into his ears. The odd mental picture this creates is supposed to remind the pilgrim to translate what he hears into visual images that will be more memorable for being visualized.[18] A similar sort of reading can be given to the mixing up of details of the built structures in the Assisi portraits. The jarring effect—jarring because they could so easily be checked against their source—of the discrepancies would be enough to suggest to the viewer that the images are more than simple backgrounds for the scenes (Figure 35).

The second, equally essential technique of the mnemonic system is the use of *loci* or architectural sites within which to place the things that are to be remembered. According to the *Ad Herennium*, these "containers" should be constructed with particular care "so that they may cling lastingly in our memory."[19] While the architecture in the frescoes functions on one level as a backdrop to the narrative, it also acts as a mnemonic for the moral lesson told in each scene. In some cases the portraits literally frame the action. The architectonic details, specifically sculpted reliefs, inserted into each building, contain references to, among other things, Francis's sanctity and the papacy. The two features of mnemonics, the use of unusual images and architectonic *loci*, are essential in our understanding of the connection between memory and pilgrimage and for decoding the architectural images in the frescoes of the *Life of Saint Francis*.

In the opening scene of the cycle, Francis appears in the center of the town of Assisi. A man, who Bonaventure calls "simple," recognizing the future saint's holiness, lays his cloak down before him (Figure 35). The building that forms the backdrop for the scene is the Temple of Minerva, a Roman building that had, by Francis's time, been consecrated as a church (Figure 59). Because this building is still standing in the center of Assisi, it is easy to pick out the discrepancies between it and the building that appears in the fresco: the number of columns, the door and the absence of the oculus in the pediment being the most noteworthy.[20] If we understand the Temple of Minerva in the painting as an architectural mnemonic, the transformations or discrepancies can be explained, as we shall see below. What the pilgrim sees is not the building as it appears in his or her own time, but rather the extant structure as a *locus* for the moral lesson told by the narrative that took place there.

The discrepancies between the built structure and its representation thus function to reinforce the memorability of the building as a *frame* for a very particular event and not simply as a building. The absence of a door, for example, is a jarring and unusual feature for a building, which, no doubt, the viewer would take note of. It can be read as a device that would help the viewer see beyond the mere building to its possible symbolic meanings. At the same time that the building in the scene is distinguished from the actual structure, other of the discrepancies can be read as containing symbolic ref-

FIGURE 59. Assisi, Temple of Minerva (PHOTOGRAPH BY THE AUTHOR).

erences to Francis himself and thus the building as a whole becomes a *locus* for his attrib-
utes: The presence of the rose window, or oculus, can be thus explained as a mnemonic
for the "future" church of San Francesco, which has a very similar oculus on its facade;
the five, rather than six, columns as a reference to the five wounds of the stigmata, which
Francis will receive.[21] The building thus acts like the mnemonic *locus*, quite literally as
a container, for the sanctity of Francis. The mnemonic also allows the site of Francis's
experience to exist for the pilgrim in both places, the fresco and the built structure, so
that both can act as triggers for a spiritual experience.

Another portrait appears in Scene 10- when Francis expels the demons from Arezzo
(Figure 56). This scene demonstrates the complexity of the language of images used in
the construction of hagiographical narratives, because not only does the building differ
from its source in its details, but it is not located correctly in relationship to the town
of Arezzo seen on the right. Francis appears kneeling slightly to the left of the apse of
a large church located clearly outside the walls of the town that appears on the right.
The building in the painting is gothic in its soaring scale and decorative details, its finials
and pointed, arched window frames. It appears to have no transept, a protruding apse,
side aisles, a peaked roof, two free-standing sculpture canopies and a high, elegantly fen-
estrated bell tower. The actual cathedral of Arezzo was distinguished from other con-
temporary churches built in Tuscany by its gothic style (Figure 60).[22] Clearly the artist

FIGURE **60.** Arezzo, Cathedral (PHOTOGRAPH BY THE AUTHOR).

FIGURE **61.** Assisi, Santa Chiara (PHOTOGRAPH BY THE AUTHOR).

of the Assisi fresco used the architectural style to identify the building, which, in a few details—the lack of independent roofs over the side aisles and the added relief decoration—differs from its source. An important discrepancy here is the fact that the built cathedral is located within and not outside the city walls as it is shown in the fresco. At the time that the fresco was painted in the late thirteenth- early fourteenth century, however, the Franciscan church at Arezzo, San Francesco, was located outside the walls of the city, as was common with early Franciscan establishments, suggesting a conflation in the scene between the cathedral and San Francesco.[23] Thus, what the pilgrim is given is a complex image that allows him to connect both the Franciscan church outside the walls and the contemporary cathedral with the life of the saint and his visit to the city.

The soaring gothic church might also be read as a *locus* for the moral lesson about civil strife to which the story directly relates. The elegant gothic building has a flip side. Not only does it mark the location of the event but its richness and prominence could also be read as symbols of the vice of pride that lead to the strife which Francis put a stop to. The Arezzo Cathedral, like other buildings being built at the time, was intended in part to symbolize the importance and wealth of the city in which it was built. Therefore this portrait could readily stand both as a symbol of the church itself and as a symbol of earthly pride.[24]

In Scene 23 in the cycle, another gothic building appears, but this one has an entirely different feel and focus (Figure 57). Francis has died and his body is brought to the convent where Saint Clare and her sisters reside so that they can mourn for him.

In the painting, Clare and the others pour out of the three doors of a massive and ornately decorated gothic basilica. At the time of Francis's death, however, the Poor Clares were still housed in the humble setting of San Damiano where Francis had first received his call.[25] The presence of the gothic church makes absolutely no sense if we see the scene as purely documentary, because San Damiano, although fixed up, was never rebuilt, nor was it intended to be rebuilt on this scale. It only makes sense if it is seen as marking a site that the contemporary pilgrim should visit. Because San Damiano is identified on the other side of the nave (where it plays a pivotal role in Francis's spiritual journey) some other site must be intended. In 1260, after the death of Saint Clare, the order of Poor Clares was moved to a new, elegant gothic building within the walls of the town of Assisi.[26] Thus, by the time the fresco was painted, the Poor Clares would no longer have been associated with the humble church of San Damiano but with the new church of Santa Chiara. The elegant gothic structure in the painting—the mnemonic key is the gothicness of both the actual building and the image—is therefore a mnemonic device intended to spark the pilgrim's memory of the present church of Santa Chiara (Figure 61), so that she places this contemporary Assisian site within the context of Francis's life. By including the church in the saint's journey, it becomes a part of the Franciscan pilgrimage. This building also contains within it other features that can augment the reading of the story. Unlike the angels pictured on the image of the cathedral of Arezzo, the reliefs here all show angels fully draped, symbolizing their sanctity. Also the elegant Cosmatesque decoration that covers the facade of the building signifies the papal patronage of both the Franciscans and the Poor Clares.[27]

The collapsing of the fourteenth-century pilgrim's experience onto that of Saint Francis via architectural portraiture works in two ways. First, the pilgrim is made to understand that the Italian architectural environment through which Francis made his journey can be used by the pilgrim to reenact that journey and thus become an active participant in it. Simultaneously, new sites, such as Santa Chiara, which did not exist in Francis's lifetime are given roles in Francis's life, and thus a place in his history. While this reading of the Assisi images does not, and is not intended to, lessen the narrative importance of the Francis cycle, it does offer another level of meaning to fourteenth-century architectural imagery and its function. The use of visual mnemonics to call upon the pilgrim's own knowledge and understanding reinforces the pilgrim's personal experience, both of his own pilgrimage and Francis's spiritual journey. In this way the frescoes serve to deepen the theological message of the site and to reinforce the power of pilgrimage. In addition to this very specific reading of how the portraits work within the context of the individual pilgrim's experience we must also consider the broader environment, geographical and historical in which the cycle of the Saint's life functioned.

Assisi, Rome and Pilgrimage in the Late Thirteenth Century

While it is clear that the architectural portraits assisted the pilgrim to fully experience Francis' model life this only offers us part of picture of how they functioned. Their referential quality operated in a much larger context than the narrative retelling

of the life of the Franciscan patron saint. Three important features of this larger context are: (1) the intimate relationship between Assisi and the papacy, (2) the by-then well-established iconographic and spiritual connection between Francis and Christ, and (3) events transpiring at the time that the frescoes were executed, specifically the loss of the Holy Land on the heels of the dissolution of the Latin Empire in Constantinople, as discussed in Chapter Two. In the discussion that follows we will see how the architectural portraits suggest links between Francis and the church in Rome, reinforce the connection of Francis with Christ by offering the pilgrim-viewer a model for devotional experience at the shrine itself, and offer an alternative pilgrimage route in Italy to replace the pilgrimage to Jerusalem that was lost in the thirteenth century.

Two of the six portraits represent sites in Rome (Figures 55 and 58). In Scene 6, the Lateran Basilica is the backdrop and site for Pope Innocent III's first encounter with Saint Francis. This is an important scene because it sets the stage for the pope's subsequent involvement with Francis and the Franciscans. In Scene 28, one of Francis's posthumous miracles is performed before three classical Roman structures: the Castel Sant'Angelo, the Column of Trajan, and the Septizodium.[28] Francis's life and spiritual journey are thus framed by the presence of both the pope and the papal city. Thus both the institution of the Franciscans—exemplified by Francis's first visit to the pope when the Franciscan rule was sanctioned—and its mystical powers—exemplified by Francis's ability to work miracles even after his death—are shown within the context of Rome and the papacy.

These portraits thus serve to reinforce the importance of the link between Assisi and the church in Rome, and the powerful role played by the papacy in Franciscan affairs. From the time that Pope Gregory IX issued an official document, or "bull," announcing the building of San Francesco in Assisi through the period of its construction and decoration, the popes were the formative force behind the work on the building. The basilica of San Francesco was begun in 1228 when land was donated to the order with the intention that it be used as a site for a building to house Francis's body. In this year, Pope Gregory IX issued the bull *Recolentes Qualiter* announcing the building of the church and exhorting all the faithful to contribute money to its construction.[29] Gregory IX issued a series of bulls between 1228 and 1235 establishing and then confirming the central position of the Assisi Church in the Franciscan order.[30] When the building was consecrated in 1253, Pope Innocent IV, who was present in Assisi for the ceremony, demanded that the church should be made "more beautiful and ornate."[31] This papal support was further increased by frequent and generous "indulgences," forgiveness from sins, that were offered to anyone visiting the shrine.[32] In addition, subsequent popes made certain that San Francesco would be recognized by all as the mother church of the order.[33] Papal interest in the shrine is also evidenced by the number and importance of the relics, such as a drop of the Virgin's milk and a piece of the true cross, which various popes donated to the basilica (relics being one of the essential ways to attract pilgrims). Most important for the church as a pilgrimage site, in 1258 Alexander IV granted the friars at San Francesco the right to hear confessions and absolve the sins of all the pilgrims who visited the shrine.[34]

The popes' interest in the Assisi basilica can be read as part of a plan to oversee the rapidly growing, extremely popular and thus potentially divisive, cult of Saint Francis.[35] This concern received visible form in the images of Rome that appear in Scenes

6 and 28. In addition, two of the other portraits, the Temple of Minerva and the gothic church of Santa Chiara, also make references to Rome. In scene 1 (Figure 35) the temple calls Rome to mind because it is obviously a classical Roman building. In scene 23 (Figure 57) the church that rises behind the figures of the mourning nuns is decorated with Cosmatesque designs. This type of inlaid stonework decoration, which the reader will remember was used on the floor of the Sancta Sanctorum, was Roman in origin. Thus the power of the papacy and its position in relationship to Francis and the Assisi Church was consistently reinforced via the architectural portraits.

In addition to reinforcing papal jurisdiction over the cult of the Saint, the use of architectural portraits should also be seen in the context of the revival of Rome as a pilgrimage destination, which began with Innocent III.[36] A pilgrim who had only intended to go as far as Assisi could easily be persuaded to go on to Rome, particularly when the city played such an important role in Francis's own journey. The impact of the portraits on the pilgrim's envisioning of the precise location of the events at the opening and the close of the saint's life guided him beyond Assisi to Rome. Once in Rome, the memory of the important events that took place there would be triggered by the pilgrim's recognition of the architecture. Rome has now become a part of his spiritual quest because he has followed Saint Francis's spiritual journey.[37]

There is an even more significant context for the promotion of the cult of Saint Francis and his travels within Italy than the rise in the importance of Rome. At the end of the thirteenth century not only was Latin influence waning in the Byzantine empire, but the last of the Crusading strongholds fell in 1299 making pilgrimage to the Holy Land a great deal more dangerous and less appealing. Assisi, because of the particular character of its Saint, offered a viable alternative to the Holy City. This idea is reinforced by the Franciscan patronage in the later centuries of the *Sacra Monte*, sites within Italy in which the landscape and places of Christ's Passion were reproduced so that the pilgrim could literally follow in Christ's footsteps without having to go all the way to the Holy Land to do so.[38] As we have seen the six scenes that contain architectural portraits include both the opening and the closing episodes in the narrative. Five out of the six scenes correspond iconographically and compositionally to specific scenes in the Passion of Christ.

In Scene 10, Francis is shown casting demons out of Arezzo (Figure 56). While this scene has often been noted by historians as evidence of the prevalence of civil strife in the Italian city-states during the medieval period, this does not explain its importance for the Assisi cycle and for the pilgrim's understanding of the life of Saint Francis. In order to understand the choice of this episode for the visual narrative of Francis' life we must recall the particularity of the saint himself.

In his lifetime Francis had been and, indeed, sought to be, identified as an *alter christus* or second Christ.[39] According to the various texts of Francis's life, the saint consciously modeled his behavior according to Jesus's teachings to the Apostles.[40] His dedication to poverty, the simplicity of his teaching and most importantly the stigmata received while praying on Mount La Verna two years before his death, all supported the saint's identification with Christ.[41] This connection was further reinforced by the language of Gregory IX's bull of canonization[42] and by Bonaventure's text of the life that is filled with references that connect Francis's life to Christ's and the Franciscans

to the Apostles. The connection was initially made explicit in Assisi by the juxtaposition of the lives of Christ and of Saint Francis in the first series of frescoes painted along the nave of the lower basilica,[43] and was then reinforced by the crucifixion scenes by Cimabue in the transept of the Upper Church and, in the late thirteenth century, the passion cycle in the upper zone of the nave above the level later occupied by the frescoes of Francis's life.[44]

Francis's identification with Christ is a critical theme when seen in relation to the decline of the popularity and possibility of a pilgrimage to Jerusalem, which resulted from the successive defeats suffered by the crusading knights over the course of the thirteenth century.[45] Assisi, and the surrounding sites that played a role in the saint's life, offered an alternative to Jerusalem because of the popularity of the saint and because of his link to Christ. The way in which the architectural portraits are used in the Assisi cycle suggests that Francis's identity as an *alter christus* may have offered the possibility that Assisi could function as a surrogate for the Holy City itself. Evidence that this was recognized in the thirteenth and fourteenth centuries is found in the donation of important and specifically Christological relics to the building. Noteworthy among the relics given to the shrine in the thirteenth century are a part of the true cross, a thorn from the crown of thorns given by Louis IX of France and a crystal containing a drop of the Virgin's milk given by Pope Clement IV in 1266.[46] I would argue that these relics demonstrate not only the importance of the shrine, but also constitute evidence of a desire to create another site within Europe that could act as a substitute for Jerusalem.[47]

The scenes chosen to be highlighted with architectural portraits reinforce the connection between Francis and Christ. The opening scene of the simple man is typologically linked to the *Entry of Christ into Jerusalem*. The *Dream of Innocent III* (Figure 55), which appears in Scene 6, is the only episode which is difficult to relate to Christ's life, although its essential function in the life of the saint and his connection to the papacy suggests that the justification for its use of the portrait lies in that fact alone. Of the others, the scene of Arezzo (Figure 56) corresponds to Christ's expulsion of the money changers from the Temple, the stigmata received on Mount La Verna is obviously linked to the Crucifixion, while the mourning of the "Poor Clares," the order named for Saint Clare, is evocative of the Lamentation over the body of the dead Christ, a scene often included in cycles of the Passion (Figure 57). Finally, the *Liberation of the Heretic Peter* corresponds in its general theme to Christ's posthumous reappearances. Tentatively then, because we cannot confirm this reading through textual collaboration, I would like to suggest that the use of the architectural portraits provides a pictorial memory guide to help the pilgrim to remember the events of Francis's life that have been grafted onto the landscape of contemporary Italy, and to underline the connection between Francis and Christ and thus Italy with the Holy Land.

Changes in Portraiture Form in the Fourteenth Century

With the rise in importance of mimetic details that overwhelmed the less recognizable Byzantine forms discussed in Chapter Two, the interest in architectural portrai-

ture, already quite developed as we have seen in the Assisi, is expanded. Both in Assisi and in the Roman cycles where these particular representations occur, they are either used to focus the viewer on the patron, as is the case of Nicholas III in the Sancta Sanctorum, or, as in San Francesco, they are used to augment the mystical experience of the pilgrim, by encouraging him to internalize the moral teachings of the Saint's exemplary life. Before ending this discussion it is necessary to turn to the later uses of architectural portraiture to see how the type developed and was made to serve multiple iconographic ends beyond those found in Rome and Assisi. The portraits emerge in the fourteenth century after Assisi with striking rapidity and power. Their form and intricate makeup, as well as their complex relationship to actual buildings, signal that they should be seen as articulate features within the structured language of pictorial imagery. A close examination of their form and iconographical function sheds light on how they communicated their meaning in the fourteenth century.

As we have seen in both the previous discussion and in Chapter One, the rise in the use of architectural images of extant or known buildings cannot be fully explained as evidence only of artists engaging in an increased observation of the actual built environment. The iconographical significance of the marked discrepancy in a number of the frescoes between the model and the corresponding image discussed above argues against this, as do the selective contexts in which the portraits appear. The emergence of the architectural portrait points to a fundamental reassessment of the capacity of the image to mediate between the viewer and the biblical, hagiographical or historical narrative presented in the scene. In this new dialogue, accuracy and the relationship of the representation to the source building plays an important role. As with the mnemonic devices embedded in the Assisi portraits it is the discrepancies between the representation and its model, that holds the key to understanding these images and explaining their development.

Like human portraiture, architectural portraits are not all of the same type. The different categories are distinguished by the degree to which they differ from their source. Some reproduce a single salient feature of the original building or buildings. For example, three well-known Roman monuments are rendered in the fresco just discussed of the *Liberation of Peter the Heretic*: the Castel Sant' Angelo, the Column of Trajan and the Septizodium (Figure 58). The Castel Sant' Angelo is denoted only by its circular plan, but it is made recognizable by its association with the two other structures, the column and the Septizodium which would have been recognizably Roman.[48] Other portraits reproduce almost every detail of the source structure. An example of this type is the fresco of the *Expulsion of the Duke of Athens from Florence* (Figure 4) now in the Palazzo Vecchio in Florence. The subject, function and context of the paintings in which these different types of architectural portraits appear offer a key to understanding how and why they are used.

The scene of the *Liberation of Peter the Heretic* brings to a close the narrative that began on the other side of the nave and functions, together with the other portraits, to impress upon the viewer's memory the sites that are included in an Italian Franciscan pilgrimage. This pilgrimage is timeless, as is the possibility of Francis working a posthumous miracle like the one he is shown performing in this scene. Because the event in the scene emphasizes Francis's saintly powers, the specificity of a temporal

location that would be offered by an exact portrait is not necessary. Thus the representation of the Roman sites is not as specific as some of the other portraits in the cycle. Instead the recognizable roundness which denotes the Castel Sant'Angelo and the size and form of the Septizodium are general mnemonics for "papal Rome."

By contrast, the close relationship between the image and the built structure in the fresco of the *Expulsion of the Duke of Athens from Florence* is essential to the reading of the scene (Figure 4). Although the exact circumstances of the creation of this image are unknown, it is generally believed that it commemorates the expulsion of Walter of Breinne, the Duke of Athens, from Florence on Saint Anne's day in 1343.[49] The fresco has unfortunately been damaged so that its framing devices and part of the left side are no longer discernable. However, the central role of the Palazzo Vecchio in the scene is undeniable. The building is seen from an oblique angle. Its proportions are elongated in such a way that it echoes in height and breadth the stature of the saint whose left hand hovers over the crenellated roof in a gesture which conveys both her blessing and the act of conferring the palace on the soldiers of the commune who kneel on her right. Other than its somewhat more slender proportions and its small scale in relation to the soldiers to whom is it given, the palace follows its model very closely in its design and decoration. Even the specific details of the windows have been faithfully reproduced.

In the close relationship between the model and the image, this fresco can be linked to the *New Town* fresco discovered below the *Guidoriccio da Foligno*, attributed to Simone Martini in the Palazzo Pubblico in Siena (Figure 62).[50] The controversial history of the *New Town* fresco is not of concern to us here, although it is important to note that despite the disagreement over its authorship the scene is generally acknowledged to depict a surrender of a previously independent town to Siena.[51] What is of interest is the fact that in this image, as in the image of the Palazzo Vecchio, the artist has paid close attention to rendering specific architectural details of the building. While the exact identity of the source building in the fresco is not known, the precision of the details, the carefully described tower with its wooden watchbox and the windows, differ enough from generic images of public buildings to allow us to suggest that this contemporary building was intended as a portrait and would have been recognized as such by the viewers of the day when the building it depicts was still standing.[52]

The accuracy of both this image and the one of Palazzo Vecchio is not dictated by style but by the subject and the purpose of the image. Both frescoes are commemorative, like human portraits, and like human portraits their primary purpose is to capture a specific unique likeness at a particular moment in time. This chronological specificity is key to the functioning of the image as a historical document, which is primary in both frescoes. The Sienese wished to commemorate specific military triumphs, and the fact that the *New Town* fresco is only one of a collection of images of conquered cities, and one without an identifying inscription, suggests that the specific reproduction of the salient features of the actual building was essential.[53] In the Florentine fresco, the accurately represented Palazzo Vecchio establishes the location and importance of the contemporary event. More importantly, the faithfully rendered details, such as the barbican added to the palace by the duke and noted by the chronicler Giovanni Villani, reinforce the fact of the duke's tyranny and underscore the righteousness

FIGURE 62. *New Town.* Siena, Palazzo Pubblico, Sala del Mappamondo (GERMAN INSTITUTE FOR ART HISTORY, FLORENCE).

of the men who expelled him, thereby reinforcing the reading of this image as commemorative.[54]

Closeness to the model, or mimetic accuracy, thus functions iconographically as a sign of historical specificity. The subject in both images is a particular event in time— in one, the submission of a conquered town; in the other, the successful ousting of the hated tyrant. The accurate representation of the building is used to anchor the image to a specific time as much as it is to a specific event. In this way architectural portraits can be seen to function in the same way as human portraits, although the iconographical reading is different because, for the most part the human portrait is specifically created to stop the march of time across the face of the sitter while architectural portraits play with time in important iconographical ways. There are specific examples where the chronological moment represented is essential to a complete reading of the significance of a portrait. For example, the image of Enrico Scrovegni in the Arena Chapel shows the Paduan merchant presenting his chapel to the Virgin during the Last Judgment. That Enrico will appear at the Last Judgment and be pardoned is the essential purpose behind this portrait, thus both the man and his building are rendered with close archaeological attention. The accurate architectural portrait, likewise, is intended to freeze a building, and thus a place, in a particularly important historic moment. The stress is on the moment and the event that transpired then, rather than in the Assisi portraits where the moment changes with the arrival of each new pilgrim.[55]

The relationship between the accuracy of the image and its iconographic function

FIGURE 63. Ambrogio Lorenzetti, *Effects of good and bad government on the city.*
Siena, Palazzo Pubblico, Sala delle Nove (SUPERINTENDENT P.S.A.D—SIENA—WITH
PERMISSION OF THE MINISTRY FOR ART AND CULTURAL ACTIVITY).

becomes clearer when we examine examples of architectural portraits that diverge from
the source buildings. The most well known example of this type of portrait is Ambro-
gio Lorenzetti's *Good and Bad Government* fresco in the Palazzo Pubblico in Siena (Fig-
ure 63). The allegorical elements in the fresco, such as the dancing women in the *Good
Government* and the seated figures on the middle wall, in contrast to the numerous "nat-
uralistic" details, have led some scholars to identify the entire fresco as an allegory of
an ideal city and not an image of contemporary Siena. Ambrogio's alterations in the
details of the cathedral in the upper left and the Porta Romana on the far right, which
are the only two identifiable structures in the town, have been used as evidence for this
reading.[56] The discrepancy between the image and its model here releases the represen-
tation from temporal specificity and allows it to function on two levels: as a talismanic
concretization of the good city presented in opposition to the bad city on the facing
wall, and as an allegory with the personifications which appear on the adjacent wall. In
both these readings time does not play a role except in that the fresco represents con-
temporary Sienese ideals. Thus, whereas in the documentary frescoes discussed previ-
ously, the *New Town* and the *Expulsion of the Duke of Athens* (Figures 62 and 4), accuracy
enables the depiction to be temporally and historically specific, the discrepancy between

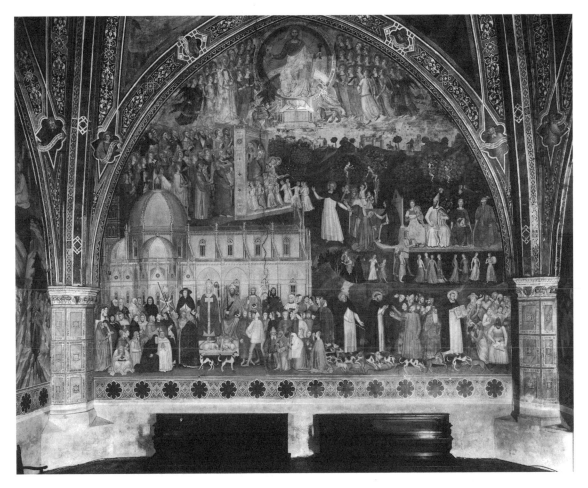

FIGURE **64**. Andrea Bonaiuto, *Church Militant and Church Triumphant*. Florence, Santa Maria Novella, Spanish Chapel (ALINARI/ART RESOURCE, NEW YORK).

the source and the image in Ambrogio's fresco signals a remove from historical time into a more flexible time zone which includes the past, the present, and the future. "Inaccuracy" thus functions as a signifier of the allegorical mode.

Andrea da Firenze's image of the Florentine cathedral (the Duomo) in the *Church Militant and Church Triumphant* fresco in the Spanish Chapel in Santa Maria Novella operates in the same fashion (Figure 64).[57] This building is related in plan and in design (the dome in particular, but also the projecting east-end chapels) to the projected, but not yet completed, cathedral in Florence. At the time this fresco was painted work on the cathedral had recently recommenced.[58] There is some speculation that the image here was one of the many plans for the final design of the building, which were under examination by the building committee.[59] The aspects of the building which were being debated at this time are important for our understanding of the appearance of Andrea's duomo in the Spanish chapel. Under discussion were the number of bays, the shape of the windows in both the aisles and the clerestory and, in fact, the final shape of the whole building, since the east end had yet to be started. In 1366, when this fresco was

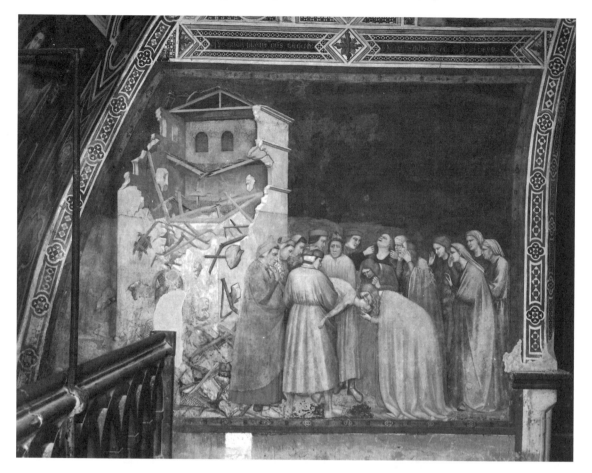

FIGURE 65. Follower of Giotto, *Miracle of the youth revived by Saint Francis*. Assisi, Lower Church of San Francesco, right transept (GERMAN INSTITUTE FOR ART HISTORY, FLORENCE).

begun, Andrea da Firenze was on the committee of painters, which was assembled to help plan the next phase of construction on the Florentine cathedral and which made the model for the building.[60] Andrea's position on the committee is interesting given that the cathedral pictured in the fresco is different from the artists' projected plan. Howard Saalman's interpretation of the wording of the documents leads him to conclude that the plan put forward by the committee of painters included the project for a drum between the piers and the dome, a feature absent from the Spanish chapel fresco.[61]

An explanation for this discrepancy between Andrea's painted building and the cathedral plan is that by subtly varying the appearance of the represented building, Andrea intended to evoke the proposed cathedral but without reference to a specific time period, in much the same way the portraits of Siena represent good government in the Palazzo Pubblico. What is represented here is not a particular building so much as a concept, in this case the universal church, shown in the guise of the Florentine cathedral. The cathedral that appears in the fresco is both the Florentine cathedral and

the ideal universal church, which Florentine citizens and specifically the Dominicans hope to achieve in their city. Both these images can thus be linked to the idealized human portrait, which shows the sitter not as he or she really is, but rather in relation to a set of social protocols and moral values. Examples of such portraits abound in donor images showing the patron as a worthy supplicant at the feet of Christ.[62]

The links between temporal/chronological specificity, descriptive accuracy, and iconographic or symbolic meaning can be seen even more clearly in Maso di Banco's image of *Saint Sylvester Muzzling the Dragon* (Figure 2). This scene, on the lower right wall of the Bardi di Vernio Chapel in Santa Croce, Florence, shows Sylvester overcoming a dragon which has been terrorizing the citizens of Rome. What is striking about this image is the way in which it consciously diverges from the text, which reports that part of the city has been destroyed by the dragon.[63] The destruction of the buildings in this fresco has been wrought by time, not by a dragon. The monumental structures rising up around the figures have weeds growing in their cracked surfaces and grasses covering the fallen remains of their roofs. They are in striking contrast to the depictions of ruined buildings that other trecento artists produced. For example, Maso's fresco can be compared to the collapsed house depicted by a follower of Giotto in a scene from the *Saint Francis Miracles* in the right transept of the lower church in Assisi (Figure 65). In this scene the immediacy of the collapse of the house, which has killed the child, is vividly displayed in the scattered debris and broken timber of the roof vaults. Contrast this to the carefully rendered plant life growing in and around the fallen stones, as well as the complete absence of wooden vaults (which time would have wasted away) in Maso's Rome.

Maso's representation of Rome in ruins refers to the fourteenth-century city of Rome more accurately than it does the Rome of Saint Sylvester's day. The artist's decision to depict this particular Rome was certainly a conscious one. We can get some idea of the appearance of Rome in the Trecento from sixteenth-century prints (Figure 66).[64] In the example shown here the roofless ancient building in the deserted field seems to echo the building rising up behind the court officials at the far right of Maso's fresco. In order to understand the motivation for Maso's choice we must recognize the particular historical consciousness of trecento Florentines and the place that Rome played in their national identity.

The twelfth-century *Chronica de Origine Civitatis* created a context for Florence's destined greatness by constructing a foundation myth in which the city is established by prominent Roman citizens.[65] In the fourteenth century, Giovanni Villani clarified the connection and firmly asserted Florence's destiny by linking it to Rome's decline.[66] In the explanation that he gives for writing his history he states: "[O]ur city of Florence, daughter and creation of Rome, was rising and achieving great things, whereas Rome was declining."[67] Maso's fresco thus can be understood as a visual rendering of Villani's passage. Maso shows Rome in decay to his Florentine audience as a device to reinforce the historical destiny of his own native city. The historical specificity and accuracy of the represented buildings is what enables the viewer to read this image in this way. The anachronism of the architecture does not detract from the overall reading of the hagiographical event but it does introduce for the Florentine audience the evidence of Rome's fall, which by this time was generally understood to herald and to explain the ascent of

FIGURE 66. View of the diabitato, as of 1534–36, detail showing Saint Anastasia and Saint Maria in Cosmedin, Berlin, Kupeferstich Kabinett, 79, D2A, fol. 91v and 92 (PICTURE ARCHIVE OF PRUSSIAN CULTURE, ART RESOURCE, NEW YORK).

Florence as a center of culture, trade and power. In addition, the oblique reference to Florence's destiny is further embellished by its appearance in this particular cycle. Saint Sylvester was, after all, the pope who presided over the rise of the Catholic church, which followed upon Constantine's conversion. Florence's rise is thus connected to the divinely sanctioned ascent of the church.

Maso's use of anachronism to insert a civic statement into his fresco makes use of a tool already well established in liturgical drama.[68] This, as well as the complexity of the message that is conveyed, leads one to conclude that Maso's misrepresentation is not the result of simple ignorance. The artist was certainly aware that the Rome of Sylvester's day was not the Rome of his own. This image, therefore, demonstrates a trecento artist's sophisticated understanding and exploitation of the iconographic and symbolic potential of descriptive accuracy. It is also evidence of a link between historical specificity and the relationship between the model and the image. Finally, the lack of chronological accuracy in rendering Rome in the fresco demonstrates that in hagiographical narratives architectural images were not always used to link the depicted event to a specific time. This is important for our understanding of the use of portraits in general, because it suggests that artists could have been relatively assured that some viewers would recognize the different types of portraits and their relationship to history. This in turn suggests that the language of architectural portraiture was well understood by both artists and viewers.

Thus, the development in the use of architectural portraiture in the late thirteenth and early fourteenth century is a facet of pictorial language which has been underesti-

mated as evidence of the complex relationship between the visible world and its representation. A careful reading of these portraits suggests that, while each image differed in the particulars of its iconographic message, there is consistency in the way in which "accuracy" signified in architectural portraiture. Accuracy in the rendering of a recognizable building anchored it in time, while deviation from the prototype was a means of transcending temporal boundaries, separating actual experience from an ideal and utilizing the potential of the image to act as a mnemonic. The portraits that we have examined have consistently demonstrated that descriptive accuracy was a flexible tool, manipulated by artists to expand upon or make more complex the narrative that is being told. Evidence of the artists' understanding of this tool is found in the variety of contexts in which the portraits appear.

Conclusion

Trecento painters utilized architectural portraiture to transform, deepen, mediate and modify the relationship between the audience and the depicted narratives. These portraits of buildings and monuments demonstrate a sophisticated understanding of the iconographic potential of the observation of nature in general, and specific settings or urban environments in particular. The sheer number of different examples of portraits also demonstrates that they cannot be explained as idiosyncratic manifestations of individual artistic style but rather make up a part of a widely recognized and used language. The rise and sophistication of architectural portraits, seen not just in the variety of their functions, but also in the variety of different buildings which are chosen for reproduction, allows us to postulate that the growing interest in constructing individual identity and subjectivity evident in the development of human portraiture in this period was accompanied by a new sensitivity to being situated—geographically, historically and culturally—in time and place. As we shall see in Chapter Four, these features are also found in nonspecific or generic architectural imagery which include various features of form and detail that are taken from the contemporary built environment.

As we noted in Rome and Assisi and as we will see in the painting of Florence and Siena, the architectural portrait was not as prevalent as other forms of architecture. In fact, it was used in very specific instances when its potential to augment or deepen the viewer's reading of a scene was at its highest—either by virtue of the circumstances of the viewing environment, such as the pilgrim cycle in Assisi, or the viewer, such as the Florentine looking at Rome in Maso's image. The key feature of the makeup of the architectural portrait, its connection to the built environment, is found in the majority of architectural imagery in painting of the first half of the fourteenth century. If we return briefly to Ambrogio Lorenzetti's image of ideal Siena in the Palazzo Pubblico (Figure 63), we will see that, alongside the buildings of the city, Ambrogio has also represented another aspect of the urban scene that is new to the fourteenth century: the space of the piazza in front of the Palazzo Pubblico from which the city is viewed. This acknowledgment of urban space, as well as the innovative angles from which the buildings themselves are viewed, is rooted in an awareness of the transformation of the built

environment that occurs in the early Trecento. This awareness and appreciation should be probed further in order to understand its effect on architectural imagery in terms of the way buildings are used compositionally as well as iconographically. Thus in Chapter Four we shall examine the development of the scale, siting and use of mimetic details in otherwise generic structures in the architectural imagery in the first half of the Trecento.

Chapter Four

The Celebrated City: Civic Ritual and the Language of Architectural Imagery, 1300 to 1340

The fourteenth century in Florence opened on a scene of communal upheaval. Nowhere is this more evident than in the *Chronicle of Dino Compagni* written some ten years after the events that form the center of his narrative. The city was divided by an ideological split between different members of the Guelf Party into Blacks and Whites. In October of 1301, unable to settle their differences, the city prepared for the arrival of the pope's emissary, Charles of Valois, who was also the brother of the king of France, Philip IV. Compagni was one of the major players in this political drama, well known because it was this that led to the exile of Dante Alighieri and the subsequent composition of his *Divine Comedy*. For our purposes, Compagni's chronicle gives us our first insights into how secular ritual functioned for the nascent city-state. The narrative details the fall of the White Guelfs, a faction of the Guelf Party, the party that held power after the institution of the *Ordinances of Justice* (1293), which established the basic framework by which the republic was governed. What is useful about this narrative is Compagni's language in describing the decision to allow Charles to enter the city and the way in which subsequent entries are described and used as tools to create a vision of a unified community. In the process of foreign relations, the entry was a key ritual that used the whole city as a stage. Its symbolic importance cannot be underestimated. Compagni notes that he says to his fellow citizens, as they prepare for the arrival of Charles of Valois in 1301: "Now this lord Charles is coming and he should be received honorably. Set aside these enmities and make peace among yourselves so that he does not find you divided...."[1] The entry is thus a staged event in which the unity of the Florentine citizenry is acted out for the benefit of both Charles and for the Florentines themselves. It is Compagni's fervent desire that this unity will become a reality by means of the ritual. According to ritual theorists, Compagni is not alone in this assumption.

I have chosen to begin this chapter by evoking Compagni because, at the same time

FIGURE 67. Duccio, *Christ's Passion*. Siena, Museo del'Opera del Duomo (SIENA, CITY AUTHORITY).

that images of architecture were developing a more complex and sophisticated relationship to actual architecture, ritual activity was taking on a more important role in the creation of civic identity. One particular ritual act is especially important for our purposes, the procession. Processions were key to ritual practice. They marked every major and minor civic and religious holiday and called to mind, with their literal passage through time and space, the spiritual journey that viewers made when approaching a religious image. In addition, the procession utilized the built environment as both setting and symbol. In Chapter Three we have seen clearly how images of architecture served to underscore the religious experience of the pilgrim. The images of Ambrogio Lorenzetti and Maso di Banco (Figures 63 and 2) also showed how the same kinds of references to the built environment could have political as well as religious meaning. In this chapter we shall investigate this potential further and we shall use the ritual city as a guide for doing so.

Civic religious rituals and pictorial imagery are often found side by side in the Trecento. For example, the history of trecento painting in Siena might be said to begin with the triumphant procession that took place in 1311 to accompany the magnificent altarpiece of the *Maesta* just completed in the workshop of the master Duccio to its place on the high altar of the cathedral (Figure 67).[2] The account refers to tiers of Sienese citizens led by the bishop holding candles and accompanying the huge panel through the streets while all the bells of the city rang out in celebration. They march through the city, where all the stores have been closed in honor of the day, around the central piazza, the *Piazza del Campo*, in front of the Palazzo Pubblico and on to the cathedral where the enormous panel is triumphantly installed. This quintessential civic-religious ceremony is related in much scholarly literature to demonstrate the rise in the importance of art as well as the immediate appreciation of one of the period's most remarkable works. But it also tells us something essential about how the fourteenth-century city was experienced. By bringing together painting and the ceremonial city we have a model through which we can gain insight into the particularities of the makeup of the architectural images and their meaning.

Throughout this study the built environment has been shown to be a force in images of architecture. But the formal relationship between the image and the building it references or represents is by no means straightforward, as we have seen in Chapter Three. In the case of the portraits variations on the built source were icongraphically significant. It is the purpose of this chapter to demonstrate that this icongraphical complexity was not unique to the architectural portraits. Many art historians have used the links between painted and real architecture in fourteenth-century painting as evidence of a developing interest by trecento artists in observation of the visible world or "naturalism" for its own sake. Clearly this is not the case when specific buildings are referenced. But by far the vast majority of architectural images found in fourteenth-century painting are not portraits, they make reference to contemporary structures' details and forms, but do not render specific buildings. How are we to understand these images both in relationship to what we have just seen in the portraits, and with regards to the issue of "naturalism." Careful examination of this generic, or non-specific, architectural imagery, in fact, shows that alongside the details that derive from the innovative architectural forms of the contemporary moment, architectural imagery of the early four-

teenth century also contains many conventional forms that seem to contradict the "naturalism" of the many links between built and imaged forms. We cannot, therefore, assess the meaning of the links without taking into consideration the conventional forms that counteract them.

In fact, the continued presence of these conventional forms remind us of two key features of pictorial imagery in the Trecento which are often underplayed by scholars' emphasis on the rise of so-called naturalism: (1) that painting in this period was a way of transferring information that, because it related to the spiritual world of unseen things, could not be conveyed by the mere representation of the visible world as was clearly demonstrated in Chapter Three; and (2) that it functioned within a broad realm of social circumstance that must be taken into consideration in any discussion of its meaning. In this chapter then, we shall expand our field of vision beyond specific architectural references to examine the general connections between real and represented architecture and set them against the events of the contemporary moment all the while paying attention to the viewing context. Most important for our understanding of this context is how the city itself functioned as a symbol during this period. Again, the portraits lead the way in demonstrating this, Maso di Banco's consideration of the relationship between his own city and Rome or Ambrogio Lorenzetti's evocation of Sienese public space come immediately to mind. Beyond the images, the symbolic function of the urban setting is no more clearly articulated than in the multiple and increasingly more elaborate civic and religious ceremonies of which Siena's *Maesta* procession and the entry or Charles into Florence are but two examples.

Images of Architecture and Real Buildings

By now the reader is well aware that artists, and patrons, of the late thirteenth and early fourteenth century are acutely attentive to their architectural environment. In the case of Rome, the monumentality and history of its built fabric certainly justified this attention. But Florence and Siena were somewhat different because the period of building coincided with, rather than preceded, the rise and development of the architectural imagery that we are discussing. Before looking at the images then, we must look more closely at this building activity. It is well known that in central Italy, the first half of the fourteenth century was a time of great building activity. In most of the cities now regularly visited by eager tourists the urban environment is essentially unchanged from what it had become by the end of the fourteenth century. Not only were the new buildings large, expensive and innovative in design, they were also beginning to be surrounded by new and carefully planned urban spaces, piazzas and streets.[3] Let us try, for a moment, to conjure these new sites as they would have struck the eye of the participant marching alongside Duccio's *Maesta*.

The procession began outside the gate of Stalloreggi at the house where Duccio had worked (see Figure 68). In this way the procession mimicked the ceremonial entry, because then too the guest was met at the gate by the officials and other members of the community and they all moved together through the city.[4] As the lengthy procession entered the *Piazza del Campo* in front of the Palazzo Pubblico they would have been

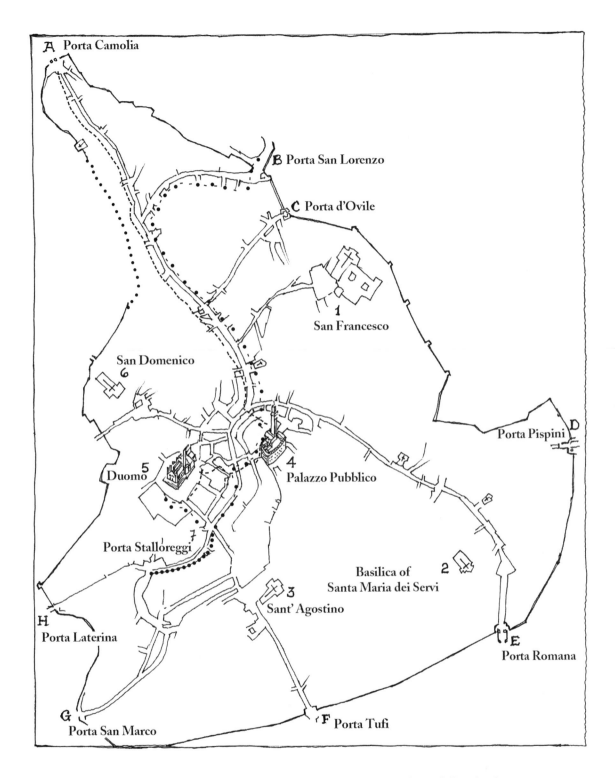

FIGURE 68. Map of Siena showing three processions. The dotted line is the route followed by Duccio's *Maesta* in 1311. The dashed line is the one followed by the cardinal Giovanni Orsini in 1326. The dash-dot line is the procession of Pietro (the brother of Robert of Naples) in 1314 if he entered via the Porta San Lorenzo (DRAWING BY JOHN RATTÉ).

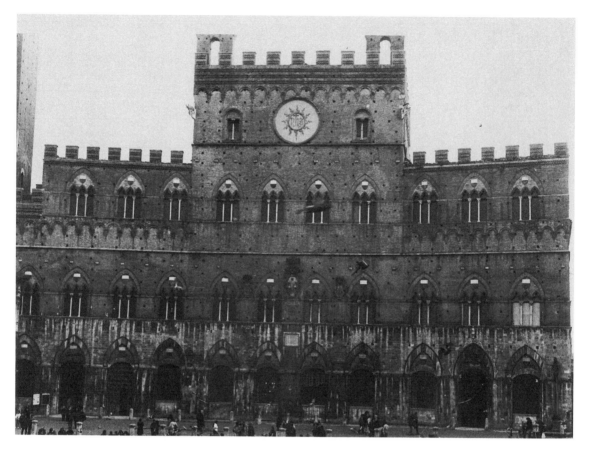

FIGURE 69. Siena, Palazzo Pubblico, Facade (PHOTOGRAPH BY THE AUTHOR).

greeted by the stunningly elaborate winged block of the palace, which, begun a little over ten years earlier, would have been striking in its mix of materials and monumental design (Figure 69).[5] The siting of the building at the low point of the *Campo* focused and dramatized the space in a new and striking way.[6] From the final years of the thirteenth century throughout the early years of the fourteenth, the statutes of the Sienese commune are full of careful commentary on, and discussion of, the new monumental face of the city. We know from these documents that the view that greeted the visitor to the campo was not haphazard but carefully thought out and controlled.[7] Around the piazza the viewer would have seen repeated the particular trifore windows found in the Palazzo Pubblico, creating a complete image that encompassed the entire space of the piazza (Figure 70).[8] This coherence could not have escaped the viewer, who might have seen it as a reflection of the power and stability of the government of the Nine housed in the palace and overlooking the piazza. It is important to note here that the very idea of a building specifically dedicated to the use of the government was new; the governing body had rented space in private palaces prior to the construction of the Palazzo Pubblico.[9] The symbolism of the building was thus all the more striking.

As the procession moved on to its final destination on the high altar of the cathedral our hypothetical participant would again have been confronted by more new con-

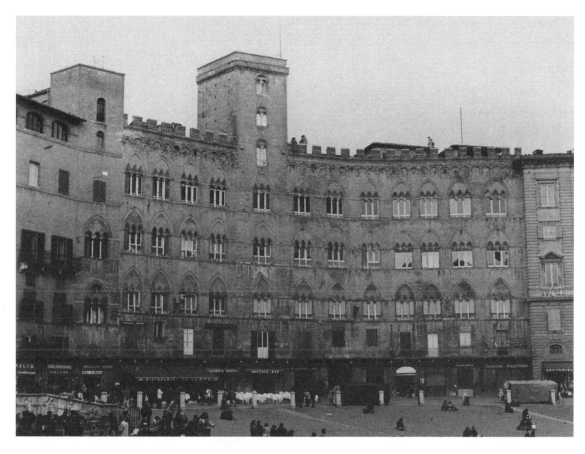

FIGURE 70. Siena, Sansedoni Palace (PHOTOGRAPH BY THE AUTHOR).

struction. The monumental west facade designed by Giovanni Pisano had probably been completed just the year before (Figure 71).[10] In addition, plans were underway for a new baptistery, and the south flank of the church boasted the relatively new Episcopal Palace built in the 1270s. Directly in front of the cathedral was the impressive facade of the hospital of Santa Maria della Scala.[11] It must have seemed to this viewer that Duccio's magnificent new altarpiece was in fact matched in its grandeur by the new civic structures. And, like the Virgin herself, whose demonstrated care and concern for the city were a symbol of its destiny, the buildings and monumental spaces stood as mute testaments to the power of the city-state.

Florence too was transformed by new building from the late thirteenth into the first half of the fourteenth century.[12] And, like Siena, Florence's new buildings were displayed to its people and to visitors who marched along processional routes that knit together the various different areas of the city. We can follow along in the train of Cardinal Pellegrue, who entered the city in August of 1310, in order to get a sense of the building going on at this point (see Figure 72).[13] The cardinal arrived outside the city walls and was met by a mounted greeting party at the Porta San Gallo (built in 1285 and part of the new circuit of walls begun in 1284). He and his entourage were probably then accompanied down the Via San Gallo or the Via Larga to the Piazza del

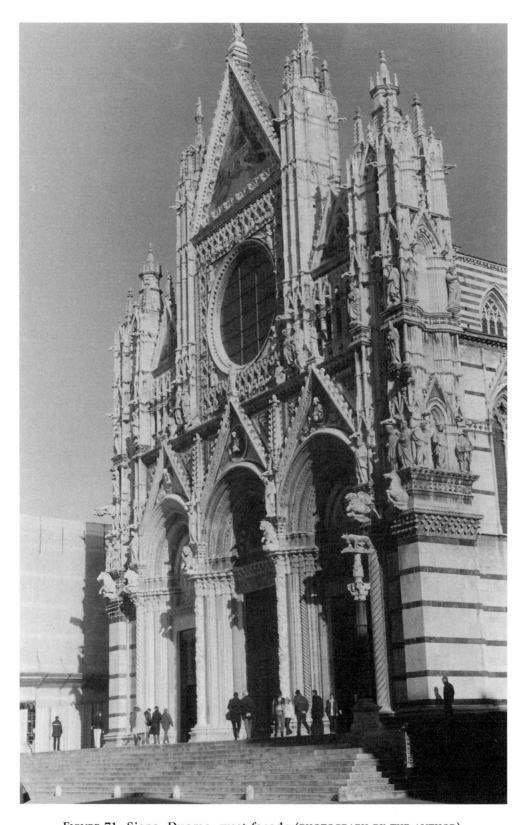

FIGURE 71. Siena, Duomo, west facade (PHOTOGRAPH BY THE AUTHOR).

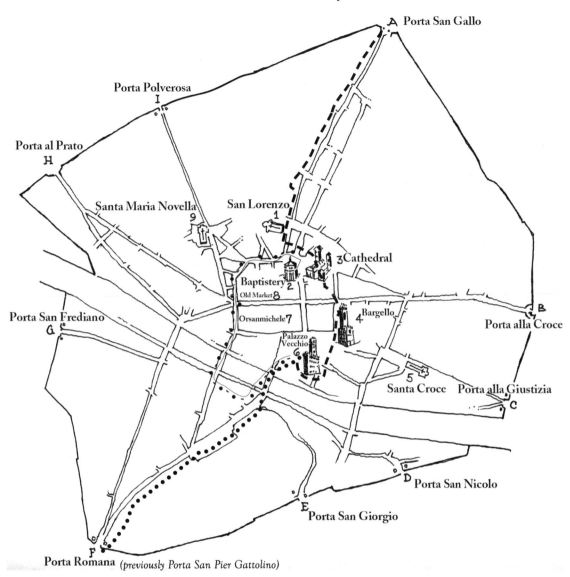

FIGURE 72. **Map of Florence showing various processions. The dotted line shows the procession of the image of Saint Agatha from the 13th century** *Mores*. **Dashes show the arrival of Cardinal Pellegru in 1310. The dash-dot line is the 16th century procession on Saint John's Day** (DRAWING BY JOHN RATTÉ).

Duomo where they would have encountered the foundations for the facade of a vast new cathedral begun only a few years before. We can only speculate on their route from this point on, because the chronicler did not say anything more about the entry. It is certain, however, that the cardinal would have gone to the Palace of the Priors (Palazzo Vecchio pictured in figures 4 and 73). He could have reached this either through the heart of the city past the old market and relatively new grain market (built in 1284 later to be Orsanmichele) or by going behind the cathedral down the Via Proconsolo past the Palazzo del Podesta, now known as the Bargello, built in 1250, and then on to the

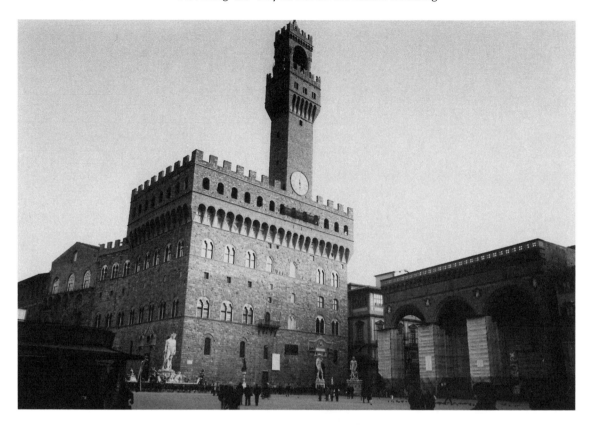

FIGURE 73. Florence, Palazzo Vecchio and the piazza della Signoria (Loggia dei Lanzi on the right), Florence (PHOTOGRAPH BY THE AUTHOR).

Palace of the Priors. At this point, in 1310, the new Palace of the Priors was almost complete (Figure 73) but the monumental piazza that would eventually frame the striking building would not be complete until the end of the century. After the ritual of greeting was complete the cardinal was led to the place where he would stay. Because Pellegrue was a papal legate, or emissary, he might have been housed in the Dominican monastery of Santa Maria Novella whose church, the third church on this site begun in the mid-thirteenth century, would have been substantially complete by the time of the cardinal's arrival (Figure 74).[14]

Like the procession for the *Maesta* in Siena, the welcome shown to the cardinal offered the citizenry an opportunity to see their city in a broader context, in this case the broader political world symbolized by the foreign visitor. In this context, the city's buildings played an important role, one that we can see was recognized by the commune itself from the amount of time and attention that was paid to architectural planning in the deliberations of the various civic councils during this period.[15] In many of them the reason for spending money, such as in 1322 when the council decided to pay for the completion of Santa Croce, is for the greater beauty of the city.[16] Because Santa Croce, as well as Santa Maria Novella, are listed as places where honored guests are housed, we can see quite clearly that, although these building complexes were under the auspices of the mendicants, their symbolic significance stretched beyond the orders

FIGURE 74. Florence, Santa Maria Novella, south transept facade (PHOTOGRAPH BY THE AUTHOR).

to the city as a whole. We shall return to these points shortly, but now we must turn to the images of architecture and their links to built forms. The very specific use of details of contemporary architecture in the portraits has already been noted in Chapter Three. Now the more general ways in which artists' observation of the built environment appears to have affected images of architecture needs to be addressed. As will become clear, the built environment appeared in the images in a variety of ways from specific details of actual buildings, to scale and siting to the use of buildings to create specifically urban space.

The first and perhaps most easily noticed link between built and imaged structures are the quotations of specific details taken from actual architecture, such as roof types, corbelling, window treatments, sculptural decoration and doorways. In Santa Croce, for example, Taddeo Gaddi repeatedly utilized contemporary window types, including the roundels and bifore windows found in Santa Croce itself. Both window types are shown in the palace before which the Marriage of the Virgin and Joseph takes place (Figures 75 and 76). A similar use of contemporary window types and building forms are found in Bernardo Daddi's image of Jerusalem that rises up behind the walls in his *Meeting at the Golden Gate* from the so-called San Pancrazio altarpiece (Figure 1).[17] In this image Anne and Joachim embrace before a tall city gate behind the walls of which rise a series of buildings whose crenellations, shape and windows are reminiscent of

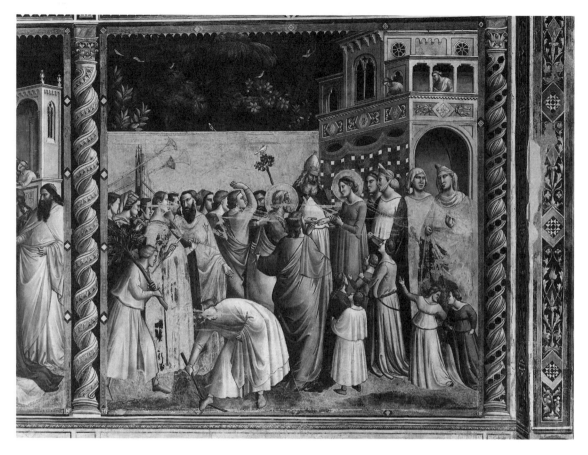

FIGURE 75. Taddeo Gaddi, *Marriage of the Virgin*. Florence, Santa Croce, Baron-celli Chapel (SUPERINTENDENT OF FINE ARTS, FLORENCE).

contemporary architecture, such as the Bargello (Figure 77). Close examination of this image as well shows that Daddi has articulated the rooftops of two of the buildings with sculpted figures. Similar figures appear in a number of paintings, such as Pietro Lorenzetti's *Flagellation* (Figure 78), and they too can be directly related to the ornate new facades being erected at this time, such as the facade of the Siena Cathedral mentioned above (Figure 71).[18]

Giotto's quotation of the surface of the Florence's Palazzo Vecchio in his Bishop's palace in the scene of Saint Francis renouncing his father from the Bardi Chapel in Santa Croce is also noteworthy (Figures 79 and 73). In this scene the building is presented at a striking angle coming to a point just at the naked body of the saint. The building forces itself into the reading of the scene emphasizing its form but also the rough stone that makes up its lower story, clearly a quote from the roughly contemporary town hall. This particular quotation is important because the use of rusticated stone was an innovation in the design of the new building and thus demonstrates a

FIGURE 76 *(opposite)*. Florence, Santa Croce, south transept looking toward the Baroncelli Chapel (PHOTOGRAPH BY THE AUTHOR).

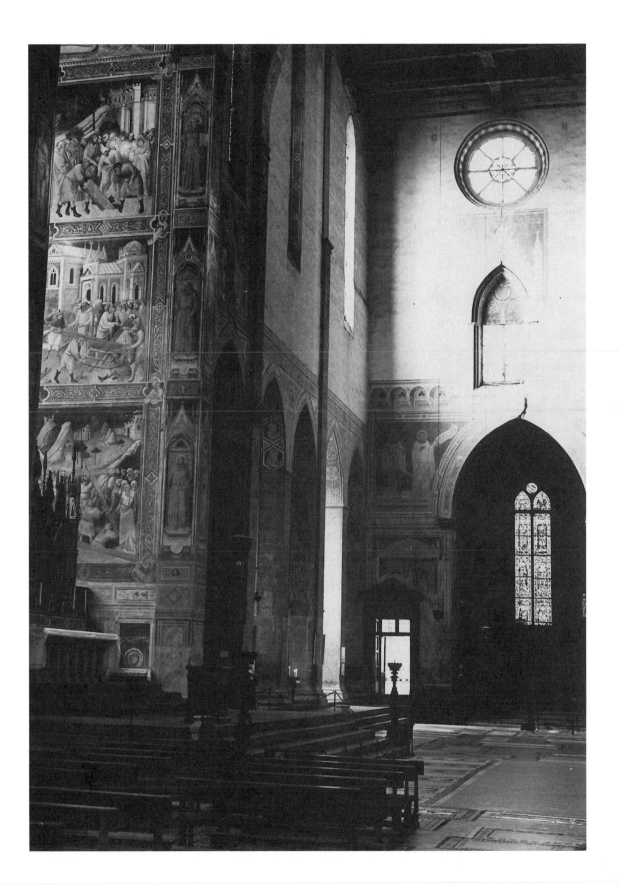

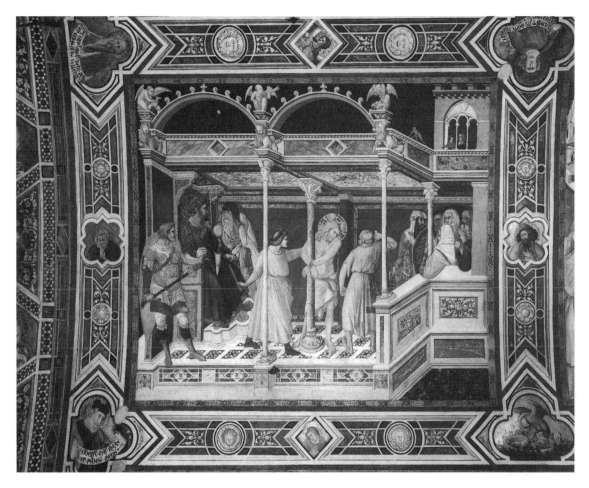

FIGURE **78.** **Pietro Lorenzetti,** *Flagellation.* **Assisi, Lower Church of San Francesco, Transept Chapel** (GERMAN INSTITUTE FOR ART HISTORY, FLORENCE).

keen awareness on the part of the artist of the built forms going up around him. The same can also be said for Pietro Lorenzetti's *Flagellation* where, in the upper right corner the tower of Pilate's Palace sports a typically Sienese style trefoil window (Figures 78 and 69).

In Siena, indeed, the evidence of artists using the vocabulary of built forms is extensive, particularly in the work of the brothers Ambrogio and Pietro Lorenzetti. Two altarpieces painted by the brothers, who followed Duccio, not only in time but also in working on the program of decoration for the altars of the city's patron saints in the Sienese cathedral, clearly evidence the growing interaction between real and represented architecture.[19] The commissioning of the altarpieces coincided with an ambitious renovation of the cathedral begun in 1317 and designed to update the Romanesque building, making it gothic. This renovation included the enlarging of the crossing to make way for four new altars, each one dedicated to one of Siena's patron saints—Savinus,

FIGURE **77** *(opposite).* **Florence, Bargello** (PHOTOGRAPH BY THE AUTHOR).

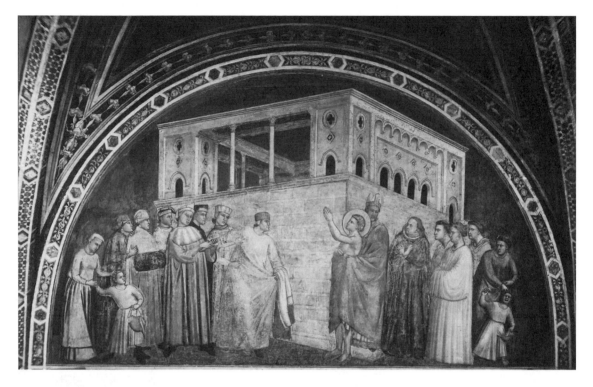

FIGURE 79. Giotto, *Saint Francis renouncing his father.* Florence, Santa Croce, Bardi Chapel (SUPERINTENDENT OF FINE ARTS, FLORENCE).

Ansanus, Victoriuns and Cresentius—and building a baptistery at the east end which subsequently was used to extend the apse by two bays (Figure 80).[20] The developing gothic space of the Sienese cathedral appears in Ambrogio Lorenzetti's *Presentation* (Figure 81) which was completed in 1342 for the altar of Saint Crescentius. In addition to the spatial configuration, Ambrogio has included some quite specific details of the built cathedral, such as the depressed arch that appears in the portal directly above the head of the high priest standing behind the altar and the compound piers with their elaborate Corinthian capitals found in the central space where the figures stand.[21] But the octagonal dome that rises above this three-aisled basilica comes from the generally understood appearance of the temple in Jerusalem rather than from the form of the Sienese dome.[22] Other differences include the piers and capitals in the aisle space that recedes behind the inner portal and the lancet window in the apse wall. These distinctions suggest that Ambrogio is seeking to evoke but not to render the Sienese building.

In the same year that Ambrogio painted his altarpiece, the cathedral *Opera*, that supervised the renovation and decoration of the building, requested a panel from his brother, Pietro, who painted the *Birth of the Virgin* for the altar of Saint Savinus (Figure 82).[23] In this image Pietro quotes the recently completed courtyard of the Palazzo Pubblico in the court that appears beyond the figure of Joachim, who sits just outside of the central chamber in which Anna lies on a wide bed covered with a handsome checked cloth (Figure 83). Here too the local structure is evoked rather than represented exactly.

Not only do we find a marked increase in the appearance of details taken from

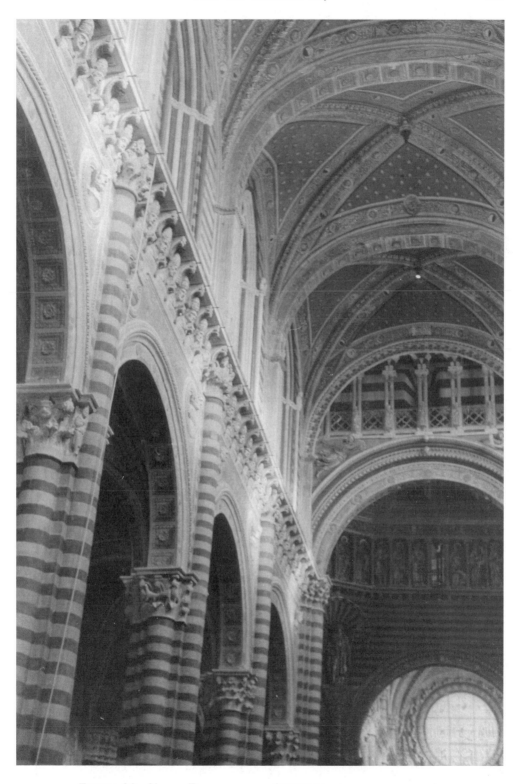

FIGURE **80.** **Siena, Duomo, nave** (PHOTOGRAPH BY THE AUTHOR).

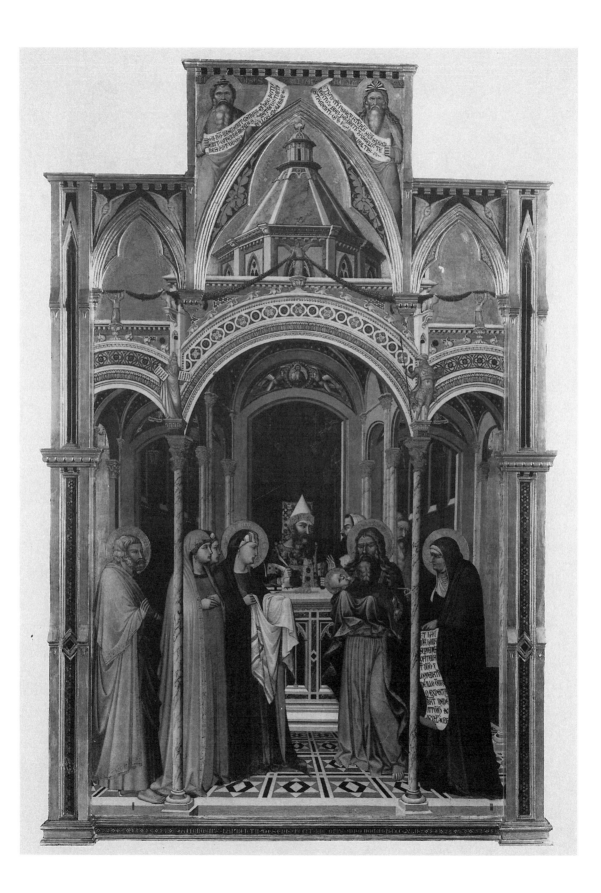

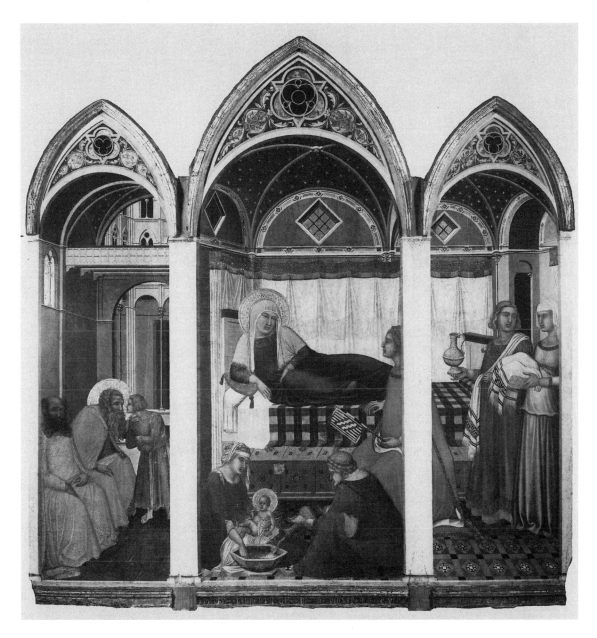

FIGURE 82. Pietro Lorenzetti, *Birth of the Virgin*. Siena, Museo del'Opera del Duomo (SIENA, CITY AUTHORITY).

built structures in the first half of the Trecento, but also painted architecture is connected to the built environment through the creation of specifically urban spaces defined and contained by architecture. A good example of this is found in a fresco attributed to the school of Pietro Lorenzetti in the church of San Clemente dei Servi where the *Massacre of the Innocents* takes place within a trapezoidal piazza defined on three sides by large buildings (Figure 84).[24] Here too the articulation of the architecture refers to

FIGURE 81 (*opposite*). Ambrogio Lorenzetti, *Presentation in the Temple*. Florence, Uffizi (SUPERINTENDENT OF FINE ARTS, FLORENCE).

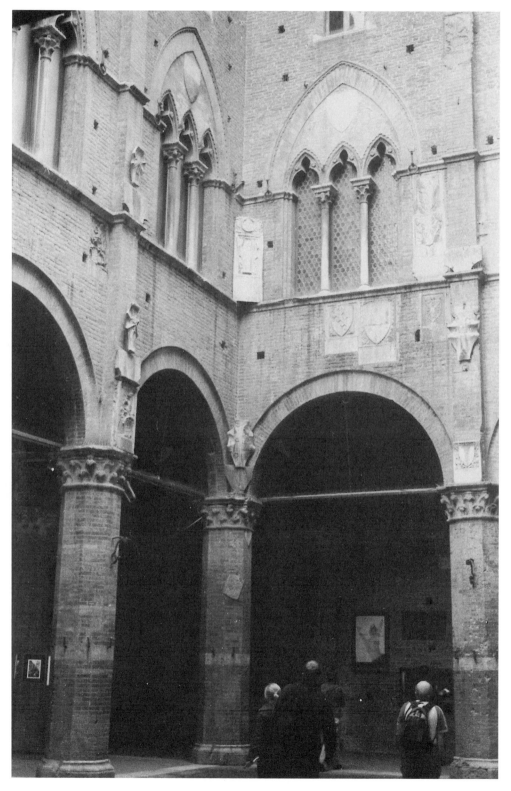

FIGURE 83. Siena, Palazzo Pubblico, courtyard of the Podestá (PHOTOGRAPH BY THE AUTHOR).

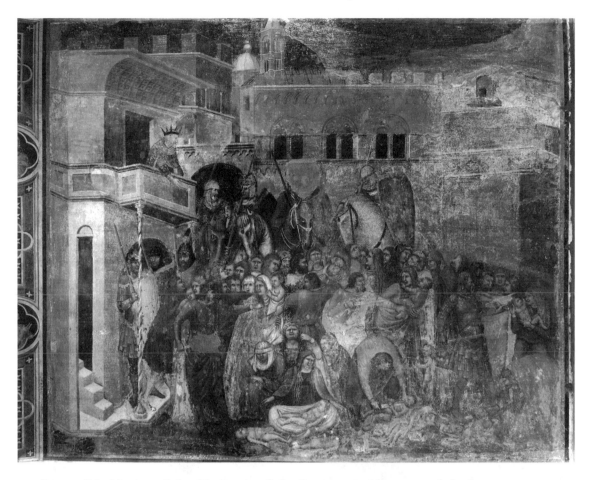

FIGURE 84. Master of the Massacre of the Innocents, *Massacre of the Innocents.* Siena, San Clemente dei Servi (SUPERINTENDENT P.S.A.D–SIENA, WITH PERMISSION OF THE MINISTRY FOR ART AND CULTURAL ACTIVITY).

the local environment. The large building that frames the piazza in which the action takes place is embellished with bifore windows and an arched corbel table reminiscent of the Palazzo Pubblico (Figure 69). Behind this rises a dome and campanile that are distinctly like Siena's cathedral, although care is taken not to represent these structures precisely. The tower, for example, is a uniform shade of grey rather than black and white stripe.

Such specifically urban space can be found in a number of images in both Florence and Siena. Ambrogio's image of the Piazza del Campo from the cycle of *Good Government* discussed in Chapter Three springs immediately to mind, but there are others (Figure 63). For example, the scene of Beato Agostino reviving a child who has fallen from the balcony in the left of that Saint's altarpiece shows us a carefully articulated city street complete with overhanging sporti (Figure 3). Duccio also chooses to set the scene of *Christ Healing the Blind Man* within urban space defined by crenellated palaces at the back and a short wall articulated with an arched corbel on one side (Figure 85). In these examples architecture is used on two or three sides of the scene to create a unit of space

FIGURE 85. Duccio, *Christ healing the blind Man*. London, National Gallery (GERMAN INSTITUTE FOR ART HISTORY, FLORENCE).

which can be directly related to the spatial units of the built city that were being created at this time, such as the Piazza del Campo or the space in front of Siena's cathedral. Another method for creating a specifically urban space is exemplified by a number of scenes in Jacopo del Casentino's San Minato altarpiece, where a series of ineffectual tortures are visited upon the saint (Figure 86). In three of these scenes (the middle two on left and second from the top on the right) an urban space is created using two tall buildings on either side of the scene where the action takes place. These buildings present a flat face to the surface of the picture plane, but then their sidewalls recede obliquely toward each other creating a zone of space bounded by architectural forms, that is,

FIGURE 86. Jacopo del Casentino, *San Miniato and scenes of his life*. Florence, San Miniato al Monte (SUPERINTENDENT OF FINE ARTS, FLORENCE).

FIGURE 87. Bernardo Daddi, *Martyrdom of Saint Stephen*. Florence, Santa Croce, Pulci and Beraldi Chapel (ALINARI/ART RESOURCE, NEW YORK).

urban space. A distinction between this specifically urban space and nonurban space is illustrated by Bernardo Daddi in his *Martyrdom of Saint Stephen* in Santa Croce (Figure 87). In this scene the saint is shown twice, once within the city receiving the judgment of the high priest, who gestures toward the saint from his loggia. The stepped space here is created by built forms, not only the loggia but a tower that rises up behind and to the right of it to meet the wall that divides the scene into two spatial and temporal zones. On the right, urban space gives way to nonurban space when the wall and its gate are the only built forms to be found and the ground plane rises up behind the figures to meet an infinite blue sky.

There are two other features of early fourteenth-century architectural imagery that would have reminded the trecento citizen of his or her built environment. The first of these is the increased scale and complexity of the architecture that surrounds the figures in the scene. We can see this in all of the examples discussed above if we set them beside the images from the Duecento discussed in Chapter Two where the represented buildings barely rise above the heads of the figures as in the scenes from the Bardi *Saint Fran-*

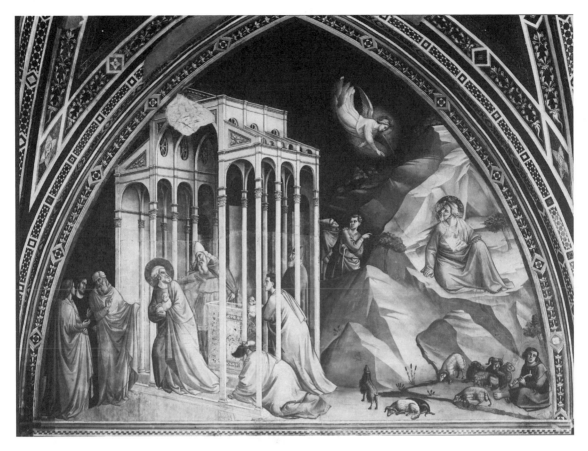

FIGURE **88.** Taddeo Gaddi, *Expulsion of Joachim from the Temple*. Florence, Santa Croce, Baroncelli Chapel (SUPERINTENDENT OF FINE ARTS, FLORENCE).

cis panel (Figure 49). The increased scale of the buildings in the trecento images adds a sense of "naturalism" to the scene, but it also serves to draw the viewer's attention to the buildings themselves, suggesting that they are an important part of the reading of the scene. In the scene of the *Expulsion of Joachim* from Taddeo Gaddi's Baroncelli cycle, the temple looming over the figure of the fleeing Joachim is as much a player in our understanding of the scene as is the priest who gestures malevolently at the older man (Figure 88). Iconographic complexity is also a feature of the architecture in many of the early trecento images. Ambrogio Lorenzetti's temple is an example of this as is Giotto's Bishop's Palace in the Saint Francis scene (Figures 81 and 79). While some specific details of these imaged buildings related directly to built forms, one could also say that the very complexity itself was a feature of the developing built environment that trecento viewers were coming into contact with.

The second feature that connects imaged architecture to actual buildings in early trecento paintings is the prominence of the oblique angle of view. This is particularly visible in the civic miracles performed by Beato Agostino (Figure 3) and in the Lorenzettian *Massacre of the Innocents* (Figure 84). In both these scenes the buildings are set on a sharp oblique angle to the picture plane creating deep space that either offers a

place for the action, as in the *Massacre*, or recedes into the background, as in the Simone Martini. Giotto's palace from the Saint Francis scene discussed above, is also a good example of the use of the dramatic, space-creating oblique angle. In this case, the forceful outward push of the building creates space both in front of the surface of the picture plane and within it (Figure 79). Taddeo Gaddi's temple from the *Expulsion* (Figure 88) also utilizes the oblique angle in the siting of the building and the scene. The dominance of the oblique angle brings us back to ways of seeing architecture discussed at the outset of the chapter. In fact, both the increased scale and the angle of view are evocative of the way in which buildings would have been seen during the ritualized movement through the city that occurred over the course of the calendar year.

Thus, what we see in images of buildings from the first half of the century is a close link between their forms and the forms of the built environment by way of a number of different features, including: the increase in specific details, like windows, that relate directly to built forms; the use of buildings to create a specific urban space, like that that was being created in the actual city; and the increased size, complexity and siting of buildings that relate the viewing experience of the image of a building with that of a real building. Siting the image of a building on an oblique angle relates the viewing experience to that of one who is moving past a building, suggesting a link to ritual activity that presented the built city in just this way. Before turning to look more carefully at how ritual activity can help us to understand images of architecture, however, we must assess one last and extremely important facet of the representations of buildings in the early Trecento. That is, the continued presence of conventional, nonnaturalistic, forms. This facet, because it appears at first to contradict the "naturalism" that we have just described, is mostly overlooked or underemphasized by scholars who purposefully ignore the outstanding examples of conventional forms that persist in the paintings of all the major artists of the first half of the century, including Giotto and the Lorenzetti brothers, who are generally considered to stand at the forefront of the "naturalistic" revolution. The persistence of convention alongside naturalistic detail, however, suggests there is more to the "naturalism" than meets the eye.

Continued Presence of Conventional Ways of Representing Architecture

For purposes of this discussion we can define a conventional form as a shorthand way of representing something using a language of forms that evokes, but does not literally render, the thing it represents. Because of the shorthand, its relationship to its source is what semioticians would call "symbolic" rather than "iconic." That is, its identity depends more upon a culturally agreed upon meaning rather than resemblance to it source. The history of art is, of course, filled with such conventions. As far as we are concerned, there are three quite interesting conventional ways of representing architecture that persist from the earlier pictorial traditions into the fourteenth century, despite the growing interest in rendering buildings based upon existing actual structures.

Two of these conventional systems we have met with before in Chapter One, the inside/outside view and the synecdocal structure. The other two we have seen but not

yet discussed in detail. The most well-known example of the inside/outside view in the Trecento is found in Ambrogio's *Presentation* discussed above (Figure 81) in which the viewer sees both what is happening inside the temple and on the exterior cupola of the building.[25] This particular image makes sense iconographically because the cupola is an important part of the iconography of the scene: The presentation took place in a specific place, the temple in Jerusalem, and this temple was known to have this specific type of cone-shaped roof.[26] But its necessity does not negate the fact that the form, that is the simultaneous view of both the interior and the exterior of the same structure, implicitly contradicts the apparent "naturalism" of the various details based upon the actual structure of the Siena Cathedral. In fact this type of representation is found in thirteenth-century architectural images, although its antecedents go much further back. It appears in the scene of the burial of Saint Magnus in the crypt frescoes in the cathedral at Anagni painted circa 1250 (Figure 89).[27] In this image the congregation surrounding the bishop and the body of the saint all appear within the nave of the church, the tiled roof of which is just visible above their heads. The interior space of the church is encompassed by an arch cut into the wall of the building. Like Ambrogio's *Presentation*, the use of the inside/outside view in the Anagni fresco is dictated by the necessity of locating the events within a specific architectural site, in this case the church at Anagni.[28] Another example of the persistence of this view in the trecento is found in Pietro Lorenzetti's palace in the Assisi *Flagellation* (Figure 78). Pilate's Palace is denoted in the scene not just by its elegant marble interior, but also by the tower rising up to the right with its rich trefoil window, emblematic of contemporary public buildings.[29]

The synecdocal form will be remembered as the one in which a part of a building is made to stand for the entire structure. This type is most often used to represent interior locations and was particularly popular with Giotto. Numerous examples of it appear in the Arena Chapel. In the scene of the *Expulsion of Joachim*, for example, the temple is evoked by the ciborium, screen and the platform from which Joachim is about to step (Figure 90). This is quite similar to the scene of the *Communion* from the portico frescoes of the church of San Lorenzo in Rome (Figure 91). In the Roman fresco as well the religious building is evoked by the altar and ciborium.[30] The synecdocal form is also found in a number of scenes in the *Life of Saint Francis* in Assisi. There it can be related to similar architectural constructions found in the scenes of the New Testament in the upper zones of the nave.[31] This convention again counteracts the naturalism of the other architectural features discussed above. But both its persistence and legibility suggest that it was not seen simply as a necessary expedient but as a viable way of rendering the scene.

The third conventional system that is used to create an interior view, that has it roots in the Antique period but is seldom found in imagery before the late thirteenth century, is commonly dubbed by art historians as the "space-box," which might be said to be an innovation of the artists of the late Duecento. However, the conventionality of its form is nonetheless undeniable.[32] It is also used to show a scene that is taking place inside a building, giving the viewer some sense of interior space by dispensing with the fourth wall of a room. Cavallini's mosaic of the *Birth of the Virgin* from Santa Maria in Trastevere offers us a good example of this form in its early manifestation (Figure 46).[33] Although the box is modified with details added and shifted slightly on an

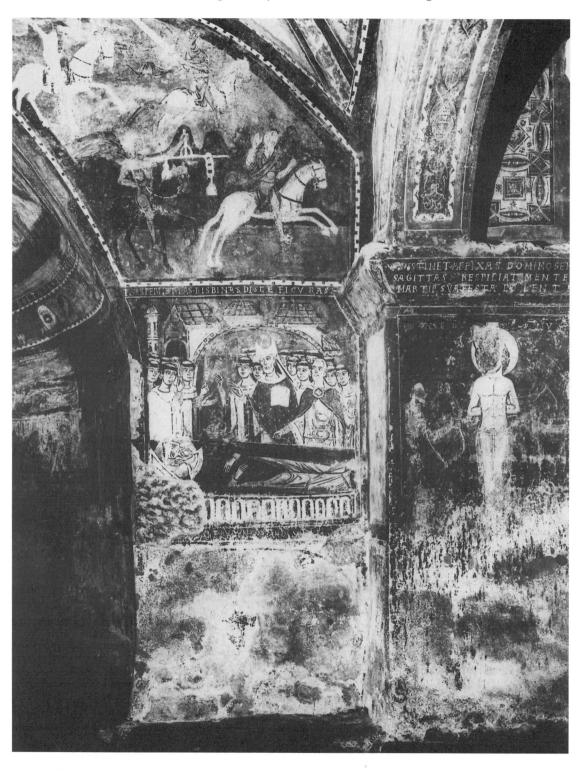

FIGURE 89. *Burial of Saint Magnus*. Anagni, Duomo, crypt (PHOTOGRAPHIC ARCHIVE, VATICAN MUSEUMS).

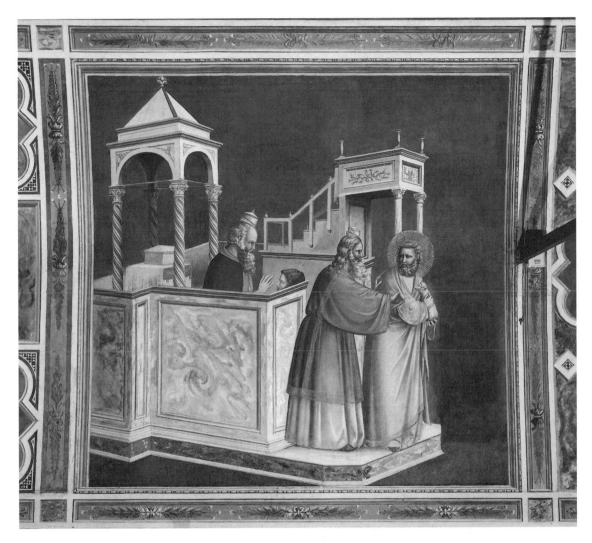

FIGURE 90. Giotto, *Expulsion of Joachim from the Temple*. Padua, Arena Chapel (CITY MUSEUM, PADUA).

angle, it persists through the fourteenth century, as can be seen in a number of examples, from the back of Duccio's *Maesta* to Maso di Banco's *Dream of Constantine* (Figures 67, 92 and 93). Duccio, however, introduces some modifications to the basic formula including the very interesting conceit of literally cutting away the roof beams of the palace in order to allow both the viewer and some of the other participants "into" the scene (Figure 93). The usefulness of these conventions, which allow the viewer access to interior scenes, is not the issue here. What is important to recognize is the use of a conventional system, which so clearly in its very form denies the solidity and therefore the architectonic quality of the represented building. It suggests that the architectural image is recognized as a pictorial device that conveys information important for the meaning of the scene, and is not there to merely mimic the viewer's world.

A fourth feature, which is not conventional per se, but does reflect the dialectical,

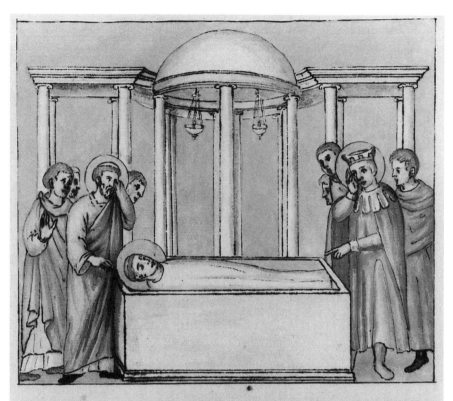

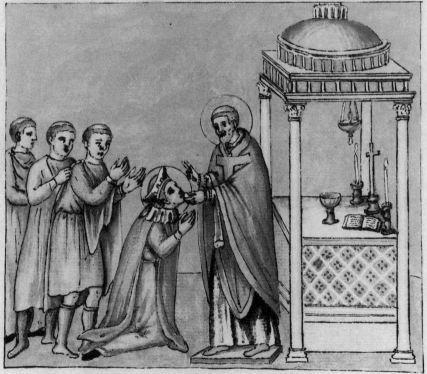

FIGURE 91. *Scenes from the life of Saint Lawrence*. Vatican City, Biblioteca Apostolica Vaticana, Barb. Lat 4403, f. 21r (APOSTOLIC LIBRARY, VATICAN).

FIGURE 92. Maso di Banco, *Dream of Constantine*. Florence, Santa Croce, Bardi di Vernio Chapel (SUPERINTENDENT OF FINE ARTS, FLORENCE).

FIGURE 93. Duccio, *Flagellation of Christ.* Siena, Museo del'Opera del Duomo (SIENA, CITY AUTHORITY).

rather than literal, relationship between the visible world and the image, is in the use of specific mimetic details that are evocative of extant buildings but they are situated in the wrong topographical sites, for example, in Giotto's Bishop's Palace in the *Renunciation*, noted above for the use of rough stone in the lower story that was reminiscent of Florence's newly built town hall, the Palazzo Vecchio (Figure 79). Because Giotto is documented as having been in Assisi, he was no doubt aware that the heavy stonework with which he articulated the palace in this scene was not a defining characteristic of the Bishop's Palace in Assisi.[34] Instead it is a specific Florentine detail with which the local viewer is offered a way into the narrative, a way, in fact, that inserts his or her own

experience into the narrative of the saint. But because the viewer is fully aware that the event depicted did not take place in Florence the image is not to be understood literally, but rather emblematically. In this case, the reference to the Palazzo Vecchio could be understood as a symbol of the earthly power that Francis is in the act of renouncing.

The consistent use of these conventional forms alongside the features and details that connect the representations directly to the visible world suggests immediately that we should not be persuaded to understand these "naturalistic" details as functioning in a simple mimetic fashion. However, neither should we discount that some sort of connection between the experienced world and that of the religious narrative is being made in the images. In order to understand how architectural imagery is being used, therefore, we need to look deeper into the innovative "naturalism" of the details—scale and siting. And we need to understand them in conjunction with, rather than as separate from, the conventional forms. The use of the conventional forms suggests that architecture in painting was read symbolically rather than literally. This reading is in fact consistent with scholarship's deepening understanding of the complex language of imagery that used to be referred to simply as "naturalism" as discussed in the Introduction.

Once we understand that references to the world of visual experience were meant to convey a specific meaning in relationship to the scene in which they appear, as indeed we saw in Chapter Three in relationship to the architectural portraits, then we must ask what sorts of specific meanings could the naturalistic details derived from the built environment have had. In Chapter Three, the "period eye" that was evoked was that of the pilgrims in Assisi who found in architectural portraiture a map for their spiritual and physical journey through the sites of Francis's terrestrial experience. The "period eye" for the more general details can be as clearly described as moving, but this time through the earthly city of lived experience. And as we noted at the outset of this chapter, nowhere is this earthly city and its myriad potential seen more clearly than in ritual practice.

Increasingly, scholars trying to understand the language of trecento images have been looking at the ritual context of their use. Within the practice of civic religion, images participate at times when they are carried in procession, but mostly they are the end point of processional activity and the locus of liturgical practice.[35] However, it is the movement through the streets that focuses the viewer's eye on architecture, and it is to this movement that we must turn to understand something of the symbolic potential and thus the meaning of architecture as it appears in our images.

The symbolism of actual architecture was a consistent feature of everyday life in both Florence and Siena. As we saw at the outset of the chapter, the built environment received constant attention and money over the course of the first half of the century. This attention alone has been used by scholars to argue for the profound symbolic importance of buildings.[36] But the link between the way in which built structures operated symbolically and images of architecture in painting is to be found in the more specific context of ritual practice where the symbolic potential of actual architecture could be most fully exploited. Most of the rituals that punctuated the daily experience of the trecento city predated the fourteenth century. However, their meanings and symbolic importance were made distinctive by the developing power of the oligarchic regimes

and their utilization of all types of ritual to reinforce their control. A good example of this is the changes that took place in the procession that occurred annually on the eve of the Day of the Assumption in Siena. On this day the citizens of Siena were required to bring offerings of candles to the cathedral. This procession has ancient roots, but only in the beginning of the Trecento did the government of the Nine begin to oversee it and to dictate the activity of its citizens during the procession.[37] In addition, the new and iconographically complex built environment created an ordered stage in which the rituals were acted out. These two factors distinguish the rituals of the early Trecento from those that came before and allow us to use them to understand something of the "period eye" in which our images functioned.

Ritual Life in Early Trecento Florence and Siena

Ritual activity dominated the quotidian experience of the urban dweller in the Trecento. What does this mean? On the one hand, the ecclesiastical calendar, which began in March with Lenten celebrations and continued throughout the year celebrating the events in the life of Christ and the birth and death days of many saints, determined days of work and rest, feasts and processions (in which participation was mandatory) which accompanied almost all of the celebrations. On the other hand, the commune marked particular days as celebrations of civic successes. The concept of civic religion is illustrated here, because civic victories would be celebrated via devotion to the particular saint upon whose day the victory was achieved.[38] In addition, the daily running of the state involved multiple interactions with the wider world outside the city walls in which the urban population participated as witnesses and celebrants.[39]

At this point, it becomes important to draw distinctions not only between specific cities in Tuscany but also historical moments. At the outset of the fourteenth century the fortunes of Florence and Siena bare a number of resemblances. Both cities are developing their hold over their immediate surroundings. Both are solidifying a signorial government structure, although factional fighting between different groups within the city is also a constant.[40] Both supported a rising merchant class and international trade that made them rich and powerful in the first half of the century. At mid-century, however, the fortunes of Florence and Siena go their separate ways. Therefore we shall examine ritual practice in this chapter only up to mid-century.[41]

As noted above, processions from church to church and through the city were a constant part of ritual practice. Two thirteenth-century sources of ritual practice in the city cathedrals, the *Ordo Officiorum Ecclesia* in Siena (1215) and the Florentine *Mores Et Consuetudines Ecclesiae Florentinae* (1230) demonstrate that movement through space was an important part of liturgical practice.[42] The Florentine document also describes processions through the city such as those held to celebrate Saint Agatha's feast day during which the image of the saint held at the cathedral was processed throughout the city visiting, among other sites, a number of the city gates (see Figure 72).[43] In Siena the greatest procession was that held on the eve of the day that marked the Assumption of the Virgin, on August 14. This involved the entire city, organized according to the different areas of the city, the *contrade*, processing to the cathedral probably begin-

ning at one of the city's major gates (see Figure 68).[44] Thus, not only did celebrants move through architectural space, they also moved through urban space, and this movement became increasingly important in the early fourteenth century because it was at this point that the city, as an entity of consolidated power represented by the Signory that wielded it, started to take on specific meaning and form. We noted three examples of such processions at the outset of the chapter, the arrival of Charles of Valois in Florence in 1301, the procession that accompanied the installation of Duccio's *Maesta* on the high altar of the Siena cathedral in 1311 and the entry of cardinal Pellegrue into Florence in 1310. To these examples many others can be added. In the first half of the century, Florence welcomed a number of important visitors. Among them were foreign dignitaries specifically asked to the city to help make peace among the divisive citizenry. One such example is Charles of Calabria who came to the city in July of 1326.[45] The description of his entry that can be gleaned from various sources gives us an idea of both the pomp and the civic importance of this event. The entry is described in detail and with great pride by Giovanni Villani.[46]

Unlike the cardinal, Charles was met by an entourage of citizens at the opposite side of the city at the Porta San Pietro Gattolino (now Porta Romano; see Figure 72). This would mean that he would have processed through the Oltrarno past the church of Santa Felicita to cross the Ponte Vecchio and then move up the Via Por Santa Maria toward the Piazza della Signoria. However, another chronicler, Antonio Pucci, notes that he dismounted at the Bargello (Palazzo del Podesta) so it is possible that he was received there rather than at the Palazzo Vecchio. In any case, he was housed at the Bargello.[47] The entire city turned out to greet the Duke and to welcome him. The descriptions of the entry, which are unfortunately limited in the details they offer of the Duke's route through the city, nonetheless offer us a rich image of its pageantry. Pucci lists a vast number of dignitaries who were in attendance on the Duke and describes the costly jewelry worn by his wife.[48]

Siena likewise welcomed a number of important visitors over the course of the first half of the fourteenth century.[49] Unfortunately the sources that give evidence of these entries are as limited in the details of the route as are those in Florence. Generally, when locations are given they are of the gate, where the procession begins and the palace where the honored guest is housed, where the procession ends. Chroniclers spend a great deal more time describing the costumes and number of people participating.[50] In 1326, Cardinal Giovanni Orisini visited the city of Siena. He was met with great ceremony at the Porta Camolia (see Figure 68) by an entrouage of the cathedral clergy as well as those from "all the churches of Siena."[51] Presumably, he was then conducted to the cathedral. It is clear, thus, that the standard form of entry that occurred in Florence also transpired at Siena with the official being met outside the city or at the gate, depending upon his rank, and then being escorted through the city to its civic core with great pomp. The documents describe great bonfires in honor of the guest and often note, as in the case of Cardinal Orsini, that he arrived under a *baldachino* and is met by all of the great men of the commune decked out in their finery.[52] Again, the city turned out and the visitor was welcomed with *grande onore*.[53]

Both Florence and Siena, and the other towns in Tuscany as well, included among their civic ceremonies elaborate events that marked the feast days of their patron saints.

Florence's Festival of San Giovanni has been the subject of much research, and its use as a tool for both presenting and maintaining the city's power is well understood.[54] The celebrations that took place on Saint John's Day included various processions through the city and markets and games. In Siena, the most elaborate civic religious ritual, as noted above, was held on the eve of Assumption Day to honor the Virgin, the city's patron and savior at the famous battle of Montaperti in 1260.[55] This event, like that to honor Saint John in Florence became increasingly elaborate over the course of the late thirteenth and early fourteenth century. The importance of these rituals for reinforcing a sense of collective civic identity is made manifest not only in the fact that all citizens were required to participate but also that subject towns were required to be present and to bring offerings to the saint.[56] Dedication to a particular saint was thus a manifestation of a link to a particular city.

In addition to the use of the gates, piazzas and secular monuments as backdrops for these civic religious celebrations, the city and its most important churches and public spaces were also used as stages upon which, with increasing elaboration, biblical events were reenacted over the course of the calendar year. Recent studies have begun to collate the vast and varied evidence of these late medieval proto-theatrical performances, which developed out of the *laude*[57] that were at first sung and later acted out. This evidence speaks of dramatic reenactments of the Annunciation, Nativity, Temptation of Christ, and most of all, the varied events that surrounded Christ's Passion, his Entry into Jerusalem, Betrayal, Crucifixion and Burial.[58] The increasing detail and realism of these productions is attested to by the props, such as the reddened leather skin vest worn by the figure who played Christ in the Passion play in Perugia.[59] The Passion plays were the earliest to develop and thus the ones that are quite elaborate by the fourteenth century, involving not only costumes, such as the outfit worn by the Perugian Christ figure, but also stage sets such as a tomb or table that could be used as the sepulcher from which Christ rises at the Ascension.[60] In addition, the relatively recent recognition of the actual function of hinged crucifixes as props for deposition reenactments further increases our sense of the dramatic effect that was sought after in these productions.[61] Texts of the dramatic dialogues of the early *laude* suggest that the aim of these performances was to bring the biblical narrative to life. For example, in the Adoration of the Magi performed in Siena, the text calls for angels, who introduce the action; the three kings, each of whom are given long lines to speak; Herod; the Virgin; Joseph and the child Jesus, as well as numerous animals. And the scene changes more than six times as the Magi make their way to pay homage to the child Jesus.[62] In addition, elaborate stage designs augmented the "reality effect."

Evidence of props and staging reinforce our sense of the increasing detail and theatricality of these stagings. One detailed account that exists, for the staging of a May Day celebration on the Arno in 1304, gives some sense of the extent of such productions:

> [T]he inhabitants of Borgo San Friano [San Frediano], accustomed since the old days to produce the most original and varied spectacles (giuochi), published a proclamation that whoever wanted to get news of the other world should make sure of being on the Carraia bridge and along the banks of the Arno on the first day of May; and they constructed stages (palchi) on barges and boats on the Arno, on which they built a represen-

tation and likeness of Hell, with fires and other punishments and torments, with men disguised as demons of most horrible appearance and others who appeared like people in the form of naked souls.[63]

The elaboration of these events as well as the degree to which the production was supported by props is demonstrated in this narrative.[64] In this example the production is set on the river; in others the actual built environment of the city is used, as for example in the Palm Sunday procession in Florence, which begins at San Lorenzo and processes on to the cathedral and during which the Bishop's Gate (also known as the Gate of the Duomo), located across from the old Bishop's Palace on the Piazza of the Baptistery, acts as the gate of Jerusalem.[65] In Siena, the cathedral formed the backdrop for a presentation of the Nativity that involved quite extensive stage directions.[66]

The Symbolic Role of Architecture in Ritual Life

The existence of multiple forms of processional and ritual activity within the city is clear. Architecture's symbolic role in them now needs to be discussed. In order to understand this, we need to look more closely at the social situation. The late thirteenth- and early fourteenth-century witnessed the consolidation of the oligarchic regimes in both Florence and Siena. Although it should be noted that the systems of government in each town differed in important ways, for our purposes the key feature that each held in common was their need to constantly reinforce their legitimacy in the face of threats to their power from both within and without the city. We have already noted that this was done in part via architectural form. It is clear that the rituals too operated in this realm. In the case of the ceremonial entry, the arrival of a foreign dignitary was an extremely charged event, as actual experience proved that these men could both assist in maintaining the stability of the commune and the city or bring about its downfall.[67] As noted above, sometimes these foreign visitors were invited specifically to bring peace to a divided city and to do so they were granted extensive powers over its elected government.[68] The symbolism of the entry is thus profound as, above all, it needed to demonstrate the potential unity of the city to the visitor in order to stave off thoughts that peace might only be achieved by a unilateral grasp for power.[69] This symbolism was meant to be read and understood by the citizens as well.[70]

At the beginning of the chapter, we noted an example of the importance of the symbolism of the ritual entry in Dino Compagni's account of the arrival of Charles of Valois in 1301. Compagni urges his fellow citizens to present themselves as united to the prince, the implication being that the presentation will make it real. Scholars of ritual echo this sentiment. It is precisely this transformation of ideal into real that makes political rituals so important.[71] According to Catherine Bell: "In ritual, the world as lived and the world as imagined, fused under the agency of a single set of symbolic forms, turns out to be the same world."[72] Or as Barbara Myeroff explains, "[r]itual dramas especially are elaborately staged and use presentational more than discursive symbols, so that our senses are aroused and flood us with phenomenological proof of the symbolic reality which the ritual is portraying."[73] Richard Trexler has done the most extensive study of public life in early modern Florence that has reinforced this general reading

of the importance of ritual practice for creating the image of a coherent state and thereby encouraging the individual to sublimate his needs to those of the state. Trexler's assessment of the value of ritual practice is worth quoting in full here:

> First of all, the Florentine political and social order was illegitimate; formal behavior had to make that order legitimate. Second, the city, even with its patronal system, lacked honor; formal behavior had to create it. Third, inhabitants did not trust each other and foreigners did not trust Florentines; ritual had to provide the setting to encourage trust. Finally, Florentines lacked self-confidence, and were more convinced that the republican and merchant order was necessary than that it was culturally defensible; men acting in common forms would have to infuse each other with pride and thus individual identity.[74]

1300 is when this system was just beginning to be put in place and its power was therefore tenuous. This tenuousness made its *symbolic* power all the more important. The ritual of creating a vision of stability is asserted as well in later entries. In each repeated ceremonial entry in 1305 (Duke Robert), 1310 (Robert, King of Naples), 1314 (Count Peter of Eboli), and as we have seen in 1301 with the arrival of Charles of Valois, the citizenry acted out this unity and thus made it real. The symbol by which this unity was concretized was the city itself.

But it was not only entries that were manifestations of the ritual reinforcement of civic order and the collective urban identity. Almost all ritual activity can be seen as in some way performing this complex task.[75] Evidence for this includes the fact that participation in these rituals was mandatory and that the feasts of the patron saints—John in Florence and the Virgin in Siena—were celebrated not only with the giving of gifts of the citizenry but also of subject cities.[76] In addition, the movement through the city that marked all of these celebrations knit the quarters of the city together forming a unified whole that attempted to counter the day-to-day factionalism that plagued both cities. In relation to this, it is interesting to note that Giovanni Villani, in describing the festivities that accompanied the Saint John's Day celebration in 1283, first tells of the fabulous show put on in the *contrada* of Santa Felicita on the other side of the Arno with the companies all dressed in white, and then remarks: "And note that in this time Florence and its citizens were in the happiest state ever, and this lasted until the end of the year 1284, when the divisions between the people and the magnates, and then between the Whites and the Blacks began." Villani idealizes the ritual here as a both a manifestation and a demonstration of civic unity.[77]

In each entry, procession and public display, the city's key monuments, not just the citizenry, played a role. The gate where the visitor was met symbolized the strength of the city and the ability of the ruling body to keep the visitor out, should they wish to do so.[78] The Florentine Palazzo of the Signoria, before which are assembled the members of the ruling body seated on a *ringhiera* (platform) constructed for the purpose in 1323, symbolizes the government of the city itself in its complex combination of features derived from public and private buildings.[79] The parish churches, particularly Santa Maria Novella and Santa Croce, that hosted honored guests and were the sites of games, also contributed to the architectural coherence and wealth of the city celebrated in the rituals. Marvin Trachtenberg has demonstrated the explicit link between

the Florentine state and the buildings and spaces that it created.[80] He has argued that the power of the state was established using the buildings themselves as symbols of the power that the state had yet to achieve. Its representation via the iconography of the buildings themselves, in conjunction with their presentation in ritual, helped to make the government's power a reality.[81] In Siena, we have already seen that the sites of ritual activity, the *campo* in front of the Palazzo Pubblico and the cathedral, were key symbols. Thus, it is clear that as a ritual took place repeatedly it served to anchor a particular vision of the architectural environment in the mind of the viewer, a vision that the architecture itself, when the ritual ended, stabilized and maintained. It is interesting to note that in the 1304 enactment of "hell" described above, hell was located on the river Arno, at a distinct remove from any of the city's buildings where it might leave behind a negative symbolic residue.

Thus within the ritual life of the city, the built environment played two particularly important roles. On the one hand, when it formed the backdrop for a ceremonial entry, sometimes festooned with elaborate drapery, the buildings symbolized the civic ideals of strength and wealth and, more importantly, the unity of its citizenry. At another time, when before them the members of a confraternity acted out the last days of Christ's life, the buildings became simulacra for specific places in the Holy Land. In both these different types of events, the buildings represent something more than themselves and in so doing create a bridge between the real and the ideal worlds that allows the participants and the viewers to envision the city as something more than mere stone. In fact, it becomes an image of the ideal city/holy city, and within this image the identity of the citizenry as a collective unit is both forged and maintained. Another way of understanding how the built environment operates is through the concept of collective identity, a term which contemporary urban theorists have evoked in describing how architectural environments work today.[82] In contemporary urban theory the architectural environment is seen to anchor this sense of collective identity via mnemonic devices referencing the common history of the community or collective memory. Arguably, a similar thing was happening in Florence in the early fourteenth century. In other words, the buildings themselves became associated with common themes of civic life that the citizens increasingly associated with the survival of the community and their own well being.

The "period eye" then was continuously presented with a vision of the city that was idealized; but its idealization was not abstract or distanced from the experience of the viewer but rather highly charged with a sense of collective identity. Our viewer is given a way of seeing the city that calls forth his or her own role in the creation of that city. Going back to the images, we can see that a viewer could not possibly see imaged architecture that referenced the built environment as neutral. As we have already seen, contemporary artists were looking at their own urban environment and this is reflected in their representations of architectural imagery. It is equally clear that they did not choose to represent that environment as it appeared to them in daily life but by how the city was presented ritually. This may be seen through the oblique angle of view, which not only allows one to see the depth and substance of a building but it suggests movement past a building. But there are other clues as well. For example, Taddeo Gaddi's image of *The Marriage of the Virgin*, complete with the boisterous rejected suitors and

FIGURE 94. Pietro Lorenzetti, *Patriarch Albert gives the Carmelites their rule*. Siena, Pinacoteca (SUPERINTENDENT P.S.A.D–SIENA, WITH PERMISSION OF THE MINISTRY FOR ART AND CULTURAL ACTIVITY).

elegantly draped palace where the event takes place, closely follows contemporary descriptions of weddings (Figure 75).[83] Similarly, two examples from Siena show that artists were reflecting the way the built environment was seen during rituals. The entry of the son of Robert, the King of Naples, into Siena in 1327, is echoed in Pietro Lorenzetti's decision to show the procession of Saint Albert out of the city of Jerusalem on the central predella panel of the Carmelite altarpiece painted in 1329 (Figure 94) rather than a gathering of men which the subject demanded.[84] Duccio has made a similar choice in his *Christ Healing the Blind Man* (Figure 85) where a blind man is met in the center of an open piazza by a procession of apostles led by Christ. Neither scene calls for a procession specifically; these artists have made a conscious choice to show their subjects in a way which mimics contemporary civic events and more importantly displays architecture in the way it would have been viewed during the processions which marked feasts and holidays.

In addition, many of the images that were painted during this period actually rendered events that were acted out over the course of the calendar year. There has been much discussion in recent scholarship of the links that can be drawn between the proto-theatrical representations of biblical events and painted images of the same subject. The vivid interweaving of the proto-theatrical and pictorial representation of a biblical event is illustrated in a scene from the reverse predella of Duccio's enormous altarpiece. In this scene, showing Christ's temptation by the devil, the architectural setting immediately strikes the eye (Figure 95). A vast multisided marble building articulated by engaged pilasters fills the entire picture plane. Its rising roof even fails to be encompassed within the bounds of the frame. Small in comparison to the enormity of this building and yet centrally placed and the focus of the scene, are two figures on the second-story balcony. On the left, the devil gesticulates wildly, while on the right, Christ calmly responds. The text that was used when the citizens of Siena staged a representation of *Christ's Temptation* still exists and it is difficult not to see the real, the representation and the theatrical event all intertwined when we note that through the open door on the right we can see into the vaulted space of the temple paved in black and white and ornamented with the Sienese coat of arms.[85] Further such links between the ceremonial city and the images of architecture abound in the examples that we have been looking at.

FIGURE 95. Duccio, *Temptation of Christ in the Temple*. Siena, Museo del'Opera del Duomo (SIENA, CITY AUTHORITY).

For example, the *Massacre of the Innocents* (Figure 83), portrayed by the follower of Pietro Lorenzetti as taking place within a quite distinctly Sienese architectural environment, was an important feast celebrated annually with a reenactment on the 28th of December.

Although these examples show that there was a connection between ritual practice and images in the first half of the Trecento, I am not willing to argue that it is this connection that explains the interesting mixture of naturalistic and conventional details in the images of architecture.[86] The role, substance and temporal qualities of these two media are too distinct for there to be this kind of one-to-one relationship. Ritual practice and the view of the city that it presented were introduced into our discussion as a way of getting at the "period eye" and how that eye saw and understood architectural

form. The rituals stressed the way in which architecture could be used to represent the civic ideal. Although the historical record demonstrates that for both Florence and Siena throughout the period in question that ideal always remained elusive, its presentation became a theme around which rituals and civic identity circulated. In the images, that same identity is called forth, but there it was combined with that of the holy personages whose activity was represented thus idealizing, in another sort of way, civic experience.[87] The idealization of the imaged city is clear from the continued use of conventional forms that were clearly not seen as contradictions of the naturalistic features but rather as enhancements to the potential meaning of the scene. They reinforce the viewer's understanding of it as ideal.

In Florence the patrons of the private chapels at the church of Santa Croce where Giotto, Taddeo Gaddi, Maso di Banco and Bernardo Daddi all worked in the first half of the century, were the merchants and bankers whose fortunes were most bound up with those of the city and who, by virtue of their membership in the major guilds, would have served in the government.[88] The Franciscan church of Santa Croce that stands today was the third building erected on the site.[89] The popularity of the saint and of the order at the end of the thirteenth and beginning of the fourteenth century is what necessitated the newer larger structure. Funding for the building came not only from the commune but also from private citizens who wished to have the privilege of being buried within the church. Among the patrons were the Peruzzi, Baroncelli, Bardi and Bardi di Vernio families who had private chapels in the transept of the church. The Peruzzi and Bardi were two of the most important banking families in trecento Florence; one branch of the Peruzzi family was also involved in international trade. All of these families most likely had members who held government posts and therefore who participated in the rituals described above.[90] In Siena, likewise the patron of many of the works discussed above was the commune itself. Thus we see a congruence of audiences who staged and engaged in ritual activities that celebrated and made "real" the strength and power of the state, and those who paid for and gazed upon the images that reinforced this "ideal/real" relationship between their city and the city of god.[91]

Going back to the issue of "naturalism," we are reminded by the quote from the Sienese statutes in the Introduction that imagery in this period, specifically the imagery under discussion, was focused not on relating the viewer's experience to what he or she saw in the image but rather on asking the viewer to experience a fundamentally different form of seeing—one that transcended the visible world and gave access to the world of the spirit.[92] In the images discussed here, the mimetic details and compositional modes that reproduce, to an extent, those of the visible world establish an entry point from which the viewer could begin his or her experience, both spiritual and civic, which as I have said, were not distinct. The idealized civic vision represented in the image provided the viewer with an opportunity to enter into the experience of that ideal. The distinction between this ideal life and that of the viewer is maintained by the continued presence of pictorial conventions as anchors of difference between the real and the ideal, because neither the spiritual nor the civic ideal is ever achieved. The fact that the viewer for our images is an urban individual who exists within a complex world of closely controlled and intertwined religious and civic responsibilities and identities suggests why it is that architecture is utilized to provide an entry point into this process of

visualizing the ideal. What is suggested here is that the choreographed use of the city during civic events, which by its very nature is ideal rather than real, can be used to help us see more clearly the meaning of the "naturalistic" and non-"naturalistic" forms found in the architectural imagery of the first half of the century.

It is useful here to reflect upon how the way architectural imagery is being used in these first years of the Trecento builds upon what we have seen in the representations from earlier periods discussed in the previous chapters. Over the course of the first three chapters we have seen artists in Rome, Assisi and Tuscany increasingly refer to built structures in their paintings. We saw this in Rome specifically within the context of the papal revival of the classical city for its symbolic force in their political battles. We saw the rise of specific references to local built structures take over from more Byzantine-inspired generic forms at mid-century and again we noted the rise of architectural portraits throughout the fourteenth century. What is occurring in all of these images is an increased interest in imaged architecture's symbolic potential as it relates to the specific *urban* viewing context, either within a particular city, such as references to local structures, or a specific time period. In addition, particularly in the case of the movement away from Byzantine forms, specific building types are associated with a particular local identity. The buildings are references not just to places but also to civic identities associated with those places. In Chapter Five we shall examine what happens to the symbolic potential of the architectural image when the urban environment is no longer able to sustain the ideal.

Chapter Five

Crisis and Convention: Change in Architectural Imagery in the Second Half of the Fourteenth Century

In 1388, Agnolo Gaddi, the son of Taddeo, began work on a vast cycle of frescoes in the apse of the Franciscan church of Santa Croce that represented the Legend of the True Cross (Figure 96). This cycle immediately offers us a different vision of architecture than that which we have just examined from the first half of the century. Gone are the specific references to local structures, replaced by stylized decorative details and noteworthy evocations of painted architecture. Unlike the images painted by his father, a significant number of Agnolo's buildings discreetly recede into the background of the scene giving way to a vast array of elegantly dressed figures. In addition, the overall cycle exhibits a loss of architecturally circumscribed urban space. As we shall see, these differences are repeated in many of the paintings dating between circa 1350 to 1400 in Florence and Siena. The precipitous drop-off in references to built structures in the painting of the second half of the century begs the question: What has happened?

From around 1270 until about 1340 the images of architecture we have examined functioned as symbols of the ideal of urban existence. They equated local built environments with the civic ideals of Rome and the Holy City, Jerusalem, and they offered their viewers a chance to participate in the collective identity of urban life. In a few examples, this process carried on into the second half of the century, but for the majority of representations of built forms that occurred in painting, both in Siena and in Florence in this period, the idealized urban environment, based upon selective quotations of known buildings mixed with conventional forms of architectural imagery, is not to be found. This fifty-year period witnessed a transformation in the images of architecture that fundamentally altered their iconographical potential and accompanied an overall shift in pictorial style that has been the focus of much scholarly debate.

FIGURE 96. Agnolo Gaddi, *Legend of the true Cross*. Florence, Santa Croce, Capella Maggiore (SUPERINTENDENT OF FINE ARTS, FLORENCE).

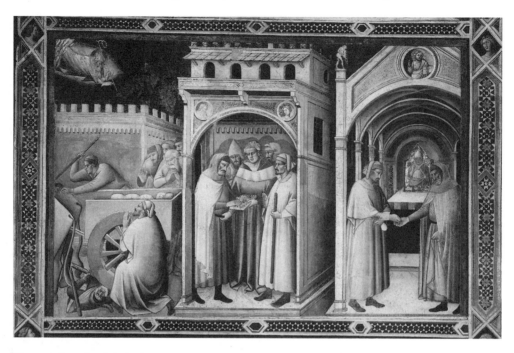

FIGURE 97. St. Nicholas Master, *Story of the bad debtor*. Florence, Santa Croce, Castellani Chapel (SUPERINTENDENT OF FINE ARTS, FLORENCE).

FIGURE 98. Agnolo Gaddi, *Making of the Cross*. Florence, Santa Croce, Capella Maggiore (SUPERINTENDENT OF FINE ARTS, FLORENCE).

Inspired by the drama of the historical record, art historians have, for the last fifty years, speculated about the overall stylistic changes that took place in the painting of the second half of the century, which began with the arrival of the bubonic plague in the spring of 1348. In 1951, Millard Meiss eloquently linked the visitation of the devastating plague to changes in pictorial style.[1] Since the publication of his book, several scholars have contributed to the question, critiquing and modifying Meiss's thesis.[2] Many of the key paintings that Meiss looked at have now been shown to have been painted before the arrival of the plague, and many others have been shown to contain stylistic features, such as illusionistic space, that Meiss argued were antithetical to the new world view inspired by the devastation of the plague.[3] Throughout these studies the presence of stylistic change has never been denied, and scholars have continued to try to understand it.[4] The striking stylistic changes in images of architecture are equally intriguing. Given what we have just seen of their iconographic importance in the first half of the century, we cannot fail to wonder why these changes occurred and what they mean. A key feature of the stylistic change is the severing of the relationship between the built environment and the images. It is there that we should begin our examination. The "period eye" that led us through the representations of the first half of the century helped to elucidate the meaning of those forms through the context of civic ritual. In the second half of the century as well, a look at ritual practice can give us a context for understanding the changes in architectural imagery as manifestations of a loss of confidence in the civic ideal and collective urban identity.

Changes in Images of Architecture

We shall return to the fresco cycles of Santa Croce with which this chapter opened to classify the changes that took place in artists' approach to architectural form in the second half of the century. After a slowdown in pictorial commissions around mid-century, during which time the Rinuccini Chapel in the sacristy was painted, three more major cycles were painted in the eighth decade of the century. All four of these cycles offer us a very different image of architecture than what we have seen earlier. Three characteristic distinctions strike the eye immediately: In the sacristy, the cycle begun by Giovanni da Milano and completed by the Master of the Rinuccini Chapel, the second artist, has studiously repeated the architectural forms from Taddeo's earlier cycle in the Baroncelli Chapel.[5] In the Castellani Chapel, the architecture seems stooped and heavy; it does not rise majestically over the figures but rather seems to bend and hug them, nodding just above their heads (Figure 97). And finally, in the apse itself, as we noted at the outset, much of the architecture seems to fade into the background of each scene, its formal makeup sometimes even contradicting rather than reinforcing the textual description of the scene (Figures 96, 98 and 99). In each instance, the differences in architectural images show that the represented buildings of the second half of the century are no longer as concretely linked to built forms in their siting, scale or details as they were in the first half. Instead, what we see is a series of quotations from pictorial sources, which we will discuss in detail later. Also, the loss of scale and expansiveness of urban space foregrounds the figures and their activity over their setting, the smaller

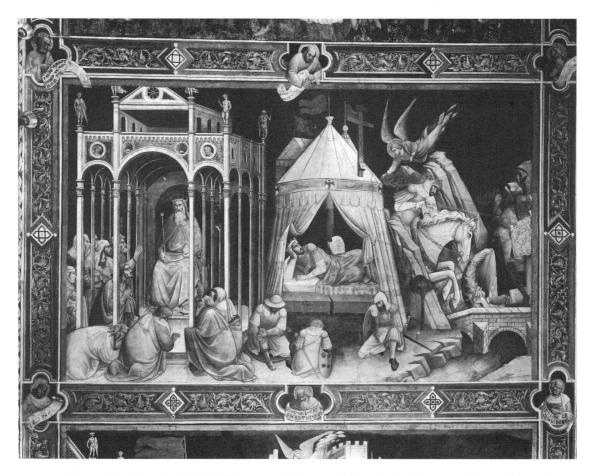

FIGURE 99. Agnolo Gaddi, *Chrosroes being worshipped, the Dream of Heraclius and Battle between Heraclius and Chrosroes.* Florence, Santa Croce, Cappella Maggiore (SUPERINTENDENT OF FINE ARTS, FLORENCE).

scale of which reduces not only its presence but its iconographic potential. These features are consistent in almost all of the paintings of the second half of the century, with the exception of some noteworthy architectural portraits discussed in Chapter Three (See Figures 4 and 64). Let us look at these changes more closely.

We can begin with the reduction of the detailing of the images of buildings. For example, if we examine the detailing in both structure and decoration of the architecture in a set of four scenes by Spinello Aretino painted in the 1380s in the sacristy of the church of San Miniato al Monte on a hill overlooking Florence, we will see a general reduction in both these elements (Figure 100). We can compare the loggia, in which the king receives Saint Benedict in the lower left scene, with a similar structure from Bernardo Daddi's *Martyrdom of Saint Stephen* (Figure 87). Spinello's loggia is made of simple cantilevered struts, which support a narrow roof that just shields the king's head. Behind him the wall of the loggia and the receding wall behind are simply embellished with corbel tables. These same corbels run across the facade of the church in the scene of the saint's death on the right. In Daddi's image, one the other hand, not only is the

FIGURE 100. Spinello Aretino, *Scenes from the life of Saint Bernard*. Florence, San Miniato al Monte, sacristy (SUPERINTENDENT OF FINE ARTS, FLORENCE).

FIGURE 101. Bartolo di Fredi, *Joseph is recognized by his brothers*. San Gimignano, Collegiata, nave (GERMAN INSTITUTE FOR ART HISTORY, FLORENCE).

interior of the loggia hung with elaborate drapes, but the floor above it is articulated with carefully wrought fenestration. The rather reduced articulation noticeable in Spinello's images is, in fact, found on quite a number of diverse examples of building types in the second half of the century, from the work of Giovanni del Biondo to that of Niccolo di Pietro Gerini.[6] In cases where imaged buildings are more complex in detail or decoration, the artist appears to be copying an earlier pictorial image, rather than observing the details from a built structure, as in the Rinuccini Chapel cycle noted above.

There are, in fact, a number of instances in which we can see late trecento artists referring directly to the architectural forms found in early fourteenth-century painting. This happens not only in the details but also, as in the Rinuccini, with the copying of

FIGURE 102. Pietro Lorenzetti, *Honorius IV gives the Carmelites their white habits.* Siena, Pinacoteca (SUPERINTENDENT P.S.A.D–SIENA, WITH PERMISSION OF THE MINISTRY FOR ART AND CULTURAL ACTIVITY).

the entire building. For example, Bartolo di Fredi's fresco of *Joseph is Recognized by his Brothers* from the Old Testament cycle in San Gimignano (Figure 101), shows a cut-away interior that quotes the basic form found in Pietro Lorenzetti's image of *Honorius IV Gives the Carmelites Their White Habits,* another of the predella scenes from the Carmelite altarpiece of 1329 (Figure 102). A similar quote is found in Giovanni del Biondo's image, the *Miracle of the Bread,* from the Saint John Gualbertus altarpiece painted possibly for the monastery of "Le Donne dei Faenza" in 1365–1370 (upper right side of Figure 103).[7] This scene, which shows the miracle of Saint John feeding his monks, seems almost to have been lifted verbatim from Taddeo's image of Saint Louis feeding the poor from the refectory in Santa Croce, which was painted not much earlier, around 1360 (Figure 104).[8]

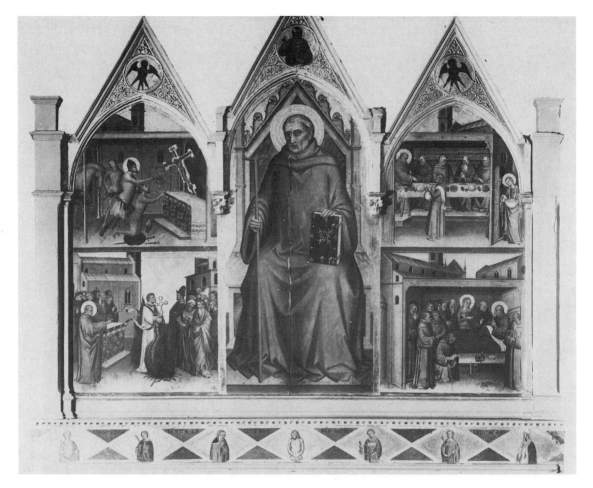

FIGURE 103. Giovanni del Biondo, *Miracle of the bread*. Florence, Santa Croce (ALI-NARI/ART RESOURCE, NEW YORK).

Although it is rather commonplace in the history of art for later artists to freely quote from the work of their predecessors, the prevalence of copying architectural forms in the second half of the century, at the expense of both invention and examination of contemporary architectural forms, is noteworthy. This can be seen clearly in the repetition of a particular building in a number of different kinds of images. Outside the Baroncelli Chapel in the Florentine church of Santa Croce, Taddeo Gaddi painted, circa 1330, a scene of *Christ in the Temple* (Figure 105). Although the creation of a grand doorway into the sacristy wing of the church in the mid-fifteenth century resulted in the destruction of the lower section of the scene, the upper part, in which Christ is shown seated in a square temple structure with an open front, is still very much visible. The temple is a square structure with four gables articulating its roof. Above and behind the gables rises a shallow, orange dome. It is this dome, and the gables that frame it, that is picked up on and repeated in numerous examples over the course of the second half of the century.[9] Jacopo di Cione uses a very similar dome and gabled form in the *Martyrdom of Saint Matthew* in the Saint Matthew altarpiece painted for Orsanmichele in

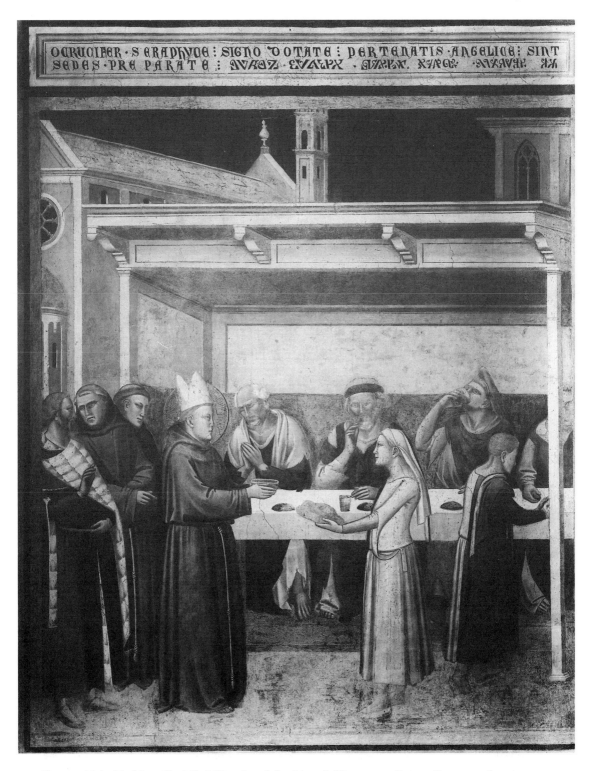

FIGURE 104. Taddeo Gaddi, *Miracle of the bread.* Florence, Santa Croce, refectory (SUPERINTENDENT OF FINE ARTS, FLORENCE).

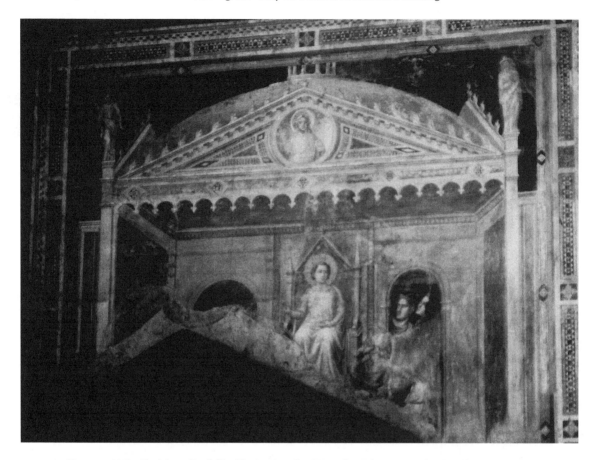

FIGURE 105. Taddeo Gaddi, *Christ in the Temple*. Florence, Santa Croce, transept (PHOTOGRAPH BY THE AUTHOR).

1367/68 (Figure 106). It appears again in Spinello Arentino's frescoes of the *Life of Saint Benedict* in San Miniato painted a good deal later in 1387 (Figure 107). And finally, Taddeo's son Agnolo quotes it in the curious church-like structure at the far right of the scene of the *Making of the Cross* in the apse of Santa Croce, painted close to the end of the decade of the 1380s (Figure 98).[10]

Interest in the dome form in the second half of the century might have come from the debates that were going on at this point regarding the final form of the cathedral, discussions that were touched upon in Chapter Three, which, as we know, involved many of the important painters of the day. But because the cathedral was not domed until the following century any conception of a dome would have been pictorial rather than built. This distinction between built structures and pictorial images of buildings is quite different from what we observed in the painting of the first half of the century.

There is further evidence of the late trecento artists looking at the architectural images of their predecessors rather than the buildings around them. A quite straightforward example of this, as was mentioned above, is the repetition of Taddeo's temple by the Rinuccini Chapel master. But this same temple form also reappears in the much more curious place in Agnolo's rendition of the story of Chrosroes in which he is being

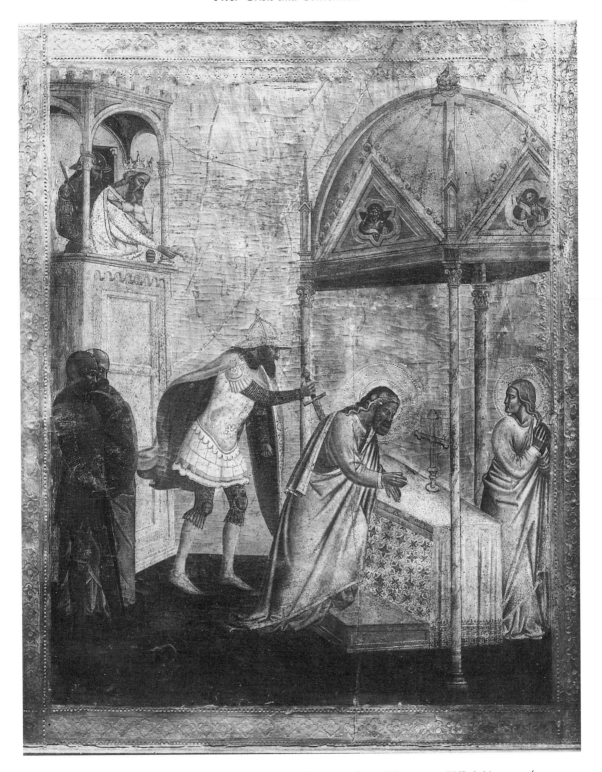

FIGURE 106. Jacopo di Cione, *Martyrdom of St. Matthew*. Florence, Uffizi (ALINARI/ ART RESOURCE, NEW YORK).

FIGURE 107. Spinello Aretino, *St. Bernard exorcises the young monk*. Florence, San Miniato al Monte, sacristy (PHOTOGRAPH BY THE AUTHOR).

worshipped, one scene from the *Legend of the True Cross* (Figure 99 and 88). The artist's choice to reuse this particular structure here is peculiar and noteworthy, because according to the textual source for this cycle, Jacopo Da Voragine's *Golden Legend*, the tyrant Chrosroes is said to have made himself a tower in which he sat to receive the worship of his subjects.[11] Agnolo, however, places him not in a tower but rather in a very close copy of his father, Taddeo Gaddi's, temple (Figure 88). Two things are noteworthy about this. First it shows the artist's willingness to depart from the rather specific architectonic direction of the text, which calls for a tower. The second is that rather than use a form from the built environment, of which the documentary record assures us there were numerous examples, Agnolo quotes a painting, thus directing his viewer's attention to the pictorial rather than the architectural tradition of the commune.

Agnolo's repetition of his father's temple structure suggests a marked lack of interest in linking the architecture in an image with the architecture outside it. This is because the image and its textual source cannot be reconciled with the viewer's experience of actual built structures.[12] Certainly everyone in Florence in 1380 knew what a tower looked like. But what is stressed by the use of the pictorial reference is a pattern of visual links between pictorial typologies that anchor the viewer's experience of the narrative in the realm of painting rather than to his or her own urban environment.

As we noted in Chapter Four, the mimetic, or "naturalistic" details in the paintings of the first half of the century were clearly intended to make that link to the built environment. The shift suggests a marked break from the connection fostered in the pictorial images of the first half of the century between the built environment and the painted one.

It is important to clarify this relationship between images of architecture in the first and second half of the century. Because images of architecture in the first half of the century were noted for their references to built forms, how could copies of these images not also reference built forms? Close examination of the architectural imagery of the late fourteenth century shows that the references to painted forms that appear are always to those forms that are most conventional in their structure that is, that rely most on the viewer's ability to read the form as architecture, even though it lacks structural integrity. For example, in the image just discussed, Agnolo's use of Taddeo's cutaway temple in the Chrosroes' scene, he has made a series of alterations to the structure that reduce its equation with built forms. First he has cut away the back wall. Second, he has reduced it significantly in scale so that Chrosroes, were he to stand up, would barely be able to fit in the building. And finally, the reference that Taddeo makes to Santa Croce using the roundels with their spokes of tracery, have been reduced by Agnolo to simple lancets with no relationship to the fenestration in Santa Croce at all. Two other distinctions between images of architecture in the first half of the century and those of the first reinforce this break between the experienced built environment and the pictorial one.

We noted in Chapter Four that an important component of the link between the built city and the imaged urban environment was the creation of a specifically urban spatial zone. This was done by using architecture as a frame for an open space, such as was seen in the *Massacre of the Innocents* by the follower of Pietro Lorenzetti (Figure 84), or even more remarkably in his brother Ambrogio's representation of the Sienese *campo* on the fresco of *Effects of Good and Bad Government* in the Palazzo Pubblico (Figure 63). In the second half of the century, the representation of space enclosed by buildings, or urban space, is markedly diminished. It is important to recognize that I am not arguing, as Millard Meiss does, that there is an overall loss in *illusionistic* space in the painting of the second half of the century. But rather that the representation of specific, architecturally circumscribed *urban* space is severely curtailed. In its place we find abstract, nonspecific space, whose relationship to experienced urban space is remote at best. This is done in four different ways (1) by simply reducing the amount of architecture in a scene in order to make the space surround the buildings, rather than vice versa; (2) by "pulling wide" the architecture, having it appear only on the far edges in some scenes, reducing both its physical and iconographic presence; (3) by constricting and closing off space, and (4) by reduction of the scale of the buildings resulting in loss of interior space.

The first of these is exemplified by the scene of Saint Matthew healing the king's son from the Orsanmichele Saint Matthew altarpiece (Figure 108). In this scene Matthew stands to the right of the young man's bed, and both figures are placed before a three-story tower. The tower fills out the top half of the scene but it does not offer information regarding the setting or location of the event. Despite the fact the tower is shown

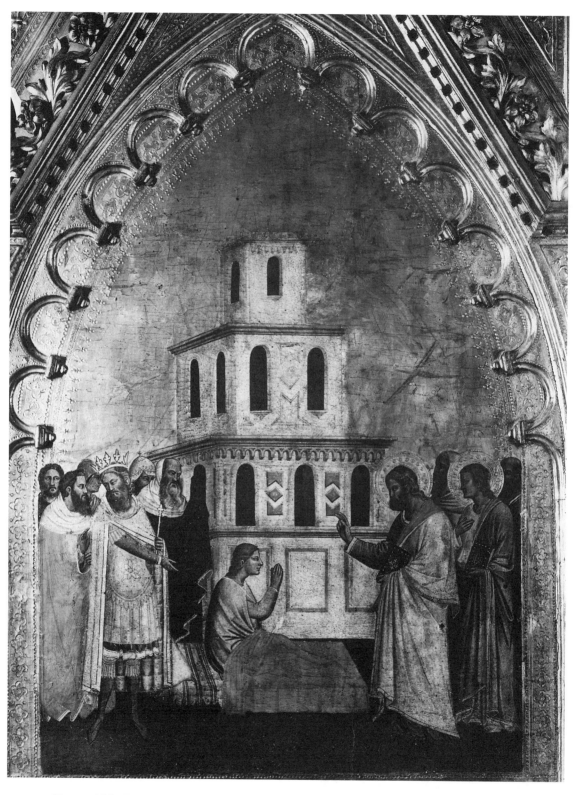

FIGURE 108. Jacopo di Cione, *Saint Matthew healing the king's son*. Florence, Uffizi (SUPERINTENDENT OF FINE ARTS, FLORENCE).

FIGURE 109. Giovanni del Biondo, *Saint Sebastian preaching*. Florence, Museo del'Opera del Duomo (MUSEUM OF THE CATHEDRAL WORKS).

at a slightly oblique angle, the groups of people that hem in its sides prevent it from creating any sense of urban space.

Giovanni del Biondo's scene of Saint Sebastian preaching in the altarpiece painted for the cathedral in the 1370s offers an example of the way in which urban space is "dismissed" from late trecento narratives by virtue of the fact that the architecture that previously is used to create urban space is set so far to the margins of the painting that it is hardly visible, this technique I referred to above as "pulling wide" (Figure 109). In this image, which clearly takes place in an urban setting, the saint stands on the porch of one structure that is mostly cut off by the left side of the frame, while on the far right the second story of a palace is just visible. The extent to which this shows a change in the use of the architectural image to create an urban space can be see by comparing it

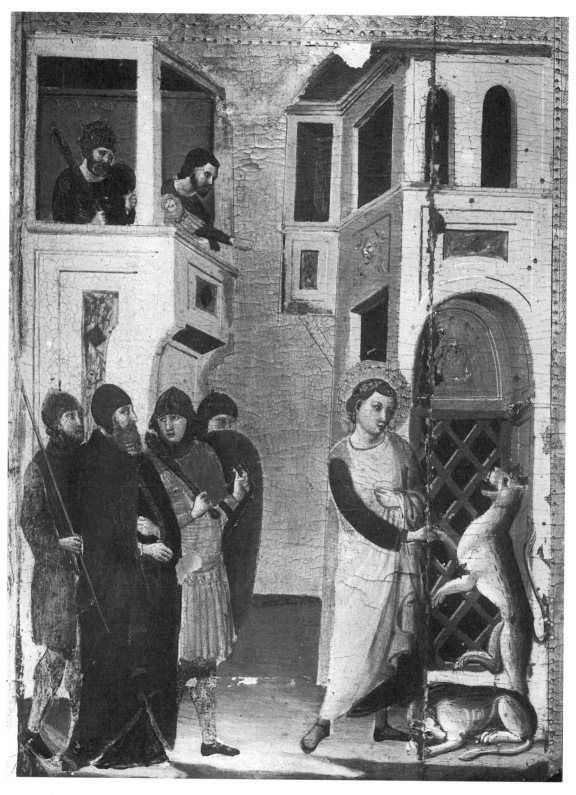

FIGURE 110. Jacopo del Casentino, *Saint Minias and the leopard*. Florence, San Miniato al Monte (MIKLÒS BOSKOVITS).

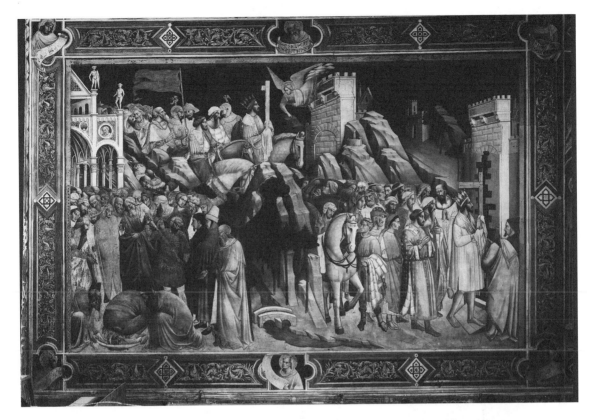

FIGURE 111. Agnolo Gaddi, *Heraclius returns with the true Cross*. Florence, Santa Croce, Capella Maggiore (SUPERINTENDENT OF FINE ARTS, FLORENCE).

to a similar scene painted in the first half of the century by Jacopo Casentino discussed in the Chapter Four in the San Miniato altarpiece (Figure 110).

In the third mode by which urban space is lost—the use of the imaged architecture to reduce or curtail space—frontal views dominate and the imaged buildings are pushed right up to the surface of the picture plane. For example, in the Castellani Chapel the architectural images, when they occur, tend to restrict rather than open up urban space. In this series of scenes of the *Bad Debtor* from the Saint Nicholas cycle, the architecture is pressed against the surface of the picture plane its small scale serving to frame the figures. Between the buildings a narrow corridor is all that remains of the wide streets of the earlier images (Figure 97). What seems striking in looking at the various scenes in the Castellani Chapel is this reduction in the way architecture structures the scenes and plays alongside the figures. Not only does architecture seem to no longer create a specific urban space but it also seems to have become far less consequential for the reading of the scene. This loss of importance is found in the apse frescoes as well. Here the vast and complex cycle of the *Legend of the True Cross* offers numerous examples for architecture to play a role, and yet the overall impression offered by the multiple scenes undercuts the architecture in favor of the expansive nonurban space and the parades of figures that process through each scene (Figure 111). We will return to this point later.

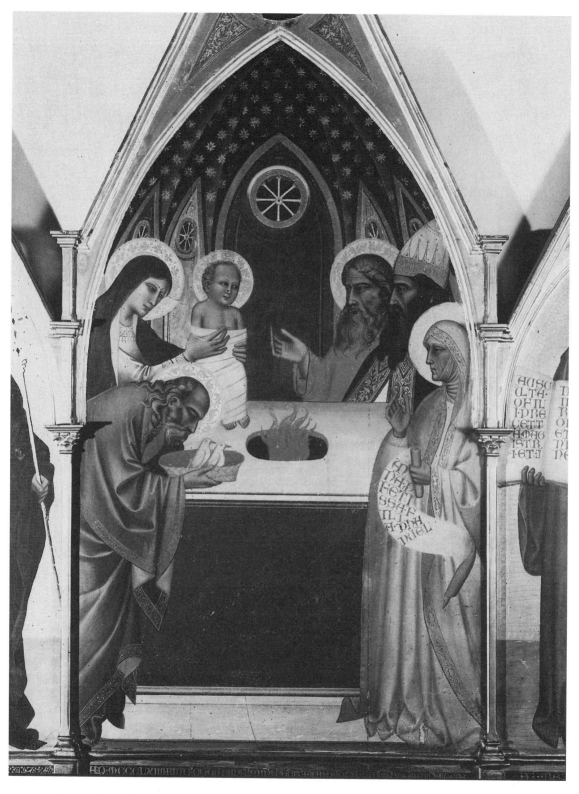

FIGURE 112. Giovanni del Biondo, *Presentation in the Temple*. Florence, Accademia (SUPERINTENDENT OF FINE ARTS, FLORENCE).

FIGURE 113. **Master of the Magdalen Cycle,** *Christ in the House of Mary and Martha.* **Florence, Santa Croce, Rinuccini Chapel** (SUPERINTENDENT OF FINE ARTS, FLORENCE).

The *Presentation in the Temple* by Giovanni del Biondo, an interior representative of late trecento painting (Figure 112), is a good example of the fourth and related feature to change in architectural imagery of the second half of the century—the general reduction of the scale of buildings and their consequent loss of interior space. The rib vaults of the temple press down on Giovanni's figures seemingly forcing them to stoop and crowd around an altar that is squeezed into a decidedly narrow space. In the Rinuccini Chapel scene of *Christ in the house of Mary and Martha* (Figure 113), the space of the narrow room barely contains the cluster of apostles that stands on the left, their heads pressing against the low ceiling. Clearly linked to the loss of interior space is the reduction in scale of buildings that now sometimes appear, despite their identity, to be only slightly larger than the figures that interact around them. This can be seen again in the Rinuccini Chapel in the scene of the *Raising of Lazarus* where the heads of the witnesses to the miracle press up against the soffit of the arch of the city gate. Like the architecture in the Castellani Chapel this architecture frames the figures tightly, restraining and constricting movement and is strikingly unmonumental. This is quite different from the gate in Taddeo Gaddi's *Meeting at the Golden Gate*, also in Santa Croce.

Together these various changes in the stature and siting of architectural images have

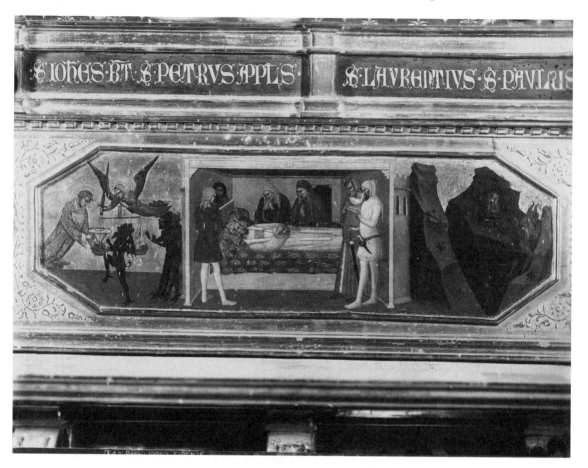

the effect of reducing the visual impact of architecture in the scenes. Thus not only is the relationship between represented and real architecture made more abstract by the reduction of mimetic details, but also the overall visibility of architecture in the scene is reduced. We should also note that while the visual links between imaged and built forms are curtailed, the use of the three conventional building types that date back to the thirteenth century continue to appear, although there are some modifications mainly in the complexity of forms.[13] The inside/outside view, for example, is not used with the same elaboration of forms that it was in Ambrogio's *Presentation*, in any of the paintings from the second half of the century. In many examples the inside/outside view is reduced to something akin to the space-box with some slight detailing of the exterior of the building. An example of this can be found in the palace that houses the dead king on the right predella of Orcanga's Strozzi altarpiece (Figure 114).

In the images from the first half of the century we understood the persistence of conventions alongside the naturalistic details as evidence of the artist's use of architecture as symbolic, referring to the ideal, as opposed to the real, city. We contextualized this ideal city by equating it to the one that the viewer helped to create during civic

rituals. The maintenance of the conventions alongside the loss of references to built structures in the second half of the century suggests that what has shifted are attitudes toward the symbolic meaning of buildings, although it continued to be important that both hagiographical and biblical narratives contain some reference to architectural form. The changes that we noted above focused on cutting the link to the experienced architectural space and form of the viewer rather than to the architecture itself. But the architecture that remains in the images is pictorial, as we have noted, in that it refers to architectural forms found in painting.

In Chapter Four we looked at the specific way in which imaged architecture related to built forms as they appeared during ritual entries, this suggested that architectural representations at that time could best be understood within the context of the creation of a collective urban identity framed by architectural imagery. It was noted there that this was also one of the aims of the rituals. In this process of identity construction, architecture, or more generally the built environment, was a powerful signifier of a positive ideal. Our aim now is to see how this ideal could have become untenable as this would help to explain the loss of mimetic references in the architectural imagery of the second half of the century. Many scholars have closely examined the social, political and economic changes that could have played a role in the stylistic changes in pictorial imagery in the second half of the century; nowhere are these changes more symbolically articulated than in the ritual experience of the city.[14] In fact, in the second half of the century ritual practice in the city is made more ambiguous by the rise in the necessity for a different type of activity, the "crisis procession,"[15] which presented the city and the built environment in a very different light from what we witnessed in the first half. In this ritual, the city is no longer the ideal that was used in the first half of the century, when ceremonial entries created a sense of collective identity around a common destined greatness, but rather something much more troubling.

Civic Experience in the Second Half of the Century

In the first half of the century citizens of Florence and Siena participated in a variety of rituals that, whether they were focused on celebrating a civic event or a religious holiday, joined the citizens of the city together in such a way as to reinforce the power of the commune and the current government. One thing that is certain about the rituals described in the chronicles of the first half of the century is that they consistently presented the city in a positive light in spite of, or indeed because of, the instability of the political reality. As I noted at the outset of this chapter, in Florence there was a shift in ritual activity in the second half of the century.[16] The chronicles of the period repeatedly describe processions that take place in an attempt to avert or end some natural or man-made disaster. These crisis processions were quite elaborate, and their prevalence contrasts sharply with the almost total lack of such performances in the first half of the century.[17] The key here is that the character of these processions was opposite to what was presented in ceremonial entries. The ritual of the crisis procession unified the citizenry in a cry for help rather than in a common sense of civic identity, and in doing

so it introduced a certain ambiguity of meaning to ritual activity and, more importantly, to the city, something that we did not see in the first half of the century. In addition to the shift in the character of ritual, the crisis procession also presented the city differently—the city now was not an ideal which citizenry could aspire to make real. Instead, the city's inability to protect its citizens was laid bare for all to see and acknowledge, as the city's religious communities and its citizens pleaded for divine assistance. It does not seem possible to underestimate the impact that this ritual activity had upon the way in which the built fabric of the city was conceptualized as a symbolic tool.

Scholars in search of a way to understand the stylistic change of the second half of the century have spent a great deal of time outlining the circumstances of historical change in this brief period. It behooves us therefore to set the stage for an examination of the crisis procession and its relationship to architectural imagery within the context of historical circumstances that certainly played a role in both. Through this review it will become clear that the events of the second half of the century were both troubling and complex. This complexity suggests, as scholars have said in the past, that it is unlikely that any one single factor can be said to have caused this or that stylistic change. My aim here is not to pinpoint a specific factor but rather to contextualize the changes that we have seen in architectural imagery within those that were occurring in the larger civic environment. A note here about the documents: Florentine chronicles that detail the events of the second half of the century abound in details of crisis processions, whereas those in Siena have little to offer. Therefore, while it is important to describe here what is known about the changing situation of civic life in Siena we are not able to paint as detailed a picture of ritual experience as we can of Florence.[18]

Perhaps the most noteworthy event of the second half of the century as all students of history know, was the arrival of the bubonic plague off the coast of Italy in the spring of 1348. The devastation of that visitation of the plague cannot be doubted, although its effect on the psyche of the population will probably never be fully understood. Some concrete facts, however, are well known. The loss of population caused a migration of people into the city, and the chaos that followed the mounting death toll had a profound effect on the immediate state finances. Both Florence and Siena, however, recovered quite quickly from this first outbreak, and although the plague struck again in 1363, twice more in 1374 and 1383 and again in 1399–1400, the economy of Florence recovered quickly while Siena's might have but for the atrocious cost of repeated attacks of the mercenary companies. These companies were a plague unto themselves upon the city-states of Italy in the second half of the century, but Siena, because of its geographical position, seems to have suffered more than any other city-state.[19]

Recent historical and art historical analysis has focused attention on the later arrivals of plague, particularly the one in 1363, as being more significant in shifting private behavior. Samuel Cohn's analysis of wills demonstrated, for example, that it was not until after 1363 that people began to stop dividing up their estates in favor of leaving rather large sums for monuments that would assure their safe passage through the afterlife.[20] We cannot forget that there was an undeniable economic effect of the plague on painting, created both by a changing demographic situation when new patrons moved in from the countryside, and by the needs of artists, who shifted their practices to accommodate the different market.[21] In Florence, the political situation was transformed

by the arrival of people from the countryside who had no family in the city. These *gente nuovo* (literally "new men") soon dominated the political arena.[22] These new patrons must also have had different attitudes toward civic identity, because they had not participated in the rituals of collective identity construction of the first half of the century.

On another level, the repeated visitations of the plague introduced different aspects to the appearance and thus the visualization of the city. The chronicles and literary descriptions give some evidence as to the physical transformations that took place in the city itself as a result of the Plague of 1348. Boccaccio remarks that, "...everyone felt he was doomed to die and, as a result, abandoned his property, so that most of the houses had become common property."[23] He describes the houses left open to all comers. Indeed, the desolate house is an image that reappears in a number of descriptions.[24] Perhaps more importantly, these same texts note that city streets and piazzas were used as repositories for the bodies of the dead and sometimes even burial grounds.[25] In the chronicle of Marchionne di Coppo Stefani the arrival of the plague in 1363 coincides with an attack by the Pisans with whom the Florentines were at war (a war that lasted from 1362 until 1364). Stefani describes the looting and the taking of prisoners and "grave damage" sustained by Florence and its *contado*, the countryside under the jurisdiction of the city.[26]

For the people of central Italy in the second half of the century, the repeated bouts of plague were but one of the difficulties that they faced. Crop failures in 1346, 1374 and again in 1383 led to famine in Florence. In addition, the Arno city's imperial aspirations drove the city increasingly into financial difficulties. On top of this, the political instability that characterized the first half of the century intensified with the ousting of the Duke of Athens and the establishment of the regime of the *gente nuove* in 1343.[27] Over the course of the next fifty years the government of Florence changed hands four times, a number which might have been much higher except for the fact that numerous plots to overthrow the government were foiled before they could be carried out.[28] Florence's imperial ambitions cost it dearly, particularly as, over the course of the second half of the century, the city depended increasingly on mercenaries to fight its battles. The war with Pisa, mentioned above, cost the city over 1,000,000 florins alone.[29] In order to pay for these increased expenses the Florentines instituted the consolidated public debt known as the *monte comune*, what historian Marvin Becker translates as the "mountain of indebtedness"[30] whereby the citizens lent the commune money at a healthy rate of interest (15 percent).

The public debt increased by 125 percent because of the war with Pisa, and in the war-torn years between 1369 and 1378, the war fund was sustained by borrowing money from the *monte* itself.[31] Over the course of the fourteenth century the *monte* increased dramatically, reaching 3,000,000 florins by the end of the century.[32] At the same time that the wealthy class who had invested in the communal debt felt increased pressure to keep the government stable in order to secure their investment, there was a developing sense of disengagement among the lower classes who reaped no benefits from the institution of the *monte* but ended paying for it through an increase in indirect taxes.[33] The wealthy ruling class repeatedly refused to impose an *estimo*, a direct tax on property, to solve the city's fiscal ills, preferring to pass the burden on to foreigners and the general citizenry through *gabelles*, or indirect taxes, which were increased repeatedly.[34]

The example that is most well known of these class difficulties was the revolt of the *Ciompi* (wool workers) in 1378 that led to a very brief reign of the working class between July and August of that year.[35] The *Ciompi* regime was followed by the guild regime that stabilized the city until its overthrow in 1382. The overthrow of the guild regime was followed by the conservative group lead by the wealthy *popolani*.[36] This conservative regime with some modification stayed in power until the end of the century.

In addition to factional infighting, the Florentines experienced increasing diplomatic difficulty with the pope beginning with the pontiff's continued support for the Duke of Athens, Walter of Brienne, even after his expulsion in 1343.[37] Florence was placed under interdict in 1346 and again in 1353.[38] By the 1370s, relations were so strained that war broke out between the papacy and the Arno city, leading the pope to place the city under interdict from 1376 until 1378. This war was known as the War of Eight Saints after the eight individuals chosen to collect taxes from the bishops, an act that precipitated the conflict.[39]

Siena suffered as well from the increased financial and political difficulties of the postplague decades. The government of the Nine, which had been in power since 1287, fell in 1355. The decade leading up to its demise was marked, as in Florence, by financial difficulties and violence.[40] After the fall of the Nine, control over the government changed hands three times before the close of the century. The Nine were succeeded by the "*Dodici*," the Twelve,[41] whose reign ended in 1368 when they were replaced by craftsmen who called themselves the "*Riformatori*." The government of the "*Riformatori*" fell in 1385 to be replaced by the "*Priori*."[42] Siena, like Florence, witnessed a rebellion of the class of woolworkers known as the *Compagnia del Bruco* after the region of the city where they lived. This rebellion took place in 1371 when the woolworkers stormed the Palazzo Pubblico and installed some of their own on the governing council.[43]

Siena was also plagued in this period by roving bands of mercenaries who periodically entered Sienese lands and destroyed or stole all they could find. Over the course of the second half of the century, as detailed by William Caferro, mercenary bands, sometimes called "companies of adventure," attacked and pillaged Sienese lands no less than thirty-seven times. According to Caferro's research, the money that Siena spent on the various expenses of these attacks, including bribes, salaries to ambassadors to make terms with the attackers, and compensation that was paid not only to the citizens in the countryside but also to the members of the companies themselves, far exceeded any other civic expense and often made up almost half of the annual budget for the city.[44] Caferro argues convincingly that it was the repeated attacks of the companies alongside the political turmoil and devastation of the plagues that led to Siena's decline in importance on the European stage over the course of the second half of the century.

In terms of architectural development, the second half of the century was far less prolific than the first half had been. Certainly this was due in part to the fact that the tremendous growth of the late thirteenth and early fourteenth century actually completed many of the needed buildings. However, many projects, such as the Florentine cathedral, dragged on through the end of the fourteenth century. Two other major building projects that are not often remarked upon in this period were the completion of the large magisterial piazzas in front and to the side of the Palazzo della Signoria

(Palazzo Vecchio) and the cathedral. Again, these projects are noteworthy in conjuring a sense of the visual environment of the city because they involved the *destruction*, rather than the creation, of a number of buildings. The one major project that was carried out in this period was the building of the Loggia dei Lanzi adjacent to the Palazzo della Signoria, which took eight years to build and was met with a certain civic ambivalence.[45] In Siena, the building history of the second half of the century is symbolized by the fate of the cathedral project. In 1339, ongoing renovations at the cathedral took a dramatic turn when a new plan to build an enormous new structure using the present building as the transept was begun. Construction began on the walls and piers of the nave but almost immediately there were structural problems with the project. Building stopped in the 1350s and finally in 1389 the plan appears to have been abandoned when alternative uses for the partially constructed nave were put forward.[46]

A faltering economy, repeated bouts of plague, unrest in the government and unrelenting violence characterized the experience of both Florence and Siena in the second half of the century. In Florence, one concrete effect of these repeated crises that can help us to contextualize and visualize the change in images of architecture is the shifting patterns of ritual activity. In the first half of the century, the ceremonial entry was an important tool for creating a sense of collective unity and destiny as well as demonstrating the city's strength to the visitor. It is thus interesting to note that from 1343 until the close of the century no popes, kings, emperors or lesser princes were admitted to the city.[47] Gene Brucker and Richard Trexler both suggest that during this period the Signory's confidence was so low that they could trust neither the visitor nor the citizenry to not take advantage of the chance to enter the city to seize power from the current government.[48] The behavior of the Duke of Athens, who was admitted with great ceremony in May of 1342, seized power shortly thereafter and was expelled from the city in a popular uprising in 1343, exemplified this possibility.[49] Indeed, these precautions were justified by circumstances in Siena when in 1355 the longstanding government of the Nine was toppled when the city admitted the German emperor-elect, Charles IV.[50]

Even more important than the reduction in the number of celebrated entries was the rise in occurrences of a different kind of procession and a different kind of entry. An examination of contemporary chronicles reveals a dramatic increase in the number of processions designed to avoid or curtail natural and manmade disasters. These crisis processions took place with striking regularity in the second half of the century and had a particular character that was clearly and quite obviously distinct from the character of the other ceremonies. Through the chroniclers' descriptions we can see a distinctly different face of the city presented to the citizenry. It is important to note that the crisis procession was by no means an invention of the second half of the fourteenth century as there are earlier instances of such processions in Rome, Florence and Siena. The legend of the Castel Sant' Angelo in Rome gives us an example of an early crisis procession. When the city was in the grip of a devastating plague in the year 590, Pope Gregory I led the population around the city in a grand procession pleading for divine assistance. At the close of their march the pope was assured of God's positive response when he had a vision of the archangel Michael atop Hadrian's Mausoleum sheathing his sword.[51] In Siena, perhaps the most famous crisis procession took place on the eve

of the battle of Montaperti in 1260.[52] In Florence itself, a crisis procession is described by Villani on Epiphany in 1327. However, what is distinct about the crisis processions in the second half of the century is their number and regularity. An examination of the numerous chronicles that record the events in Florence from around 1340 to 1390 offers evidence of twelve major crisis processions as opposed to the one that is described in Villani from 1300 to 1340.[53]

As noted in Chapter Four, it is in the repetition of ritual, theorists argue, that their power becomes part of the identity-making process. Thus the repeated ritual presentation of the city as riven by crisis would have had to have an effect on the built environment's symbolic potential, which we articulated in the Chapter Four. The repetition of the crisis procession would have altered the way in which the city as a symbol of the political hierarchy and of collective identity was conceptualized. Rather than reinforce the status quo of the ultimate power resting with the officials of the commune and of civic stability residing with the citizenry, the crisis procession established the basis of power outside the city, with God. In addition, by introducing different symbols around which civic identity was created—the relics and the cult images—the symbolic power of the built environment was temporarily destabilized.

The chroniclers' descriptions of the crisis processions offer us a very different vision of the city than appears in the narrations of ceremonial entries found in the earlier chronicles. Giovanni Villani describes in 1340 a penitent procession of Florence's citizenry in which the enumeration of the wealth and honor of the participants is noticeably absent. According to Villani, the bishop of Florence advised the people to make a general procession, in which almost all of the healthy citizenry, male *and* female, took part. They circumambulated the city with lighted torches following behind groups of religious men carrying a relic kept at the church of Sant'Ambrogio.[54] In 1347, a similar procession is called for again by the bishop to protect the city from a great hailstorm. This procession goes on for three days. In his description, Villani laments: "And note, reader, how much turmoil was experienced by our city in this year, from hunger, sickness, ruin, storms, and fire and discordance between citizens, because of the amount of our sins."[55] This can be contrasted to the same author's proud descriptions of the city's strength upon the occasion of the entry of Charles of Calabria in 1326.[56]

Beginning in 1354, these apotropaic processions were augmented by the ceremonial arrival of a cult painting of the Virgin and child known as the *Madonna of Impruneta* after the city where she was housed. She returned to the city periodically in 1368, 1372, 1383, 1385, 1388 and 1390.[57] This panel performed a series of civic miracles over the course of the second half of the century, relieving drought and famine and protecting the city from political enemies. The ceremonies that accompanied her arrival in the city grew increasingly elaborate over the course of the century. In many of her entries when she arrived at the city she entered in the company of the commune's most important relics.[58] The panel and the relics replaced the visiting dignitary and the city's own governors in the pageant of the entry thus transforming the visual impact of the procession. According to the description of the panel's first known arrival in the city in 1354, the entire city was circumambulated. Matteo Villani notes that the image was met at the gate of San Pier Gattolino, and from there it was processed to the Baptistery and

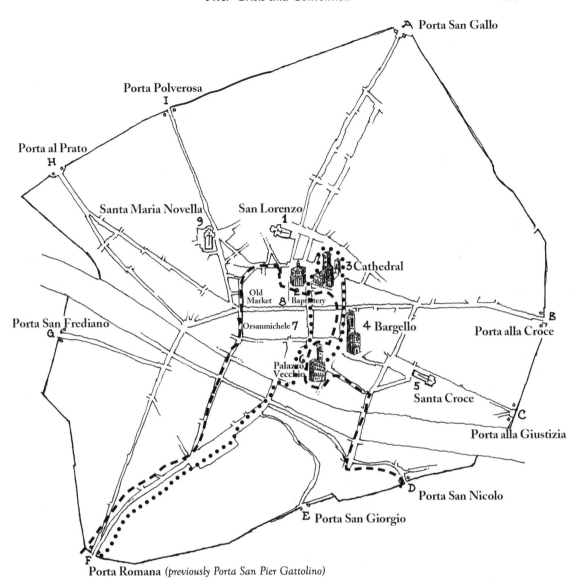

FIGURE 115. Florence Map 2. Showing the two possible routes that the Madonna of Impruneta took through the city in 1354 in dots and dashes. She either came across the Ponte Vecchio and went straight through the heart of the city or came across the ponte Santa Trinita and arrived at the Baptistery from the west before proceeding out of the city to the church of San Miniato al Monte (DRAWING BY JOHN RATTÉ).

then up to the church of San Minato al Monte overlooking the city before it was returned to its home in Impruneta (see Figure 115).[59]

In 1383, there was a great rain in the city and the civic officials decided that they needed the assistance of the Madonna. In the *Chronicle of Naddo da Montecatini* the arrival of the Virgin is carefully described down to the details of the altar that is constructed in front of the Palazzo Vecchio upon which the image was set.

> [M]onday the 25th they had a very great procession, and the Panel of St. Mary of Impruneta came to Florence and before her came all the relics of the saints of Florence, and from the *contado* there were more than twelve thousand Christians. The said panel was installed on the altar that had been built on the *ringhiera* [platform] of the palace of the Signori [Palazzo Vecchio] with great honor; all the knights and other notable citizens were there. The people, whose number was immeasurable, prayed to her with great devotion that the grace of her beloved son, that is Jesus Christ, be bestowed and that he would watch over this city,[60]

Again, the chronicler stressed the crowds that accompanied this event, and again we should picture the city's urban space permeated not with the music of celebration but with solemn hymns, prayers and laments. In 1385, when the *Madonna* was brought in order to save the city from rain she is met with great pomp at the Gate of San Pier Gattolino and processed to Piazza San Felice where a fight broke out because the bishop wanted the relics of Saint Zenobius, one of the city's patron saints, to precede her.[61] This is an interesting event because it demonstrates something of the competition between the city's relics and the cult image and tells us something about the importance of hierarchy in the organization of the procession. In addition, the description gives us information about the extent of the procession.[62] The author opens by saying that the procession went around the entire city and was accompanied by all of the city's religious groups and the bishops of both Florence and Fiesole. Again, the drama of these processions is clear.

In addition to the processions that accompanied the arrival of the *Madonna* there were also crisis processions held to deal with political turmoil, such as the processions held in 1376 during the War of the Eight Saints.[63] In these events, as well, each solemn procession featured the participation of the city's religious communities. The richly attired knights with their draped horses were noticeably absent. In their place the most important relics of the city and the number of participants take center stage in the descriptions. The late fourteenth-century Florentine chronicler Marchionne di Coppo di Stefani described the daily processions that were held during the period when the city had been placed under interdict by the pope from 1376 to 1378:

> ...and again they went every day in procession with the relics [of the city] singing hymns with all the people behind; and all those assembled went beating themselves numerous times, even ten-year-olds were among them and certainly there were more than 5,000 flagellants and as the general procession began there were more than 20,000 people who followed the procession.[64]

In this description we can conjure the picture of the streets filled with 20,000 Florentines solemnly following behind the city's most important relics—Saint Zenobius, John the Baptist and perhaps even the numerous sacred pieces held at the Certosa outside the city—and the city's flagellant confraternities.

The spectacle that this description evokes is quite different from that of Antonio Pucci's description of the arrival of Charles of Calabria discussed in Chapter Four. In that description, the ritual, as is so clearly illustrated by Pucci's careful detailing of the participants, displays worldly goods and the social hierarchy. The citizens who participate and witness this display are asked to affirm their city's position on the world stage.

This position is reinforced by Giovanni Villani's additional note in his description of the entry that not only was the city's ability to host such a honored guest noted by all Italians but "whenever one knew of it, by the whole world."[65] In the descriptions of the crisis processions, the details focus instead on the symbols of the city's dependence upon divine grace, the relics, the miracle-working panel and the city's churchmen and confraternities. To be sure these were political entities, but what is important here is that the symbolic focus of the rituals had shifted. A striking image that evokes (almost consciously) the distinctions between the civic celebration and the crisis procession is found in Agnolo Gaddi's *True Cross* cycle discussed above. In the lowermost scene on the left hand wall, Heraclius is shown returning to Jerusalem with the true cross (Figure 111). The scene is divided into three episodes reading left to right: On the far left the body of the beheaded Chrosroes is just visible in front of his tower-temple. Just above and to the right, Heraclius is shown on horseback clothed in his rich cape with his pennant flying behind him, approaching the gate. An angel flying above the closed gate instructs him that approaching in this way he will not be able to enter the city. Below and to the right, he has divested himself of his rich cloak and descended from his horse; barefoot and dressed in white (white was the flagellant color) he enters the city, his pennant furled. Although it is unlikely that this image represents a specific procession that took place in Florence, Agnolo, born around 1350, would have been witness to many of the crisis processions described in the chronicles.

We noted in the rituals of the first half of the century that the citizenry who took part participated in a symbolic demonstration of the city's strength. What, in contrast, did the citizens who solemnly followed in the wake of the crisis procession experience? The wording of the documents does not allow us to answer this question with any amount of certainty, but we can certainly suggest that it was different from what they had experienced in the earlier celebrations.[66] In both types of rituals, the crisis and the noncrisis, the city is the stage but the symbols in one augment the civic environment, while the symbols in the other subvert it. In the descriptions of the noncrisis procession, as noted above, the key components are the identities of the individuals, their rank and their clothing, and the locations which they visit are augmented and enriched by their presence. These symbols of worldly wealth can be said to exist upon the same plane as the buildings themselves, they are literally what they represent, wealth and power. In the crisis procession, the symbols, the relics and the cult images, are conduits to another, greater hierarchy, one that transcended the city itself. Although the path they follow through the city is similar to that followed by the honored guests, their juxtaposition with the city's monuments has quite a different visual impact. In the earlier images the local city is equated with the ideal city by virtue of the fact that details of local structures are found in representations that are meant to be read iconographically as Jerusalem. In the non-crisis rituals, this equation is conveyed by the procession itself, which is emblematic of the city's strength. In crisis processions on the other hand, the activity suggests that this civic aspiration has not been achieved.

This transformation of the celebratory face of the city suggests a context for understanding the changes that were noted in architectural imagery at the outset of this chapter. Because those changes were directed specifically at the details of architecture that linked the imaged buildings to built structures, they suggest that artists were no longer

certain of the symbolic power of actual architecture. Given the shift of modes of pre-senting the city in the ceremonial entry and the crisis procession this loss of symbolic power makes sense. The loss of reference to local structures and the curtailment in the representation of urban space, when seen in light of changes in the representative force of the built environment in ritual, becomes emblematic of changing outlooks of the second half of the century in which the urban ideal becomes a question rather than an assertion.

This leads us back to the discussion of the previous chapter that touched upon a key issue of pictorial culture for historians of late medieval Italy—that is, the question of exactly how we are to understand the rise of naturalistic representation in the paint-ing of this period. As I noted at the outset of this study, the underlying argument of much of this book has been about the need to expand our understanding of the term "naturalism" and its meaning in relationship to early modern pictorial culture. I argued in Chapter Four that references to built structures in the first half of the century should not be seen as "naturalistic" per se because they refer more to the ideal city than to the real city of lived experience. What the rise in occurrence of crisis processions suggests is that this ideal city is lost, or at least its presence is made ambiguous by changes in the experience of the real city. In pictorial imagery this translates into a lessening of the symbolic impact of references to built structures. Put more simply, the loss of the ideal results in the loss of references to the real through which that ideal was thought to be achievable.

The changes in civic ritual in the second half of the century, in particular the rise in the use of processions to prevent or curtail natural disasters, offer a different way of seeing the real city that was inconsistent with how it had to be represented in the bib-lical and hagiographical narratives that decorated church walls, altarpieces and other panels. In these pictorial images the architectural environment had not undergone any shift in its meaning; it continued to represent a civic ideal. It would have been overly confusing to the viewer had this ideal reflected the city of lived experience, because that experience of the city was undergoing a change in its symbolic meaning. When artists stopped, momentarily, quoting from the built city they were doing so not because they had ceased to look at that environment but because it had ceased to be able to signify the civic ideal unambiguously. This shift reinforces the underlying argument of each of the four preceding chapters of this book: that references to built structures were not simple examples of artists taking note of their own architectural environment but very specific and complex symbols in which we can read the changing attitudes toward the city and its meaning.

Conclusion

The subject of this book has been the function of, and formal changes in, images of architecture from the mid-thirteenth century through the end of the fourteenth century. My aim has been to show not only that these images are artistically significant but also that they can be read in terms of both their religious and their political-social significance. In these images the viewer is offered a recognizable vision of the city, although consistent use of pictorial convention maintained the distance between the experience of the viewer and that of the ideal rendered in the image. What was recognized within the image was a collective ideal of the city and not necessarily the city of everyday life. We noted in Chapter Five how ephemeral this ideal city was, a quality that perhaps speaks most eloquently for the importance of these images.

In Chapters 1 and 2 we saw how images of architecture, beginning with the paintings commissioned by pope Nicholas III, reflected a developing awareness of the power of architecture to signify abstract concepts, such as the wide reach of papal power, in multiple ways in a single image. Not only did the antique monuments flanking the crucified Saint Peter in the Sancta Sanctorum fresco evoke the exact site where that saint had breathed his last (Figure 11); they also stressed the longevity and, ultimately, the power of the papacy. The specificity of the architectural environment in the late duecento fresco cycles also helped to transform Tuscan images of architecture, offering them a path away from Byzantine forms, which earlier in the century they closely resembled. A growing ideological and political divide between Byzantium and Italy reinforced the stress that local artists had begun to put upon their own architectural environment and its evocation. As we saw in Chapter Three, simultaneous with the movement away from Byzantine forms was a Franciscan-inspired experiential spirituality that ultimately involved architectural imagery of pilgrim sites that marked and signified Francis's earthly existence. In Chapter Four the economic, political and historical rise of the city-states of Florence and Siena were manifested in images of architecture that reflected desired ideals of civic stability and strength. These characteristics of the city were given concrete form in ritual practice. By understanding something of how these rituals worked we gained deeper insights into the significance of the architectural images. The last

chapter demonstrated how precarious the urban ideal was, and how important architectural images were in mediating between real and ideal experience. Once the city was transformed by misfortune, it was imperative that its image should change as well.

I have tried to stress throughout that no one single force can be pointed out as the source or inspiration for changes witnessed in the images of architecture. Neither is there one particular artist who stands above the others for his contribution to the articulation of a multivalent architectural image. The images instead suggest that the movement toward a more powerfully symbolic architectural setting was generally pervasive. One of the forces certainly at play in this movement was the rise in importance of the civic environment, in terms of both its structural forms and its political coherence.

What these images serve to demonstrate is that the late thirteenth and early fourteenth century in central Italy was a moment in which the *civitas*, the real city as well as the idea of the city, rose to prominence in the consciousness of artists, politicians and the faithful. But as the images demonstrate, this was not just any city, but specific cities—Rome, Assisi, Florence and Siena—that became compelling symbols of spiritual and social prosperity. It is also clear that, although images of architecture do reflect some aspects of the visible world, their meaning is far more complex and nuanced than is conveyed by the old concept of "naturalism." This term, as has been shown by other authors dealing with other periods, needs to be made much more complex so that it can encompass a series of concepts rather than a single stylistically reliant artistic trend.

In Chapter Three the development of the architectural portrait, an image that might be characterized as quite specifically "naturalistic," was examined. In that discussion we saw clearly that the images of known buildings derived as much symbolic strength from the details, which directed the viewer's attention *away* from the source building as from the details that reflected it. This was true particularly in relationship to its iconographic meaning as a device that aided in both the spiritual experience of the pilgrim and the civic consciousness of the city dweller, such as the Florentine who gazed upon Maso's image of the decrepit Rome (Figure 2). Similarly, as discussed in Chapter Four, the local urban environment reflected in pictorial imagery was contextualized in terms of the ritual experience of the city and shown to be a powerful tool in strengthening the urban dweller's vision of the ideal and, quite specifically, not the real city. In Chapter Five, the change in that ideal was shown to be quite influential in the transformation of the architectural image. Here, as in all of the four preceding chapters, no single force, such as the devastation of the plague or the prevalence of the crisis procession, can be said to be *the* reason for the stylistic changes described. One simply has to understand that for a number of reasons, the way the architectural image operated, specifically in relationship to its capacity to evoke the urban context, was no longer tenable by mid-century.

In relationship to the other issues with which we have been concerned, we can also draw some conclusions. It is clear that the artist's initial conception of architecture in the late thirteenth century in Rome undeniably influenced later renderings in Assisi, Florence and Siena. Without the signifying power of the ancient city and its revival by the thirteenth-century papacy it is hard to imagine that such conceptions of urban existence as those of Giotto and Taddeo Gaddi, to say nothing of Pietro and Ambrogio Lorenzetti, would have been possible. Likewise, a history of trecento paint-

ing that does not see the break with Byzantium—made manifest by a number of different artists in a number of different ways—as an extremely complex social phenomenon rather than a simple stylistic movement misses a great deal. The images of architecture demonstrate that changes in style can be read as evidence of shifts in things other than artists' approach to form. Vasari's image of Giotto triumphing over the *maniera greca* leaves us a rather flat picture of this particular art historic moment. As for Byzantine and Italian cultural interaction, a deeper examination of their political relationship reveals the number of forces that were in play; these forces can be productively examined for how they influenced Italian movement away from Byzantine style.

Each of these conclusions to particular issues discussed in the book lead us to one overall thought: that architecture, urban design, urban experience and painting were inextricably linked in the Due- and Trecento. They influenced and played off each other in the daily process of making meaning and creating and reinforcing collective urban identity. It is clear that these links were a powerful and pervasive force in providing the impetus for artistic change. Examining them offers insights into trecento pictorial culture that are inaccessible when looking at the imagery alone.

Chapter Notes

Introduction

1. *Altre dignita e magnificenza della nostra città di Firenze non sono da lasciare di mettere in memoria per dare aviso a quelli verranno dopo noi. Ell'era dentro bene albergata di molti belli palagi e case, e al continovo in questi tempi s'edificava, migliorando i lavori di farli agiati e ricchi, recando di fuori asempro d'ogni miglioramento e bellezza. Chiese cattedrali e di frati d'ogni regola, e monisteri magnigichi e ricchi; oltre a ccio non era cittadino che non avesse posessione in contado, popolano o grande, che non avesse edificato od edificasse riccamente troppo maggiori edifici che in città...* Giovanni Villani, *Nuova Cronica*, Fondazione Pietro Bembo, Parma, 1991, II, Book 11, 94, p. 201. Translation Marietta Cambareri.

2. See the first chapter of Hayden B. J. Maginnis, *Painting in the Age of Giotto: A Historical Reevaluation* (University Park, PA: Pennsylvania State University Press, 1997).

3. A note of explanation. The generalizations that I am making here relate most directly to surveys of art history, both in books and in the classroom. The standard chronological way of examining works of art has imposed upon them a progressive or at times a cyclical model in which naturalistic representation always seems to be the goal. This is not true of more scholarly texts, which cannot be reduced or summarized according to this model. For a discussion of the difficulties in the survey text see Robert S. Nelson, "The Map of Art History," *Art Bulletin*, LXXIX, 1 (1997):28–40. For further discussions of the history of art history see Eric Fernie, ed., *Art History and Its Methods* (London: Phaidon, 1995). For a discussion of the development of the discipline of art history, particularly in relationship to medieval art in the nineteenth century, see Kathryn Brush, *The Shaping of Art History: Wilhelm Vöge, Adolph Goldschmidt, and the Study of Medieval Art* (New York: Cambridge University Press, 1996).

4. A good reassessment of this idea is presented by Jas Elsner, *Art and the Roman Viewer: The Transfor-*mation *of Art from the Pagan World to Christianity* (New York: Cambridge University Press, 1995).

5. Unfortunately, this view is still the one that is found in most survey books, although it should be said that this positivist vision of art history is not unique to the area of the Trecento.

6. Two scholars in particular are Hayden Maginnis and Marvin Trachtenberg. See the bibliography for their works.

7. Among these challengers would be the semioticians Bryson and Bal, who argue that one simply cannot get at the original viewing context. See Mieke Bal & Norman Bryson, "Semiotics and Art History," *Art Bulletin*, 73 (1991): 174–208.

8. See Diana Webb, *Patrons and Defenders The Saints in the Italian City-States* (New York: I. B. Tauris, 1996).

9. See Jacques Legoff, *Time Work and Culture in the Middle Ages*, trans. A. Goldhammer (Chicago: Chicago University Press, 1980); and Maginnis, *Painting in the Age of Giotto*, pp. 114–123.

10. Alongside this public profession of faith was the private one as well. But by and large, the paintings used for these private rituals did not include very many images of architecture except for one interesting example of a small triptych by Bernardo Daddi that has two scenes from the life of Saint Nicholas in the upper sections of the flanking wings. The first scene shows the boy Deodatus as a prisoner in the Saracen court denoted only by a decorated curtain. The second scene, however, shows Saint Nicholas returning the boy to his parents, whose locale is designated by a background of architecture. This was noted and discussed by Chiara Frugoni. See C. Frugoni, *A Distant City Images of Urban Experience in the Medieval World*, trans. William McCuaig (Princeton, N.J.: Princeton University Press, 1991): 5, figure 2.

11. See Maginnis, *The World of the Early Sienese Painter* (University Park, PA: Penn State University Press, 2001). Richard Trexler uses this term also in *Public Life in Renaissance Florence*, p. 46. Evidence of

the validity of this term is found in government support for the cult of civic patron saints in the fourteenth century, including assisting in the collection of relics, organization of feasts on the saints' feast days and funding for those feasts. This is discussed by Webb in *Patrons and Defenders*. This same issue is now also being approached via the study of reliquaries. See Sally J. Cornelison., "Art Imitates Architecture: A Relic of Saint Philip, Its Reliquary, and Ritual in Renaissance Florence," *Art Bulletin*, 84, 4 (2004): 642–58. My thanks to the author for letting me read the typescript in advance of its publication. Another side of this same issue is the politico-religious meaning of many of the works of art that are discussed in this book. There has been a great deal published on this issue, much of it related to specific works of art, in particular Ambrogio Lorenzetti's *Good and Bad Government* in the Palazzo Pubblico in Siena. See N. Rubinstein, "Political Ideas in Sienese Art," *Journal of the Warburg and Courtauld Institute*, 21 (1958): 179–207; Helene Wieruscowski, "Art and Commune in the Time of Dante," *Speculum*, 19 (1944): 14–33; and Quentin Skinner, "Ambrogio Lorenzetti: The Artist as Political Philosopher," in Hans Belting & Dieter Blume, eds., *Malerei und Stadtkultur in der Dantezeit: Die Argumentation der Bilder* (Munich: Hirmer, 1989) pp. 85–103.

12. This text is quoted from Maginnis, *The World of the Early Sienese Painter*, p. 163. For a slightly different translation see Sixten Ringbom, *Icon to Narrative: The Rise of theDramatic Close-up in Fifteenth-century Devotional Painting*, 2nd ed., revised and augmented (The Netherlands: Davaco, 1984, first pub. 1965), p. 11, n. 2 which gives the original Latin citation: St. Gregory, *Epistles*, XI: 13 in *Patrologia Latina*, 77, cols. 1128, 1129.

13. In Constantinople in 726 the emperor Leo II took down the famous the image of Christ from the Calkhe gate of the imperial palace. At this point iconoclasm became the official doctrine of empire until 780 when it was repealed during the reign of the Empress Irene. The doctrine returned, however, from 814 to 842 after which it is officially proclaimed heretical during the reign of Theodora, acting as regent for Michale III. See Henry Maguire, *The Icons of Their Bodies Saints and their Images in Byzantium* (Princeton, NJ: Princeton University Press, 1996) for a discussion of the Byzantine pre-and posticonoclastic use of images and the image debate, particularly with regard to images of saints. The Byzantine prohibition against images inspired many defenses of their use in Europe. For relevant documents see Caecilia Davis-Weyer, *Medieval Art, 300–1150: Sources and Documents* (Englewood Cliffs, NJ: Prentice-Hall, 1971).

14. This text is quoted from Maginnis, *The World of the Early Sienese Painter*, p. 162, who quotes it from Baxandall, *Painting and Experience in Fifteenth-century Italy: a primer in the Social History of Pictorial Style* (New York: Oxford University Press, 1971) p. 41.

15. This is certainly true of other periods and is amply demonstrated by Herbert Kessler. See Kessler, *Spiritual Seeing: Picturing God's Invisibility in Medieval Art*, 2000.

16. Siena, BC, ms F.VI.II, cited in Maginnis, *The World of the Early Sienese Painter*, p. 163.

17. We shall discuss Franciscan influence on architectural imagery further in Chapter Three.

18. Bonaventure, *The Journey of the Mind to God*, trans. Philotheus Boehner, ed. Stephen F. Brown (Indianapolis, IN: Hackett, 1993).

19. See Bonaventure, *The Journey*, pp. 41–53. Also see Lars R. Jones, "Visio Divina? Donor Figures and Representations of Imagistic Devotion: The Copy of the 'Virgin of Bagnolo' in the Museo dell'Opera del Duomo, Florence," in *Italian Panel Painting of the Duecento and Trecento*, ed. Victor M. Schmidt, Studies in the History of Art, 61, Center for Advanced Study in the Visual Arts, Symposium Papers, XXXVIII, National Gallery of Art, Washington, 2002, pp. 37–39 for a related discussion on the role of images in medieval worship. See also Bram Kempers, *Painting, Power and Patonage: The Rise of the Professional Artist in the Italian Renaissance*, 1997, trans. Beverley Jackson, Allen Lane (London: Penguin Press, 1997, first pub. in Dutch 1987): 21, n. 5.

20. It continues to have this function throughout the fourteenth century, though, because it is Ghibellinism that Matteo Villani is accused of by his political opponents. See Gene Brucker, "The Ghibelline Trial of Matteo Villani," *Medievalia et Humanistica* 13 (1960), 48–55.

21. Although those eligible for office represented only about 2 percent of the population of any given city, these regimes were still the most representative in Italy.

22. The seven major guilds in Florence were as follows: the Judges and Notaries (Giudici e Notai), Calimala Merchants (Arte di Calimala), Wool (Lana), Bankers and Money-changers (Cambio), Silk (Seta), Doctors and Apothecaries (Medici e Speziali), and the Skinners and Furriers (Pellicciai e Vaiai). Membership in one of these guilds was required for eligibility for government office, but membership in a guild did not necessarily denote participation in a particular trade. The fourteen minor guilds included: Butchers (Beccai), Blacksmiths (Fabbri), Shoemakers (Calzolai), Masters of Stone and Wood (Muratori e Scarpellini), Retail Cloth Dealers and Linen Manufacturers (Linaiuoli), Wine Merchants (Vinattieri), Inn-Keepers (Albergatori), Tanners (Cuoiai e Caligai), Oil Merchants and Provision Dealers (Oliandoli e Pizzicagnoli), Saddlers (Coreggiai), Locksmiths (Chiavaiuoli), Armourers and Sword Makers (Corazzai e Spadai), Carpenters (Legnaiuoli), and the Bakers (Fornai). Becker notes that one did not have to practice the specific trade in order to be inducted into the guild; see Marvin Becker, 1967, *Florence in Transition*, vol. 1, p. 18.

23. See Randolf Starn, *Contrary Commonwealth: The Theme of Exile in Medieval and Renaissance Italy* (Berkeley, CA: University of California Press, 1982).

24. Over the course of the fourteenth century, the *populo minuto* were used by the more powerful players in the political game, as for example by the Duke of Athens. When he was in power in Florence he granted unheard-of powers to the tradesmen as a way of weakening the power of the upper classes.

25. Marcia Hall's "The Ponte in S. Maria Novella: The Problem of the Rood Screen in Italy," *Journal of the Warburg and Courtauld Institute*, XXXVII (1974),

157–73; and her "The Tramezzo in Sta. Croce, Florence, Reconstructed," *Art Bulletin*, LVI (1974): 325–341. For a discussion of the spatial hierarchy within the church, see Kempers, *Painting, Power and Patronage*, pp. 36ff.

26. See John Henderson, *Piety and Charity in Late Medieval Florence* (Chicago: University of Chicago Press, 1994) p. 35. See also the general discussion of access behind the tramezzo in Ena Giurescu, "*Trecento Family Chapels in Santa Maria Novella and Santa Croce: Architecture, Patronage and Competition*," Diss., New York University, 1997, pp. 205–211.

27. See Giurescu, "Trecento Family Chapels," 1997.

28. See Bram Kempers, *Painting, Power and Patronage* for a general study of patronage in this period. Bibliography on the patronage of the medieval papacy can be found in Chapter One, and for some specific commissions in fourteenth-century Florence and Siena in Chapter Four.

29. Here it is interesting to note that Marvin Becker found few distinctions between the magnate Bardi family and the nonmagnate Peruzzi family, both of whom patronized chapels in the early years of the Trecento in Santa Croce in Florence. See Marvin B. Becker, "A Study in Political Failure: The Florentine Magnates (1280–1343)," (first pub. 1965 and republished in *Florentine Essays Selected Writings of Marvin B. Becker,* collected by James Banker and Carol Lansing (Ann Arbor, MI: University of Michigan Press, 2002) p. 99. It is Becker who also notes that "almost every politically eligible Florentine male would have to be pressed into service [in the government] once during each two-year interval to sit on the communal councils." Becker, *Florence in Transition*, vol. 1, p. 119.

30. See Giurescu, "Trecento Family Chapels," 1997, p. 253, and Dieter Blume, *Wandmalerei als Ordenspropaganda. Bildprogramme in Chorbereich franziskanischer Konvente Italiens bis zur mite des 14. Jahrhunderts* (Worms: Werner, 1983)

31. According to Kempers, *Painting, Power and Patronage*, Giotto, Bernardo Daddi, Maso di Banco, Gaddo Gaddi and Ambrogio Lorenzetti all matriculated into the guild between 1312 and 1327. p. 167

32. Kempers, *Painting, Power and Patronage*, p. 167

33. The painters elected to the Concistoro of the Sienese commune included: Lippo Vanni, Niccolo di ser Sozzo (Tegliacci), Andrea Vanni, Bartolo di Fredi and Paolo di Giovanni Fei. See Valerie Wainright, "Andrea Vanni and Bartolo di Fredi: Sienese Painters in their Social Context," Diss., University of London, 1978, p. 10.

34. This text is reproduced from Becker, *Florence in Transition*, vol. II, 1968, p. 84.

Chapter One

1. The Jubilee is a Holy year during which pilgrims coming to Rome and visiting the churches would be granted forgivness for their sins for their entire lives. Boniface was the first to enact a Jubilee.

2. Including St. Peter's, Santa Maria Maggiore, St. John the Lateran, Santa Maria in Trastevere and San Lorenzo. See Richard Krautheimer, *Rome: Profile of a City, 312–1308* (Princeton, NJ: Princeton University Press,, 1980).

3. See Colin Morris, *The Papal Monarchy from 1050 to 1250* (Oxford: Oxford University Press, 1989).

4. Honorius III(Cencio Savelli, 1216–1227); Nicholas III (Giovanni Gaetano Orsini, 1277–1280); Honorius IV (Jacopo Savelli, 1285–1287) are native Romans. Innocent III (Lotario dei Conti de Segni, 1198–1216), Alexander IV (Orlando dei Conti di Segni, 1254–1261) and Boniface VIII (Benedetto Gaetani, 1294–1303) were all from nearby Anagni.

5. See Robert Brentano, *Rome Before Avignon: A Social History of Thirteeth-Century Rome*(New York: Basic Books, 1974).

6. See Richard Krautheimer, *Rome: Profile of a City,* and Herbert L. Kessler & Johanna Zacharias, *Rome 1300: On the Path of the Pilgrim* (New Haven, CT: Yale University Press,2000) for discussions of the appearance of the city in the medieval period. The Kessler book is particularly aimed at recapturing the appearance of the city circa 1300 using a variety of documentary and pictorial sources.

7. The facade, with its ceremonial loggia (which obscure the view of the late thirteenth- early fourteenth-century mosaics on the facade) of Santa Maria Maggiore was built in 1743 by Ferdinando Fuga. The building itself is encased by two palaces; the one on the right dates to 1605, while the one on the left dates between 1721 and 1743. Renzo Salvadori, *Architect's Guide to Rome* (London: Butterworth Architecture, 1990), p. 60.

8. *The Marvels of Rome*, Francis Morgan Nichols, ed. and trans. (New York: Italica, 1986).

9. The *Mirabilia* has been interpreted in a number of ways. Its author's interest in the classical monuments of Rome allows it to be inserted into the twelfth-century Renaissance, while its conscious neglect of the Lateran Basilica has been used as evidence to show that it is a piece of propaganda linked to the conflict between the Vatican and the Lateran. Its attention to the Capitoline Hill has been used to suggest a link between it and the mid-twelfth-century revival of the Roman Senate. See Robert L. Benson, "Political Renovatio: Two Models from Roman Antiquity," in *Renaissance and Renewal in the Twelfth Century,* ed. Robert L. Benson and Giles Constable (Cambridge, MA: Harvard University Press, 1982), pp. 339–386; Dale Kinney, "Mirabilia Urbis Romae," in *The Classics in the Middle Ages. Papers of the 20th Annual Conference of the Center for Medieval and Early Renaissance Studies,* eds. A. S. Bernardo and S. Levin eds. (Binghamton, NY: SUNY Medieval & Renaissance Texts and Studies, 1990), pp. 207–221; and Bernhard Schimmelpfennig, "'Guide di Roma' im Mittelalter," *Christianita ed Europa miscellanea di studi in onore di Luigi Prosdocimi*, vol. 1, C. Alzati, ed. (Rome: Herder, 1994), pp. 273–288

10. Gregory was less concerned with the architectural monuments than he was with its sculpture. See Master Gregory, *Marvels of Rome*, trans. John Osborne (Toronto: Pontifical Institute of Medieval Studies, 1987).

11. Only the left arm of the transept received the intended fresco decoration. The program was aban-

doned when the Colonna family (its patron) was expelled from the city by Boniface VIII in 1297. See Julian Gardner, "Pope Nicholas IV and the Decoration of Santa Maria Maggiore" *Zeitschrift fur Kunstgeschite*, no. 36, 1973, p. 12.

12. Giacomo Grimaldi, *Instrumenta autentica translationum sanctorum corperum et sacraum reliquiarum e veteri in novum templi sancti Petri*, BAV, MS Barb. Lat. 2733.

13. The Barberini copies of the frescoes at St. Paul's are found in the Vatican Library, Barb. Lat. 4406.

14. These copies have been the focus of much scholarly attention, although they are not widely known outside of the academic community. See Stephan Waetzoldt, *Die Kopien des 17. Jahrhunderts nach Mosaiken und Malerein in Rom* (Vienna/Munich: Römische Forschungen der Bibliotheca Herziana XVIII, 1964); and John Osborne & Amanda Claridge, *Early Christian and Medieval Antiquities*, vol. 1 Mosaics and Wall paintings in Roman Churches (London: Harvey Miller, 1996).

15. The manuscript that contains the watercolor copies of the apse mosaics in Santa Maria in Trastevere is also in the Vatican Library, MS Barb. Lat. 4404, folios 18, 20 and 21.

16. BAV, MS Barb. Lat. 4403.

17. See Carlo Pietrangeli, Angiola Maria Romanini, Julian Gardner, Serena Romano, Maria Andaloro, Alessandro Tomei, Patrizia Tosini, Gianluigi Colalucci, Bruno Zanardi, Nazareno Gabrielli, Fabio Morresi, Pietro Moioli, Raffaele Scafé, Claudio Seccaroni, and Attilio Tognacci, *Sancta Sanctorum* (Milan: Electa, 1995).

18. See Achille Petrignani, *Il santuario della Scala santa : nelle sue successive trasformazioni, dalla sua origine ai recenti lavori compiuti per l'ampliamento della cappella di S. Lorenzo* (Città del Vaticano, Rome: Pontificio Istituto di Archeologia Cristiana, 1941), pp. 58–59.

19. Described by Julian Gardner in "Nicholas III's Oratory of the Sancta Sanctorum and Its Decoration," *Burlington Magazine*, CXV (1973): 283.

20. See Gardner, "Nicholas III's Oratory," pp. 283–294. This article is still the most comprehensive discussion of the history of cycle, although it was written before the restoration. For a discussion of the restored frescoes as well as extensive color photographs, see Serena Romana, "Il Sancta Sanctorum: Gli Affreschi," in Pietrangeli et. al, *Sancta Sanctorum* (Milan: Electa, 1995). See also Ingo Herklotz, "Die Fresken von Sancta Sanctorum nach der Restaurierung. Umberlegungen zum Ursprung der Trecentomalerei," in *Pratum Romanum* (Wiesbaden: Dr. Ludwig Reichert Verlag, 1997), pp. 149–180.

21. For a discussion of this and other Roman relics and their importance see Gerhard Wolf, *Salus Populi Romani die Geschichte romischer Kultbilter im Mittelalter* (Weinheim: Acta Humaniora, 1990); and Herbert L. Kessler, "Configuring the Invisible by Copying the Holy Face," in *The Holy Face and the Paradox of Representation*, eds. Herbert Kessler & Gerhard Wolf (Bologna: Electa, 1998), pp. 129ff.

22. The Cosmati were a family of artisans working in medieval Rome who specialized in marble

flooring. The name is thus used to characterize the multicolored marble inlaid floors.

23. These figures were replaced in the sixteenth century. See Patrizia Tosini, "La loggia dei santi del Sancta Sanctorum: Un episodio di pittura sistina," in *Sancta Sanctorum* (Milan: Electa, 1995), pp. 202–223.

24. Serena Romano identifies this building as the Meta Romuli. See Romano, "Gli affreschi," 1995, p. 63. The Meta Romuli resembled in form the still extant Tomb of Cestius outside the Ostian gate. The Terebinth had a different appearance according to the description in the *Mirabilia Urbis Romae*, where it is described specifically in connection to the location of Saint Peter's martyrdom. According to the *Mirabilia* it is "... no less high than the Castel of Hadrian, which is called Castel Sant' Angelo, encased with marvelous stone.... This building was round like a castel with two circles with overhanging stones for drainage." (p. 35) When we compare the Lateran artist's rendering of this scene with that of the possibly contemporary image from the portico at St. Peter's in which both the Meta Romuli and the Terebinth are clearly represented (Figure 8), we can see that the artist at the Sancta Sanctorum took pains to specify that the building he was representing was the Terebinth by representing both the marvelous stone (which he distinguishes from the stone of the Castel Sant'Angelo by its vibrant color) and the "overhanging stones for drainage." (p. 35) If he had wanted to represent the Meta he would have done so using the same vocabulary as the St. Peter's painter—the pyramidal form and clearly rendered ashlar blocks which are consistent with the actual appearance of the built structure. See J. M. Huskinson, "The Crucifixion of St. Peter: A Fifteenth-Century Topographical Problem," *Journal of the Warburg and Courtauld Institutes*, 32 (1969): 137 for a discussion of the history of the Terebinth. The *Mirabilia* is the first text that describes the Terebinth as a building. In the text of the pseudo-Marcellus it is noted that Saint Peter, when he was taken down from the cross, was buried under the terebinth tree. (See R. A. Lipsius, ed., *Acta apostolorum apocripha, acta Petri, acta Pauli*, 1891, p. 173 cited in Huskinson, p. 137, n. 11). For this reason it was thought that the author of the *Mirabilia* had simply misunderstood the earlier text and translated a tree into a building. In 1948–49, however, excavations carried out by Guglielmo Gatti at the site of the Terebinth revealed a large circular foundation coinciding with the *Mirabilia*'s description of the building as round. See G. Gatti, *Fasti Archaelogici*, iv, 1949, 3771. See also *Codice Topografico della Città di Roma*, ed. Roberto Valentini & Giuseppe Zucchetti, vol. 3 (Rome: Tipografia del Senato, 1946), pp. 45–46, n. 1; and *The Marvels of Rome*, trans. Francis Morgan Nichols (New York: Italica, 1986), p. 35.

25. Gardner states that the scene of the crucifixion in the Sancta Sanctorum might be dependent upon the one in the portico of St. Peter's. I disagree with this and wonder if he might change his mind in light of the restoration. See Gardner, "Nicholas III's Oratory," p. 291.

26. See Robert L. Benson, "Political Renovation: Two Models from Roman Antiquity," in *Renaissance*

and *Renewal in the Twelfth Century*, ed. Robert L. Benson and Giles Constable (Cambridge, MA: Harvard University Press, 1982), pp. 339–386; and Charles T. Davis, "Roman Patriotism and Republican Propaganda: Ptolemy of Lucca and Pope Nicholas III," *Speculum* (1975): 411–433. This complex is identified as the Capitoline Hill first by H. Grisar, *Die Romische Kapelle Sancta Sanctorum und ihr Schatz* (Freiburg im Breisgau: Herder, 1908), p. 37; and again by Jens Wollesen in "Die Fresken in Sancta Sanctorum. Studien zur Romischen Malerei zur Zeit Papst Nikolaus III (1277–1280), in *Romisches Jahrbuch fur Kunstgeschichte*, 19 (1981): 46. Serena Romano also agrees with this identification. See "Gli affreschi," 1995, p. 63. The buildings on the Capitoline are not classical, however, as she notes; but rather what is represented is the thirteenth-century senatorial palace begun by Innocent IV in the fourth decade of the century. The way in which architecture is represented also makes this identification clear. See Pio Francesco Pistilli, "L'Architettura a Roma nella Prima Meta del Duecento," in Angiola Maria Romanini, ed., *Roma nel Duecento L'arte nella città dei papi da Innocenzo III a Bonifacio VIII* (Torino: Seat, 1991), p. 59. For drawing of the palace in the thirteenth century and for a discussion of its appearance at that time see Richard Krautheimer, *Rome: Profile of a City* (1980), pp. 206–207, fig. 164.

27. On the right, opinion seems to differ. Some scholars argue that this complex of buildings should be identified as the Vatican, others that the open door is used to signify that the building is a classical structure of the palace of Nero. Romana argues for this reading. See Romana, "Gli affreschi," 1995, p. 63, n. 53.

28. John Mitchell, "St. Sylvester and Constantine at the SS Quattro Coronati," *Federico II e l'arte del Duecento Italiano*. Atti della III. settimana di studi di storia dell'arte medievale dell'universita di Roma, May 15–20, 1978, vol. II, pp. 15–32.

29. They are also represented in such close detail because they mark the site at which Saint Peter was crucified, as we shall see in our discussion of the same scene in the portico of St. Peter's.

30. See in particular Romano, "Gli affreschi," 1995 and Gardner, "Nicholas III's Oratory."

31. Nicholas passed a constitution that forbade foreign powers to hold the position of senator, and he forced Charles of Anjou, the king of Sicily, to resign the post in 1278. See Bernhard Schimmelpfenig, *The Papacy* (New York: Columbia University Press, 1992); See Marina Righetti Tosti-Croce, "L'Architettura tra il 1254 e il 1308," in Romanini, ed., *Roma nel Duecento l'arte*, pp. 96–112 for a discussion of the architectural and artistic projects carried out by Nicholas III.

32. Robert Brentano, *Rome Before Avignon: A Social History of Thirteenth-Century Rome* (Berkeley, CA: University of California Press, 1990), pp. 98–101. See also Charles T. Davis, "Roman Patriotism," pp. 411–433.

33. Tosti-Croce, "L'Architettura," p. 98.

34. This potential, in fact, seems always to have been present, although it is never exploited on the scale that it will be in the late Due- and early Trecento.

35. Romano also remarks on the presence of the two towers, which makes the identification of the basilica difficult. The building is rendered using the same kind of style as the medieval structures in the *Crucifixion of Saint Peter* and thus its identity is open, but the portico front and peaked roof relate directly to the Pauline Basilica. See S. Romano, "Gli affreschi," 1995, p. 64 n. 58–59.

36. This potential will be further discussed in the following Chapters 2, 3 and 4.

37. See Romano, "Gli affreschi," 1995; and Maria Andaloro, "Ancora una volta sull'Ytalia di Cimabue," *Arte Medievale*, 2 (1984)143–177 for a similar discussion of the Cimabue fresco in Assisi.

38. The only source for these frescoes is Ghiberti, who says that Cavallini painted the Old Testament cycle there. He does not mention the Acts cycle. Lorenzo Ghiberti, *I Commentarii*, ed. Lorenzo Bartoli (Rome: Giunti, 1998), p. 87. See also Paul Hetherington, *Pietro Cavallini: A Study in the Art of Late Medieval Rome* (London: Sagittarius, 1979), p. 81. Despite this, the general trend in trecento scholarship is to attribute both cycles to Cavallini and to date them between 1270 and 1290. See John White, "Cavallini and the Lost Frescoes in S. Paolo," *Journal of the Warburg and Courtauld Institutes*, vol. XIX (1956): 84–95; and Stephan Waetzoldt, *Die Kopien des 17. Jahrhunderts nach Mosaiken und Wandmalereien in Rom* (Munchen: Römische Forschungen der Bibliotheca Hertziana, Band XVIII, Schroll-Verlag, Wien, 1964. The extent of the work carried out by Cavallini in the frescoes is not universally agreed upon. See Wollesen, *Pictures and Reality: Monumental Frescoes and Mosaics in Rome around 1300* (New York: Peter Lang, 1998). Julian Gardner has suggested that there was another master here, whose name has been lost, who was in fact the person put in charge of the restoration, and that Cavallini only worked here as an assistant at first, although later he took on more responsibility. See Julian Gardner, "S. Paolo fuori le mura, Nicholas III and Pietro Cavallini," *Zeitschrift fur Kunstgeschite*, no. 34 (1971): 240–248

39. Hetherington, *Pietro Cavallini*, 1979, p. 90.

40. See White, "Cavallini and the Lost Frescoes in S. Paolo," pp. 84–95.

41. BAV, MS Barb. Lat. 4406.

42. See White, "Cavallini and the Lost Frescoes," 1956, p. 86.

43. J.-B.Seroux d'Agincourt, *Storia dell'arte col mezzo dei monumenti dalla sua decadenza nel IV secolo fino al suo risorgimento nel XVI*, 7 vol., Prato, 1828–1829; Hetherington, *Pietro Cavallini*, 1979, p. 85.

44. John White also notes this difficulty and cites the copies of existing cycles as proof that the baroque copyists were quite accurate in their renderings of architecture. See White, "Cavallini and the Lost Frescoes," 1956, p. 84, n. 3.

45. Guglielmo Matthiae, *Pittura Romana del medioevo*, vol. II (Rome: Palombi, 1966), p. 231; and Luciano Bellosi, "La decorazione della Basilica Superiore di Assisi e la pittura Romana di fine Duecento," in Angiola Maria Romanini, *Roma Anno 1300: Atti della IV Settimana di Studi di Storia dell'Arte Medievale dell'Universita di Roma "La Sapienza,," (Rome: L'Erma di Bretschneider, 1983) pp. 130, notes that they are

now attributed to the painter Jacopo Torriti, p. 130. See also S. Romano, "Gli affreschi," 1995, p. 83. M. R. Petersen, "Jacopo Torriti: Critical Study and Catalogue Raisonne," diss., University of Virginia, 1989

46. See L. Eleen, "The Frescoes from the Life of St. Paul in San Paolo Fuori le Mura in Rome: Early Christian of Medieval," *RACAR/ Revue d'art Canadienne/Canadian Art Review*, 12 (1985): 251–259; and Herbert Kessler, "'Caput et speculum omnium ecclesiarum': Old St. Peter's and Church Decoration in Medieval Latium," in *Italian Church Decoration of the Middle Ages and Early Renaissance*, ed. William Tronzo (Bologna: Nuova Alfa, 1989), pp. 119–146. Wollesen dismisses the cycle outright as an example of thirteenth-century painting preferring to see it, despite the remarkable architectural imagery in some of the scenes, as Early Christian. See Wollesen, *Pictures and Reality*, 1998, p. 39.

47. J. Garber, *Wirkungen der frühchristlichen Gemäldezyklen der altern Peters- und Pauls-Basiliken in Rom* ([Berlin: Bard, 1918); and Waetzoldt, *Die Kopien des 17*, 1964, p. 56, repeats Garber's separation of the scenes into those done by Cavallini and the ones that remain faithful to the Early Christian originals.

48. John White, "Cavallini and the Lost Frescoes in S. Paolo" (1956): 84–95.

49. This is exemplified by the duplication of the scene of the *Death of the Firstborn of Egypt* in the plague cycle. This duplication was caused when it was decided to limit the number of scenes in the plague cycle. The *Death of the Firstborn* was moved from the end to fourteenth position, in order to add scenes elsewhere at the end of the cycle. Herbert Kessler suggests that these scenes may have included the *Crossing of the Red Sea, Manna, Brazen Serpent, Giving of the Laws*, and *Golden Calf*. The plan was not carried out, however, thus leaving the duplicate scenes. See Herbert Kessler, "Old St. Peter's as the Source and Inspiration of Medieval Church Decoration," *Fragmenta picta: Affreschi e mosaici staccati nel medioevo romano* (catalogue of an exhibition) (Rome, 1989), pp. 45–64, reprinted in Kessler, *Studies in Pictorial Narrative* (London, Pindar Press, 1994) pp. 452–468.

50. Curiously enough John White does not mention this dramatic difference in his assessment of the Conversion scene. See White, *The Art and Architecture in Italy 1250–1400* (New Haven, CT: Yale University Press, [first published 1946], 1993), p. 146. Despite the differences, however, both images do convey the clear monumentality of the architecture that dominated this scene.

51. See the Waetzoldt critique of this image, *Die Kopien des 17. Jahrhunderts*, 1964, p. 59.

52. Acts 23:23–32.

53. Acts 22:25.

54. Another example of a similar architectural setting is the scene of *Saint Paul before Agrippa* on folio 120, Acts 25:23 and 26:1–29.

55. BAV, Barb. Lat. 2733, folios 135–143.

56. Archivio di San Pietro Cod. A 64 Ter. See Antonio Pinelli, "The Old Basilica," in Antonio Pinelli, ed., *The Basilica of St. Peter in the Vatican* (Modena: Franco Cosimo Panini, 2000), p. 31.

57. Folio 41 of the Tassili album, MS Archivio di San Pietro Cod. A 64 Ter, is a vertical sheet in pen with blue watercolor wash with a scene of *Saint Peter and Simon Magnus*. In this scene (corresponding to folio 135 in the Grimaldi, BAV, Barb. Lat. 2733) there is a soldier in the lower right whose figure has been drawn, erased and drawn over suggesting that the copyist was unclear what he was looking at. The lines are so tentative it seems that the artist might only be seeing a piece of drapery. In the Grimaldi drawing, however, this figure is definitely a soldier, leading one to conclude that that Tassili drawings were probably executed on site, and then Grimaldi copied from them resolving areas that were unclear, such as the "soldier" in folio 135. This, in turn, suggests that the Tassili drawings are the more dependable of the two.

58. See Wollesen, *Pictures and Reality*, 1998, Appendix I, pp. 161–165.

59. Also discussed by Wollesen, *Pictures and Reality*, 1998, pp. 56–57.

60. For example, Wollesen suggests that the scene of Constantine founding the basilica of Saint Peter's was one of the scenes. Wollesen is using the almost contemporaneous copy of the portico cycle that was executed in the Pisan church of San Piero a Grado. In this cycle, however, because it is not located near any of the sites where the narrative depicted took place, there was no relevance to the use of architectural details that relate to the built environment and therefore, while the scenes may be comparable in terms of subject matter, in terms of architectural imagery they are not. See Wollesen, *Die Fresken von San Piero a Grado bei Pisa* (Bad Oeynhausen, 1977).

61. *Saint Peter and Simon Magnus*, the *Fall of Simon Magnus*, the appearance of Christ at Domini Quo Vadis, the *Crucifixion of Saint Peter*, the *Decapitation of Saint Paul* with the miracle of the three fountains, *The Temporary Burial of the Saints in the Catacombs, The Excavation of the two Bodies from the Catacombs*, the *Dream of Constantine*, and *Pope Sylvester showing the double portrait of the two apostles to Constantine*. Archivio di San Pietro, Cod. A 64 Ter, folio 10.

62. This scene is identified by inscription in the drawing in the Tassili MS, Archivio di San Pietro, Cod. A 64 Ter, folio 43.

63. The scenes begin with *Saint Peter and Simon Magnus* (folio 135), *Domini Quo Vadis* (folio 136), the *Crucifixion of Saint Peter* (folio 137), the *Decapitation of Saint Paul* (folio 138), *Burial of Saint Peter* (folio 139) (attempted theft of the bodies?) burial of the two apostles in the catacombs (folio 140), raising of the bodies out of the catacombs (folio 141), the *Dream of Constantine* (folio 142) and Pope Sylvester showing the double portrait of the two apostles to Constantine (folio 143). BAV, Barb. Lat. 2733.

64. Wollesen discusses this. See *Pictures and Reality*, p. 55. See also *Acta Sanctorum*, June V, 1864: 428, 435.

65. Wollesen, *Pictures and Reality*, 1998, p. 66; and twelfth-century description of the Lateran by Johannes Diaconus & Herbert L. Kessler, "La Decorazione della Basilica Medievale di San Pietro," in D'Onofrio, Mario, ed., *Romei & Giubilei: Il Pellegrinaggio Medievale a San Pietro (350–1350)*(Rome: Electa, 1999), pp. 269–70.

66. Wollesen, *Pictures and Reality*, 1998, p. 56, n.

133. See also Richard Krautheimer, *St. Peter's and Medieval Rome* (Rome: Unione Internazionale degli Istituti del Archeologia, Storia e Storia dell'Arte in Roma, 1985), p. 33.

67. Wollesen suggests that this claim is further reinforced by the use of the obviously (to a contemporary viewer) classical, stirigated sarcophagus in which the body is laid. See Wollesen, *Pictures and Reality*, 1998, p. 65

68. Folio 39 in Cod A 64 Ter and folio 137, in Grimaldi, Barb. Lat. 2733.

69. This structure was thought to mark the tomb of one of the founders of Rome. It correspondes in form to the still extant Tomb of Cestius just outside the Ostian gate. The Meta Romuli was destroyed in the fifteenth century.

70. See note 23 above.

71. *Mirabilia*, Nichols, ed., 1986, p. 35.

72. Folio 43 in Cod A 64 Ter and folio 139, Grimaldi, Barb. Lat. 2733.

73. The Medieval appearance of the basilica can be reconstructed using the Tassili nave view on folio 12 of Archivio di San Pietro, Cod A, 64 Ter. Wollesen links these architectural images to the antique *scenae frons*, a type of stage set. Wollesen, *Pictures and Reality*, 1998, p. 65.

74. For example the fifth-century ivory casket now in Venice shows the baldachino (or canopy) which used to rise above the altar in the basilica of Old St. Peter's. In form and detail this structure can easily be seen as the basis for the spatially developed construction that rises behind the figures in this scene of the burial of Saint Peter, figure 4, in Krautheimer, *St. Peter's and Medieval Rome*, 1985. Similar frame-like interior scenes are found in the late eleventh-century frescoes in the lower church of San Clemente. See Eileen Kane, "The Painted Decoration of the Church of San Clemente," in *S. Clemente Miscellany II* (Rome: Apud S. Clementem, 1978), pp. 60–151; and in the crypt in Anagni painted sometime around the middle of the thirteenth century. See Miklos Boskovits, "Gli affreschi del duomo di Anagni," *Paragone*, XXX, 357 (1979): 3–41.

75. For discussion of date see Antonio Muñoz, *La Basilica di S. Lorenzo fuori le mura*, Palombi, ed. (Rome: Palombi, 1944), p. 15; Wollesen, dates them to 1290 under the patronage of Nicholas IV, *Pictures and Reality*, 1998, p. 80.

76. For other examples see the scene of the *Decapitation of Saint Magnus*, fig. 119, in Guglielmo Matthiae, *Pittura Romana del Medioevo*, vol. II (Rome: Palombi, 1966). See also Martina Bagnoli, "The Medieval frescoes in the Crypt of the Duomo of Anagni," 2 vols. diss., Johns Hopkins University, 1998.

77. Nicoletta Bernacchio, "Una Veduta di Roma nel XIII secolo della Crypta della Cattedrale di Anagni," *Archeologia Medievale*, XXI (1995): 519–529.

78. Otto Demus, *Byzantine Art and the West* (New York: New York University Press, 1970), p. 229.

79. Baltrusaitis identifies this type of architectural representation. For general discussion, see Jurgis Baltrusaitis, "Villes sur Arcatures," in *Urbanisme et architecture, etudes ecrites et publiees en l'honneur de Pierre Lavedan* (Paris: H. Laurens, 1954), 31ff.

80. Wolfgang Erdman, *Die acht ottonischen Wand-bilder der Wunder Jesu in St. Georg zu Reichenau-Oberzell* (Sigmaringen: J. Thorbecke, 1986); and Demus, *The Mosaic Decoration of San Marco, Venice* (Chicago: Chicago University Press, 1988).

81. A number of similar rectangular structures can be seen in the icon of the Life of the Virgin now in the Byzantine Museum in Athens, no. 1561. Another example can be seen in the mosaic of the *Meeting at the Golden Gate* in the Byzantine church of the Kariye Cami in Istanbul. In this scene similar structures appear on the left of the figures of Joachim and Anna, fig. 28, in Paul Atkins Underwood, *The Kariye Djami*, vol. 4 (Princeton: Princeton University Press, 1975).

82. See Hetherington, *Pietro Cavallini*, 1978, pp. 13–36; and Alessandro Tomei, *Pietro Cavallini* (Milan: Silvana, 2000), pp. 22–51.

83. This cycle and its relationship to Byzantine imagery will be discussed further in the Chapter Two. A Byzantine prototype of this kind of structure can be found in the scene of the *Virgin's First Steps* in the church of St. Clement in Ohrid, fig. 15, in Underwood, *The Kariye Djami*, 1975, vol 4, figures for Jacqueline Lafontaine-Dosogne, "Iconography of the Cycle of the Life of the Virgin."

84. Beginning in the 1270s with the painting of the transept frescoes in the Upper Church and ending in the 1320s with the painting of the chapels in the Lower Church. This time frame can be further expanded if one includes the frescoes along the nave of the Lower church now generally dated between 1240 and 1260. See Beat Brenk, "Das Datum der Franzlegende der Unterkirche zu Assisi," *Roma Anno 1300* (1983): 229–238. Roman artists also worked together with Florentines on the mosaics of the baptistery of Florence, which is decorated with a cycle of the Old and New Testament based upon those in the apostolic basilicas in Rome. The architectural imagery in the mosaics certainly illustrates a number of forms that are found in the Roman images discussed in this chapter. For images of the baptistery mosaics and a discussion of their stylistic relationship to Roman cycles, see Irene Heuck, "Il programma dei mosaici/ The mosaic program," in Antonio Paolucci, et. al, *Il Battistero di San Giovanni a Firenze/ The Baptistery of San Giovanni Florence* (Florence: Franco Cosimo Panini, 1994), pp. 229–264. Compare the arcade-like structure in which Potiphar and his wife sit in the scene of Joseph being sold to Potiphar (Paolucci, vol. 2, pl. 443) with the *Discovery of the body of Saint Lawrence* from the porch at San Lorenzo (fig. 88), or that in Pharoah's dream (Paolucci, vol. 2, pl. 446) with the image of the *Dream of Constantine* (fig. 25). Both of these mosaics are attributed to the Magdalen master. Interestingly enough there are also a few examples of more Byzantine type buildings, such as that found in the *Accusation of Potiphar's wife* (Paolucci, vol. 2, pl. 444). For a fuller discussion of the history of the mosaics see, Irene Hueck, *Programm der Kuppelmosaiken in Florentiner Baptisterium* (Mondorf-Rhein: Krupinski, 1962).

85. These debates are nicely dealt with by Hans Belting in his brief article, "Assisi e Roma. Risultati, problemi, prospettive," in Romanini, ed., *Roma Anno 1300* (1983: 93–102).

86. See Wollesen, *Pictures and Reality*, 1998, p. 52.

Chapter Two

1. Paul Atkins Underwood, *The Kariye Djami*, [4 vols.] (Princeton, NJ: Princeton University Press, 1975). and Robert G. Ousterhout, *The Architecture of the Kariye Cami in Istanbul* (Washington, D.C.: Dumbarton Oaks Research Library and Collection, 1987).

2. For a discussion of the architecture of the Kariye see Ousterhout, *The Architecture of the Kariye Cami.*

3. The Logothete, or controller, looked after financial affairs of the empire. For more on Metochites see Underwood, ed., *The Kariye Djami,* vol. 1, pp. 14–16. There are interesting comparisons to be made between the two figures of the donors Theodore Metichites and Enrico Scrovengi, who both present models of their buildings. Theodore presents his to Christ on the lunette above the exonarthex entrance and Enrico presents his to the Virgin in the *Last Judgment* on the west wall.

4. See Jacqueline Lafontaine-Dosogne, "Iconography of the Cycle of the Life of the Virgin," in Underwood, *The Kariye Djami,* vol. 4, 1975, pp. 163–194 for a discussion of the textual source for the scenes.

5. See Lafontaine-Dosogne, "Iconography of the Cycle of the Infancy of Christ," p. 199.

6. See Decio Gioseffi, *Giotto Architetto* (Milan: Edizionid di Comunita, 1963), p. 47; and Laurie Bongiorno, "The Theme of the Old and New Law in the Arena Chapel," *Art Bulletin,* L/1 (1968): 13.

7. See Gioseffi, *Giotto architetto,* pl. 38 B, for a reconstruction of this gate. John White also noted the correspondence between the gate in the *Entry into Jerusalem* and Roman imperial gates. See White, "Giotto's use of Architecture in 'The Expulsion of Joachim' and 'The Entry into Jerusalem,'" *The Burlington Magazine* (July, 1973): 439—447.

8. See Sven Sandstrom, *Levels of Unreality* (Uppsala: Almquist & Wiksell, 1963); John White, *The Birth and Rebirth of Pictorial Space,* 3rd ed. (Cambridge, MA: Belknap, 1987, first published 1957).

9. Lafontaine-Dosogne identified the building in the scene of the *Presentation* as the entry to the temple precinct. Lafontaine-Dosogne, "Iconography," p. 180.

10. Otto Demus in fact dates the beginning of the Palaiologan style to the second decade of the thirteenth century. Its influence is not seen in Italy, however, until the 1270s. See Otto Demus, "The Style of the Kariye Djami and its Place in the Development of Palaeologan Art," in Underwood, *The Kariye Djami,* vol. IV, 1975, p. 130.

11. See p. 17 in Elvio Lunghi, *La Basilica di San Francesco di Assisi* (Scala: Florence, 1996).

12. William R. Cook attributes this panel to the school of Giunta Pisano. The architectural imagery argues against this, although given the close relationship between Byzantine and Tuscan architectonic form during this period, architectural imagery cannot be used to make attributions. The building to the right of the figures in the upper right scene of the *Possessed woman being healed at the tomb* is strikingly Palaiologan and can be compared quite nicely to both Cimabue and to the building in the Saint Nicholas

scene in the Sancta Sanctorum discussed in Chapter One. See William R. Cook, *Images of St. Francis of Assisi in Painting, Stone and Glass from the Earliest Images to ca. 1320 in Italy* (Florence: Leo S. Olschki, 1999), # 27, pp. 62–63.

13. See Figure 84 in David Talbot Rice, *Byzantine Painting The Last Phase* (London: Weidenfeld and Nicolson, 1968).

14. This structure is also the precursor to the room in which Isaac blesses Jacob and Esau in the Old Testament scenes in the Upper Church in Assisi, c. 1290.

15. This form is an important one for the subsequent development of interior illusionistic space and will be discussed further in Chapter Four. The term "space-box" is used by Erwin Panofsky and is described by Carl Nordenfalk. See Erwin Panofsky, *Perspective as Symbolic Form,* trans Chris Wood (New York: Zone Books, 1997, originally published in 1927 as "Die Perspektive als 'symbolische form,'" *Vortrage der Bibliothek Warburg,* Leipzig,) p. 54; and Carl Nordenfalk, "Outdoors-Indoors: A 2000-Year-Old Problem in Western Art," *Proceedings of the American Philosophical Society,* vol. 117 (1973): 233–258. Demus, in *Byzantium and the West* (p. 229), notes that Byzantine artists never use the box. This type of architectural image is discussed further in Chapter Four. Panofsky, *Perspective as Symbolic Form,* p. 54.

16. The way in which these particular images function will be discussed in Chapter Three.

17. These scenes include: *The Vision of the Chariot* and *Francis before the Sultan;* maybe also *The Knight of Celano.*

18. *"fui ifermato nella detta arte xii anni da Agnolo di Taddeo da Firenze, mio maestro, il quale in paro la detta arte da Taddeo suo padre; il quale suo padre fu battezato da Giotto, e fu suo discepolo anni xxiii; il quale Giotto rinato l'arte del dipingere di grecho in latino, e ridusse al moderno";* "(I was trained in this profession for twelve years by my master, Agnolo di Taddeo of Florence; he learned this profession from Taddeo, his father, and his father was christened under Giotto, and was follower for four-and-twenty years; and that Giotto changed the profession of painting from Greek back into Latin, and brought it up to date;" Cennio d'Andrea Cennini, *Il Libro dell'Arte* (New Haven, CT: Yale University Press, 1932). trans. D. V. Thompson, Dover, 1960, p. 2

19. *"lascio la rozzezza de' Greci,"* Lorenzo Ghiberti, *I commentarii: Biblioteca nazionale centrale di Firenze, II, I,* introduzione e cura di Lorenzo Bartoli (Florence: Giunti, c.1998. p. 33

20. *"che sbandi affatto quella gofsta maniera greca,"* Giorgio Vasari, *Le Vite de' piu eccellenti pittori scultori e architettori* (Florence: Sansoni, 1906, vol. 1, p. 372. Translation is from Giorgio Vasari, *Lives of the Most Eminent Painters Sculptors and Architects* (New York: Scribners, 1913), p. 50. Vasari has played a pivotal role in the developing picture of Italian trecento painting, although given his historical distance from the period and his clear aim to write a history of Italian art that highlighted the achievements of the Florentines, he is no longer considered a useful source for the history of this period. A updated reassessment of the role that his history has played in contempo-

rary understanding of the period is offered in Hayden Maginnis, *Painting in the Age of Giotto*, 1997, pp. 7–37.

21. Recent studies have focused on the idea of the genesis of the pejorative picture of the Greeks as an example of "Orientalism" (see Nelson, 1995). I think that, given the fact that the term itself dates back to the time of Cennini, however, an argument can be made that instead it should be seen as simply another facet of the Italian Renaissance reconfiguring of history, in line with their "invention" of the "middle ages."

22. See in particular Ernst Kitzinger, "The Byzantine Contribution to Western Art of the Twelfth and Thirteenth Centuries," *DOP*, XX (1966): 25ff; and James H. Stubblebine, "Byzantine Influence in Thirteenth Century Italian Panel Painting," *DOP*, XX (1966): 87ff.

23. Kitzinger, "The Byzantine Contribution," 1996," p. 27.

24. Stubblebine, "Byzantine Influence in thirteenth Century Italian Panel Painting," 87ff.

25. Demus, *Byzantine Art and the West*, pp. 7 and 18 on techniques of wall painting that come from Byzantium. See in particular pp. 205–233.

26. Hans Belting, *The Image and Its Public in the Middle Ages: Form and Function of Early Paintings of the Passion*, trans. Mark Bartusis and Raymond Meyer (New Rochelle, N. Y.: Aristide D. Caratzas, 1990)

27. See Ann Derbes, *Picturing the Passion in Late Medieval Italy Narrative Painting, Franciscan Ideologies, and the Levant* (Cambridge, MA: Cambridge University Press, 1996), pp. 1–2, note 4.

28. Derbes draws the same conclusion in *Picturing the Passion*, p. 14.

29. This period continues to provoke much discussion, and thus the bibliography on this period and on the interaction between East and West is vast. Recently, a number of scholars have addressed the question of the substance of the relationship. In discussing Italian artists' use of Byzantine style in the thirteenth century, Anne Derbes, in *Picturing the Passion*, comments: "In fact, at exactly the time that central Italian painters adopted certain eastern images in their entirety, they manipulated and recast others and disregard still others altogether" (p. 15). This book also contains a succinct recapitulation of the *maniera greca* debate and relevant bibliography. For a discussion of the influence of Byzantine art on Northern European art, see Anthony Cutler, "Misapprehensions and Misgivings: Byzantine Art and the West in the Twelfth and Thirteenth Centuries," *Medievalia*, VII (1981): 41–77.

30. Derbes, *Picturing the Passion*, p. 14; see especially note 11.

31. Herbert Bloch, "Monte Cassino, Byzantium, and the West in the Earlier Middle Ages," *DOP*, 3 (1946): 192.

32. Leo, cardinal of Ostia, historian Monte Casino, life of Desiderius: "*Et quoniam artium istarum ingenium a quingentis et ultra jam annis magistra Latinitas intermiserat, et studio hujus inspiernte et cooperante Deo....*" *Patrologiae Latinae*, CLXXIII, 749. See Demus, *Byzantine Art and the West*, pp. 25–26 for a discussion of this quote.

33. Henk Van Os, *Sienese Altarpieces 121–1460 Form, Content, Function*, vol. I: 1215–1344 (Groningen: Egbert Fersten, 1988).

34. See Stubblebine, "Byzantine Influence"; and Derbes, *Picturing the Passion*.

35. See, for example, the frescoes of the New Church (Tokalı Kilise) in Cappadocia, A. Wharton Epstein, *Tokalı Kilise: Tenth-Century Metropolitan Art in Byzantine Cappadocia* (Washington, DC: Dumbarton Oaks Research Library, 1986).

36. This piece is discussed by Henry Maguire in *The Icons and Their Bodies: Saints and Their Image in Byzantium* (Princeton, NJ: Princeton University Press, 1996).

37. Vojislav J. Duric, *Byzantinische Fresken in Jugoslawien* (Munich: Hirmer Verlag, 1976), pl. IX. Other similarities abound. For example, there is a striking resemblance between the building in the *Annunciation* in the Byzantine church at Daphni (Maguire, *The Icons and Their Bodies*, pl. 139) and the scene of Potiphar's wife from the Florentine Baptistery (Paolucci, *Il Battistero di San Giovanni*, 1994, vol. 2, pl. 444). See endnote 82, Chapter One.

38. Duric, *Byzantinische Fresken in Jugoslawien*, 1976, pl. XXVII.

39. For example the Paris Psalter (now in the Paris Biblioteque National. Gr. 139) dated to the second half of the tenth century and the Menologium of Basil II (in the Vatican Library with a shelf mark BAV Gr. 1613) dated to c. 976–1025.

40. Grabar does not draw this conclusion directly, although he does note the cultural importance of the stylistic revival in the Kariye for Greek artists. "The art practiced in Byzantium at the period of the Chora mosaics and frescoes had behind it a tradition of more than a thousand years, and those who practiced it were conscious of this antiquity and proud of it. They endeavored to prolong the tradition and only rarely, and unconsciously, would break with it. This very ancient tradition was therefore a characteristic of Palaeologan art, and perhaps its determining trait." Andre Grabar, "The Artistic Climate in Byzantium During the Palaeologan Period," in Underwood, *The Kariye Djami*, vol. IV, 1975, p. 12.

41. See Maguire, *Icons of Their Bodies*, p. 193.

42. For a discussion of the events leading up to the Fourth Crusade's sack of the city, see Ostrogorsky, *History of the Byzantine State*, 1991 (1952), pp. 401–417. See Also Donald M. Nicol, "The Latin and Greek Empires, 1204–61," *The Cambridge Medieval History IV: The Byzantine Empire, Part 1: Byzantium and its Neighbors*, ed. J. M. Hussey (Cambridge, MA: Cambridge University Press, 1966) reprinted in *Byzantium: Its ecclesiastical History and Relations with the Western World*, collected studies (London: Variorum Reprints, 1972), pp. 275–330.

43. See Nicol, "The Latin and Greek Empires," p. 287, who cites Geoffrey of Villehardouin as noting that the value of the booty was worth at least 400,000 silver marks.

44. Steven Runciman, *The Eastern Schism* (Oxford: Clarendon, 1955 [1997]), p. 150.

45. Runciman, *The Last Byzantine Renaissance* (Cambridge, MA: Cambridge University Press, 1970), pp. 18–19.

46. The Latins added *filioque*, mean proceeding

from the Father *and the Son*, after the Holy Ghost, whereas the Byzantines just said from the Father. The Greeks found the Latin addition insupportable because the creed was written by the council and its power could not be superceded by anyone. See Tia M. Kolbaba, *The Byzantine Lists Errors of the Latins* (Urbana, IL: University of Illinois Press, 2000).

47. The Roman pope, because of his position in the seat of Peter, thought himself to be the head of the church; whereas the Greeks saw him to be a patriarch, equal to the other four patriarchs in Constantinople, Antioch, Alexandria and Jerusalem.

48. For a review of the historical events leading up to the break in 1054 and following see Runciman, *The Eastern Schism*, 1997 (1955)

49. Runciman, *The Eastern Schism*, 1997, p. 160.

50. See Belting, *Likeness and Presence*, 1994, pp. 47–77.

51. See Marvin Becker, *Florence in Transition*, [2 vols.] (Baltimore, MD: Johns Hopkins University Press, 1967–68; and William Bowsky, A *Medieval Italian Commune. Siena under the Nine, 1287–1355* (Berkeley, CA: University of California Press, 1981).

52. Louis Green, *Chronicle into History, An Essay on the Interpretation of History in Florentine 14th Century Chronicles* (Cambridge, MA: Cambridge University Press, 1972).

53. Joseph Gill, "John Beccus, Patriarch of Constantinople 1275–1282," *Church Union: Rome and Byzantium (1204–1453)* (London: Variorum Reprints, 1979), p. 45.

54. This is in Runciman, *The Eastern Schism*, 1997, p. 152, n. 2.

55. Ostrogorsky, *History of the Byzantine State*, 1991, pp. 427–8

56. Ibid., p. 441.

57. Gunther of Pairis does not use the term "heretic" but he does call both the Greeks and the city itself "faithless." See Gunther of Pairis, *The Capture of Constantinople*, ed. and trans. Alfred J. Andrea (Philadelphia: University of Pennsylvania Press, 1997), pp. 91, 105.

58. For the term being used to characterize Michael, see Donald M. Nicol, "The Greeks and the Union of the Churches: The Preliminaries to the Second Council of Lyons, 1261–1274," in *Medieval Studies Presented to Aubrey Gwyn*, John A. Watt, J. B. Morrall, F.X. Martin, eds. (Dublin: C. O. Cochlainn, 1961) reprinted in *Byzantium: Its Ecclesiastical History and Relations with the Western World* (London: Variorum Reprints, 1972), p. 480. John Bekkos, before he is made patriarch, uses the term (in a subtle fashion) to describe the Latins. See Gill, "John Beccus, Patriarch of Constantinople 1275–1282," Variorum Reprints, 1979, p. 254. Bekkos is later converted to the idea of union and is made patriarch. See also Julian Gardner, "The Artistic Patronage of Pope Nicholas IV," in *Annaíl della Scuola Normale Superiore di Pisa*, IV/2 (1997): 2. For the Synod of Nymphaeum, which apparently ended in the charge of heresy being leveled by both sides, he cites documents transcribed in G. Globovich, "Disputatio Latinorum et Graecorum seu Relatio Apocrisariorum Gregorii Ix de gestis Nicaeae in Bythinia et Nymphaeae in Lydia 1234," *Archivium Franciscanum Historicum*, XII (1919): 463–464.

59. Deno Geanakoplos, in *Emperor Michael Palaeologus and the West, A Study in Byzantine-Latin Relations 1258–1282* (Cambridge, MA: Harvard University Press, 1959), pp. 140–141, quotes the contemporary historian George Pachymeres as saying that one of the envoys was flayed alive. See George Pachymeres, *History: Books I-VI*, ed. A. Failler, 2 vols. (Paris), pp. 168–169. Cf Dolger, *Regesten*, no. 1899, who says that the envoys did not reach their goal.

60. Geanakoplos, *Emperor Michael Palaeologus and the West*, 1959, p. 176. In 1264, the Sienese Franciscan Ranierio da Siena is sent to Constantinople. See K. Setton, *The Papacy and the Levant, 1204–1571* (Philadelphia: American Philosophical Society, 1976–1984), pp. 100–132.

61. Geanakoplos, *Emperor Michael*, 1959, p. 180. Morea was the name for the ancient Peloponnese.

62. There is a vast bibliography on this. See Gill, 1979, Roberg, 1964 and Ostrogorsky, 1991.

63. Ostrogorsky, from the 1957 ed., p. 401; and Nicol, "The Greeks and the Union of the Churches" pp. 454–480.

64. Geanakopolos, *Constantinople and the West* (Madison, WI: University of Wisconsin Press, 1989), p.198.

65. Ibid.

66. Geanakopolos, *Constantinople and the West*, "Bonaventure, Two Mendicant Orders, and the Council of Lyons," p. 197.

67. Geanakopolos, 1989, p. 203, n. 84, points out that the *Ordinatio*, which is the official record of the event, notes the doubts in very clear language. According to Geanakopolos: "As Gregory pointedly emphasized (not without exaggeration), Michael had returned to obedience of the papacy, voluntarily and with no other motive than the religious," [here the *Ordinatio* steps out of character, as it were, and records "de quo multum dubitabatur," meaning "which was strongly doubted"]. See also Franchi, *Concilio II di Leone*, 86, 112. p. 215.

68. For a discussion of the Council of Lyons and a Latin transcription of the letter from the Byzantine clergy see Roberg, 1964, Anhang I, no. 5, pp. 235–239 cited in Donald M. Nicol, "The Byzantine Reaction to the Second Council of Lyons, 1274," *Studies in Church History*, VIII, ed. G. J. Cuming and D. Baker (Cambridge, England; Cambridge University Press, 1971), reprinted in *Byzantium: Its Ecclesiastical History and Relations with the Western World* (London: Variorum Reprints, 1972), pp. 113–146, p. 122, n. 2. See also Geanakopolos, *Constantinople and the West*. pp. 183–211

69. There were problems right from the beginning because Michael did not have the agreement of the church or the Byzantine people when he proposed unification with the pope. See Gill, 1979, p. 130.

70. "On 22 February 1281 the Frenchman Martin IV, a willing tool of the powerful Sicilian king, ascended the papal throne. The Curia abandoned its position as sovereign arbitrator and obediently fell into line with the Angevin policy of aggression. Under the patronage of the Pope, Charles of Anjou and the Latin titular Emperor Philip, son of Baldwin II, concluded a treaty with the Venetian republic at Orvieto on 3 July 1281 'for the restoration of the

Roman imperium usurped by the Palaeologus.'"
Ostrogorsky, 1991, p. 463.

71. This happens at the council of Blachernai in
1283. See Nicol, "The Byzantine Reaction," 1971, p.
140.

72. See Nicol, *The Last Centuries of Byzantium*,
1972, p. 115.

73. See Runciman, *The Last Byzantine Renaissance*
(Cambridge, England: Cambridge University Press,
1970)

74. This cultural domination is attested to by
Abbot Suger in the twelfth century and by the above
noted reliance of Italian artists on Byzantine picto-
rial style. See Abbot Suger, *Abbot Suger on the Abbey
Church of St.-Denis and its art treasures*, edited, trans-
lated, and annotated by Erwin Panofsky, 2d ed. by
Gerda Panofsky-Soergel (Princeton, N.J. : Princeton
University Press, 1979) and Demus, *Byzantine Art and
the West*.

75. The emperor Nikephoros Phokas in 968 had
been very annoyed when he was referred to by the
pope as *imperator Graecorum*. See Nicol, "The Byzan-
tine View of Western Europe," in *Greek, Roman and
Byzantine Studies*, VIII (1967), p. 318. Michael VIII, on
the other hand, did not flinch at the title. See Runici-
man, *The Last Centuries of Byzantium* , p. 18.

76. Gill, 1979, p. 46. See also Ostrogorsky, 1991,
p. 431, and Runciman, *The Last Byzantine Renaissance*,
1970, pp. 18–19

77. Villani, *Cronica*, IX, 36, p. 58, translated in
Nicholai Rubinstein, "The Beginnings of Political
Thought in Florence," *Journal of the Warburg and Cour-
tauld Institutes*, 5 (1942): p. 214.

78. Villani's Florentine foundation myth and that
of the earlier *Chronica delle origine civitatis* trace the
origins of the city to classical Rome and then to
Charlemagne. See "Topographical and History Pro-
paganda in Early Florentine Chronicles and in Vil-
lani," *Medioevo e Rinascimento*, Annuario, 2 (1988):
33—51; and Rubinstein, "The Beginnings of Politi-
cal Thought in Florence," pp. 198–227.

79. The first article that I have found that dis-
cusses it is a recent study by Amy Neff that focuses
on two images in an Italian manuscript, which sug-
gest a critical attitude toward Byzantine imagery. She
suggests in fact that these images show the Italians
making fun of their Byzantine sources. See Amy Neff,
"Byzantium Westernized, Byzantium Marginalized:
Two Icons in the Supplicationis Variae," *Gesta*, vol.
XXXVIII/1 (1999): 81–102.

80. See for example Robert S. Nelson, "The Ital-
ian Appreciation and Appropriation of Illuminated
Byzantine Manuscripts, ca. 1200–1450," *Dumbarton
Oaks Papers*, 49 (1995): 209—236.

81. Richard Goldthwaite, *Building of Renaissance
Florence* (Baltimore, MD: Johns Hopkins University
Press, 1980; and Hayden B. J. Maginnis, *The World of
the Early Sienese Painter* (University Park, PA: Pennsyl-
vania State University Press, 2001).

82. Maginnis notes that there is evidence of an
early trecento Sienese merchant, Vieri del fu Cola di
Oliviero Barote, in the Levant (he is robbed by
Genoese pirates). See Maginnis, *The World of the Early
Sienese Painter*, p. 20, n. 13; and L. Catoni, "La brutta
avventura di un mercante senese nel 1309 e una ques-

tione di rappresaglia," *Archivio storico italiano*, CXXXII
(1976): 65–78. According to Robert Davidsohn, the
first Florentine businessman to be active in Constan-
tinople was Buondelmonte Ugolini. See Davidsohn,
Storia di Firenze, vol. VI, p. 768. Later (1317) the
Peruzzi family was also there, Davidsohn, p. 770.

83. See Davidsohn, *Storia di Firenze*, vol. VI, p.
768.

84. Angeliki E. Laiou, "Observations on the Re-
sult of the Fourth Crusade: Greeks and Latins in
Port and Market," *Medievalia et Humanistica*, 12
(1984): 47–66.

85. See Geanakoplos, 1976, and R. Wolff, "Latin
Empire of Constantinople and the Franciscans," *Tra-
ditio*, 2 (1944): 213–37.

86. The first letter that the four monks sent back
to Gregory on the eve of the Council of Lyon is
reprinted and discussed in Roberg, 1964. See also
Maginnis, 2001, p. 20, who notes that Ranierio da
Siena was sent by Urban IV to Constantinople in
1264 and Fra Bartolomeo da Siena, the Franciscan
provincial minister of Syria, was sent by Nicholas III
in 1279. Maginnis, *The World of the Early Sienese
Painter*, p. 20, n. 13. See also K. Setton, *The Papacy
and the Levant, 1204-1571*, pp. 100, 129–32.

87. An argument put forward by Anne Derbes,
Picturing the Passion.

Chapter Three

1. This chapter is a revision and expansion of my
article "Re-presenting the Common Place: Architec-
tural Portraiture in the Trecento," *Studies in Iconogra-
phy*, volume 22 (2001), pp. 87–110.

2. *Meditations on the Life of Christ*, ed. and trans.
I. Ragusa and R. Green (Princeton, NJ: Princeton
University Press, 1976), p. 51.

3. According to Hans Belting, "Within the
framework of increased participation in religious life
for which new forms of affective activity unconnected
to theological structures and language were discov-
ered, the image came to play a new role. Instead of
an abstract ordering it offered a plastic mode of per-
ceiving the religious world and was applied to direct
sensory experience." Hans Belting, *The Image and Its
Public in the Middle Ages: Form and Function*, trans.
Raymond Meyer and Mark Bartusis (New York: Aris-
tide D. Caratzas, 1990), p. 7.

4. See David L. Jeffrey, "Franciscan Spirituality
and the Growth of Vernacular Culture," in *By Things
Seen: Reference and Recognition in Medieval Thought*, ed.
David L. Jeffrey (Ottowa: University of Ottawa Press,
1979), p. 150.

5. Bonaventure, *The Journey of the Mind to God*
(1993).

6. Architectural portraits are a well recognized,
although still little studied, iconographic features of
trecento painting. The term "portrait" is used in rela-
tionship to architectural images of known buildings
in many scholarly contexts. Panofsky uses the term
"portrait" to refer to architectural representations in
his discussion of Ambrogio Lorenzetti. See Erwin
Panofsky, *Renaissance and Renascences in Western Art*
(New York: Harper and Row, 1972), p. 141. White

also uses the term in reference to the Temple of Minerva in the Assisi fresco. See John White, *Art and Architecture in Italy 1250–1400*, 3rd ed. (New Haven, CT: Yale University Press, 1993), p. 217. None of these authors qualifies or explains their use of the term. See also Andrew Martindale, *Gothic Art from the Twelfth to the Fifteenth Century* (New York: F. A. Praeger, 1967), p. 236. More recently, Hayden Maginnis uses the term in discussing trecento naturalism in *Painting in the Age of Giotto*, p. 124; and by Joanna Canon in her discussion of the lost fresco cycle of the life of Saint Margherita of Cortona. See Joanna Cannon and Andre Vauchez, *Margherita of Cortona and the Lorenzetti* (University Park, PA: Pennsylvania State University Press, 1999), p. 197. The term is also used by M. V. Schwarz in his discussion of Giotto's Santa Croce cycles. See M. V. Schwarz, "Ephesos in der Peruzzi-, Kairo in der Bardi-Kapelle," *Romisches Jahrbuch*, 27 (1991/2): 23–57. See also Nicoletta Bernacchio, "Una Veduta di Roma nel XIII secolo dalla Crypta della Cattedrale di Anagni," *Archeologia Medievale*, XXI (1995): 519–529.

7. According to Victor Turner, this process is part of what happens to a pilgrim. "The pilgrim 'puts on Christ Jesus' as a paradigmatic mask, or persona, and thus for a while becomes the redemptive tradition, no longer a biopsychical unit with a specific history— as in tribal initiations, where the individual who dons the ceremonial mask becomes for a while the god or power signified by the mask and the costume linked to it. But since Christ signifies 'the individual' (he represents uniqueness for everyone), a fundamental difference between corporate and singular initiatory traditions is still discernable." Victor and Edith Turner, *Image and Pilgrimage in Christian Culture* (New York: Columbia University Press, 1978), pp. 10–11.

8. For a discussion of the use texts in Italian medieval painting see Hayden B. J. Maginnis, *Painting in the Age of Giotto: A Historical Reevaluation* (University Park, PA: Pennsylvania State University Press, 1997), pp. 146–163. For a more general discussion of texts and images in the medieval period see Herbert Kessler, *Studies in Pictorial Narrative* (London: Pindar Press, 1994).

9. See Domenico P. Cresi, OFM, "Per la Storia de Santuario della Verna," *Studi Francescani*, 59/3–4 (1962): 391–399, and "Osservazioni e Documenti di Storia Alverna," *Studi Francescani*, 63/3 (1966): 78–86; and Marino Damiata, *Pellegrini alla Verna* (Biblioteca di Studi Fracescani, 23) Firenze, Studi Francescani, 1994.

10. Francis Yates, *The Art of Memory* (Chicago: University of the Chicago Press, 1984 [1966]), p. 55, 85 and 89–90 for a discussion of the movement of memory techniques out of the cloister and into the world.

11. See Yates, *Art of Memory*, p. 55 and Mary Carruthers, *The Book of Memory* (New York: Cambridge University Press, 1996 [1990])

12. Cesare Cenci, *Bibliotheca Manuscripta ad Sacrum Conventum Assisiensem*, Regione dell'Umbria—Sacro Convento di Assisi, Casa Editrice Francescana, Assisi, 1981. The earliest catalogue of the library dating to 1381 and published in 1906 by L. Alessandri lists a number of copies of the *Ad Herenium* known

in the medieval period as the *Second Rhetoric of Tullius*. Two copies of this text are listed in Cenci Inv. no. 451 and 453. Inv. no. 451 is dated by its hand to the twelfth or thirteenth century.

13. Cenci, *Bibliotheca Manuscripta*, no. 107 lists the Aquinas text not as the full *Summa* but only the *Secunda Secunde* (Alessandri, Inv. 22, n. 107). See also Yates, *Art of Memory*, p. 82–85.

14. See Susan K. Hagen, *Allegorical Remembrance. A Study of the Pilgrimage of the Life of Man as a Medieval Treatise on Seeing and Remembering* (Athens, GA: University of Georgia, 1990).

15. Yates made a start at analyzing how medieval mnemonics could be seen to have influenced the construction of pictorial imagery in the fourteenth century, but unfortunately her call for a more focused examination of this potential source of iconography has thus far been largely ignored by art historians. See Yates, *Art of Memory*, pp. 82–104.

16. Yates *The Art of Memory*, p. 87.

17. See Hagen, *Allegorical Remembrance* (Athens, GA: University of Georgia, 1990).

18. Hagen, *Allegorical Remembrance*, pp. 48–49.

19. Carruthers, *The Book of Memory*, p. 72.

20. Michael Schwarz connects the discrepancy in the number of columns with references to Saint Francis as the second Christ. See Schwarz, M. V., "Ephesos in der Peruzzi-, Kairo in der Bardi-Kapelle," 43.

21. A reading suggested by Gloria Allaire when I gave this paper as a talk at the conference on "Memoria" at the University of Miami in February, 1999.

22. Louis Grodecki notes the uniqueness of the Arezzo building for its use of gothic forms unmixed with the Italian transformations visible on the other great cathedral complexes of Florence, Siena and Orvieto. Louis Grodecki, *Gothic Architecture*, 2nd ed. (New York: Harry N. Abrams, 1977), p. 326.

23. Mario Salmi, "Un'Antica Pianta di San Francesco in Arezzo," *Miscellanea Francescana*, xxi, 1920, pp. 101–102.

24. See Marvin Trachtenberg, *Dominion of the Eye: Urbanism, Art and Power in Early Modern Florence* (New York: Cambridge University Press, 1997), for the most recent and complexly argued discussion of the link between architecture and civic pride and the symbolic use of architectural form in the Trecento. Also the Assisi artist has augmented the possibility of the viewer reading the building this way by adding the nude figures to the relief above the apse.

25. Bonaventure's text is specific in its mention of the church of San Damiano, although this is not the part of the text which is copied in the inscription of the fresco. Bonaventure, *Major Life*, XV, *Omnibus*, p. 5.

26. See Facesta Casolini, *Il Protomonastero di S. Chiara in Assisi. Storia e Cronaca (1253–1950)* (Florence: Garzanti, 1950), pp. 35–48.

27. It is pope Innocent IV who is instrumental in getting the church of S. Chiara built and in expediting the canonization process at Clare's death. See Casolini, *Il Protomonastero*, p. 36–39.

28. The Septizodium, built by Septimius Severus, was located northeast of the Circus Maximus below the Palatine Hill. It was an enormous structure, which must have been quite impressive when it was

still standing. In the medieval period it was fortified and then ceded to the monks of the church of S. Gregorio on the hill opposite the Palatine. Although part of it was leased to the Frangipani family in the twelfth century, part of the building was kept under control of the monks and was used as a church stronghold throughout the twelfth and thirteenth centuries. It was the site of a number of papal elections in the thirteenth century, including that of Gregory IX in 1227 and Celestine IV in 1241. In 1299, Boniface VIII contributed funds to the restoration of the building. Enrico Stevenson, "Il Settizonio Severiano e la distrazione dei suoi avanzi sotto Sisto V," *Bullettino della Comissione Archeologia Comunale di Roma*, vol. 16 (1888): 269–298, p. 295

29. The extensive patronage of the popes is recorded in the volumes of the *Bullarium Francescanum*, and in the histories of the order written by Moorman and Huber. For Gregory see *Bullarium Francescanum*, vol. I, p. 40 and John Moorman, *A History of the Franciscan Order* (Oxford: Clarendon, 1968), p. 85. See also Raphael M. Huber, *A Documented History of the Franciscan Order* (Milwaukee, WI: The Nowiny Pub. Apostolate, 1944), p. 85, who notes that at this time Gregory donated funds himself to the construction of the church but he does not footnote where he got this information. He cites the *Bullarium Francescanum*, but I have so far been unable to find the bull to which he refers.

30. List of these bulls in chronological order: In April of 1228 Gregory IX issued the bull *Recolentes Qualiter* announcing the building of the great church and exhorting the faithful to contribute to it. *Bullarium Francescanum*, I, p. 40, Moorman, *History*, p. 85; Huber, *History*, p. 85. In July, 1228 Gregory IX came to Assisi, canonized Francis and lay foundation stone for the basilica. See *Analecta Francescana*, x, no. 98; Moorman, *History*, pp. 85–86; for the bull of canonization see *Bullarium Francescanum*, I. pp. 42–44. For the laying of the foundation stone see *Annales Minorum*, II, 205, *Miscellanea Francescana*, II, pp. 83–137 and Huber, *History*, p. 86. At this time Gregory also asked Thomas of Celano to write the saint's Life. Moorman, *History*, p. 86. On July 19, 1228 the bull *Mira circa nos* sets Saint Francis's feast day at October 4th. *Bullarium Francescanum*, I, 42 no. 25, *Miscellanea Francescana*, II, pp. 83–84; and Huber, *History*, p. 86. On October 22, 1228, Gregory IX wrote a letter to John Parenti saying that "the church in which the body of St. Francis would rest, must enjoy special privileges and prerogatives, and for that reason must be directly subject to the Holy See." *Bullarium Francescanum*, I, no. 46 p. 18; and Huber, *History*, p. 86. Giuseppe Abate, *La Maestá del Romano Pontifice*, pp. 9–10 notes that this bull is to be found in *Bullarium Francescanum*, I, n. 25 and that the fact that the church is under the direct jurisdiction of the Roman Pontiff is confirmed by Alexander IV, Clement IV, Urban IV, Boniface IX, Callisto III, Pius II, Gregory XIII, Benedict XIV and Pius VII. On February 21, 1229, the bull *Sicut phialae aureae* is written and directed to the prelates ordering them to support the cult of the saint. *Bullarium Francescanum*, I, no. 49 cited in both Moorman, *History*, p. 87 and Huber, *History*, p. 86. On April 22, 1230, Gregory IX with *Is, qui Ecclesiam suam* set down grave penalties for anyone who went against San Francesco or the bulls that they have set down in support of it. Abate, *La Maesta del Romano Pontifice*, p. 13. Apparently, this bull also stated that San Francesco is to be understood as the head and mother of the Order "...*vestri Ordinis ... Caput habeatur et Mater. Ibid*, p. 22. On June 16, 1230, in the bull *Speravimus*, Gregory IX writes "*Libertatis titulis decorata, semper niteat celebris et insignis.*" Abate, *La Maesta del Romano Pontifice*, p. 11. On April 20, 1235, Gregory IX consecrated the "Lower Church." *Miscellanea Francescana*, II, p. 87 and Huber, *History*, p. 96, who dates the completion of the Upper Church to 1243.

31. Moorman, *History*, 1968, p. 99.

32. The first indulgence for those who visit the shrine is given by Innocent IV in 1252. Abate, *La Maesta del Romano Pontifice*, p. 24.

33. This is first noted in Gregory IX's bull *Is, qui Ecclesiam suam* of 1230, Abate, *La Maesta del Romano Pontifice*,1931, p. 22. This is reconfirmed by Clement IV in 1266 and again by Nicholas IV in 1288. See *Bullarium Francescanum*, II, no. 77, cited in Huber, *History*, p. 98.

34. Abate, *La Maesta del Roman Pontifice*, p. 31.

35. For a summary of the political events surrounding the building of the basilica, particularly the pope's use of the basilica in the developing conflict between the Spirituals and Conventuals, see Alistair Smart, *The Assisi Problem and the Art of Giotto* (New York: Oxford University Press, 1971) and Rona Goffen, *Spirituality in Conflict St. Francis and Giotto's Bardi Chapel* (University Park, PA: Pennsylvania State University Press, 1988).

36. See Birch, *Pilgrimage to Rome*.

37. Within this context it is interesting to note that the buildings that are used to signify Rome are papal strongholds. The Castel Sant' Angelo, discussed in Chapter One was of course the defensive structure attached to the Vatican. The Septizodium was also associated with the pope's as noted in note 28 above. The Lateran is of course called for by the textual narrative.

38. On these, William Hood, "The Sacro Monte of Varallo. Renaissance Art and Popular Religion," *Monasticism and the Arts*, T. Verdon, ed. (Syracuse, NY: Syracuse University Press, 1984), pp. 291–311.

39. See Henk Van Os, "St. Francis of Assisi as a Second Christ in Early Italian Painting," *Simiolus*, VII (1974): 115–132. He suggests that the idea does not occur in literature until the fourteenth century. I might argue on the basis of the appearance of the cave in the image of the stigmata, that Francis's identity with Christ appears in imagery first and then is picked up on in the literature. See also sermons by Saint Bonaventure that link Francis to Christ. Eric Doyle, ed. and trans., *The Disciple and the Master: St. Bonaventure's Sermons on St. Francis of Assisi* (Chicago: Franciscan Herald Press, 1983), pp. 68, 93.

40. I Celano 22, in *St. Francis of Assisi Writings and Early Biographies: English Omnibus of Sources for the Life of St. Francis*, ed. M. A. Habig, 4th ed. revised (Chicago: Franciscan Herald Press, 1972), pp. 246–47. See also Lester Little, *Religious Poverty and the Profit Economy in Medieval Europe*, 3rd printing (Ithaca, NY: Cornell University Press, 1992), p. 149.

41. According to John Moorman "[T]hroughout his life the goal of Francis' endeavor was not only an outward imitation of Christ whereby men might see him reflected in his faithful servant, but also a personal closeness to Jesus, the son of man, in his joys and in his sorrows, in which the soul of man can in some way share. To this end all the characteristics of Francis' own life—renunciation and poverty, humility and self-abasement, the complete conquest of self-love and self-interest—were made to contribute. And those who came under his influence did the same, concentrating their contemplative love upon the historical facts of Christ's earth life seen in terms of human feelings and emotions," Moorman, *History*, 1968, p. 256. See also I Celano, *Omnibus*, p. 84 and II Celano *Omnibus*, p. 200.

42. *Mira Circa Nos*, trans. Medieval Sourcebook at *http://www.fordham.edu/halsall/sbook.html* (accessed 10/30/1999)

43. See Joanna Canon "Dating the Frescoes by the Maestro di S. Francesco at Assisi," *Burlington Magazine*, 124 (1982): 65–69 and S. Romano, "Le Storia parallele dei Assisi: Il Maestro di S. Francesco," *Storia dell'Arte*, 44 (1982): 73–81.

44. There a numerous instances in the cycle of the life of Saint Francis in which this connection is reinforced including the presence of the boy in the tree in the scene of Francis being mourned by the Poor Clares, an iconographic feature which is directly recognizable as quoting from the standard iconography of scene of the *Entry into Jerusalem*. See M. Roy Fischer, "Assisi, Padua and the Boy in the Tree," *Art Bulletin*, 38 (1956): 47–52.

45. Since the capture of Jerusalem during the first Crusade in 1099, the Holy City had been the focal point of ritual pilgrimage. By the thirteenth century, however, the popularity of the pilgrimage to Jerusalem was on the wane, not least because of the slow decline of the Latin holdings and the loss of power by the crusading knights. Over the course of the century the Mameluks pushed progressively further into what had been the Latin Kingdom, until the fall of Acre in 1291 effectively ended the Latin presence in the Middle East. The decline of Latin power in the Near East might be said to have really begun with the sack of Constantinople by the armies of the Fourth Crusade in 1204. But it was not until the reign of Sultan Baibars, beginning in 1260, that the Latins began to lose, for good, the cities that they had controlled since the First Crusade. By the time the Upper Church in Assisi was ready to receive its fresco decoration, the pope would no longer have been able to imagine that very many of the faithful would be willing or even able to make a journey to Jerusalem. See Steven Runciman, *A History of the Crusades*, vol. III (Cambridge, UK: Cambridge University Press, 1998 [1955]). With the fall of Acre the pilgrimage to Jerusalem became prohibitively dangerous. Already in 1271, Gregory X's researches had demonstrated that affairs in Europe had severely curtailed interest in maintaining the kingdom in the Holy Land and a declining interest in the arduous pilgrimage to Jerusalem followed. Because the rise in the difficulty of the pilgrimage to Jerusalem was not accompanied by a lessening of interest in pilgrimage

itself, alternatives to the Holy Land could expect to attract travelers who might otherwise have gone to Jerusalem. See Runciman, *A History of the Crusades*, vol. III, 1998.

46. According to the *Collis Paradisis*, this was given to the monastery in 1266 by Clement II. See *Patris Magistri Francisci Mariae Angeli a Rivolerto Ord. Min. S. Francisci Conventualium, Collis Paradisi Amoenitas Sev Sacri Conventus Assisiensis Historiae*, Libri II, Montefalisco, 1704. In 1230, Gregory IX gave a piece of the cross, p. 50. In 1260, Louis gave part of the crown of thorns, p. 50. And in 1266, Clement IV gave a drop of the Virgin's milk, p. 51.

47. The creation of surrogate structures or sites that could stand in the place of Jerusalem is actually a well documented and studied phenomenon in medieval Italy. Beginning with Richard Krautheimer's work on architectural copies of the Holy Sepulchre, Alick McClean has discussed the creation of a Jerusalem structure in Pistoia, and Mirable Deetz is currently working on the identification of the church of Santa Croce in Gerusaleme in Rome as Jerusalem itself. Richard Krautheimer, "Introduction to an 'Iconography of Medieval Architecture,'" *Journal of the Warburg and Courtauld Institute*, V (1942); Alick McLean, "Sacred Space and Public Policy: The Establishment, Decline and Revival of Prato's Piazza della Pieve," diss. Princeton University, 1993; and Dietz (forthcoming).

48. While the round building, to my knowledge, has not been identified as the Castel Sant'Angelo I believe that the noteworthy circular plan of the building allows for this identification. The Castel Sant'Angelo had been used as both a fortress and a prison since the time of Theodoric in the sixth century. Although, according to Bonaventure's text, Peter was imprisoned outside of Rome, the presence of Trajan's column clearly demonstrates that it was not necessary to specify the exact location of Francis's miraculous eponymous visit and subsequent release of the convict. Thus the Castel Sant'Angelo would have been the obvious choice.

49. See Samuel Edgerton, *Pictures and Punishment: Art and Criminal Prosecution during the Florentine Renaissance* (Ithaca, NY: Cornell University Press, 1985), p.78.

50. Controversy over the date and the author of the *New Town* fresco is a good example of how the "style" of the representations of architecture is used as a hallmark of a particular artist and not as an element in a system of conventions. See Luciano Bellosi, "'Castrum pingatur in palatio' 2. Duccio e Simone Martini pittori di Castelli senesi 'a l'esemplo come erano,'" *Prospettiva*, 28 (1982): 41; and Max Siedel, "'Castrum pigatur in palatio' I. Ricerche storiche e iconografiche sui castelli dipinti nel Palazzo Pubblico di Siena," *Prospettiva*, 28 (1982): 17–35. See also Giovanna Ragionieri, *Simone o non Simone* (Florence: Casa Uscher, 1985) for a overview of the controversy surrounding the *Guidoriccio* fresco and the role of the *New Town* fresco in the discussion. Also useful overviews are found in Joseph Polzer, "Simone Martini's Guidoriccio Fresco: The Polemic Concerning Its Origin Reviewed, and the Fresco Considered as Serving the Military Triumph of a Tuscan Com-

mune," *RACAR Revue d'art Canadienne*, 14/1 (1987): 16–69; and Hayden B. J. Maginnis, "The 'Guidoriccio' Controversy: Notes and Observations," *RACAR Revue d'art Canadienne*, XV, 2 (1988): 137–144.

51. The figures on the far left of the scene are understood in this context to be participating in some kind of formal handing over of the city. Scholars have attempted to identify this fresco by associating it with the two groups of documents that deal with the painting of subject castles on the walls of the Palazzo Pubblico in Siena. These documents date from the year 1314 and between 1331 and 1333, Max Seidel, "'Castrum pingatur,' 1,," p. 19. If the fresco was the one commissioned in 1314, then it most likely represents Guincarico. This is the argument put forward by Seidel and Bellosi. Both these scholars wish to attribute the fresco to Duccio. See Seidel, "'Castrum pingatur,' 1," pp. 17–35 and Bellosi, "'Castrum pingatur,' 2," pp. 41ff. This hypothesis does not seem to have gained wide acceptance, however, see Andrew Martindale, "The Problem of 'Guidoriccio,'" *Burlington Magazine*, 128 (1986): 259ff. If it was painted in 1333 then the subject is Arcidosso. This dating is argued by Michael Mallory and Gordon Moran, "New evidence concerning 'Guidoriccio,'" *Burlington Magazine*, 128 (1986): 250–259.

52. Public palaces generally appear as backdrops in scenes where some sort of authority figure is represented. These buildings are characterized by an elaboration of architectural decoration, such as trifore windows and balconies rather than direct copies of extant public palaces. See, for example, the scene of the *Martyrdom of Saint Lawrence* by Bernardo Daddi in the Pulci-Berardi Chapel in Santa Croce, Florence. Figure 57 in Alastair Smart, *Dawn of Italian Painting* (Ithaca, NY: Cornell University Press, 1978).

53. See Edna Carter Southard, *The Frescoes in Siena's Palazzo Pubblico 1289-1539 Studies in Imagery and Relations to other Communal Places in Tuscany* (New York: Garland, 1979); and Siedel, "'Castrum pingatur,' 1," pp. 17ff.

54. Giovanni Villani, *Nuova Cronica*, XIII: 8, Fondazione Pietro Bembo, Parma, 1991, p. 309.

55. See Gilbert's discussion of the functioning of human portraits in Creighton E. Gilbert, "The Sitter in history (Renaissance portraits: review article)," *The New Criterion*, 9 (1991): pp. 67–74, p. 70

56. It is generally agreed that the architectural references to Siena in the representation of "Good Government in the City" are symbolic of both Siena and the ideal city, according to Belting, "The New Role of Narrative," p. 159. See, George Rowley, *Ambrogio Lorenzetti* (Princeton, NJ: Princeton University Press, 1958), p. 112; Jack Greenstein, "The Vision of Peace: Meaning and Representations in Ambrogio Lorenzetti's *Sala della Pace* city scapes," *Art History*, II/4, 1988, p.493. Randolf Starn acknowledges the contradiction between the use of the term "realism" and the attribution of symbolic meaning by putting realism in quotes, see Starn, "The Republican Regime of the 'Room of Peace' in Siena, 1338–40," *Representations*, 18 (1987): 223; but he does not suggest an alternative. Greenstein saw the artist's deviation from his model as establishing the distinction between the ideal city pictured in the frescoes and the real city beyond the walls of the Palazzo Pubblico. Greenstein outlines in detail discrepancies between the gate and the cathedral representations and their source structures in the first section of his analysis of the Lorenzetti fresco. Greenstein's aim is to demonstrate that the city portrayed is not actually Siena but rather the ideal city, pictured as Siena. Thus the whole series does not depict the actuality of trecento life in the Tuscan hill town, but rather is symbolic of the peace, prosperity and communality personified in the figures on the south wall, Greenstein, "The Vision of Peace," p. 493.

57. The most recent discussion of the iconography of the fresco cycle in the Spanish Chapel is by Joseph Polzer, "Andrea di Bonaiuto's *Via Veritas* and Dominican Thought in Late Medieval Italy," *Art Bulletin*, LXXVII, 2 (1995): 263–289. See also Julian Gardner, "Andrea di Boniauto and the Chapter House Frescoes in Santa Maria Novella," *Art History*, 2 (1979): 107–138.

58. When this fresco was painted, in the mid-1360s, work on the Duomo had been suspended for more than twenty years, from 1334 to 1355, when the resources of the city were directed towards the construction of the Campanile. There is a great deal of bibliography for the history of the construction of the Duomo and the Campanile. The summary which follows is based principally upon the work of Howard Saalman published first in 1964 in the *Art Bulletin* ("Santa Maria del Fiore: 1294–1418," *Art Bulletin*, XLVI [1964]: 471ff) and republished with only a few changes in 1980 as a chapter in his book *Fillipo Brunelleschi and the Cupola of Santa Maria del Fiore* (London: Zwemmer, 1980), pp. 32–54.

59. Saalman, "Santa Maria del Fiore," pp. 471 ff. Franklin Toker, "Florence Cathedral: The Design Stage," *Art Bulletin*, LX (1978): 214ff; and Marvin Trachtenberg, "Brunelleschi, Ghiberti and l'Occhio Minore of the Florence Cathedral," *Journal of the Society of Architectural Historians*, 42 (1983): 249–257.

60. A committee made up of some of the most well-known painters of the day was assembled by the Silk Guild to debate and/or offer a design for the ongoing project of the cathedral in 1366. This committee included Taddeo Gaddi and Andrea Orcagna as well as Andrea da Firenze. See Saalman, *Fillippo Brunelleschi*, pp. 45ff. According to Saalman's reading of the documents the existing structure consisted of the first and second bays and was just being vaulted, Ibid., pp. 43ff. The committee of painters was commissioned to make a design for the Duomo in July of 1366. Ibid,, p. 45.

61. Ibid, p. 48.

62. See for example the image of the donor in the tomb niche painted by Taddeo Gaddi in the Bardi di Vernio Chapel in Santa Croce. Figure 98 in Smart, *Dawn of Italian Painting*. Also the portrait of Nicholas III in the Sancta Sanctorum, pl. 25, p. 53, in Carlo Pietrangeli, et al., *Sancta Sanctorum* (1995).

63. This episode appears in the *Legenda Aurea*, but the text is not specific as to the setting except to say that the dragon has laid waste to a part of the city. See Jacobus de Voragine, *The Golden Legend of Jacobus de Voragine*, trans. Granger Ryan and Helmut Ripperger (London: Longmans, 1941), p. 81.

64. See Richard Krautheimer, *Rome Profile of a City* (1980), pp. 237ff.

65. See Nicolai Rubinstein, "The Beginnings of Political Thought in Florence," *Journal of the Warburg and Courtauld Institutes* (1942): 198–227; and Charles T. Davis, "Topographical and History Propaganda in Early Florentine Chronicles and in Villani," *Medioevo e Rinascimento*, Annuario, 2 (1988): 33–51.

66. The rise in importance of chronicles in the fourteenth century has been explained by Green as inspired by both a desire to explain the prosperity of the city-states and to "graft their age meaningfully within the texture of time," Louis Green, *Chronicle into History, An Essay on the Interpretation of History in Florentine 14th Century Chronicles* (Cambridge, Eng.: Cambridge University Press, 1972), pp. 2, 7.

67. "*Ma considerando che la nostra città di Firenze, figliuola e fattura di Roma, era nel suo montare e a seguire grandi cose, si come Roma nel suo calare....*" Villani, *Cronica*, IX, 36, p. 58 translated in Rubinstein, "The Beginnings of Political Thought," p. 214.

68. See V. A. Kolve, *The Play Called Corpus Christi* (Stanford, CA: Stanford University Press, 1966), p. 109.

Chapter Four

1. Dino Compagni, *Dino Compagni's Chronicle of Florence*, translation and introduction by Daniel F. Bornstein, Book 2, 8 (Philadelphia: University of Pennsylvania, 1986), p. 38.

2. "La qual tavola la depense fuore a la porta a Stalloregi nel borgo a Laterino in casa de' Muciatti. E la detta tavola i Sanesi la condussero al duomo a dì 9 di giugno in mezedima, con grandi divotioni e procissioni, col vesovo di Siena misser Rugeri da Casole, con tutto il chericato di duomo e con tutte le religioni di Siena, e' signori co' gli ufitiali de la città, podestà e capitano e tutti i cittadini di mano e mano più degni, co' lumi accesi in mano; e così doppo le donne e' fanciulli con molta divotione andoro per Siena intorno al Canpo a processione, sonando tutte le canpane a gloria; e tutto questo dì stero le buttighe serate per divotione, facendosi per Siena molte limosine a povare persone co' molti oratiani e preghi a Dio e a la sua Madre...." *Cronache Senese* attributed to Agnolo di Tura del Grasso, p. 313. This event is also related in two other chronicles, one that is dated to the mid- Trecento by an unknown author and the other dated to the mid-Quattrocento and attributed to Paolo Montauri. The accounts differ slightly from the anonymous chronicler. We learn that Duccio's new altarpiece replaces the image of the Virgin known as the "Madonna delgli Occhi grossi." See Alessandro Lisini and Fabio Iacometti, eds., *Cronache Senesi*, in *Rerum Italicarum Scriptores*, Nuova edizione riveduta ampliata e corretta, XV, parte VI, Bologna, Zanichelli, 1931–1937, pp. 90, 234. The procession is discussed by a number of scholars. See for example, H. Van Os, *Sienese Altarpieces*, vol. 1 (1988), pp. 39–40.

3. There is a large bibliography for the architecture of this period both in overviews and monographs on particular buildings. Some important ones are: Marvin Trachtenberg, *Dominion of the Eye* (1997); Richard Goldthwaite, *The Building of Renaissance Florence: An Economic and Social History* (Baltimore: Johns Hopkins University Press, 1990 [1980]) David Friedman, *Florentine New Towns: Urban Design in the Late Middle Ages* (Cambridge, MA: The MIT Press, 1988) and Wolfgang Braunfels, *Mittelalterliche Stadtbaukunst* (1988); also Alick McLean, *The Urban Construction of Social Order in Medieval Prato* (typescript). My thanks to Professor McLean for allowing me to read the typescript of his book before it was published.

4. An example of such entry can be found in the anonymous chronicle of 1313–1320 for the entry of Piero the brother of King Robert in 1314. See Alessandro Lisini and Fabio Iacometti, eds., *Cronache Senesi*, p. 167.

5. Cesare Brandi, ed., *Palazzo Pubblico di Siena: Vicende costrutivve e decorazione* (Siena: Monte dei Paschi di Siena, 1983). See also Hayden Maginnis, *The World of the Sienese Painter* (2001). The bell tower was not built until 1338–48. According to the Agnolo di Tura *Chronicle*, the Nine would have only recently moved into the palace at the time of the *Maesta* procession. See *Cronache Senesi*, p. 312.

6. The campo was the market center of the city before the building of the town hall but was transformed by the Nine into the ceremonial center of the city. See Braunfels, *Stadtbaukunst*, p. 94.

7. Even before construction was begun on the palace, rules were passed regulating the appearance of buildings on the piazza. See John White, *Art and Architecture in Italy 1250–1400* (New Haven: Yale University Press, 1993 [1966]), p. 227; and Braunfels, *Stadtbaukunst*. For a summary discussion of the development of Sienese urbanism in this period see Duccio Balestracci and Gabriella Piccini, *Siena nel Trecento, assetto urbanistico e strutture edilizie* (Florence: Edizioni CLUSF, 1977).

8. This image is actually of the Sansedoni palace that was not begun until after 1340, but it is one of the few remaining intact trecento buildings on the piazza. See Franklin Toker, "Gothic Architecture by Remote Control: An Illustrated Building Contract," *Art Bulletin*, LXVII, 1 (1985): 67–94.

9. Maginnis, *World of the Early Sienese Painter*, 2001, p. 123; and William Bowsky, *A Medieval Italian Commune* (1981), p. 58.

10. The dating of the cathedral is extremely complex since it is based upon reading of documents from the thirteenth through the fourteenth century that discuss the various and extensive projects going on at the site. These projects included: the new west facade designed by Pisano, which was begun circa 1284 and probably finished circa 1310. The raising of the nave vaults probably happened circa 1320. The decision to build a new baptistry beneath the east end of the building, extend the east end and expand the crossing to include four new altars dedicated to Siena's four patron saints was made around 1317. Finally, there was the ambitious project to transform the entire building into the transept of a brand new structure that would have more than doubled the size of the new building. This project was officially begun in 1339 but some scholars argue that it was already under deliberation as early as 1320. For this history

see Van Der Ploeg, Kees, *Art, Architecture and Liturgy Siena Cathedral in the Middle Ages* (Groningen: Egbert Forsten, 1993), pp. 98–107; A. Middeldorf Kosegarten, *Sienesische Bildhauer am Duomo Vecchio; Studien zur Skulptur in Siena 1250-1333* (Munich: Bruckmann, 1984), p. 33; and V. Lusini, *Il Duomo di Siena*, 2 vols, Siena, 1911–1939.

11. The hospital is first mentioned in the eleventh century. The building received attention in the fourteenth century including a cycle of frescoes on its facade by Pietro and Ambrogio Lorezetti in 1335. See Hayden Maginnis, "The Lost Facade Frescoes from Siena's Ospedale di S. Maria della Scala," *Zeitscrift fur Kunst Geschichte*, 59 (1988): 180–194.

12. Many more buildings than those noted here were constructed over the course of the building boom from the late thirteenth into the first half of the fourteenth century. See Richard Goldthwaite, *Building Renaissance Florence*.

13. Documentation on the routes followed during ceremonial entries in the fourteenth century is rather scanty. But from the few specific sites that do appear and from the much more detailed later accounts of entries we can get a good idea of where the visitor would have gone. Meeting with the representatives of the commune's government in front of either the Palazzo Vecchio or the Bargello would have been an important part of any entry, although it is not mentioned by the chroniclers. See Trexler, *Public Life in Renaissance Florence* (1980), p. 318 ff. The arrival of Cardinal Pellegrue is mentioned by the anonymous chronicler. See Domenico Maria Manni, ed., *Cronichette Antiche di Varii Scrittori del buon secolo della lingua Italiana* (Milano: Giovanni Silvestri, 1844), p. 227; and Villani, *Nuova Chronica II*, book X, 4, 1995: 213 (with very little detail, however).

14. The facade was not finished until the following century, but according to Wood Brown the rest of the church was probably finished by circa 1300. The figure I am using to illustrate the church of Santa Maria Novella here is the eastern transept facade and the piazza in front of it, because at this point, this may still have been the gathering place for public presentations. This piazza was where the citizenry gathered to hear the sermons of Peter (later to be Peter Martyr) in 1243-1245. See Davidsohn, *Storia di Firenze*, vol. II, 1977 [1896–1927], p. 410. The "old piazza," which is what this piazza was called [now called the Piazzo dell'Unita Italiana] was later replaced as a setting for preaching when the facade of the church was completed and the city began construction. See J. Wood Brown, *The Dominican Church of Santa Maria Novella at Florence: A Historical, Architectural, and Artistic Study* (Edinburgh: O. Schulze, 1902), pp. 62–72. He notes also that it was at Santa Maria Novella that the priors met to hand over the keys to Charles in 1301, which suggests something about the civic importance of this church, p. 66. And for the piazza see Guido Pampaloni, ed., *Firenze al Tempo di Dante Documenti sull'urbanistica fiorentina* (Rome: Ministero dell'Interno pubblicazioni degli Archivi di Stato Fonti e Sussidi, IV, 1973), doc. nos. 43–49, pp. 67–84.

15. One of the best examples of the symbolic significance of building and urban design in the Trecento is the construction of the Florentine New Towns, which were political and military outposts in the Florentine *contado* (countryside). These towns are discussed by David Friedman in *Florentine New Towns*. A more nuanced discussion of the significance and complexity of urban design is to be found in Trachtenberg, *Dominion of the Eye*, 1997.

16. Braunfels, *Stadtbaukunst*, 1988, p. 148.

17. The use of the term "so-called" here is because it has recently been suggested that this altarpiece was not made for the church of San Pancrazio at all but rather initially adorned the high altar of the Florentine cathedral. See A. Padoa Rizzo, "Bernardo di Stefano Rosselli, il 'Politicco Rucellai' ed il politicco di San Pancrazio di Bernardo Daddi, *Studi di Storia dell'Arte*, 4 (1993): 211–222.

18. In specific cases, these figures are clearly identifiable and therefore play an iconographical role in the scene. This is true of Pietro's *Flagellation* (Figure 77) and Giotto's *Feast of Herod*. See Hayden B. J. Maginnis, "Pietro Lorenzetti and the Assisi Passion Cycle," diss. Princeton University, 1975, p. 87–88, LeonettoTintori and Eve Borsook, *Giotto: The Peruzzi Chapel* (New York: Harry N. Abrams, 1965), p. 19; and Erwin Panofsky, *Renaissance and Renascences*, 1972, pp. 148–149.

19. K. M. Frederick, "A Program of altarpieces for the Siena Cathedral," *Rutgers Art* (1983): 18–35. The project for these altars is also discussed by Maginnis, *The World of the Early Sienese Painter*, pp. 135–144.

20. See Kees Van Der Ploeg, *Art, Architecture and Liturgy, Siena Cathedral in the Middle Ages* (1993), p. 61 for a review of the renovations. It was not until after 1348 that the vaults of the east end were raised to include a clerestory, but it is possible that this was planned at the time that the renovations began in 1317, which would mean that Ambrogio, like Andrea da Firenze in the Spanish chapel fresco in 1365, was offering a vision of the planned building. He was also certainly looking at the nave vaults that would have been completed by this time.

21. See Maginnis, "Ambrogio Lorenzetti's *Presentation in the Temple*," *Studi di Storia dell'Arte*, II (1991): p. 37; and G. Rowley, *Ambrogio Lorenzetti* (Princeton, NJ: Princeton University Press), 1958, p. 112.

22. Carol Krinsky, "Representations of the Temple of Jerusalem before 1500," *Journal of the Warburg and Courtold Institutes*, 33 (1970): 1–19.

23. Simone Martini and Bulgarini are the artists of the last two panels; actually, Simone's altarpiece was the first in the program since it was completed in 1333. See Andrew Martindale, *Simone Martini* (Oxford: Phaidon, 1988), pp. 41–43; and Judith Steinhoff-Morrison, "Bartolomeo Bulgarini and Sienese Painting of the Mid-Fourteenth century," diss., Princeton University, 1989, pp. 62–185.

24. This piece is attributed to an artist known as the Master of the Massacre of the Innocents. See Carlo Volpe, *Pietro Lorenzetti* (Milan: Electa, 1989).

25. I should note here that this type of representation is called the "canopy type" by Carl Nordenfalk. See Nordenfalk, "Outdoors-Indoors: A 2000-Year-Old Problem in Western Art," *Proceedings of the American Philosophical Society*, vol. 117 (1973): 233–258, pl. 6.

26. Richard Krautheimer, "Introduction to an

'Iconography of Medieval Architecture,'" *Journal of the Warburg and Courtold Institute*, V (1942): 1–33.

27. I should note here that the inside/outside view has a much longer history than just the Duecento. It appears also in the twelfth-century frescoes in the lower church of San Clemente in Rome as well. See Guglielmo Matthiae, *Pittura Romana del Medioevo*, vol. II (Rome: Palombi, 1966), pl. 13, *The Mass of Saint Clement* that takes place within the church, although the exterior walls of the nave are clearly visible on either side of the apse.

28. See Martina Bagnoli, *The Medieval Frescoes in the Crypt of the Duomo of Anagni*, 2 vols., diss., Johns Hopkins University, 1998, p. 105, in which this scene is discussed in relationship to the founding of the church at Anagni.

29. This trefoil window, which is clearly Sienese, is also used by Simone in the St. Martin Chapel and is discussed by Joel Brink. See Brink, "A Sienese Conceit in a Painting by Simone Martini at Assisi," *Simone Martini Atti del Convegno*, Siena, March 27–29, 1985, Luciano Bellosi ed., Florence, 1988, 67–73.

30. Again, antecedents of this form can be found much earlier in the twelfth-century frescoes of San Angelo in Formis, for example, and earlier. See Nordenfalk, "Outdoors-Indoors," 1973.

31. Compare Figure 30 (*Presentation in the Temple*) to the *Vision of the thrones* of which an image can be found in A. Smart, *The Assisi Problem and the Art of Giotto* (Oxford: Clarendon Press, 1971), pl. 56.

32. Erwin Panofsky refers to these constructions as "space boxes." See Panofsky, *Perspective as Symbolic Form*, trans. Chris Wood (New York: Zone Books, 1997, originally published in 1927 as "Die Perspektive als 'symbolische form,'" *Vortrage der Bibliothek Warburg*, Leipzig,) p. 54. See also Nordenfalk, "Outdoors-Indoors," 1973: 233–258.

33. A contemporaneous example in Florence, found in the scene of *Pharoah's Dream* in the Baptistery, was noted by Panofsky. See Panofsky, *Perspective as Symbolic Form*, p. 55 and Paolucci, ed., *Il Battistero*, vol. 2, 1994, pl. 446 for an illustration of this scene.

34. See Julian Gardner's discussion of this building and Giotto's use of it in "A Minor Episode of Public Disorder in Assisi: Francis Renounces His Inheritance," in *Murry Festschrift* (England), forthcoming. Thanks to Professor Gardner, who very kindly let me read the typescript for this article. He cites C. Cesare Cenci, *Documentazione di vita assisana*, I, 1300–1448 (Grottaferrata: Ed. Collegi S. Bonavenarae ad Claras Aquas, 1975).

35. Generally speaking, the images that were carried in procession were icons, or nonnarrative representations of a holy personage, the Virgin being the most popular, but images of saints and Christ are also found. The tradition of carrying images in procession was quite an old one by the fourteenth century, and it stretched from Constantinople to Rome, where the most famous procession of the image of Christ from the church of the Lateran out to meet the image of the Virgin from Santa Maria Maggiore was held on Assumption Day. Only very specific images that had performed miracles were carried in procession, such as the image of Saint Agatha that was carried around Florence to protect it from fire,

or later in the century the Madonna of Impruneta, which will be discussed further in Chapter Five. See Gerhard Wolff, *Salus Populi Romani die Geschichte romischer Kultbilter im Mittelalter* (Weinheim: Acta humaniora, 1990); and Herbert Kessler, *Rome 1300: On the Path of the Pilgrim* (2000) for a discussion of the images processed in Rome; and Richard Trexler, "Florentine Religious Experience: The Sacred Image," in *Studies in the Renaissance*, 19 (1972):7–41 for a discussion of the later cult of the Madonna of Impruneta in Florence, which also involved much processing.

36. Trachtenberg, *Dominion of the Eye*, 1997.

37. See G. Cecchini, "Palio e Contrade nella loro evoluzione storia," in A. Falassi and G. Catoni, eds., *Palio* (Milan: Electa, 1982), pp. 309–357.

38. See Webb, *Patron and Defenders*, 1996; and McLean, *The Urban Construction of Social Order in Medieval Prato* (typescript).

39. For example, in 1328, upon hearing the news of the death of the son of King Robert of Naples, the Sienese proceeded to close their shops and the bishop conducted a solemn mass in his honor that was attended by all the citizenry. See anonymous fourteenth-century chronicle reprinted in Alessandro Lisini and Fabio Iacometti, eds., *Cronache Senesi*, p. 138.

40. Much has been written about factional strife in fourteenth-century Italy, although because of its complexity, there is no single source that deals with the issue concisely. See L. Martines, ed., *Violence and Civil Disorder in Italian Cities, 1200-1500* (Los Angeles, CA: Center for Medieval and Renaissance Studies, 1972). Basic features of the conflict are between the *popolo grasso* (fat people), merchants and some manufacturers, and the *popolo minuto* the working class who were systematically excluded from rule and who paid the largest price for the city's expansion in debilitating taxes. A good summary of the political and economic systems can be found Marvin B. Becker, *Florence in Transition*, vol. 1 *The Decline of the Commune* (Baltimore, MD: Johns Hopkins Press, 1967).

41. Richard Trexler, who has done the most extensive work on ritual activity in Florence, argues that the character of ritual activity in the Arno city changes after the departure of the Duke of Athens in 1343.

42. The Sienese *Ordo* is discussed in detail by Van der Ploeg in *Art, Architecture and Liturgy Siena Cathedral*, 1993. See also G. C. Trombelli, *Ordo officiorum ecclesiae Senensis* (Bologna, 1766). And for the Florentine document, see Mario Tubbini, "Due Significativi Manoscritti della Catedrale di Firenze, Studio Introduttivo e Trascrizione," Thesis ad Lauream, n. 224, Pontificium Athenaeum S. Anselmi de Urbe (Rome: Pontificium Institutum Liturgicum, 1996). The *Mores* is reprinted in *Mores et Consuetudines Ecclesiae Florentinae*, codex MS Ex Archivio Aedilium S. Mariae Floridae, A Dominico Moreni Academico Florentino, Erutus Editus Et Illustratus. Accedit Vicariorum Generalium Ejusdem Ecclesiae, Catalogus, Florentiae MDCCXCIV, Typis Petri Allegrinii. Nowhere was organized ritual progression through the city stressed more than in Rome where the stational liturgy, in

action since the fifth century, ritualized the pope's movement through the city and celebration at various of the city's major churches over the course of the calendar year. It is certain that both Florence and Siena were influenced by this longstanding tradition. For more on the stational liturgy, see John Baldovin, *The Urban Character of Christian Worship* (Rome: Pont. Institutum Studiorum Orientalium, 1987); and Sible de Blaauw, "Contrasts in Processional Liturgy. A Typology of Outdoor Processions in Twelfth-Century Rome," in N. Bock, P. Kurmann, S. Romano, and Jean-Michel Spieser, *Art, Cérémonial et Liturgie au Moyen Âge* (Romer: Viella, 2002), pp. 357–396.

43. *Mores et Consuetudines*, p. 43.

44. See Maria A. Ceppani Ridolfi, Marco Ciampolini, and Patrizia Turrini, *L'Immagine del Palio Storia cultura e Rappresentazione del Rito di Siena* (Siena: Monte dei Paschi di Siena, 2001). Cecchini suggests that the processions began at either Porta Camoillia or Porta Romana (see map, Figure 68), because the city statutes legislate that overhanging arches and other obstructions on the main streets that run from these gates to the Porta Stalloreggi near the cathedral must be cleared so that the men holding banners can pass through them. See Cecchini, "Palio e Contrade," 1982, p. 312.

45. Charles was granted widespread powers in a dramatic effort on the part of the Florentine signory to firm up its strength, which was waning because of the defeats inflicted upon the commune by the Luccan Castruccio Castrocani. This episode is only one example of the complex economic and political situation of early fourteenth- century Florence. For more, see Becker, *Florence in Transition*, vol. 1, 1967, pp. 84–86.

46. Villani's writing is roughly contemporaneous with Charles's arrival, but the entry is also described in the verse chronicle of Antonio Pucci based upon Villani but penned circa 1370. See G. Villani, *Nuova Cronaca*, XI, 1, pp. 521–22, and Antonio Pucci, *Centiloquio*, ed. Fr. Ildefonso di San Luigi, *Delizie degli Eruditi Toscani*, III-VI (Florence: Gaet. Cambiagi Stampatore, 1772–1774), vol. V, pp. 216–218.

47. See Ibid., and Robert Davidsohn, *Storia di Firenze*, vol. IV, Le Ultime Lotte contro L'Impero (Florence: Sansoni, 1960), pp. 1053–1054. G. Villani, *Nuova Cronaca*, XI, 1, pp. 521–22 mentions that the Duke was housed at the Bargello but not where he was met.

48. See Pucci, *Centiloquio*, p. 217–218.

49. These entries included the brother of King Philip of France (1301), King Robert of Naples (1311); Pietro, the son of the king of Naples (1314); and Giovanni, the son of Charles of "Ciclia" (1316). See anonymous chronicler in Lisini and Iacometti, eds., *Cronache Senesi*, pp. 41–172.

50. The anonymous chronicler notes that, in 1315, during the entry of King Charles and his son, they were accompanied by 200 knights all dressed in velvet. See the anonymous chronicle in Alessandro Lisini and Fabio Iacometti, eds., *Cronache Senesi*, p. 106. When Charles of Calabria went to Siena before his arrival in Florence in 1326 he apparently spent 16,000 gold florins while in Siena, a sum that suggests something of the pomp of the affair. See Bowsky, *A Medieval Italian Commune*, p. 177.

51. "E nel tenpo della detta signoria [March 1, 1326] venne in Siena miser Giovanni Orsino ed era chardinale ed era leghato vice papa, entrò alla porta a Chamolia sotto el ghonfalone del Duomo chon tuti e' cherici di Duomo e di tutte le chiese di Siena, e fugli fatto grandi presenti e grande onore, e uscì di Siena, a dì xviii di marzo e andonne a Roma." (In the said year of the signory, Mssr Giovanni Orsini, a cardinal and legate of the pope, came to Siena, he entered by the porta Camollia under the banner of the cathedral with all of the clerics of the cathedral and of all the churches of Siena, and they made him great presentations and great honor, and he left Siena on the 18th of March and went to Rome) Anonymous chronicle, in Alessandro Lisini and Fabio Iacometti, eds., *Cronica Senese*, p. 133

52. The chronicler describes the arrival of King Robert in 1311: "E al tempo detto di sopra venne e' re Ruberto in Siena, e tutte le compagnie di Siena col ghonfalone in mano se le fece in contro, e fugli fatto grandissimo onore; e fecesi giostre e balli e motli altri giuochi per fargli onore; e molti grandi presenti se gli feceno; e fecesi falò per le torri, e in sul Canpo come è usanza a fare a un uomo come lui." (In the said time King Robert came to Siena and all the companies of Siena with their banners in hand met him and they did him great honor; they had jousts and dances and many other games to honor him; and they gave him many great gifts; and they set bonfires on the towers and in the Campo as was the custom to do for a man such as he.) Anonymous chronicler, in Lisini and Iacometti, eds., *Cronache Senesi*, p. 89.

53. This term is used to describe most of the celebrations held to honor visitors.

54. See Heidi Chretien, *The Festival of San Giovanni Imagery and Political Power in Renaissance Florence* (New York: Peter Lang, 1994); and Webb, *Patrons and Defenders*.

55. See note 44 above and Bram Kempers, "Icons, Altarpieces, and Civic Ritual in Siena Cathedral, 1100–1530," in *City and Spectacle in Medieval Europe*, Barbara A. Hanawalt and Kathryn L. Reyerson, eds. (Minneapolis, MN: University of Minnesota Press, 1994), pp. 89–136.

56. See Webb, *Patrons and Defenders*, 1994, p. 222; and Kempers, "Icons, Altarpieces, and Civic Ritual." I should note here also that the document, dated to the late thirteenth century, which outlines the requirements for citizen participation in the Sienese procession, requires that all men between the ages of 18 and 70 participate. Women are not mentioned. See Cecchini, "Palio e Contrade," 1982, who reproduces and discusses this document, p. 309. Note also that Cecchini dates this document to the end of the twelfth century, but it has been subsequently redated to the end of the thirteenth century. See M. Ascheri, "Siena nel 1208: Immagini della piu antica legge conservata," in M. Ascheri, ed., *Antica Legislazione della Repubblica di Siena*, "Documenti di Storia," 7, Siena, 1993, pp. 41–66, in particular pp. 64–66.

57. A *lauda* is defined by Sandro Sticca as: "a poetico-musical composition originating in liturgical psalmodic singing, that must be looked upon as the matrix of Italian vernacular theater." See Sandro

Sticca, "Italy: Liturgy and Christocentric Spirituality," in Eckehard Simon, ed., *The Theatre of Medieval Europe New Research in Early Drama* (Cambridge, Eng.: Cambridge University Press, 1991), p. 169.

58. See Alessandro D'Ancona, *Origini del teatro Italiano*, 2nd ed., 1891, rpt. Rome, Bandi, 1971; Mark Christopher Rogers, "Art and Public Festival in Renaissance Florence: Studies in Relationships," diss., University of Texas at Austin, 1996; Sandro Sticca, "Italy: Liturgy and Christocentric Spirituality," and Sandro Sticca, "Italian Theater of the Middle Ages: From the *Quem Quaeritis* to the *Lauda*," *Forum Italicum*, 14, 3 (1980): 275–310 for Italy; and Dunbar H. Ogden, *The Staging of Drama in the Medieval Church* (Newark, NJ: University of Delaware Press, 2002); and Karl Young, *The Drama of the Medieval Church*, 2 vols. (Oxford: Clarendon Press, 1955 [1933]) for general studies of medieval drama. Information regarding the props and staging of church dramas can be found in Johannes Tripps, *Das Handelnde Bildwerk in Der Gotik Forschungen zu den Bedeutungsschichten und der Funktion des Kirchengebaudes und seiner Ausstattung in der Hoch- und Spatgotik*, 2nd ed. (Berlin: Mann Verlag, 2000). Examples of dramatic texts and staging can be found in Vicenzo DeBartholomaeis, *Laude drammatiche e rappresentazioni sacre*, 3 vols. (Florence: Le Monnier, 1943) and Peter Meredith and John E. Tailby eds., *The Staging of Religious Drama in Europe in the Later Middle Ages: Texts and Documents in English Translation*, Early Drama, Art and Music Monograph series no. 4, Kalamazo, Medieval Institute Publication, 1983, p. 67.

59. This text is quoted in Rogers, "Art and Public Festival," p. 40.

60. Rogers describes a modification done to the altar of Saint Daniel so that it can serve as a sepulchre in a thirteenth-century Passion play in Padua, Rogers, p. 47, n. 43 (Rogers quotes De Bartholomaeis, *Origini della Poesia Drammatica*, pp. 118–119.) Virginia Galante Garrone, *L'apparato scenico del drama sacro in Italia* (Turin: Fondo di Studi Parini-Chirio, 1935), pp. 9–10, notes that the same altar of Daniel symbolically served as "the castle" during reenactments of the "Supper at Emmaus." The pilgrims broke bread on the altar and suddenly recognized the Lord. See also D'Ancona, *Origini*, vol. I, pp. 81–111 for earliest records of drama at Siena, Padua, Cividal del Fruili where Passion, Easter, Ascension, Pentecost, Annunciation, Magi and Nativity plays were presented.

61. See again Rogers, "Art and Public Festival," p. 42. "Although the Florentine crucifixes with hinged arms were made continuously after Giovanni Balduccio created one for the Baptistery, sometime before 1339, not a single liturgical text referring to their use has survived." and note 28, "Balduccio's crucifix is given the earliest date of all those catalogued, c. 1350. Taubert, *Farbige Skulpturen*, 1978, p. 39, Catalogue no 4, and p. 46." p. 42. Donatello's crucifix in Santa Croce is a fifteenth-century example of this type of crucifix. See Margrit Lisner, "Intorno al Crocifisso di Donatello in Santa Croce," in *Donatello e il Suo Tempo Atti dell'VIII Convegno Internazionale di studi sul Rinascimento* (Florence: Instituto Nazionale di Studi sul Rinascimento, 1966), pp. 115–129.

62. See DeBartholomaeis, *Laude Drammatiche*, 1943, pp. 203–216.

63. This production ended in tragedy when the bridge upon which the audience was standing collapsed. Town records from Florence (1304), translated and reprinted in Peter Meredith and John E. Tailby, eds., *The Staging of Religious Drama in Europe in the Later Middle Ages: Texts and Documents in English Translation*, Early Drama, Art and Music Monograph series no. 4 (Kalamazoo, MI: Medieval Institute Publication, 1983), p. 67.

64. See Rogers, "Art and Public Festival," appendix 1 for a more detailed discussion of this event and other May Day celebrations.

65. This gate is no longer extant, dated to the period of the first circuit of walls. See Davidsohn, *Storia di Firenze*, I, p. 788. See Charles T. Davis, "Topographical and Historical Propaganda in Early Florentine Chronicles and in Villani," *Medioevo e Rinascimento*, Annuario, 2 (1988): 33–51; and Davidsohn, *Storia di Firenze*, vol. 1, pp. 1063–1064.

66. Meredith and Tailby, eds., *The Staging of Religious Drama*, 1983, p. 164–165.

67. See Trexler, *Public Life*, pp. 297–306.

68. Such was the case with both Charles of Calabria in 1326 and Walter of Brienne in 1342 in Florence.

69. Walter of Brienne (Duke of Athens) decided upon the latter course. See Trexler, *Public Life*, 1980, pp. 298, 300; and Becker, *Florence in Transition*, I, 1967, pp. 84–89 and 148–171. In Siena, ceremonial entries were controlled until the arrival in 1355 of King Charles. This will be discussed in Chapter Five.

70. This represented unity was not only a feature of the entries. It is also clear by the staging of the procession in Siena on the eve of the Assumption that the aim was to create a vision of a unified city. This is clear first because citizens were made to participate and second because they were required to come together with the people with whom they lived in their *contrade*.

71. Catherine Bell, in her summary analysis of ritual studies, offers a series of categories of types of ritual of which political ritual is one. It was Clifford Geertz, however, who first articulated the idea that political ritual not only represents but actually also constitutes power. See Bell, *Ritual Perspectives and Dimensions* (Oxford: Oxford University Press, 1997), pp. 128–129; and Clifford Geertz, *Negara: The Theater-State in Nineteenth-Century Bal* (Princeton, NJ: Princeton University Press, 1980), pp. 102, 124, 131. I would like to thank my colleague Dana Howell for introducing me to this and other texts on Ritual studies.

72. Catherine Bell, *Ritual Theory Ritual Practice* (New York: Oxford University Press, 1992), p. 27. Barbara Myeroff also notes that: "By dramatizing abstract, invisible conceptions, it [ritual] makes vivid and palpable our ideas and wishes, and as Geertz has observed, the lived-in order merges with the dreamed-of order." Barbara G. Myeroff, "A Death in Due Time: Construction of Self and Culture in Ritual Drama," in J. J. MacAloon, *Rite, Drama, Festival, Spectacle Rehearsals Toward a Theory of Cultural Performance* (Philadelphia: Institute for the Study of Human Issues, 1984), p. 151.

73. Myeroff, "A Death in Due Time," p. 151.

74. Trexler, *Public Life*, 1980, p. 43.

75. For further reading on ritual theory see Bell, *Ritual Perspectives and Dimensions*, 1997.

76. See Webb, *Patrons and Defenders*, pp. 114, 115.

77. "E nota che ne' detti tempi la città di Firenze e' suoi cittadini fu nel più felice stato che mai fosse, e durò insino agli anni MCCLXXXIIII, che si cominciò la divisione tra 'l popolo e' grandi, appresso tra' Bianchi e' Neri." See G. Villani, *Nuova Cronica*, VIII, 89, p. 548.

78. This too was often symbolic, because, as has been noted, some of the entries were the last resort of an embattled commune attempting to maintain its stability.

79. See A. Lensi, *Palazzo Vecchio* (Florence: Alinari 1929); and Jurgen Paul, *Der Palazzo Vecchio in Florenz: Ursprung und bedeutung Seiner Form* (Florence: L.S. Olschki, 1969).

80. Marvin Trachtenberg, *Dominion of the Eye* (1997).

81. "Thus the ideological potions of the dominant power structures of Florentine society were not diffusely or circuitously propagated in urbanism, but instead were mainlined directly through code-governed practice into its veins, where it can be sampled and read with some certainty." Trachtenberg, *Dominion of the Eye*, pp. 149–50.

82. See in particular M. Christine Boyer, *The City of Collective Memory: Its Historical Imagery and Architectural Entertainments*, 5th ed. (Cambridge, MA: MIT Press, 2001)

83. Such a description appears in the anonymous chronicle edited by A. Gherardi. Although this description relates to a wedding held in 1384, it can be assumed that it describes a long standing tradition. A. Gherardi, ed., *Cronache dei Secoli XIII e XIV*, one volume only, *Diario d'Anonimo Fiorentino dall'anno 1358 al 1389* (Florence: Cellini, 1876), pp. 209–481, 452.

84. See Joanna Cannon, "Pietro Lorenzetti and the History of the Carmelite Order," *Journal of the Warburg and Coutauld Institutes*, L (1987): 18–34, who relates this scene to the actual location of the Carmelite Church in Siena. The description of the entry of Robert's son is found in the *Cronache Senese*: "E nel detto anno venne in Siena il figliuolo del re di Napoli e l prenze suo figliuolo, e fu lo'fatto grande onore, e staciorsi bandiere e facesi falo per le torri e grandissima festa della sua venuta." *Cronache Senese dei Fatti Riguardanti la Città e il suo Territorio, di autore anonimo de secolo XIV*, Lisini and Jacometti ed., *Cronache Senese*, pp. 131–132.

85. For the text *laude*, which is written as a dialogue between Christ and the Devil see Emile Faccioli ed., vol. 1, *Il Teatro Italiano dalle origini al Quattrocento* (Turin: Einaudi, 1975), pp. 62–64.

86. Although this was once argued, recent scholarship has not found any evidence of the possibility of a connection between the staging of religious drama and the composition of narrative altarpieces. Given the fact that the media are so distinct spatially and temporally, I think it is highly unlikely there is any specific connection. However, as Baxandall notes, by the fifteenth century some sort of relationship was noticed between painting and the sacred productions. See Baxandall, *Painting and Experience*, 1988, p. 72. See also Mark C. Rogers "Art and Public Festival," p. 6 who notes: "Frederick Hartt states of the Annunciation scene in the Arena Chapel, 'The two stages on which Giotto has placed the participants of the Annunciation are probably derived from constructions used in the dramatizations that took place during the Trecento in Padua, starting at the Cathedral and culminating in the Arena chapel.' Yet, research on the dramatization at Padua and of that era has produced no evidence whatsoever that the stagecraft included little architectural constructions like those in Giotto's frescoes."

87. Julie Codell makes a similar argument for the representation of the city by Giotto in the Peruzzi Chapel scene of the *Raising of Drusiana*. See J. Codell, "Giotto's Peruzzi Chapel Frescoes: Wealth, Patronage and the Earthly City," *Renaissance Quarterly*, 41 (1988): 583–613.

88. Becker, *Florence in Transition*, vol. 1, 1967, p. 119.

89. See Rona Goffen, *Spirituality in Conflict: Saint Francis and Giotto's Bardi Chapel* (1988), pp. 1–12 for a review of the history of the construction of the third building.

90. The Peruzzi family can be taken as an example here. Numerous members of the family served as priors on the city council and some held the most important office of standard-bearer of justice. See Roberto Ciabani and Beatrix Elliker, eds., *Le famiglie di Firenze*, 4 vols. (Florence: publisher, 1992), p. 40; and Leonetto Tintori and Eve Borsook, *Giotto: The Peruzzi Chapel* (New York: Harry N. Abrams, 1965), p. 8. For a discussion of patronage in Siena see Maginnis, *The World of the Early Sienese Painter*, 2001.

91. For a discussion of patronage in Siena see Maginnis, *The World of the Early Sienese Painter*, 2001.

92. See Kessler, *Spiritual Seeing and Sixten Ringbom, Icon to Narrative: The Rise of the Dramatic Close-Up in Fifteenth-Century Devotional Painting*, 2nd ed., revised and augmented (Doornspijk, The Netherlands: Davaco, 1984 [1965]).

Chapter Five

1. Millard Meiss, *Painting in Florence and Siena after the Black Death* (Princeton, NJ: Princeton University Press, 1951 (republished 1964, 1973, 1978).

2. Both Hayden Maginnis and Henk Van Os have written summaries of the historiography of Meiss's thesis. These also include a bibliography of the most important contributions to the argument. See Maginnis, *Painting in the Age of Giotto*, pp. 164–191; and Henk Van Os, "The Black Death and Sienese Painting: A Problem of Interpretation," *Art History*, 4 (1981): 237–49 (an article also published in *Sienese Altarpieces, 1215–1460*, vol. II, , II pp. 24–33).

3. See for example Bruce Cole, "Some Thoughts on Orcagna and the Black Death Style," *Antichità Viva*, 22 (1983): 27–37; John Paoletti, "The Strozzi Altarpiece Reconsidered," in *Memorie Domenicane*, NS, 20 (1989): 279–300; and C. K. Fengler, "Bartolo di Fredi's Old Testament Frescoes in San Gimignano," *Art Bulletin*, 63 (1981): 374–84.

4. The dominant theory now seems to be that changes in patronage and workshop practices were a major force in stylistic change. This is argued by Van Os and Steinhoff, whereas Maginnis has put forward a theory that suggests the roots of stylistic change were inherent in the painting of the 1330s. See Van Os, "The Black Death," J. Steinhoff, "Artistic Working Relationships after the Black Death," *Renaissance Studies*, vol. 14, no. 1 (2000): 1–45; and Maginnis, *Painting in the Age of Giotto*, p. 186.

5. In order to limit the number of illustrations I am going to cite pl. numbers in Miklòs Boskovits, *Pittura Fiorentino alla vigilia del Rinascimento 1370–1400* (Florence: Edam, 1975), that can be referred to for images not illustrated here. For an image of the Rinuccini Chapel Master's *Presentation of the Virgin in the Temple*, that is the most detailed of his copies of Taddeo's images, see plate. 59.

6. See for examples Boskovits, *Pittura Fiorentina*, pls. 85 and 99. Note here that a number of paintings from the second half of the century are in the Accademia of Florence where better images can be found in the catalogue of that museum.

7. Anna Padoa Rizzo, ed., *Iconografia di San Giovanni Gualberto* (Pisa: Edizioni Vallombrosa, 2002), pp. 54–55.

8. It is interesting to note here that Taddeo is clearly referencing the church of Santa Croce in his image, since this fresco was in the refectory of the convent that opened onto a cloister in which a very similar view to the one shown in Taddeo's fresco can be seen. In comparison, the *Gualbertus Miracle* takes place in Vallombrosia whereas the painting was made for Florence. Giovanni also notably reduces the detailing of the church by excluding its apse and fenestration.

9. I should note here that this dome is also very similar in form to the one that the sculptor/painter Orcagna created for the tabernacle of Orsanmichele in the 1350s.

10. The dome appears again in Niccolo di Pietro Gerini's version of the life of Saint Matthew and also in the scene of the saint's death painted in San Franceso in Prato. Boskovits, *Pittura Fiorentina*, pl. 99.

11. "Chosroes wanted to be worshipped as God. He built a gold-and-silver tower studded with jewels, and placed in it images of the sun, the moon, and the stars. Bringing water to the top of the tower through hidden pipes, he poured down water as God pours rain, and in an underground cave he had horses pulling chariots around in a circle to shake the tower and produce a noise like thunder. Then he abdicated his kingdom in favor of his son and, profane as he was, settled himself in the tower as in a fane, put the Lord's cross at his side, and decreed that all should call him God." Jacopo de Voragine, *The Golden Legend: Readings on the Saints*, vol. 2, trans. William Gamper Ryan (Princeton, NJ: Princeton University Press, Princeton, 1995), pp. 168–169.

12. Any reader worth her salt is going to ask: Would the viewer know the text? The answer to that question is yes, I would venture to say, because since the apse at this point was the preserve of the monks of Santa Croce rather than the Florentine community as a whole (the *tramezzo* would have excluded everyone other than those who owned chapels in the transept) we can assume that the monks were literate and that they had read the legend of the True Cross. Towers were significant structures in the fourteenth century because they provided defense against rival factions and were emblems of civic and ecclesiastical strength (witness the building of the *Campanile* before the actual cathedral in Florence). Further proof of their importance is apparent in the city regulations that were put in place to limit the height of private towers in favor of those of the commune. See Villani, *Nuova Cronica*, VII, 39, p. 329. Therefore Agnolo's choice to depict a temple rather than a tower was most likely conscious and noted. For further discussion and bibliography of the significance of towers see D. Friedman, *Florentine New Towns*, pp. 215–216.

13. The inside/outside view and the space-box are used into the 15th century.

14. It seems to me that shifts in this ideal are also well exemplified by a comparison of the chronicles. For example, the ebullience of Giovanni Villani's description of the riches of Florence (famous passage from bk. 11, chap. 44, pp. 197–202 in the 1993, ed.) in 1338 is nowhere to be found in the numerous chronicles that date from the second half of the century. See Gene Brucker, *Florentine Politics and Society* (1962) and Louis Green, *Chronicle into History, An Essay on the Interpretation of History in Florentine 14th Century Chronicles* (1972).

15. This is Trexler's term. See R. Trexler, *Public Life in Renaissance Florence* (1980), p. 354.

16. Florentine chronicles contain a great deal more evidence of crisis processions than do the Sienese. That said, the transformation of the civic ideal that was experienced in Florence and made manifest in the repeated use of the crisis procession is evidenced in Siena mainly by the repeated crises, changes in government, economic decline and devastation of the countryside because of the plague and the repeated attacks of the Companies of Adventure. See William Caferro, *Mercenary Companies and the Decline of Siena* (Baltimore, MD: John Hopkins University Press, 1998).

17. For a discussion of this category of ritual identified as Rites of Affliction, see Catherine Bell, *Ritual Perspectives and Dimensions* (Oxford: Oxford University Press, 1997), pp. 115–120.

18. If we were to take the chronicle of Donato di Neri, which begins in 1352, as an example, the Sienese chronicles of the second half of the century are dominated by descriptions of battles in which both Siena in particular, and Tuscany in general, were involved. See Alessandro Lisini and Fabio Iacometti, eds., *Cronache Senesi*, pp. 569–685.

19. See Caferro, *Mercenary Companies*.

20. See Samuel K. Cohn, *The Cult of Remembrance and the Black Death* (Baltimore, MD: Johns Hopkins University Press, 1992). See Maginnis (1997) for a good summary of the scholarship on the effects of the plague; and Pia Palladino, *Art and Devotion in Siena After 1350* (San Diego, CA: Timken Museum of Art, 1997).

21. Judith Steinhoff, "Artistic Working Relationships after the Black Death."

22. See Brucker, *Florentine Politics and Society,* pp. 20–21 and 40ff.

23. Giovanni Boccaccio, *Decameron* (New York: W. W. Norton & Company, 1977) p. 5

24. Boccaccio, *Decameron,* p. 9, and Michele da Piazza, reprinted in Rosemary Horrox, ed., *The Black Death* (New York: Manchester University Press, 1994), pp. 36. Marchionne di Coppo Stefani (1903–1913) describes people abandoning their houses, in *Cronaca Fiorentina,* p. 230.

25. Boccaccio, *Decameron,* p. 12; and de Mussis in Horrox, ed., *The Black Death,* p. 21.

26. Stefani, *Cronaca Fiorentina,* p. 261.

27. For my own purposes it is useful to list these regimes here and to note perhaps that this sort of shift in government was mirrored in Siena. From the ousting of the Duke in 1343 to the Ciompi revolt in 1378 the *nuove gente* regime stayed in power, although there were challenges. The Ciompi reigned for a very brief period, to be succeeded by the guild regime of 1378 to 1382, which was followed by a government run by the *popolo grasso* led by Archguelfs. See Brucker, *Florentine Politics and Society.*

28. Gene Brucker, "The Florentine Popolo Minuto and Its Political Role, 1340–1450," in Lauro Martines, ed., *Violence and Civic Disorder in Italian Cities, 1200-1500* (Los Angeles, CA: University of California Press, 1972), pp. 155–183.

29. Becker, *Florence in Transition,* vol. II, 1968, p. 160

30. Ibid., p. 157.

31. Ibid., pp. 179–80.

32. Ibid., p. 152.

33. See Becker, *Florence in Transition* vol. I, 1967, p. 25.

34. Ibid., p. 25 and vol. II, 1968, pp. 171–172; and Brucker, *Florentine Politics,*1962, p. 93.

35. Brucker, *The Civic World of Early Renaissance Florence* (1977), pp. 43–44.

36. Ibid., pp. 62ff.

37. Brucker, *Florentine Politics and Society,* 1962, p. 133; and Becker, *Florence in Transition,* vol. II, 1968, p. 2.

38. Ibid., pp. 134, 158.

39. Ibid.; and Richard Trexler, *The Spiritual Power Republican Florence under Interdict* (Leiden: E. J. Brill, 1974).

40. See W. Bowsky, *A Medieval Italian Commune: Siena under the Nine, 1287-1355,* 1981, pp. 299ff.

41. The composition of the Dodici, made up of *popolo minuto,* is described and discussed by Caferro, *Mercenary Companies,* pp. 22–23; Judith Hook, *Siena, A City and Its History* (London: H. Hamilton, 1979); and Valerie Wainwright, "Conflict and Popular Government in Fourteenth Century Siena: Il Monte dei Dodici, 1355–1368," in *Atti del III Convegno di studi sulla storia sulla storia dei ceti dirigenti in Toscana tardo comunale* (Florence: Monte Oriolo, 1983) pp. 57–80.

42. A good summary of these different regimes and their problems is found in Caferro, *Mercenary Companies,* pp. 21–24.

43. See Caferro, *Mercenary Companies,* p. 23, n. 20; and Vincenzo Buonsignori, *Storia della Repubblica di Siena* (1856), pp. 218–220.

44. See Caferro, *Mercenary Companies,* pp. 36–61.

45. The loggia was proposed in 1356 but construction was not started until 1374. The first ceremony to take place in the loggia was in 1382. The ambivalence with which this project was undertaken and received by the citizens in Florence is discussed by Kim Sexton, with addition relevant bibliography. See Sexton, "A History of Renaissance Civic Loggias in Italy: From the Loggia dei Lanzi to Sansovino's Loggetta," diss., Yale University, 1997, pp. 261–267.

46. See Kees Van Der Ploeg, *Art, Architecture and Liturgy,* pp. 97–120.

47. Gene Brucker notes: "Prior to 1343, Florence had welcomed a host of dignitaries: Pope Gregory X in 1273; King Charles I of Naples in the same year; Charles of Valois, brother of King Philip of France, in 1301; King Robert of Naples in 1310; his son Charles of Calabria in 1326. But after the Black Death the city gates were closed to emperors, kings and many lesser princes. Between 1373 and 1419 no pope set foot in Florence, and only rarely was a cardinal welcomed there. Whenever a German emperor visited Italy, citizens urged the authorities to prohibit his entry into Florence. Three reasons were invariably cited for this reluctance to admit the great. Florentines feared that a prince might be tempted to seize control of the city, as the Duke of Athens had done in 1342. Second, they felt that the visit of prominent men might adversely affect the republic's relations with other states. The most recent manifestation of this phobia occurred in 1401, when the republic concluded an alliance with the emperor-elect Rupert against Giangaleazzo Visconti." Brucker, *Civic World,* 1977, pp. 297–298.

48. Brucker, *Civic World,* 1977, pp. 297–98.

49. The duke, like Charles of Calabria before him, was given broad ranging powers in order to bring peace and stability to the commune. See Becker, *Florence in Transition,* vol. II, 1968.

50. Bowsky, *Medieval Italian Commune,* 1981, p. 299ff.

51. Kessler, *Rome 1300* (2000) p. 186.

52. A very detailed description of this procession is found in the Chronicle of Paolo Montauri (c. 1432) which includes not only the route of the procession— from the cathedral to the Campo to the church of San Cristoforo and back to the cathedral—but also descriptions of a wooden crucifix and a panel of the Virgin that the participants carried with them. This procession is discussed by Van Os and Kempers. See Van Os, *Sienese Altarpieces,* pp. 11–12 and Kempers, "Icons, Altarpieces, and Civic Ritual in Siena Cathedral, 1100–1530," in Barbara A. Hanawalt and Kathryn L. Reyerson, eds., *City and Spectacle in Medieval Europe* (Minneapolis, MN: University of Minnesota Press, 1994), pp. 89–136.

53. For the Chronicles consulted in this examination see Bibliography.

54. Il detto anno MCCCXL, all'uscita di marzo, aparve inn aria una stela cometa in verso levante nel fine del segno del Virgo e cominciamento della Libra, i quali sono segni umani, e mostrano i beni sopra i corpi humani di grande ditreazione e morte, Per questa mortalita, a di XVIII di giugno, per consiglio del vescovo e di riligiosi si fece in Firenze general processione, ove furono quasi tutti i cittadini sani maschi

e femmine col corpo di Cristo ch'e a Santo Ambro-
gio, e con esso s'ando per tutta la terra infino a ora
di nona, con piu di CL torchi accesi. Giovanni Vil-
lani, *Nuova Cronica,* book XII, 114, p. 225. Trexler
notes that this is the last time this relic is used since
it fails to aid the city this time. See Trexler, *Public
Life,* p. 353.

55. "E nota, lettor, quante tempeste occorse in
questo anno alla nostra città, di fame, mortalitya, rov-
ina, tempeste, e fuochi, e discordie tra' cittadini, per
li soperchi di nostri peccati." Villani, *Nuova Cronica,*
XIII, 91, p. 499

56. In connection with Charles' arrival after
describing the difficulties Florence has had Villani
notes: "Yet less than a year later through their effort
and money they could get such a lord to come to Flo-
rence with such a chivalry and baronage, and the
legate of the pope to boot." translated in Trexler,
1980, p. 313. See also G. Villani, *Nuova Cronica,* XI,
1, pp. 521–523.

57. See Trexler, 1980, for documents on the 1368
procession; see Manni, *Cronichette d'Incerto,* 1844, p.
273–274 for 1372; See Naddo da Montecatini,
Croniche Fiorentine, p. 64–65 for 1383; See *Diario di
Anonimo Fiorentino,* p. 59 for 1388; See Naddo da
Montecatini, *Croniche Fiorentine,* p. 98–99 for 1388
and *Diario di Anonimo Fiorentino,* p. 99 for 1390.

58. See Diana Webb, *Patrons and Defenders,* 1996,
pp. 164–168; Richard Trexler, "Florentine Religious
Experience: The Sacred Image," *Studies in the Renais-
sance,* 19 (1972): 7–41; Alessandro Bicchi and Alessan-
dro Ciandella, *Testimonia Sanctitatis Le reliquie e i
reliquiari del Duomo e del Battistero di Firenze* (Florence:
Mandragora, 1999); and Sally J. Cornelison., "Art
Imitates Architecture: A Relic of St. Philip, Its Reli-
quary, and Ritual in Renaissance Florence."

59. Matteo Villani, *Cronica,* Ugo Guanda ed. (Flo-
rence: Pietro Bembo, 1995), IV, 7, p. 481.

60. "...lunedì a' dì 25. si fece grandissima proces-
sione, e venne in Firenze la Tavola di S. Maria
Impruneta, e dinanzi a lei andarono tutte le Reliquie
de' Santi di Firenze, e del contado che furono più di
dodicimila Cristiani. La detta Tavola si pose in su
l'altare, che si fece in su la ringhiera del palazzo de'
Signori, molto onorevole; furonvi tutti li Cavalieri,
ed altri notabili cittadini. Il popolo, che vi si trovò

fu innumerabile, pregando lei con gran divozione,
che accatti grazia dal suo diletto figliuolo, cioè Giesù
Cristo, che guardi questa città,..." Naddo da Monte-
catini, *Croniche Fiorentine,* ed. *Delizie,* 1784, 1383, pp.
64–65.

61. This event is described by Webb, although not
cited. It is related in the anonymous chronicle now
known by the title *Alle Bocche della Piazza,* published
by Anthony Molho and Franek Sznura, eds., *Alle boc-
che Della Piazza Diario di Anonimo Fiorentino 1382-
1401),* Leo S. Olschki, ed., Florence, 1986, p. 59. The
original manuscript is in the Biblioteca Nazionale in
Florence with the shelf mark BNF, Panciatichi, 158;
this event is found on f. 150r.

62. On the hierarchy in processions see Webb,
Patrons and Defenders.

63. See both Marchionne di Coppo Stefani's
Cronaca Fiorentina pp. 295–296 and the *Cronichette
d'incerto,* ed. Manni, p. 288.

64. "...ed ancora s'andava ogni di a processione
colle reliquie e canti musichi con tutto lo popolo
dietro; ed ogni compagnia facea battuti in tanto
numero, che v'erano infino a fanciulli di dieci anni,
e certo piu di cinquemila battuti, quando si facea
processione generale, v'erano, e ventimila persone o
piu seguiano la processione..."Marchionne di Coppo
Stefani, *Cronaca Fiorentina,* pp. 295–296. For more on
the late fourteenth-century flagellant communities
see Daniel E. Bornstein, *The Bianchi of 1399, Popular
Devotion in late Medieval Italy* (Ithaca, NY: Cornell
University Press, 1993). Gene Brucker argues that
these processions also had a political purpose in that
they were organized by factions seeking peace with
the papacy for Florence and thus they were in oppo-
sition to government policy. See Brucker, *Florentine
Politics and Society,* pp. 320–322.

65. Translation in Trexler, *Public Life,* 1990, p. 313.

66. To the extent that it is possible, historians
have noted that the tone of the chronicles of the
second half of the century is different from that of
the first half. Caferro notes that there is a certain
hopelessness and sarcasm in the writing of the
Sienese chronicler Donato di Neri, *Mercenary Compa-
nies,* pp. 23 and 26. The same is true of the Floren-
tine chronicles; see Becker, *Florence in Transition,* vol.
II, 1968.

Bibliography

Published Primary Sources

Alle Bocche della Piazza Diario di Anonimo Fiorentino 1382–1401. Ed. Anthony Molho and Franek Sznura. Florence: Leo S. Olschki, 1986.

Anonimo Romano. *Cronica*. Ed. Giuseppe Porta. Milan: Adelphi Edizioni, 1979.

Buonsignori, Vincenzo. *Storia della Repubblica di Siena*. 2 vols. Siena: 1856.

Cennini, Cennino D'Andrea. *The Craftsman's Handbook*. Trans. D. V. Thompson. New York: Dover, 1960.

Compagni, Dino. *Dino Compagni's Chronicle of Florence*. Trans. and intro. Daniel F. Bornstein. Philadelphia: University of Pennsylvania Press, 1986.

Cronache dei secoli XIII e XIV: Annales Ptolemaei Sanzanome iudicis Gesta Florentinorum, Diario di ser Giovanni di Lemmo da Comugnori, Diario d'anonimo fiorentino dall'anno 1358 al 1389. Ed. Alessandro Gherardi. Florence: Tipi di M. Cellini, 1876.

Cronache Senesi. Ed. Alessandro Lisini and Fabio Iacometti. In *Rerum Italicarum Scriptores*, Nuova edizione riveduta, ampiata e corretta XV, pt. VI. Bologna: Nicola Zanichelli, 1931–1937.

Cronichette Antiche di Varii Scrittori del buon secolo della lingua Italiana. Ed. Domenico Maria Manni. Milan: Giovanni Silvestri, 1844.

Dati, Gregorio. *L'Istoria di Firenze di Gregorio Dati: 1380–1405*. Ed. Luigi Pratesi. Norcia: Tipografia Tonti Cesare, 1902.

Gunther of Pairis. *The Capture of Constantinople: The Hystoria Constantinopolitana*. Ed. and trans. Alfred J. Andrea. Philadelphia: University of Pennsylvania Press, 1997.

Minerbetti, Piero di Giovanni. *Cronica volgare di Anonimo Florentino, dall'anno 1385–1409 gia attribuita a Piero di Giovanni Minerbetti*. Ed. Elina Bellondi. In *Rerum Italicarum Scriptores*, vol. 27, pt. 2. Città di Castello: Tipi della Casa Editrice S. Lapi, 1915.

Naddo da Montecatini. *Memorie Storiche*. Ed. Ildefonso di San Luigi. In *Delizie degli eruditi Toscani*. Vol. XVIII. Florence: 1770–1789.

Pucci, Antonio. *Centiloquio*. Ed. Ildefonso di San Luigi. In *Delizie degli eruditi*. Vols. III–VI. Florence: 1772–1775.

Salimbene, de Parma. *The Chronicle of Salimbene de Adam*. Trans. Joseph Baird, Giuseppe Baglivi and John Robert Kane, Binghamton, N.Y.: Medieval & Renaissance Text & Studies, 1986.

Stefani, Marchionne di Coppo. *Cronaca Fiorentina*. Ed. Niccolo Rodolico. In *Rerum Italicarum Scriptores*, new edition vol. 30, pt. 1. Città di Castello: Tipi dell'Editore, 1903–1913.

Villani, Filippo. *Le Vite d'uomini illustri fiorentini*. Florence: Sansone, 1847.

Villani, Giovanni. *Nuova Cronica*. 3 vols. Parma: Fondazione Pietro Bembo, Ugo Guanda Editore, 1990–1993.

Villani, Matteo. *Cronica con la continuazione di Filippo Villani*. 2 vols. Parma: Fondazione Pietro Bembo, 1995.

Secondary Sources

Aiken, Jane Andrews. "Review of Marvin Trachtenberg, *Dominion of the Eye: Urbanism, Art and Power in Early Modern Florence.*" *Speculum*, 76 (2001): 539–541.

Al-Hamdani, B. "The Iconographical Sources for the Genesis Frescoes Once Found in S. Paolo f. l. m." *Atti del IX Congresso Internazionale di Archeologia Cristiana, Rome, 1975.* Vatican: 1978. Vol. II. pp. 11–35.

Andaloro, Maria. "Ancora una volta sull'Ytalia di Cimabue." *Arte Medievale*, 2 (1984): 143–177.

Apollonio, Mario. *Storia del teatro Italiano.* Florence: Sansoni, 1954.

Aronow, Gail Schwarz. "A Documentary History of the Pavement Decoration in Siena Cathedral, 1362 through 1506." Diss. Columbia University, 1985.

Artusi, Luciano, and Gabbrielli, Silvano. *Gioco, Giostra, Palio in Toscana.* Florence: Libreria S. P., 1978.

Bagnoli, Martina. *The Medieval Frescoes in the Crypt of the Duomo of Anagni.* 2 vols. Diss. Johns Hopkins University, 1998.

Baldovin, John F. *The Urban Character of Christian Worship.* Rome: Pont. Institutum Studiorum Orientalium, 1987.

Balestracci, Duccio, and Piccini, Gabriella. *Siena nel Trecento, assetto urbanistico e strutture edilizie.* Florence: Edizioni Clusf, 1977.

Barclay Lloyd, J. *The Medieval Church and Canonry of S. Clemente in Rome.* Rome: San Clemente, 1989.

Bec, Christian. "Il Mito di Firenze da Dante al Ghiberti." In *Lorenzo Ghiberti nel Suo Tempo* (Atti del Convengo Internazionale di Studi, 18–21 Oct. 1978). Florence: 1980.

Beck, Hans-Georg; Fink, Karl August; Glazik, Josef; Iserloh, Erwin; and Wolter, Hans. *History of the Church from the High Middle Ages to the Eve of the Reformation.* Trans. Anselm Biggs. New York: Crossroad, 1982.

Becker, Marvin B. *Florence in Transition. Vol. 1: The Decline of the Commune.* Baltimore, MD: Johns Hopkins University Press, 1967.

_____. *Florence in Transition. Vol. II: Studies in the Rise of the Territorial State.* Baltimore, MD: Johns Hopkins University Press, 1968.

Bell, Catherine. *Ritual Theory Ritual Practice.* New York: Oxford University Press, 1992.

Bellosi, Luciano. *La pecora di Giotto.* Torino: G. Einaudi, 1985.

Belting, Hans. *Likeness and Presence: A History of the Image before the Era of Art.* Trans. Edmund Jephcott. Chicago: University of Chicago Press, 1994.

_____, ed. *Il medio oriente e l'occidente nell'arte del XIII secolo.* Bologna: CLUEB, 1982.

Bennett, Jill. "Stigmata and Sense Memory: St. Francis and the Affective Image." *Art History*, 24, 1 (2001): pp. 1–16.

Bernacchio, Nicoletta. "Una Veduta di Roma nel XIII secolo dalla Crypta della Cattedrale di Anagni." *Archeologia Medievale*, XXI (1995): 519–529.

Bertoldi, M. E. *S. Lorenzo in Lucina.* Rome: Le Chiese di Roma Illustrate, [n.s. 28] 1994.

Bicchi, Alessandro, and Ciandella, Alessandro. *Testimonia Sanctitatis: Le reliquie e i reliquiari del Duomo e del Battistero di Firenze.* Florence: Mandragora, 1999.

Bloch, Herbert. "Monte Cassino, Byzantium, and the West in the Earlier Middle Ages." *Dumbarton Oaks Papers*, 3 (1946): 165–224.

Bongiorno, L. "The Theme of the Old and New Law in the Arena Chapel." *Art Bulletin*, 50, 1 (1968): 11–20.

Boskovits, Miklos. "'Quello ch'e Dipintori oggi dicono prospettiva': Contributions to Fifteenth-Century Italian Art Theory." Part I. *Acta Historiae Artium Academiae Scientianum Hungaricae*, VIII (1962): 241–60.

_____. "Orcagna in 1357 and in Other Times." *Burlington Magazine*, 113 (1971): 239–252.

_____. *Pittura Fiorentina alla Vigilia del Rinascimento.* Florence: Edam, 1975.

_____. "Gli affreschi della Sala dei Notari a Perugia e la pittura in Umbria alla fine del XIII secolo." *Bollettino d'Arte*, S. VI, LXVI (1981): 1–42.

_____. "Jacopo Torriti: un tentativo di bilancio e qualche proposta." In *Scritti per L'Instituto Germanico di Storia dell'Arte di Firenze.* Eds. Cristina A. Luchinat et al. Florence: Casa Editrice Le Lettere, 1997. pp. 5–16.

Boskovits, Miklos, and Gregori, Mina. *Corpus of Florentine Painting: The Works of Bernardo Daddi.* Sec. III, vol. III. Florence: Giunti, 1989.

Bowsky, William M. "The Impact of the Black Death upon Sienese Government and Society." *Speculum*, 39 (1964): 368–381.

_____. *A Medieval Italian Commune: Siena Under the Nine, 1287–1355.* Berkeley: University of California Press, 1981.

____, ed. *The Black Death: A Turning Point in History?* New York: Holt, Rinehart & Winston, 1971.

Brand, Charles M. "The Fourth Crusade: Some Recent Interpretations." *Medievalia et Humanistica*, 12 (1984): 33–46.

Braunfels, Wolfgang. *Die fruhchristlichen Mosaiken in S. Maria Maggiore zu Rom.* Wiesbaden: Steiner, 1975.

____. *Mittelalterliche Stadtbaukunst in der Toscana.* Berlin: Mann, 1988.

Brucker, Gene A. *Florentine Politics and Society, 1343–1378.* Princeton, NJ: Princeton University Press, 1962.

____. *The Civic World of Early Renaissance Florence.* Princeton, NJ: Princeton University Press, 1977.

Buchtal, H. "Some Representations from the Life of St. Paul in Byzantine and Carolingian Art," In *Studien zu altchristlichen und byzantinischen Monumenten.* Tortulae: Römische Quartalschrift, Supplementheft 30 (1966): 300–316.

Burresi, M., and Caleca, A. *Le croci dipinte.* Pisa: Litografia Tacchi, 1993.

Bush-Brown, Albert. "Giotto: Two Problems in the Origin of His Style," *Art Bulletin*, 34, 1 (1952): 42–46

Bynum, C. "Franciscan Spirituality: Two Approaches." *Medievalia et Humanistica*, NS, VII (1976): 193–197.

Caferro, William. *Mercenary Companies and the Decline of Siena.* Baltimore, MD: Johns Hopkins University Press, 1998.

Campbell, Thomas P., and Davidson, Clifford, eds. *The Fleury "Playbook": Essays and Studies.* Early Drama, Art and Music Monograph Series 7. Kalamazoo, MI: Medieval Institute Publications, 1985.

Cannon, Joanna, and Vauchez, Andre. *Margherita of Cortona and the Lorenzetti.* University Park: Pennsylvania State University Press, 1999.

Chretien, Heidi L. *The Festival of San Giovanni Imagery and Political Power in Renaissance Florence.* New York: Peter Lang, 1994.

Ciapelli, Giovanni. "Carnevale e Quaresima: Rituali e spazio urbano a Firenze (secc. XIII–XVI)." In *Riti e Rituali nelle Società Medievali.* Eds. Jacques Chiffoleau, Lauro Martines, and Agostini Paravicini Bagliani. Spoleto: Central Italiano di Studi sull'alto Medioevo, 1994. pp. 159–174.

Cocchi, A. *Degli Antichi reliquiari di Santa Maria del Fiore e di San Giovanni di Firenze.* Florence: Pellas, 1901.

Codell, Julie F. "Giotto's Peruzzi Chapel Frescoes: Wealth, Patronage and the Earthly City." *Renaissance Quarterly*, 41 (1988): 583–613.

Cohn, Samuel K., *The Cult of Remembrance and the Black Death.* Baltimore, MD: Johns Hopkins University Press, 1992.

____. *Creating the Florentine State: Peasants and Rebellion, 1348–1434.* London: Cambridge University Press, 1999.

Cole, Bruce. *Agnolo Gaddi.* Oxford: Clarendon Press, 1977.

____. "Some Thoughts on Orcagna and the Black Death Style." *Antichità viva*, 22 (1983): 27–37.

Cornelison, Sally J. "Art Imitates Architecture: The Saint Philip Reliquary in Renaissance Florence." *Art Bulletin*, 84, 4 (2004): 642–658.

Coulton, George G. *The Black Death.* New York: J. Cape & H. Smith, 1930.

Cutler, A. "Misapprehensions and Misgivings: Byzantine Art and the West in the Twelfth and Thirteenth Centuries." *Medievalia* VII (1981): 41–77.

____. "From Loot to Scholarship: Changing Modes in the Italian Response to Byzantine Artifacts, ca. 1200–1750," *Dumbarton Oaks Papers*, 49 (1995): 237–268.

Curzi, G. "La decorazione musiva della basilica dei SS Nereo ed Achilleo in Roma: Materiali ed ipotesi." *Arte Medievale* vii/2 (1993): 21–45.

D'Ancona, Alessandro. *Origini del teatro italiano.* 2nd ed. Rome: Bandi, 1971 [1891].

da Bra, Giuseppe. *San Lorenzo Fuori le Mura.* Rome: Tip. Pio X, 1952.

Dassmann, E. "Das Apsismosaik von S. Pudentiana in Rom." *Romische Quartalschrift*, lxv (1970): 67–81.

Davidsohn, Robert. *Storia di Firenze.* 8 vols. Translation of *Geschichte von Florenz* [Berlin, 1896–1927]. Florence: Sansoni, 1977.

Davis, Charles. "Topographical and History Propaganda in Early Florentine Chronicles and in Villani." *Medioevo e Rinascimento*, Annuario, 2 (1988): 33–51.

Davis-Weyer, C. "Das Apsismosaik Leos III in S. Susanna." *Zeitschrift fur Kunstgeschichte*, 28 (1965): 177–94.

____, and Emerick, J. "The Early Sixth-Century Frescoes at S. Martino ai Monti in Rome." *Romisches Jahrbuch fur Kunstgeschichte*, 21 (1984): 1–60.

DeBartholomaeis, Vicenzo. *Laude drammatiche e rappresentazioni sacre.* 3 vols., Florence: Le Monnier, 1943.

De Blaauw, Sible. *Cultus et Décor Liturgia e Architettura nella Roma Tardoantica e medievale.* 2 vols. Rome: Città del Vaticano, 1994.

____, and Kempers, Bram. "Jacopo Stefaneschi, Patron and Liturgist. A New Hypothesis Regarding the

Date, Iconography, Authorship and Function of His Altarpiece for Old St. Peter's." *Mededelingen van het Nederlands Instituut te Rome*, 47 (1987): 83–113.

Deimling, Barbara. "The Contamination of the Senses and the Purification of Art in Mid-Fourteenth-Century Florence." In *Ononre e Giorni: Studi su mille anni di Arte europea dedicati a Max Seidel*. Eds. Klaus Bergdolt and G. Bonsanti. Florence: Marsilio, 2001. pp. 167–176.

Demus, Otto. "Die Entstehung des Palaologenstils in der Malerei," *Berichte zum XI. Internationalen Byzantinisten-Kongress*, Munchen, 1958, IV, 2 (Munich: 1958). pp. 8ff.

_____. *Byzantine Art and the West*. New York: New York University Press, 1970.

Derbes, Anne. "Byzantine Art and the Dugento: Iconographic Sources of the Passion Scenes in Italian Painted Crosses." Diss. University of Virginia, 1980.

_____. "Documenting the Maniera Greca." *Abstracts of Papers, Twentieth Annual Byzantine Studies Conference*, University of Michigan, October 1994.

_____. *Picturing the Passion in Late Medieval Italy: Narrative Painting, Franciscan Ideologies, and the Levant*. New York: Cambridge University Press, 1996.

Dodwell, C. R. *The Pictorial Arts of the West 800-1200*. New Haven, CT: Yale University Press, 1993.

Doglio, Federico, ed. *Il Franciscanesimo e il Teatro Medioevale* (Atti del Convegno Nazionale di Studi San Miniato, 8–10 Oct., 1982). Castelfiorentina: Società Stroica della Valdelsa, 1984.

D'Onofrio, Mario, ed. *Romei and Giubilei: Il Pellegrinaggio Medievale a San Pietro (350-1350)*. Rome: Electa, 1999.

Edgerton, Samuel. *Pictures and Punishment: Art and Criminal Prosecution during the Florentine Renaissance*. Ithaca: Cornell University Press, 1985.

Edwards, Robert. *The Montecassino Passion and the Poetics of Medieval Drama*. Berkeley: University of California Press, 1977.

Ehrensperger Katz, I. "Les representationes de villes fortifiées dans l'art paleochretian et leures derivees byzantines." *Cahiers Archeologiques*, XIX (1969): 1–27.

Eleen, L. "Acts Illustrations in Italy and Byzantium." *Dumbarton Oaks Papers*, XXXI (1979): 255ff.

_____. "The Frescoes from the Life of St. Paul in San Paolo fuori le mura in Rome: Early Christian or Medieval?" *RACAR Revue d'art canadienne/Canadian Art Review*, 12 (1985): 252–59.

Elsner, Jas. *Art and the Roman Viewer: The Transformation of Art from the Pagan World to Christianity*. New York: Cambridge University Press, 1995.

Enders, Jody. *The Medieval Theater of Cruelty: Rhetoric, Memory, Violence*. Ithaca: Cornell University Press, 1999.

Fabbri, Nancy Roth, and Rutenburg, Nina. "The Tabernacle of Orsanmichele in Context." *Art Bulletin*, 63, 3 (1981): 385–405.

Fasoli, G. "La coscienza civica nelle laudes civitatum." In *La coscienza cittadina nel communi italiani del duecento*. Convengo del Cento di Studi sulla Spiritualita medievale, XI, Todi (1972): 11–44.

Fengler, Chrinstine Knapp. "Bartolo di Fredi's Old Testament Frescoes in San Gimignano." *Art Bulletin*, 63, 3 (1981): 374–84.

Fillitz, H. "Bemerkungen zum Freskenzyklus im Porticus von S. Lorenzo fuori le mura in Rom." *Wiener Jahrbuch fur Kunstgeschichte* xlvi-xlvii (1993–1994): 165–72.

Fiorani, Luigi; Mantovano, Giuseppe; Pecchiai, Pio; Martini, Antonio; and Orioli, Giovanni. *Riti, cerimonie feste e vita di popolo nell Roma dei papi*. Vol. XII. Bologna: Roma Cristiana, 1970.

Fortini, Arnaldo. *La Lauda in Assisi e le origini del teatro italiano*. Assisi: Edizioni Assisi, 1961.

Franchi, Antonion. *La Svolta politico-ecclesiastica tra Roma e Bisanzio (1249-1254)*. Rome: Pontificium Athenaeum Antonianum, 1981.

Frankfurter, David, ed. *Pilgrimage and Holy Space in Late Antique Egypt*. Boston: Brill, 1998.

Freuler, Gaudenz. *Bartolo di Fredi Cini: Ein Beitrag zur sienesishen Malerei des 14. Jahrhunderts*. Disentis: Desertina Verlag, 1994.

Gandolfo, F. "Assisi e il Laterano." *Archivio della Società romana di storia patria* CVI (1983): 63–113.

Garber, J. *Wirkungen der frühchristlichen Gemeldezyklen der altern Peters- und Pauls-Basiliken in Rom*. Berlin: Bard, 1918.

Gardner, Julian. "S. Paolo fuori le mura, Nicholas III and Pietro Cavallini." *Zeitschrift für Kunstgeschite*, no. 34 (1971): 240–248.

_____. "Pope Nicholas IV and the Decoration of Santa Maria Maggiore." *Zeitschrift für Kunstgeschite*, no. 36 (1973):1–50.

_____. "Nicholas III's oratory of the Sancta Sanctorum and its Decoration." *Burlington Magazine*, CXV (1973): 283–294.

_____. "Andrea di Boniauto and the Chapter House Frescoes in Santa Maria Novella." *Art History*, 2 (1979): 107–138.

Garrison, E. *Studies in the History of Medieval Painting*. Vol. IV. Florence: L'Impronta, 1953–62.

Gasparri, Stefano. "I Rituali della Cavalleria Cittadina. Tradizioni Militari e superiorita sociale nell' Italia del Duecento." In *Riti e Rituali nelle Società Medievali*. Eds. Jacques Chiffoleau, Lauro Martines, and Agostino Paravicini Bagliani. Spoleto: Central Italiano di Studi sull'alto Medioevo, 1994. pp. 97–114.

Gealt, A. "Nardo di Cione's Standing Madonna with Child." *Minneapolis Institute of Arts Bulletin*, 64 (1978–80): 69–79.

Geanakoplos, Deno J. *Emperor Michael Palaeologus and the West 1258-1282, A Study in Byzantine-Latin Relation*. Cambridge, MA: Harvard University Press, 1959.

_____. *Byzantine East and Latin West*. New York: Harper, 1966.

_____. "Theodore Gaza, A Byzantine Scholar of the Palaeologan 'Renaissance' in the Italian Renaissance." *Medievalia et Humanistica*, 12 (1984): 61–81.

_____. *Constantinople and the West*. Madison: University of Wisconsin Press, 1989.

Geertman, H. "*More veterum*": Il Liber Pontificalis e gli edifici ecclesiastici di Roma nella tarda antichità e nell' alto medioevo. Trans. M Beatrice Annis. Gronigen: Tjeek Willinki, 1975.

Gill, Joseph. *Church Union: Rome and Byzantium (1204-1453)*. London: Variorum Reprints, 1979.

Giurescu, Ena. "Trecento Family Chapels in Santa Maria Novella and Santa Croce: Architecture, Patronage and Competition." Diss. New York University, 1997.

Gnoli, R. *Topografia e toponomastica di Roma medioevale e moderna*. Rome: Foligno, 1984 [1939].

Goffen, Rona. "Balancing Acts: Reading Sources and Weighing Evidence in Recent Italian Renaissance Art History." *Renaissance Quarterly*, 52 (1999): 207–220. [A review of Anne Derbes, *Picturing the Passion* (1996); Martin Kemp, *Behind the Picture: Art and Evidence in the Italian Renaissance* (1997); Hayden B. J. Maginnis, *Painting in the Age of Giotto* (1997); and Anabel Thomas, *The Painter's Practice in Renaissance Tuscany* (1995).]

Grabar, A. "La decoration des coupoles a Karye Camii et les peintures italiennes du Dugento." *Jahrbuch der Oesterreichischen Byzantinischen Gesellschaft*, 6 (1957): 111–124.

Green, Louis. *Chronicle into History, An Essay on the Interpretation of History in Florentine Fourteenth Century Chronicle*. Cambridge, Eng.: Cambridge University Press, 1972.

Greenstein, Jack M. "On Alberti's 'Sign': Vision and Composition in Quattrocento Painting." *Art Bulletin*, 79, 4 (1997): 669–698.

Gross, V. P., ed. *The Meeting of Two Worlds: Cultural Exchange between East and West during the Period of the Crusades*. Kalamazoo, MI: Medieval Institute Publications, 1986.

Haines, Margaret. *La sagrestia delle Messe del Duomo di Firenze*. Florence: Cassa di Risparmio, 1983.

Halmo, Joan. *Antiphons for Paschal Triduum-Easter in the Medieval Office*. Ottawa: Institute of Mediaeval Music, 1995.

Hanawalt, Barbara A., and Reyerson, Kathryn L. *City and Spectacle in Medieval Europe*. Minneapolis: University of Minnesota Press, 1994.

Harpring, Patricia. *The Sienese Trecento Painter Bartolo di Fredi*. Toronto: Fairleigh Dickinson University Press, 1993.

Hatfield, Rab. "The Campagnia de' Magi." *Journal of the Warburg and Courtauld Institutes*, XXXIII (1970): 144–161.

Heffernan, Thomas J., and Matter, Ann E. *The Liturgy of the Medieval Church*. Kalamazoo, MI: Medieval Institute, 2001.

Herlihy, David, and Samuel K. Cohn. *The Black Death and the Transformation of the West*. Cambridge, MA: Harvard University Press, 1997.

Hetherington, Paul. "Pietro Cavallini, Artistic Style and Patronage in Late Medieval Rome." *Burlington Magazine*, 114 (1972): 4–10.

_____. "The Mosaics of Pietro Cavallini in Santa Maria in Trastevere in Rome." *Journal of the Warburg and Courtauld Institutes*, 33 (1973): 84–106.

_____. *Pietro Cavallini: A Study in the Art of Late Medieval Rome*. London: Sagittarius Press, 1979.

_____. *Medieval Rome: A Portrait of the City and Its Life*. New York: St. Martin's Press, 1994.

Hekscher, W. S. "Relics of Pagan Antiquity in Mediaeval Settings." *Journal of the Warburg and Courtauld Institutes*, I (1937–38): 204ff.

Herklotz, I. "Der mittelalterliche Fassadenportikus der Lateranbasilika und seine Mosaiken. Kunst und Propaganda am Ende des 12. Jahrhunderts." *Romisches Jahrbuch der Bibliotheca Hertziana*, XXV (1989): 25–95.

Heuck, I. "Der Maler der Apostelszenen im Atrium von Alt-St. Peter." *Mitteilungen des Kunsthistorischen Instutes in Florenz*, XIV (1969): 115–144.

Hierzegger, R. "Collecta und Statio. Die romischen Stationsprozessionen im fruhen Mitelalter." *Zeitschrift fur katholische Theologie* LX (1936): 511–554.

Hofmann, Thomas. *Papsttum und griechische Kirche in Suditalien in nachnormannischer Zeit (13–15. Jahrhundert).* Diss. Julius-Maximilians-Universitat zu Wurzburg, 1994.

Hook, Judith. *Siena: A City and Its History.* London: H. Hamilton, 1979.

Horb, F. *Das Innenraumbild des spaten Mittelalters.* Zurich and Leipzig: nd.

Horrox, Rosemary, ed. *The Black Death.* New York: Manchester University Press, 1994.

Howard, Donald R. *Writers and Pilgrims: Medieval Pilgrimage Narratives and Their Posterity.* Berkeley: University of California Press, 1980.

Hunt, Lucy-Anne. "Art and Colonialism: The Mosaics of the Church of the Nativity in Bethlehem (1169) and the Problem of 'Crusader' Art." *Dumbarton Oaks Papers,* 45 (1991): 69–85.

Huskinson, J. M. "The Crucifixion of St. Peter: A Fifteenth-Century Topographical Problem." *Journal of the Warburg and Courtold Institutes,* 32 (1969): 135–161.

Hyde, J. K. "Contemporary Views on Faction and Civil Strife in Thirteenth- and Fourteenth-Century Italy." In *Violence and Civil Disorder.* Ed. L. Martines. Berkeley: University of California Press, 1972. pp. 273–307.

Iacobini, A. "Il mosaico absidale di San Pietro in Vaticano." In *Fragmenta picta: Affreschi e mosaici stacati del Medioevo romano.* Ed. Maria Andaloro. Rome: Argos, 1989. pp. 119–29.

Jeffrey, David L. "Franciscan Spirituality and the Growth of Vernacular Culture." In *By Things Seen: Reference and Recognition in Medieval Thought.* Ed. David L. Jeffrey. Ottowa: University of Ottawa Press, 1979. pp. 143–160.

Jones, Lars R. "*Visio divina,* Eexegesis, and Beholder-Image Relationships: Indications from Donor Figure Representations." Diss. Harvard University, 1999.

Kazhdan, Alexander. "The Italian and Late Byzantine City." *Dumbarton Oaks Papers,* 49 (1995): 1–22.

Kempers, Bram. *Painting, Power and Patronage: The Rise of the Professional Artist in the Italian Renaissance.* Trans. Beverley Jackson and Allen Lane. London: Penguin Press, 1997 [1987, in Dutch].

_____. "Icons, Altarpieces, and Civic Ritual in Siena Cathedral, 1100–1530." In *City and Spectacle in Medieval Europe.* Eds. Barbara A. Hanawalt and Kathryn L. Reyerson. Minneapolis: University of Minnesota Press, 1994. pp. 89–136.

Kertzer, David I. *Ritual, Politics and Power.* New Haven, CT: Yale University Press, 1988.

Kessler, Herbert L. "'Caput et speculum omnium ecclesiarum': Old St. Peter's and Church Decoration in Medieval Latium." In *Italian Church Decoration of the Middle Ages and Early Renaissance.* Ed. W. Tronzo. Baltimore, MD: Villa Spelman Colloquia, 1989. pp. 119–46.

_____. *Studies in Pictorial Narrative.* London: Pindar Press, 1994.

_____. "La Decorazione della Basilica Medievale di San Pietro." In *Romei & Giubilei: Il Pellegrinaggio Medievale a San Pietro (350–1350).* Ed. Mario D'Onofrio. Rome: Electa, 1999. pp. 263–270.

_____. *Spiritual Seeing Picturing God's Invisibility in Medieval Art.* Philadelphia: University of Pennsylvania Press, 2000.

Kessler, Herbert L., and Wolf, Gerhard, eds. *The Holy Face and the Paradox of Representation.* Vol. 6. Bologna: Nuova Alfa Editoriale, 1998.

Kessler, Herbert L., and Zacharias, Johanna. *Rome 1300 on the Path of the Pilgrim.* New Haven, CT: Yale University Press, 2000.

Kinney, D. "S. Maria in Trastevere from its Founding to 1215." Diss. New York University, 1975.

_____. "Mirabilia Urbis Romae." In *The Classics in the Middle Ages: Papers of the 20th Annual Conference of the Center for Medieval and Early Renaissance Studies.* Eds. A. S. Bernardo and S. Levin. Binghamton, 1990. pp. 207–221.

Kipling, Gordon. *Enter the King: Theatre, Liturgy, and Ritual in Medieval Civic Triumph.* Oxford: Clarendon Press, 1998.

Kitzinger, E. "The Byzantine Contribution to Western Art of the Twelfth and Thirteenth Centuries." *Dumbarton Oaks Papers,* 20 (1966): 25–47.

_____. "A Virgin's Face: Antiquarianism in Twelfth-Century Art." *Art Bulletin,* 42, 1 (1980): 6–19.

Koehler, W. "Byzantine Art in the West." *Dumbarton Oaks Papers,* I (1940): 63–87.

Krautheimer, Richard. *Corpus Basilicarum Christianarum Romae.* 5 vols. Rome: Vatican City, 1937–1977.

_____. *Rome: Profile of a City, 312–1308.* Princeton, NJ: Princeton University Press, 1980.

Krautheimer, Richard, and Krautheimer-Hess, Trude. *Lorenzo Ghiberti.* Princeton, NJ: Princeton University Press, 1956.

Kreytenberg, Gert. *Orcagna Andrea di Cione: Ein universeller Kunstler der Gotik in Floren.* Mainz: Verlag Philipp von Zabern, 2000.

Kruger, Klaus. *Der fruhe Bildkult des Franziskus in Italien: Gestalt un Funktionswandel des Tafelbildes im 13. und 14. Jahrhundert.* Berlin: Mann, 1992.

____. *Das Bild als Schleier des Unsichtbaren. Asthetische Illusion in der Kunst der fruhen Neuzeit in Italien.* Munich: Wilhelm Fink Verlag, 2001.

Laiou, Angeliki E. *Constantinople and the Latins: The Foreign Policy of Andronicus II, 1282–1328.* Cambridge, MA: Harvard University Press, 1972.

____. "Observations on the Result of the Fourth Crusade: Greeks and Latins in Port and Market." *Medievalia et Humanistica*, 12 (1984): 47–66.

____. "Italy and the Italians in the Political Geography of the Byzantines (14th century)." *Dumbarton Oaks Papers*, 49 (1995): 73–98.

Laiou-Thomadakis, A. E. "The Byzantine Economy in the Mediterranean Trade System: Thirteenth–Fifteenth Centuries." *Dumbarton Oaks Papers*, 34–35 (1980–81): 177–222.

Lansing, Carol. *Power and Purity: Cathar Heresy in Medieval Italy.* New York: Oxford University Press, 1998 [1988].

La Piana, George. "The Byzantine Iconography of the Presentation of the Virgin Mary to the Temple and A Latin Religious Pageant." *Late Classical and Medieval Studies in Honor of Albert Matthias Friend, Jr.* Princeton, NJ: Princeton University Press, 1955. pp. 261–271.

Larson-Miller, Lizette. *Medieval Liturgy: A Book of Essays.* New York: Garland, 1997.

Levin, William. "A Lost Fresco Cycle by Nardo and Jacopo di Cione at the Misericordia in Florence." *Burlington Magazine*, 141 (1999): 75–80.

Likoudis, James. *Ending the Byzantine Greek Schism.* New Rochelle, NY: Catholics United for the Faith, 1992.

Lucchi, L. *Laude del Duecento e del Trecento.* Verona: Disco edito dalla Cassa di Risparmio di Verona, Vicenza e Belluno, 1981.

Lusini, V. *Il Duomo di Siena.* 2 vols. Siena: Tip. Editrice S. Bernardino, 1911–1939.

Mackie, G. "The Zeno Chapel: A Prayer for Salvation." *Papers of the British School at Rome*, 57 (1989): 172–199.

Maginnis, Hayden B. J. "Ambrogio Lorenzetti's Presentation in the Temple." *Studi di Storia dell'Arte*, 2 (1991): 33–50.

____. *Painting in the Age of Giotto: A Historical Reevaluation.* University Park: Pennsylvania State University Press, 1997.

____. *The World of the Early Sienese Painter.* University Park: Pennsylvania State University Press, 2001.

Maguire, Henry. "Truth and Convention in Byzantine Descriptions of Works of Art." *Dumbarton Oaks Papers*, 28 (1974): 111–140.

Maier, Cristoph, *Preaching the Crusades: Mendicant Friars and the Cross in the Thirteenth Century.* New York: Cambridge University Press, 1994.

Malmstrom, R. E. "S. Maria in Aracoeli at Rome." Diss. New York University, 1973.

Mancinelli, F. "Decorazione dell'arco trionfale e del catino absidale della chiesa di S. Pellegrino." *Bollettino dei Monumenti, Musei e Gallerie Pontificie*, iv (1983): 77–80.

Mancini, Adele. "La Chiesa medioevale di S. Adriano nel foro Romano." *Atti della Pontificia Accademia Romana di Archeologia*, 3, 40 (1967–68): 191–245.

Mancini, Andrea. "Francesco nella Lauda e nella Sacra Rappresentazione." In *Il Francescanesimo e il Teatro Medievale* (Atti del Convegno Nazionale di Studi, San Miniato, 8–10 Oct., 1982). Ed. Federico Doglio. Castelfiorentino: Società Storica della Valdelsa, 1984. pp. 135–147.

Manion, Margaret. "The Frescoes of S. Giovanni a Porta Latina—The Shape of a Tradition." *Australian Journal of Art*, I (1978): 93–109.

Manion, Margaret M., and Muir, Bernard J. *Medieval Texts and Images: Studies of Manuscripts from the Middle Ages.* Philadelphia: Harwood Academic Publishers, 1991.

Margiotta, A. "L'antica decorazione absidale della basilica di San Pietro in alcuni frammenti al Museo di Roma." *Bollettino dei Musei Comunali di Roma* n.s. ii (1988): 21–33.

Marques, Luiz C. *La Peinture du Duecento en Italie Centrale.* Paris: Picard, 1987.

Martines, Lauro, ed. *Violence and Civil Disorder in Italian Cities, 1200–1500.* Los Angeles, CA: Center for Medieval and Renaissance Studies, 1972.

Matthiae, Guglielmo. *Pittura Romana del Medioevo.* vol. II. Rome: Palombi, 1966.

____. *Mosaici medioevali delle chiese di Roma.* Rome: Instituto Poligrafico dello Stato, Liberia dello Stato, 1967.

Meiss, Millard, *Painting in Florence and Siena after the Black Death*, Princeton University Press, New Jersey, 1951 (republished 1964, 1973, 1978)

Metraux, M. "The Iconography of San Martino ai Monti in Rome." Diss., Boston University, 1979.

Middeldorf Kosegarten, A. "Zur Bedeutung der sieneser Domkuppel." *Münchner Jahrbuch der bildenden Kunst*, 3rd series, 21 (1970): 73–97.

____. *Sienesische Bildhauer am Duomo Vecchio: Studien zur Skulptur in Siena 1250–1330*. Munich: Bruckman, 1984.

Miller, Maureen C. *The Bishop's Palace, Architecture and Authority in Medieval Italy*. Ithaca: Cornell University Press, 2000.

Mitchell, Charles. "The Lateran Fresco of Boniface VIII." *Journal of the Warburg and Courtauld Institutes*, 14 (1951): 1–5.

Mitchell, John. "St. Sylvester and Constantine at the SS Quattro Coronati" In *Federico II e l'arte del Duecento italiano* (Atti della III. Settimana di studi di storia dell'arte medievale dell universita di Roma, 15–20 May, 1978) (Rome: University of Rome, 1980). Vol. II, 15–32.

Morey, C. R. *Lost Mosaics and Frescoes of Rome of the Mediaeval Period*. Princeton, NJ: Princeton University Press, 1915.

Morris, Colin. *The Papal Monarchy: The Western Church from 1050 to 1250*. New York: Oxford University Press, 1989.

Muñoz, Antonio. *La Basilica di S. Lorenzo fuori le mura*. Rome: Palombi Ed., 1944.

Myerhoff, Barbara G. "A Death in Due Time: Construction of Self and Culture in Ritual Drama." In J. J. MacAloon, ed., *Rite, Drama, Festival, Spectacle: Rehearsals Toward a Theory of Cultural Performance*. Philadelphia: Institute for the Study of Human Issues, 1984, 149–178.

Neff, Amy. "Byzantium Westernized, Byzantium Marginalized: Two Icons in the Supplicationes Variae." *Gesta*, vol. 38, 1 (1999): 81–102.

Nelson, Robert. "A Byzantine Painter in Trecento Genoa: The Last Judgment at S. Lorenzo." *Art Bulletin*, 67, 4 (1985): 548–565.

Nelson, Robert S. "The Italian Appreciation and Appropriation of Illuminated Byzantine Manuscripts, ca. 1200–1450." *Dumbarton Oaks Papers*, 49 (1995): 209–236.

Nessi, Silvestro. *La Basilica di S. Francesco in Assisi e la sua documentazione Storica*. Assisi: Casa Editrice Francescana, 1994.

Nicholson, Alfred. "The Roman School at Assisi." *Art Bulletin*, 12, 3 (1930): 270–300.

Nicol, Donald M. *The Last Centuries of Byzantium 1261–1453*. London: Rupert Hart-Davis, 1972.

Oakeshott, W. *The Mosaics of Rome from the Third to the Fourteeth Centuries*. London: Thames & Hudson, 1967.

Oertel, Robert. *Die Fruhzeit der italienischen Malerei*. Mainz: W. Kohlhammer Verlag, 1966.

Offner, Richard. "Giotto, Non-Giotto." *Burlington Magazine*, 74 (1939): 259–268.

Ogden, Dunbar H. *The Staging of Drama in the Medieval Church*. Newark, DE: University of Delaware Press, 2002.

Oikonomides, N. *Hommes d'affaires grecs et latins à Constantinople (XIIIe–XVe siècles)*. Montreal: Institut d'Etudes Médiévales Albert-La-Grand, 1979.

Osborne, John, and Claridge, Amanda. *Early Christian and Medieval Antiquities. Vol. 1: Mosaics and Wall Paintings in Roman Churches*. London: Harvey Miller, 1996.

Ostrogorsky, George. *History of the Byzantine State*. New Brunswick: Rutgers University Press, 1991 [1952].

Paatz, Walter. "Die Bedeutung des Humanismus für die toskanische Kunst des Trecento—ein Versuch." *Kunstchronik*, 5 (1954): 114–119.

Pacciani, Riccardo. "La Città come Palcoscenico: Luoghi e Proiezioni Urbane della Sacra Rappresentazione nella Città Italiana Fra Trecento e Quattrocento." *Ceti Sociali ed Ambienti Urbani nel Teatro Religioso Europeo del' 300 e del' 400*, Viterbo 30 May–2 June, 1985. Centro Studi sul Teatro Medioevale e Rinascimentale.

Pace, Valentino. *Arte a Roma nel Medioevo: committenza, ideologia e cultura figurativa in monumenti e libri*. Naples: Liguori Editore, 2000.

Padova, G. V. *Laude dugentesche*. Padua: Antenore, 1972.

Palladino, Pia. *Art and Devotion in Siena after 1350*. San Diego, CA: Timken Museum of Art, 1997.

Panofsky, E. *Renaissance and Renacences in Western Art*. San Francisco: Harper and Row, 1972 [Stockholm, 1960].

Paoletti, John. "The Strozzi Altarpiece Reconsidered." *Memorie Domenicane*, NS, 20 (1989): 279–300.

Paolucci, Antonio, and Chiarlo, Carlo R., eds. *Il Battistero di San Giovanni a Firenze/The Baptistery of San Giovanni Florence*. Modena: Franco Cosimo Panini, 1994.

Parks, George B. *The English Traveler to Italy, The Middle Ages (to 1525)*. Rome: Edizioni di Storia e Letteratura, 1954.

Paterno, Salvatore. *The Liturgical Context of Early European Drama*. Potomac, MD: Scripta Humanistica, 1989.

Pesenti, Franco Renzo. "Jacopo Torriti, Vasari e i mosaici del Battistero di Firenze." In *Scritti per L'Instituto Germanico di Storia dell'Arte di Firenze*. Eds. Cristina A. Luchinat et al. Florence: Casa Editrice Le Lettere, 1997. 17–22.

Petersen, M. R. *Jacopo Torriti: Critical Study and Catalogue Raisonné*. Diss. University of Virginia, 1989.

Pietrangeli, Carlo, et al. *Sancta Sanctorum*. Milan: Electa, 1995.

Pitts, F. L. "Nardo di Cione and the Strozzi Chapel Frescoes: Iconographic Problems in Mid-Trecento Florentine Painting." Diss. University of California, Berkeley, 1982.

Plant, M. "Portraits and Politics in Padua: Altichiero's Frescoes in the S. Felice Chapel, S. Antonio." *Art Bulletin*, 63, 3 (1981): 406–25.

Polzer, J. "Aristotle, Mohammed and Nicholas V in Hell." *Art Bulletin*, 46, 4 (1964): 457–69.

_____. "Aspects of the Fourteenth-Century Iconography of Death and Plague." In *The Black Death: The Impact of the Fourteenth-century Plague, Papers of the Eleventh Annual Conference of the Center of Medieval & Early Renaissance Studies*. Ed. Daniel Williman. Binghamton, NY.: Center of Medieval and Early Renaissance Studies, 1983. 108–130.

Ponte, Giovanni, ed. *Sacre Rappresentazioni Fiorentine del Quattrocento* Milan: Marzorati, 1974.

Prandi, A. "Roma medioevale. Urbs, Civitas, Cives." In *La coscienza cittadina nei comuni italiani nel Duecento* (Atti del XI Convegno del Centro di studi sulla spiritualita medioevale, Todi, 11–14 Oct., 1970). Todi: 1972. 231–262.

Ragone, Franca. *Giovanni Villani e i suoi continuatori. La Scrittura delle Cronache a Firenze nel Trecento*. Roma: Nella sede dell'Istituto Palazzo Borromini, 1998.

Richards, John. *Altichiero: An Artist and his Patrons in the Italian Trecento*. Cambridge: Cambridge University Press, 2000.

Rogers, Mark Christopher. "Art and Public Festival in Renaissance Florence: Studies in Relationships." Diss. University of Texas at Austin, 1996.

Roncaglia, M. *Les frères mineurs et l'Eglise grecque orthodoxe au XIIIe siècle (1231-1274)*. Cairo: Centre d'études orientales de la custodie franciscaine, 1954.

Romanini, Angiola Maria. "Il presepe di Arnolfo di Cambio." In *La Basilica romana di S. Maria Maggiore*. Ed. C. Pietrangeli. Firenze: Nardini, 1987. 171–176.

_____, ed. *Roma Anno 1300* (Atti della IV Settimana di Studi di Storia dell'Arte Medievale dell'Universita di Roma "La Sapienza"). Rome: L'Erma di Bretschneider, 1983.

_____, ed. *Roma nel Duecento: L'arte nella città dei papi da Innocenzo III a Bonifacio VIII* Torino: Seat, 1991.

Romano, Serena. *Eclissi di Roma, Pittura murale a Roma e nel Lazio da Bonifacio VIII a Martno V (129--1431)*. Rome: Argos, 1992.

Rubin, Miri. *Corpus Christi: The Eucharist in Late Medieval Culture*. New York: Cambridge University Press, 1991.

Rubinstein, Nicolai. "The Beginnings of Political Thought in Florence." *Journal of the Warburg and Courtauld Institutes*, 5 (1942): 198–227.

Runciman, Steven. *The Last Byzantine Renaissance*. Cambridge: Cambridge University Press, 1970.

Sanesi, E. *L'antico ingresso dei vescovi fiorentini*. Florence, 1931.

Schmidt, Victor M., ed. *Italian Panel Painting of the Duecento and Trecento*. Studies in the History of Art, 61, Center for Advanced Study in the Visual Arts, Symposium Papers, XXXVIII. Washington, DC: National Gallery of Art, 2002.

Schwarz, M. V. "Ephesos in der Peruzzi-, Kairo in der Bardi-Kapelle." *Romisches Jahrbuch*, 27 (1991/2): 23–57.

Setton, K. M. *The Papacy and the Levant (1204-151)*. Philadelphia: American Philosophical Society, 1976.

Sexton, Kim. "A History of Renaissance Civic Loggias in Italy: From the Loggia dei Lanzi to Sansovino's Loggetta." Diss. Yale University, 1997.

Smith, Janet G. "Santa Umilta of Faenza: Her Florentine Convent and Its Art." In *Visions of Holiness: Art and Devotion in Renaissance Italy*. Eds. A. Ladis and S. Zuraw. Athens: Georgia Museum of Art, 2001. 37–65.

Southard, Edna Carter. "The Frescoes in Siena's Palazzo Pubblico, 1289–1539: Studies in Imagery and Relations to other Communal Palaces in Tuscany." Diss. Indiana University, 1978.

Spence, R. "Pope Gregory IX and the Crusade." Diss. Syracuse University, 1978.

Starn, Randolf. *Contrary Commonwealth: The Theme of Exile in Medieval and Renaissance Italy*. Berkeley: University of California Press, 1982.

Steinhoff, Judith. "Artistic Working Relationships after the Black Death." *Renaissance Studies*, 14, 1 (2000): 1–45.

Sticca, Sandro. *The Latin Passion Play: Its Origins and Development*. Albany, NY: SUNY Albany, 1970.

_____. "Italian Theater of the Middle Ages." *Forum Italicum*, 14, 3 (1980): 275–310.

_____. *The Planctus Mariae in the Dramatic Tradition of the Middle Ages*. Trans. Joseph R. Berrigan. Athens: University of Georgia Press, 1988.

_____. "Italy: Liturgy and Christocentric Spirituality." In *The Theater of Medieval Europe: New Research in Early Drama*. Ed. Eckehard Simon. New York: Cambridge University Press, 1991.

Striker, C. L. "Crusader Painting in Constantinople: The Findings at Kalenderhane Camii." In *Il medio oriente e l'occidente nell'arte del XIII secolo*. Ed. H. Belting. Bologna: CLUEB, 1982.

Stroll, M. *Symbols as Power: The Papacy Following the Investiture Controversy*. Leiden: Brill, 1991.

Struchholz, Edith. *Die Choranlagen und Chorgestuhle des Sieneser Domes*. Munster: Waxmann, 1995.

Stubblebine, J. H. "Byzantine Influence in Thirteenth Century Italian Panel Painting." *Dumbarton Oaks Papers*, XX (1966): 87ff.

Suger, Abbot. *On the Abbey Church of St. Denis and Its Art Treasures*. Ed. and Trans. Erwin Panofsky and Gerda Panofsky-Soergel. Princeton, NJ: Princeton University Press, 1979.

Talbot, Mary-Alice. "The Restoration of Constantinople under Michael VIII." *Dumbarton Oaks Papers*, 47 (1993): 243–261.

Talbot Rice, David. *Byzantine Painting: The Last Phase*. London: Weidenfeld and Nicolson, 1968.

Tartuferi, Angelo. *La Pittura a Firenze nel Duecento*. Florence: Bruschi, 1990.

Toesca, P. *Gli affreschi del vecchio e del nuovo testamento nella chiesa superiore del Santuario di Assisi*. Florence: Artis monumenta photografice edita, 1948.

Toker, Franklin. "Gothic Architecture by Remote Control: An Illustrated Building Contract." *Art Bulletin*, 67, 1 (1985): 67–94.

Tomei, Alessandro. "Le immagini di Pietro e Paolo dal ciclo apostolico del portico vaticano." In *Fragmenta picta: Affreschi e mosaici stacati del Medioevo romano*. Ed. Maria Andaloro. Rome: Argos, 1989. pp. 41–45.

_____. *Jacobus Torriti pictor: Una vicenda figurativa del tardo Duecento romana*. Rome: Argos, 1990.

_____. "Bonifacio VIII e il Giubileo del 1300: la Roma di Cavallini e Giotto." In *Bonifacio VIII e il suo tempo*. Ed. Marina Righetti Tosti-Croce. Milan: Electa, 2000.

_____. *Pietro Cavallini*. Milan: Silvana Editoriale, 2000.

Toschi, Paolo. *L'antico dramma sacro italiano*. 2 vols. Firenze: Liberia Editrice Fiorentina, 1926.

Trachtenberg, Marvin. *Dominion of the Eye: Urbanism, Art and Power in Early Modern Florence*. New York: Cambridge University Press, 1997.

Trexler, Richard. "Florentine Religious Experience: The Sacred Image" *Studies in the Renaissance*, 19 (1972): 7–41.

_____. *The Spiritual Power: Republican Florence under Interdict*. Leiden: E. J. Brill, 1974.

_____. *Public Life in Renaissance Florence*. Ithaca: Cornell University Press, 1980.

Tripps, Johannes. *Das Handelnde Bildwerk in der Gotik Forschungen zu den Bedeutungsschichten und der Funktion des Kirchengebaudes und seiner Ausstattung in der Hoch- und Spatgotik*. 2nd ed. Berlin: Mann Verlag, 2000.

Tronzo, William. "The Prestige of Saint Peter's: Observations on the Function of Monumental Narrative Cycles in Italy." In *Pictorial Narratives in Antiquity and the Middle Ages*. Ed. Herbert Kessler and Marianna Shreve Simpson. Studies in the History of Art 16. Washington, DC: National Gallery of Art, 1986. pp. 93–112.

_____. "Setting and Structure in Two Roman Wall Decorations of the Early Middle Ages." *Dumbarton Oaks Papers*, 41 (1987): 477–492.

Tubbini, Mario. "Due Significativi Manoscritti della Catedrale di Firenze, Studio Introduttivo e Trascrizione." Thesis ad Lauream, n. 224, Pontificium Athenaeum S. Anselmi de Urbe. Rome: Pontificium Institutum Liturgicum, 1996.

Twig, Graham. *The Black Death: A Biological Reappraisal*. London: Schocken, 1984.

Tydeman, William, ed. *The Medieval European Stage, 500–1550*. New York: Cambridge University Press, 2001.

Underwood, Paul Atkins. *The Kariye Djami*. 4 volumes. New York: Routledge & Kegan Paul, 1967.

Valentini, R., and Zucchetti, G. *Codice Topografico della Città di Roma*. Rome: Instituto Storico Italian per il Medio Evo, 1946.

Van Der Ploeg, Kees. *Art, Architecture and Liturgy: Siena Cathedral in the Middle Ages*. Groningen: Egbert Forsten, 1993.

Van Os, Henk. "The Black Death and Sienese Painting: A Problem of Interpretation." *Art History*, 4, 3 (1981): 237–249.

____. "Tradition and Innovation in Some Altarpieces by Bartolo di Fredi." *Art Bulletin*, 77, 1 (1985): 50–67.

____. *Sienese Altarpieces 1215-1460*. 2 vols. Groningen: Egbert Forsten, 1990.

Varanini, Giorgio. "Due Laude Tardo-Dugentesche in Onore di San Francesco." In *Il Francescanesimo e il Teatro Medievale* (Atti del Convegno Nazionale di Studi, San Minato, 8–10 Oct., 1982). Ed. Federico Dogli. Castelfiorentino: Società storica delle Valdelsa, 1984.

Vogel, Cyrille. *Medieval Liturgy : An Introduction to the Sources*. Rev. and trans. William G. Storey and Niels Krogh Rasmussen, with the assistance of John K. Brooks-Leonard. Washington, DC: Pastoral Press, 1986.

Waetzoldt, S. *Die Kopien des 17. Jahrhunderts nach Mosaiken und Malerein in Rom*. Munich: Römische Forschungen der Bibliotheca Herziana XVIII, 1964.

Wainright, Valerie Linda. "Andrea Vanni and Bartolo di Fredi: Sienese Painters in Their Social Context." Diss. University of London, 1978.

____. "Conflict and Popular Government in Fourteenth Century Siena: Il Monte dei Dodici, 1355–1368." Atti del III Convegno di studi sulla storia sulla storia dei ceti dirigenti in Toscana tardo comunale, 57–80, Monte Oriolo, 1983.

Walter, Christopher, "Papal Imagery in the Medieval Lateran Palace." *Cahiers Archéologiques*, 20 (1970) 155–176.

Warner, David A. "Ritual and Memory in the Ottonian Reich: The Ceremony of *Adventus*." *Speculum*, 76 (2001): 255–283.

Warning, Rainer. "On the Alterity of Medieval Religious Drama." *New Literary History*, 10, 2 (1979): 265–292.

Webb, Diana. *Patrons and Defenders: The Saints in the Italian City-States*. London: Tauris Academic Studies, 1996.

Weinstein, Donald. "Critical Issues in the Study of Civic Religion in Renaissance Florence." In *The Pursuit of Holiness in Late Medieval and Renaissance Religion*. Eds. Charles Trinkaus with Heiko A. Oberman. Leiden: Brill, 1974. pp. 265–270.

Weitzman, K. "Various Aspects of Byzantine Influence on the Latin Countries from the Sixth to the Twelfth Century." *Dumbarton Oaks Papers*, XX (1966): 1–24.

____. "Icon Painting in the Crusader Kindgom." *Dumbarton Oaks Papers*, XX (1966): 51–83.

Wenzel, Siegfried, ed. *Fasciculus Morum: A Fourteenth-Century Preacher's Handbook*. University Park: Pennsylvania State University Press, 1989.

White, John. "Cavallini and the Lost Frescoes in S. Paolo." *Journal of the Warburg and Courtauld Institutes*, XIX (1956): 84–95.

Wieruszowski, Helene. "Art and the Commune in the Time of Dante." *Speculum*, 19 (1944): 14–33.

Wilkins, David. "Maso di Banco and Cenni di Francesco: A Case of Late Trecento Revival." *Burlington Magazine*, 111 (1969): 83–84.

Williman, Daniel, ed. *The Black Death: The Impact of the Fourteenth-Century Plague*. Papers of the Eleventh Annual Conference of the Center for Medieval and Renaissance Studies, New York, 1982.

Wills, Christopher. *Plagues: Their Origin, History and Future*. London: Diane, 1996.

Wisskirchen, R. *Die Mosaiken der Kirche Santa Prassede in Rom*. Mainz: P. von Zabern, 1992.

Wolff, Gerhard. *Salus Populi Romani die Geschichte romischer Kultbilter im Mittelalter*. Weinheim: Acta humaniora, 1990.

Wolff, R. "The Latin Empire of Constantinople and the Franciscans." *Traditio*, 2 (1944): 213–37.

Wollesen, Jens T. *Die Fresken von San Piero a Grado bei Pisa*. Bad Oeynhausen: A. Theine, 1977.

____. "Die Fresken in Sancta Sanctorum. Studien zur romischen Malerei zur Zeit Nikolaus' III." *Romische Jahrbuch fur Kunstgeschichte*, 19 (1981): 35–83.

____. *Pictures and Reality: Monumental Frescoes and Mosaics in Rome around 1300*. New York: Peter Lang, 1998.

Young, Karl. *The Drama of the Medieval Church*. 2 vols. Oxford: Clarendon Press, 1955 [1933].

Zanocco, Rizieri. "L'Annunciazione all'Arena di Padova (1305–1309)." *Rivista d'Arte*, XIX/II, 9 (1937): 370–373.

Zeitler, B. "Cross-Cultural Interpretations of Imagery in the Middle Ages." *Art Bulletin*, 76, 4 (1994): 680–694.

Ziegler, Philip. *The Black Death*. New York: Harper, 1971.

Index